Index of Art in the Pacific Northwest, Number 9

MASKED RITUALS OF AFIKPO

With Best Wishes
to Jean-Paul Dumont
Simon Ottenberg

Masked Rituals of Afikpo

THE CONTEXT OF AN AFRICAN ART

SIMON OTTENBERG

Published for the Henry Art Gallery
by the University of Washington Press
Seattle and London

Masked Rituals of Afikpo was published in
connection with an exhibition shown at the Henry
Art Gallery, University of Washington, May 24–
June 21, 1975.

This project is supported by a grant from the
National Endowment for the Arts in Washington,
D.C., a Federal agency.

Library of Congress Cataloging in Publication Data

Ottenberg, Simon.
 Masked rituals of Afikpo.

 (Index of art in the Pacific Northwest; no. 9)
 Bibliography: p.
 Includes index.
 1. Ibo tribe—Rites and ceremonies. 2. Masks
(Sculpture)—Nigeria. I. Henry Art Gallery.
II. Title. III. Series.
DT515.42.089 731'.75'096694 74–26954
ISBN 0–295–95391–8

The text of this book was set in various sizes of
Linofilm Super-Quick Optima Medium and Bold.
The black and white photographs are reproduced
by offset lithography, 150-line screen with
elliptical dot. Composition and printing by the
Department of Printing, University of Washington.
Color plates printed by Graphic Arts Center and
binding by Lincoln and Allen, Portland, Oregon.
Designed by Audrey Meyer

To J. Chukwu Okoro, Nnachi Enwo, Nnachi Iduma, Ɔto Ɛzɛ,
and Thomas Ibe, who have made this book possible

Index of Art in the Pacific Northwest

Foreword

This ninth volume in the Index of Art in the Pacific Northwest differs from its predecessors both in its length and in its approach to the material it discusses. Written by Simon Ottenberg, professor of anthropology at the University of Washington, it is a full-scale description and interpretation—social, psychological, and aesthetic—of the masks of the Afikpo Igbo of Nigeria, and of the various rituals in which these are used. The masks from the author's collection, which are being shown in the exhibition that accompanies the publication of this volume, were first exhibited at the Henry Art Gallery in 1964, mounted at that time with almost exclusive attention to their qualities as works of art. The Henry Gallery is delighted to have this opportunity to show them once more, with their aesthetic value further enhanced by the extensive analysis contained in this volume. We also wish to express our gratitude to the National Endowment for the Arts for the grant that made the exhibition and the book possible.

It is interesting to note that this is the fourth volume of the Index of Art, a series devoted to the documentation of art in the public and private collections of the Pacific Northwest, to deal with materials from outside the dominant Western cultural tradition. Following upon a succession of exhibitions of artworks from other cultures begun at the Henry Gallery in 1969, it demonstrates a deepening awareness of the importance of such material among the collectors of the Pacific Northwest, who continue to acquire and have so generously lent objects for these exhibitions.

LaMar Harrington

Associate Director, Henry Art Gallery

Preface

In these pages I have tried to synthesize what I know of the masquerade tradition of one people, the Afikpo of southeastern Nigeria. Styles, usages, cultural contexts and symbols, functions, and aesthetics are discussed in order to arrive at a general view of Afikpo mask art. Much has been written about African art, but generally these studies have emphasized a single facet, such as style or function. In presenting an overall view of the masquerade practices of one group, I try to break ground for a fuller perspective, one that is more comprehensive in orientation and yet, I hope, sensitive and appreciative.

In collecting my data I used traditional anthropological field methods. Discussion, observation, interviewing, and photography are the elements on which my information rests. I employed no special technical field devices or schemes, although today I would certainly use some of them if I were to return for further research. If my data on Afikpo art seem rich, credit is due to the people there who helped me gather the information. My guide and interpreter on my first field trip, Nnachi Enwo, the son of a famous Mgbom village leader and a prominent individual himself, had a good friend, J. Chukwu Okoro, who lived in another compound of the community. I was introduced to him and we became friends. Discovering that he was a carver, I asked him to make some masks for me; while watching him work, I began to acquire an understanding of the Afikpo masquerade tradition. Chukwu was an expert on many of its aspects, and through his enthusiastic guidance and that of Nnachi Enwo, I gathered a great deal more information on Afikpo art than I had originally intended.

I have already written a good deal about the social groupings and social interrelationships of the Afikpo, particularly on their interesting form of double unilineal descent (S. Ottenberg 1968) and about their political life (S. Ottenberg 1971b). The present work is meant to complement these other writings by focusing on cultural matters rather than on social relationships, and by concerning itself more with Afikpo ideas, concepts, feelings, and values, with humanity and the nature of man and woman, than with the details of social structure and social interaction. And I have tried to introduce something of the Afikpo's understandings and views of his own art, his own

perceptions and evaluations of his creations (S. Ottenberg 1971d). Little has been written on this topic for Africa. I have blended a Western eye with Afikpo concepts in an attempt to provide both an insider's and an outsider's view as one organic whole. The external view is a mixture of anthropology, art history, and my personal reactions to Afikpo art. The insider's orientation includes the statements and reactions of Afikpo—both those skilled and those unskilled in aesthetic matters—and my observations on how Afikpo relate to artistic events. I consider my synthesis to be only partially successful, and I hope that it will encourage others to go ahead with this kind of work, for we particularly need understandings rather than simply factual detail.

Field research was carried out at Afikpo between December 1951 and February 1953, with the aid of a Social Science Area Research Fellowship and a grant-in-aid from the Program of African Studies, Northwestern University. There was a second period of work between September 1959 and June 1960, with occasional visits until December 1960, under a grant from the National Science Foundation. This book was written in the summer of 1970 and the academic year of 1970/71, during a sabbatical leave from the University of Washington and with the aid of a John Simon Guggenheim Memorial Foundation Fellowship. Most of it was prepared while I was a visitor at the Institute of African Studies of the University of Ghana—a stimulating place to work, with a good library and interesting colleagues and students. Publication has been most generously aided by a grant from the National Endowment for the Arts. To all of these organizations I owe a deep debt of gratitude; it is they who have made this book possible.

My first thinking on African art was stimulated by my teachers in graduate school, William R. Bascom and the late Melville J. Herskovits. That I put aside, at the time, most of what they tried to teach me was no fault of theirs. My interests lay elsewhere. But the stimulus remained and it led me to collect the data on which this book is based. In the field it was not only through J. C. Okoro and Nnachi Enwo that I became involved in art, but also by the interest of Nnachi Iduma, a rising, middle-aged politician of Mgbom village who held a rich knowledge of local ritual. And without the

assistance of the senior leader of one of the village plays, Ɔto Ɛze, who in 1952 went over an entire production with me, a key section of this book could never have been written. On the second field trip Thomas Ibe, a friend and field assistant, worked enthusiastically to guide me to see and understand artistic things that I would otherwise have missed. These are but a few of the many persons who assisted me in gathering data for this book. In addition, my former wife, Dr. Phoebe Miller, who also carried out anthropological research at Afikpo, helped me to understand a great deal about Afikpo culture.

In writing up my research I have been particularly assisted by discussions with Professors René A. Bravmann, Herbert M. Cole, Daniel J. Crowley, Robert F. Thompson, and Meyer Fortes. The publications of Robert F. Thompson and William R. Bascom on African art have been extremely helpful. During my stay in Ghana I greatly benefited from a graduate seminar on African drama directed by Professor J. H. Nketia at the University of Ghana. I was also helped by a course on African art taught by A. K. Quarcoo, and by the reactions of persons to some of my ideas tried out in several lectures and discussion groups at the university and at the Ghana Museum in Accra (S. Ottenberg 1971c, 1971d). The field photographs are my own, but the mask portraits are the work of Johsel Namkung, with the exception of figures 8, 10, 22, 25, and 27, courtesy of the Robert H. Lowie Museum of Anthropology, Berkeley, California. I take this opportunity to thank all of these people, for they have contributed in numerous ways to this book.

Finally, my wife Nora, although she has never been to Afikpo, has encouraged and stimulated me to write this book. Her own strong interest in art, albeit that of Rome, ancient China, and the traditional and modern forms of the Pacific Northwest, has been infectious, as has been her willingness to talk with me about my work and to reflect on it with me. Her own view of persons— much more psychological than mine—has broadened my perspective in the arts. I cannot really thank her properly; the book itself is the only gratitude that I can show her.

Contents

Illustrations

FIGURES

PLATE I

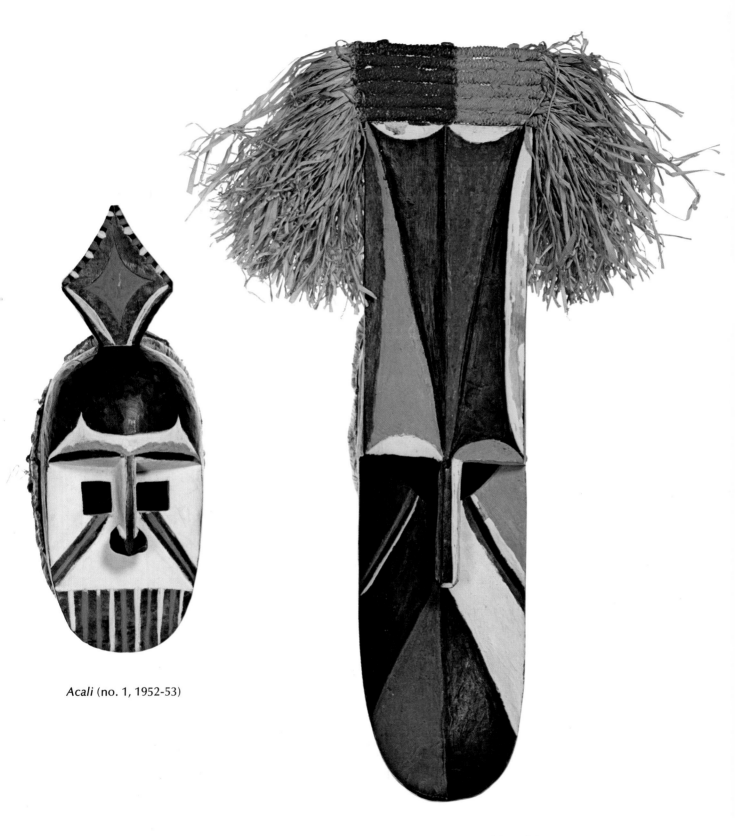

Acali (no. 1, 1952-53)

Igri (no. 2, 1959-60, Edda style)

PLATE II

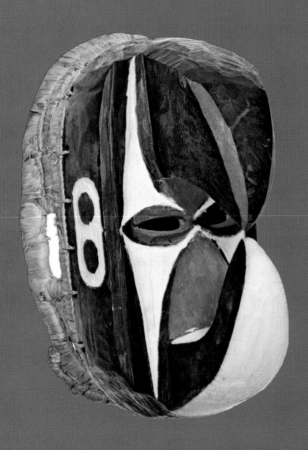

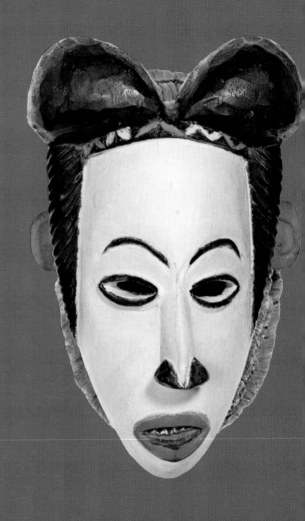

Ɔtogho (no. 1, 1952-53) Ibibio (no. 1, 1952-53)

THE MASKS

CHAPTER I

The Setting

Afikpo Village-Group, located on the west bank of the Cross River just where it turns southward, is in the East Central State of Nigeria (Map I). With a population that I estimate to have been around 35,000 persons in 1960, when I last carried out research there, it is one of some two hundred village-groups of the Igbo, each of which had, until recent times, a certain degree of autonomy, for there never was a single Igbo state. Cultural uniformity has not been the rule among the Igbo; for many years they have been an expanding and absorbing people, and the village-groups vary greatly in their features—in forms of kinship, political styles, and art. It should be noted at the very outset that I do not consider Afikpo to be "typically Igbo" (whatever that means) in cultural and social forms; rather, they are a blend of Igbo and other cultures to their south and east.

The Afikpo belong to an Igbo subgroup called Ada or Edda (Forde and Jones 1950, pp. 51–56), which includes the Okpoha, Edda, Amaseri, and Unwana village-groups, all of which border on the Afikpo, and the Nkporo and Akaeze, both short distances away (Map II). The Ada have many common features in their history and culture. They have past associations with the famous slave-trading Igbo of Aro Chuku, some forty miles to the south, and their population includes other immigrant groups from various Igbo areas, as well as a residue of ancient non-Igbo peoples having Cross River cultures (the earliest known peoples in the Ada area). The Ada are known for the prevalence of double unilineal descent, for well-developed age grade organizations, for their military and head-taking activities in the past, and for their characteristic forms of art and rituals. These features differentiate them from other Igbo and from the Cross River groups. With reference to aesthetic matters and other cultural concerns, Edda Village-Group seems to have been the nucleus, with new features and rituals moving out to the neighboring Ada peoples. Of the remaining Ada groups, Afikpo is the largest and most important.

Afikpo Village-Group has had a mixed past, quickly discernible if one tries to collect the history of any particular village there. It was probably originally composed of small settlements of a number of matrilineal Cross River peoples, one of whom today is called the Ego in the legends. Some several hundred years ago groups from Aro Chuku and other Igbo areas to the west and northwest of the village-group, primarily patrilineal in organization, moved in and conquered the area. The region became closely linked to the European slave trade through the hands of the Aro Chuku people who came to dominate Afikpo. Europeans, however, did not go there at this time, as far as we know. Afikpo is thus composed of an amalgam of Cross River and Igbo cultures. Today, non-Igbo peoples still live to the east of the Afikpo on the other side of the Cross River.

The English, using African troops, fought their way into the village-group in 1902 and the area became, and still is today, an administrative headquarters and an educational center for the much larger Afikpo Division. Peace led to a loss of much power for the Aro, to a cessation of military activities, and to greatly increased trade and contacts of Afikpo with other peoples. Thus, since the coming of the British, there has been considerable fishing activity by Afikpo on the Cross River from many miles upstream down to the coast, and a good deal of trade with the coastal city of Calabar in the Efik ethnic area. Afikpo have also had increasing contact and trade with other Igbo to the west, southwest, and north. It is not surprising, therefore, that the mask tradition at Afikpo shows recent Efik-Ibibio-Anang influences on the one hand and influences from Igbo areas on the other.

The twenty-two villages of Afikpo are divided into five subgroups by historical and cultural differences too detailed to discuss here (see table 1; Map III; and S. Ottenberg 1971b, chap. 8). Each of these five has some special masquerade feature that characterizes it. In particular, the northern subgroup of communities, Ozizza, somewhat isolated from the rest of the village-group, has different customs, shrines, and rites than other Afikpo areas. My own work was carried out primarily in the Itim subgroup, and what I describe here centers on these villages, especially Mgbom and Amuro. This subgroup has had direct and obvious contacts with Edda Village-Group, which borders it, more so than some other sections of Afikpo. Its villages are also the only ones to have certain secret society initiation rituals and a formal priest and assistant priest for each secret society.

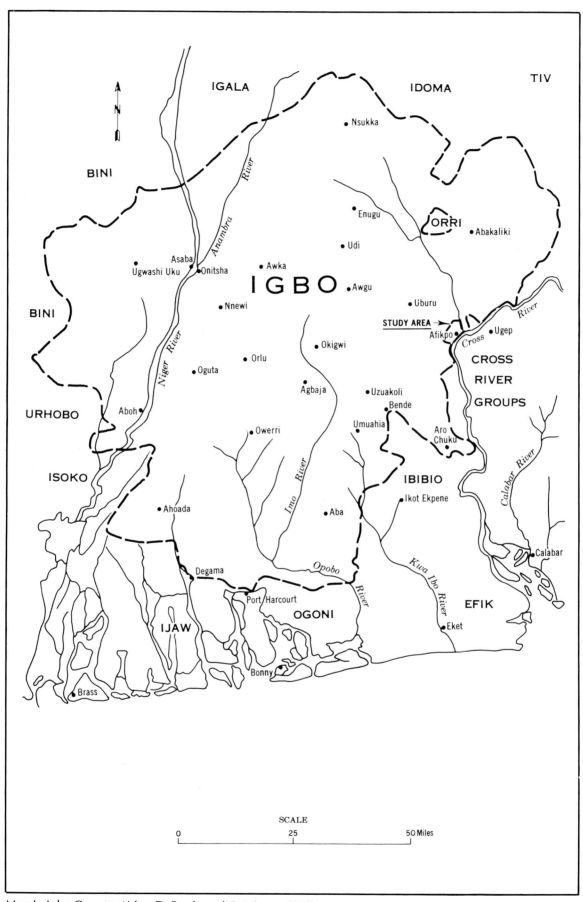

Map I. Igbo Country (After D. Forde and G. I. Jones 1950)

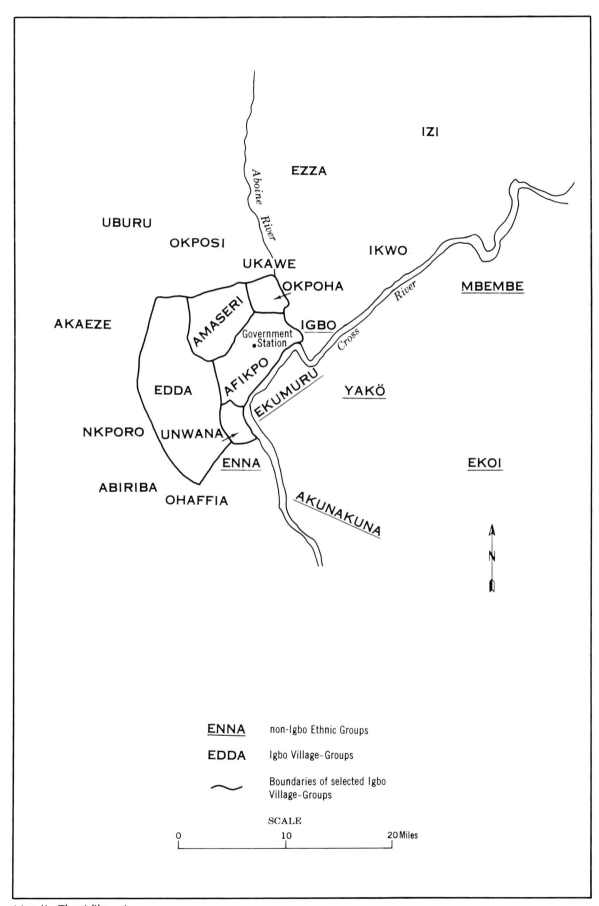

IZI

EZZA

UBURU

OKPOSI

UKAWE

OKPOHA

AKAEZE

IKWO

MBEMBE

AMASERI

IGBO

Government
•Station

EDDA

AFIKPO

EKUMURU

YAKÖ

NKPORO

UNWANA

ENNA

EKOI

ABIRIBA

OHAFFIA

AKUNAKUNA

Aboine River

Cross River

N

ENNA non-Igbo Ethnic Groups

EDDA Igbo Village-Groups

⁓ Boundaries of selected Igbo
Village-Groups

SCALE

0 10 20 Miles

Map II. The Afikpo Area

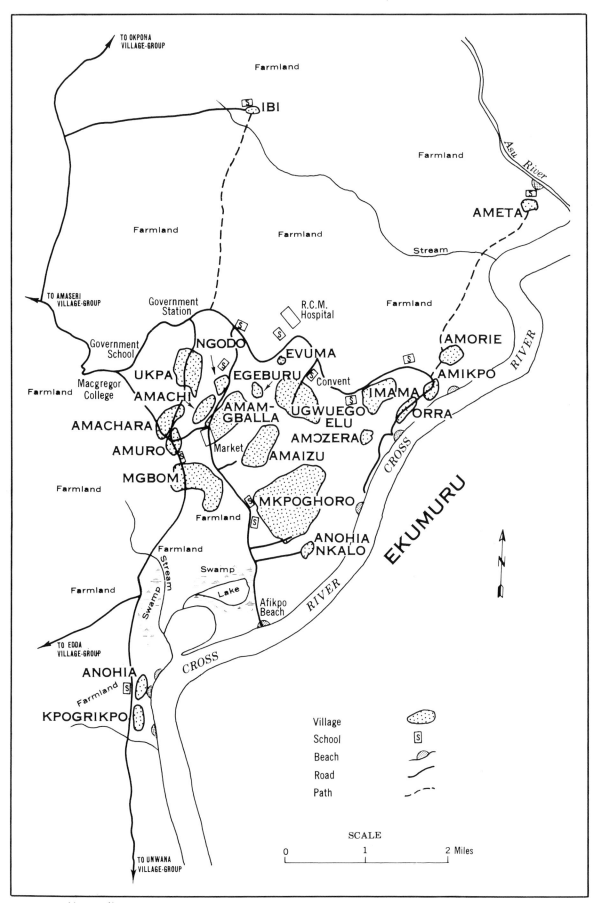

TO OKPOHA
VILLAGE-GROUP

Farmland

IBI

Farmland

Farmland

Farmland

Asu River

AMETA

Stream

TO AMASERI
VILLAGE-GROUP

Government
Station

R.C.M.
Hospital

Farmland

AMORIE

Government
School

NGODO

EVUMA

AMIKPO

UKPA

EGEBURU

Convent

RIVER

Macgregor
College

AMACHI

Convent

IMAMA

Farmland

AMAM-
GBALLA

UGWUEGO
ELU

ORRA

AMACHARA

AMOZERA

AMURO

Market

AMAIZU

CROSS

MGBOM

MKPOGHORO

Farmland

EKUMURU

Farmland

Farmland

Stream

Swamp

ANOHIA
NKALO

Farmland

Swamp

Lake

Afikpo
Beach

RIVER

N

TO EDDA
VILLAGE-GROUP

Swamp

CROSS

ANOHIA

Farmland

KPOGRIKPO

Village

School

Beach

Road

Path

SCALE

0 1 2 Miles

TO UNWANA
VILLAGE-GROUP

Map III. Afikpo Village-Group (1960)

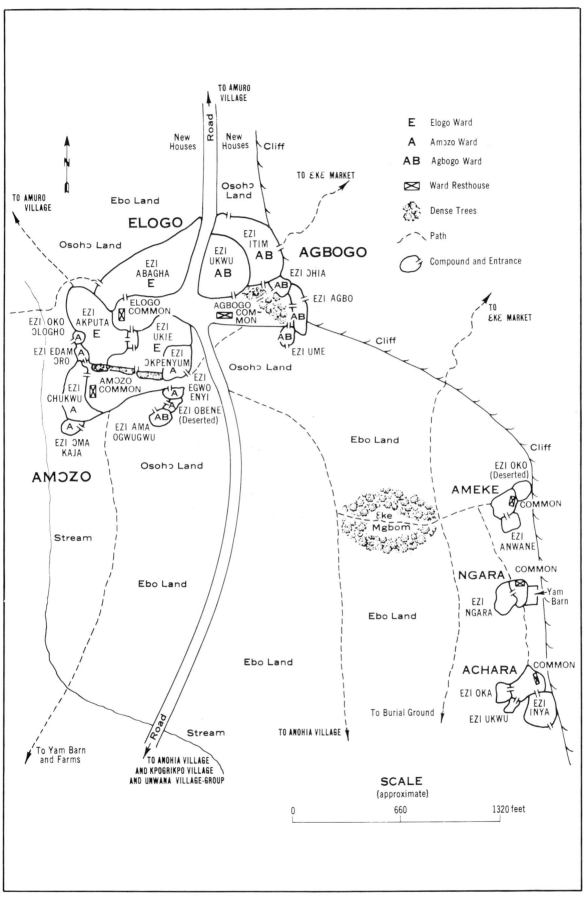

Map IV. Mgbom: A Large Afikpo Village (1960)

Legend:

- E — Elogo Ward
- A — Amɔzo Ward
- AB — Agbogo Ward
- ⊠ — Ward Resthouse
- Dense Trees
- Path
- Compound and Entrance

ELOGO

- New Houses
- Ebo Land
- Osoho Land
- EZI ABAGHA E
- EZI OKO OLOGHO
- EZI AKPUTA E
- ELOGO COMMON
- EZI EDAM ORO A
- EZI UKIE E
- EZI OKPENYUM A
- EZI CHUKWU A
- AMOZO COMMON
- EZI EGWO ENYI A
- EZI OBENE (Deserted) AB
- EZI OMA KAJA A
- AMƆZO
- Osoho Land
- Stream
- Ebo Land
- Ebo Land

Road — TO AMURO VILLAGE

TO AMURO VILLAGE

Cliff

TO ƐKƐ MARKET

AGBOGO

- EZI ITIM AB
- EZI UKWU AB
- EZI ƆHIA
- AB
- AGBOGO COMMON
- EZI AGBO
- AB
- AB
- EZI UME
- Osoho Land
- Cliff

TO ƐKƐ MARKET

Ebo Land

Ɛke Mgbom

Ebo Land

Ebo Land

AMEKE

- EZI OKO (Deserted)
- COMMON
- EZI ANWANE

NGARA

- COMMON
- EZI NGARA
- Yam Barn

ACHARA

- COMMON
- EZI OKA
- EZI INYA
- EZI UKWU

To Burial Ground

TO ANOHIA VILLAGE

Road — Stream

To Yam Barn and Farms

TO ANOHIA VILLAGE AND KPOGRIKPO VILLAGE AND UNWANA VILLAGE-GROUP

SCALE
(approximate)

0 660 1320 feet

7

TABLE 1
Afikpo Subgroups

Subgroup	Number of Villages	Names of Villages	Population[a]	
			Village	Subgroup
Mkpoghoro	1			3,662
		Mkpoghoro (or Ndibe)	3,662	
Ahisu	8			7,671
		Amachara	790	
		Amachi	479	
		Amamgballa	989	
		Egeburu	394	
		Evuma	213	
		Ibi	635	
		Ngodo	1,366	
		Ukpa	2,805	
Ugwuego	2			3,020
		Amaizu	1,366	
		Ugwuego Elu	1,654	
Ozizza	6			5,515
		Ameta	334	
		Amikpo	1,475	
		Amorie	687	
		Amɔzera	183	
		Imama	1,351	
		Orra	1,485	
Itim	5			6,437
		Amuro	1,044	
		Anohia	1,757	
		Anohia Nkalo	581	
		Kpogrikpo	997	
		Mgbom	2,058	

[a]Population figures are based on Nigeria, Census Superintendent, 1953–54, pt. IV, pp. 25–26. The figures are at least 20 percent too low; for some villages they are considerably lower.

The subgroup contains agricultural settlements (Mgbom and Amuro), fishing villages (Anohia and Kpogrikpo), and a mixed community (Anohia Nkalo). The masked rites in the fishing villages differ somewhat from those in the farming ones, which I know best. This dichotomy of farming and fishing with the concomitant ritual variations occurs elsewhere in Afikpo.

For the farming groups at Afikpo, yams, the principal crop, are grown almost exclusively by men, while females raise cassava, coco yam, corn, and many other forms of vegetables. The work is hard, for Afikpo is not a rich farming area, with its sandy soil and sandstone ridges. Farming activities —in fact, the whole life of the people—depend upon a four-day week. *Orie* is a farm day, although in the Itim subgroup of Afikpo some mask rituals are held at this time during the ceremonial season. The next day, *ahɔ*, is a small market day: some persons farm, but others do not. *Nkwɔ*, which follows, is also a farm day. This is followed by *ɛkɛ*, the major Afikpo market day, when no farm work

PLATE III

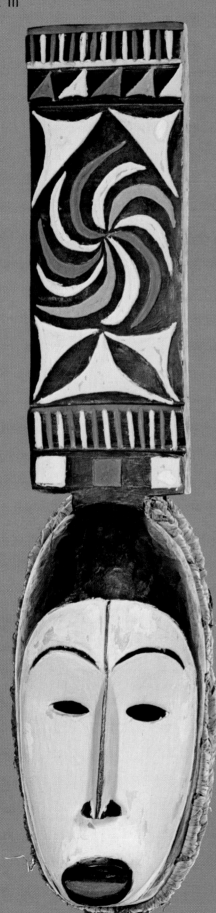

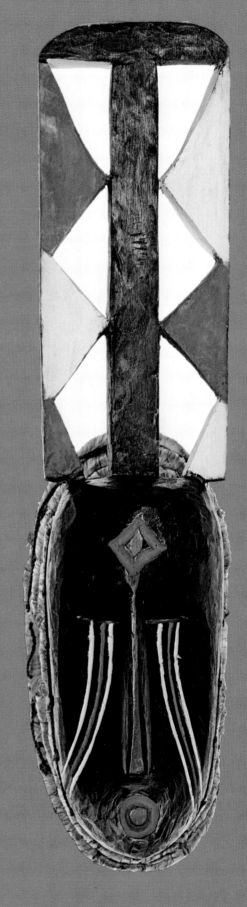

Mba (no. 1, 1952-53)

Mba (no. 3, 1959-60, *mkpere* style)

PLATE IV

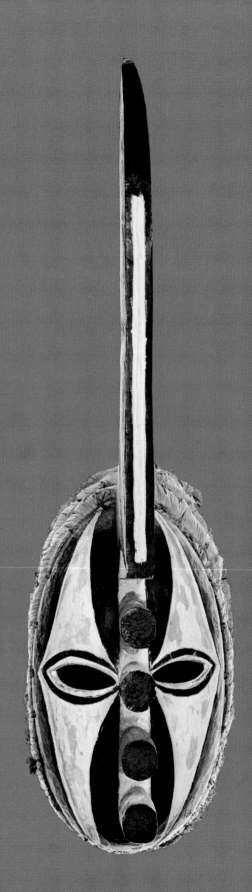

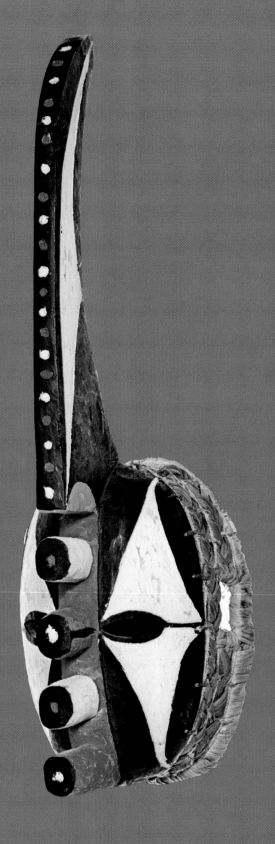

Mma ji (no. 2, 1959-60)

Mma ji (no. 1, 1952-53)

is done and many persons visit the central market to buy and sell. It is the major time at Afikpo for feasts, ceremonies of all kinds, and masked rites. The traditional month of twenty-eight days is composed of seven four-day weeks. The Afikpo weekly and monthly cycle forms the basic time sequence for the presentation of the masked rites. But the Afikpo week has now become integrated to some extent with the European one, so that the very best day for ceremonies in either context is an εkε day that falls on a Sunday.

The village-group is permeated with relationships of descent, both patrilineal and matrilineal (S. Ottenberg 1968). Everyone is a member of both types of organizations. The patrilineal ones are organized on a residential basis, associated with ancestral shrines and other shrines concerned with human and crop fertility. These agnatic groupings are the basic political units through which the village administration is organized. The members of the matrilineal groupings are widely dispersed within Afikpo. Each matrilineal clan has a central shrine at the compound of its priest, the usual meeting place of the descent group. The uterine groups are the primary land-holding organizations, and this interest provides the major basis for their unity. Inheritance of most property also goes through the uterine line. The life of an Afikpo is thus divided between the patrilineal activities of everyday life in the compounds and the matrilineal concerns involving property and inheritance.

The Afikpo village is the focus of the masked rites. This settlement, joining together persons of different patrilineal and matrilineal groupings, is the basis of much of the political life of the Afikpo. In addition, each village has its own secret society (S. Ottenberg 1971b), with which the masks are directly associated and through which the masked rites occur.

The villages vary greatly in size, being composed of from several hundred to over two thousand persons (Table 1), and it is difficult to talk about them as a whole. Each one is composed of a number of compounds made up of patrilineal groupings. The compounds in the medium-sized and larger villages (see Map IV) are grouped into wards. Each ward has its own men's resthouse (S. Ottenberg 1972b), located in an open central space which I call a common. In the resthouse, the meeting place of the ward elders, the masks and other ritual equipment of its members are stored. The village elders assemble in the resthouse of the senior ward of the village, usually the oldest residential section of the community; in this structure is found the sacred village wooden gong. This ward common, which is also the village common, is where most of the masked rites are held.

The Afikpo village, unlike many other Igbo communities, is compact and clearly delineated. It has a well-developed system of age groupings for both men and women, authority and activity being largely determined by one's age relative to that of other persons. The village is led by its elders, as are its wards and compounds, but there is no real village chief. Rather, some elders—usually from the older compounds of the settlement—are more influential than others. It is largely the elders acting as a group who rule the village and, likewise, their own particular compounds.

Each village also has a secret society, although it is not really very secret, for it lacks an exclusive character. All males are expected to join it by the time that they are adults, and many become members as children. It thus excludes females and uninitiated boys. The secrecy involves much of the initiation rites, certain titles taken within it, and some other events. The masquerades, which form one of its principal activities, are generally held in public, although there are secrets associated with them.

There is a good deal of variation in the organization and the activities of the village secret societies at Afikpo. As we have seen, the Itim villages have special ritual leaders lacking in other Afikpo secret societies. The forms of initiation also differ considerably among the villages, as do some of the masked rites. These reflect the complex and particular histories of the different communities. But every secret society is led by two groups, the holders of certain senior titles in the society and a voluntary ritual group which directs many of the society's rituals and controls its spirit shrine. The cooperative activities of these two groups of influential persons form the leadership of the society.

The secret organization draws males apart from females by exclusion and it is said by Afikpo to be the main agency "to keep women in their place." Females often fear it, its power and its spirit, and if one violates its regulations or sees activities that women are forbidden to witness, it is believed that she is defiled and will no longer become pregnant; to atone for her error, she must make a purifying sacrifice at the spirit shrine. The dichotomy between the sexes, in their life styles and activities, is great at Afikpo, and the secret society reinforces it. No women wear masks or directly take part in the society's activities—the thought of such action would be considered ridiculous by males. Men see their own roles as yam farmers, fishermen, palm wine tappers, traders, and politicians. Women carry on petty trade, make pots to sell, and farm other crops than yams; but they are, above all, domestic childbearers, the receivers of the vital fertility seeds of the male. The sense of sexual distinctiveness is strong at Afikpo, and the men, as a whole, prefer to keep it that way.

There are also secret societies for the

uninitiated boys, which emulate the activities of the village secret society, with a similar exclusion of females. The lads have their own shrines, resthouses, ceremonial areas, and masquerades, located in the back of the compounds. These boys' societies used to be quite elaborate and every uninitiated male took part, but today their importance is declining.

The Afikpo villages are joined together as a village-group by a common system of leadership through the senior age grades; through certain general shrines and priests, such as one for yams and another to control rain; and by a sense of common culture and identity, contrasted with other Igbo and non-Igbo (S. Ottenberg 1971b, pt. 2). While persons from different villages sometimes participate together in the masquerades, and other cross-village mask activities do occur, the village-group does not form the basis of the masquerades: these are organized at the village level. The leadership of Afikpo as a whole has no control over these aesthetic rituals.

What is common to Afikpo is the importance of age factors and the sexual distinctions. Individual achievements for men in politics and economic activities are highly encouraged, but cooperation and consensus in decision-making are also stressed. These major themes in Afikpo life are intimately bound up with its masquerades.

In analyzing my data I have sought, wherever possible, to distinguish between three aspects: the sociological, the psychological, and the aesthetic. I have tried to discern the social relationships involved in the organization and the presentation of the masquerades, the relationship of the viewers and the players, and the social roles of the Afikpo artists. I have also explained, where I felt that I could do so, in what ways the masked rites symbolically express social ties and conflicts at Afikpo. I see all of these elements as essentially explanations of a sociological sort.

But I also have viewed some behavior associated with the masks and the rituals in terms of psychological mechanisms involving individuals. The masked plays recall childhood feelings and states, reflect personal hostilities, and involve various emotions of the individual. These are, of course, difficult matters for the anthropologist to get at without using highly specialized techniques. Yet, I would feel remiss if I did not attempt some psychological interpretations, for these clearly deepen and broaden an understanding of the masked events.

Lastly, I have made some statements concerning the nature of Afikpo aesthetics. Little attempt has been made to study African aesthetics until recent years (Willett 1971, pp. 206–22; Wolfe 1969, pp. 3–4). At Afikpo it is possible to say some things about beauty and ugliness, about what art elements persons do or do not like. Also,

I comment on what components of artistic activity and of the artistic product itself seem to fit together to form an acceptable whole, to form acclaimed or desired patterns. I believe that aesthetics is very much concerned with the interesting arrangement of elements, and I hope that this work reflecs some of the ways in which the Afikpo organize aesthetic elements into wholes.

Afikpo Art

What justification is there for separating masks at Afikpo from other forms of art work? What reasons make it possible to handle the masked ceremonies distinct from other rituals that also employ elements of dance, song, and display? Is this not a distinction of Western culture, where masks are displayed in museums or hung on the walls at home as trophies of an African voyage (S. Ottenberg 1971d)? Is the separation of masks and masked ceremonies from other forms of plastic art, dance, and play the imposition of our world onto the African?

The Afikpo use the same word, *ihu*, for "mask" and for "face," making it clear by the context what is actually meant. The pidgin English term for wooden masks is "stick," a term generally used for any piece of wood. The English word "mask" is not often heard at Afikpo. A carver is designated by two different terms (discussed below) that also mean "carpenter." These overlaps suggest that masks and masked plays and dances may not be sharply delineated from other features at Afikpo.

On the other hand, masks as sacred objects are made under different conditions, and maintained and stored in different ways, than other objects of wood such as doors, stools, and chairs. Wooden masks are also the major sculptural form at Afikpo. There are very few carved wooden statues, posts, or doors, and virtually no sculpture in clay (S. Ottenberg 1972b, p. 88). The masks are the major Afikpo plastic art form, and for this reason they require special treatment.

There is further justification for a discrimination between masked and unmasked rituals on the basis of sociological ideas. Covering the face for a ritual creates a special form of social relationship between the masked players and their viewers. There is an aura of secrecy and "make-believe," strengthened by the idea of hidden identity, for no one is supposed to know who the masker is—although many persons do. Again, the masked players all are males and members of the village secret society. On a parallel are the uninitiated boys (*enna*), who by the age of five or so have begun to form their own imitation secret societies and to produce their own masquerades. The sense of secrecy and mystery of the adult secret society extends to the masked players. No one can take off masks in

public. They are stored in resthouses open only to members of the society, and made and worn only during the period of the year when the secret society is active. It is true that there are publicly held nonmasked rituals of the society involving music, dance, and display, such as sections of some initiation rituals. But masks are worn only in the society's activities, except for the children's imitation societies, and nowadays at some children's Christmas dancing ceremonies.

The masks allow individuals to behave in unusual ways toward one another and toward their viewers. In a conscious, planned manner, men move in exaggerated ways, say unorthodox things, act differently than they ordinarily do. The corollary is that the types of social relationships between the masked persons and the unmasked audience are prescribed and restricted in special ways; only a narrow range of interactions can occur, and in forms often differing from unmasked behavior.

Putting on a mask turns a person into a spirit (*mma*). Masked dancers have a supernatural quality lacking in other ritualists. While priests and diviners at Afikpo also have sacred qualities, they are not themselves spirits; rather, their power and skill rest in their ability to contact and manipulate supernaturals for the welfare of others. The masked person is not generally thought of as a dangerous or powerful spirit, as other supernaturals, but as a positive force of an active nature. The masks are also associated with the deity of the secret society called *egbele*, or by a variety of other names. Although this spirit does not reside in the face coverings but remains in the sacred bush, *mma* is considered a manifestation of it. It is believed that if a man is not on good terms with *egbele* and he puts on a mask, he will become ill; occasionally it is said that he may die. Chukwu Okoro, the Afikpo carver, claims that he knew a man from Ugwuego village who died for this reason. If a man dreams that he has covered his face with a mask in the compound (usually forbidden) or that he is being chased by a mask, it may be a sign that he has angered *egbele* by some violation of a taboo and that he should repeat the sacrifice associated with the secret society initiation to "cool" the matter.

If one wishes to address *egbele*, say in a sacrifice, one does not call the spirit by its name,

for it is too powerful and would be insulted; out of respect one addresses it as *mma*, which here almost means "sir." But one can refer to the spirit by its proper name. People can have *egbele* in them as a form of *mma*, as in the case of the dreamers mentioned above. But *mma* in an individual can also be a positive force. I once showed the secret society priest at Mgbom village some of the photographs that I had taken of the *ɔkumkpa* masquerade. He seemed to admire them and he said that I had *mma* in me. In the plays, then, the process of masking is a conscious and deliberate attempt to produce *mma* in the person, to connect the person with the spirit of the secret society.

Mma is also a term used for any unknown spirit or thing. Afikpo say that the white man or a typewriter is *mma*, for they are not familiar with them. And women regard masked players as *mma* for much the same reason. So *mma* has a quality of uncertainty about it. Sometimes a diviner will inform a client that he is being troubled by a *mma*, but without indicating anything more specific. He will ask the person to carry out a sacrifice in order to remove it. The spirit of a dead person is *mma*; likewise, the ancestors, generally patrilineal ones, are called *ndɛ mma*, or "people-spirits," and the main patrilineal shrine house is referred to as *mma obu* ("spirits-house"). Nevertheless, the masquerade players are not considered to be representations of ancestors, though they, like departed persons, represent tradition.

There are twelve types of wooden masks at Afikpo, in addition to one calabash form and two main types made of netting. These represent the basic corpus of Afikpo face coverings, except for the numerous masks of coconut shell and coconut bark fiber, calabash, netting, leaf, paper, and cardboard—generally of lesser aesthetic quality—worn by young uninitiated boys in their own imitation secret society. Each one of the mask forms of the adult society has its own stylistic features easily recognizable by Afikpo and one or more names by which it is referred to. Many of the masks are associated with particular forms of behavior. A mask is sometimes found with a certain type of costume; sometimes the names of the mask and costume are the same. However, if one puts on a certain type of mask, one is not usually expected to wear a certain form of costume and behave in certain ways; rather, if one wishes to act in a particular way, then a specific costume and mask are appropriate.

The masks are absent from about the end of February to September, during which time, from the middle of the dry season to the beginning of the rainy period, the farmlands are cleared and the crops planted and tended. Few ritual activities occur other than the *rites de passage* associated with birth, death, and marriage, although a few title ceremonies are held at this time, and there is

a wrestling season about June. It is a quiet time of hard physical labor, one which focuses on productivity, on gaining material goods and wealth through farming and fishing. It is also the major fishing season on the Cross River. Foodstuffs are obtained that become a major part of the resources to be used during the rest of the year, either directly or by conversion to cash.

The ceremonial period, in which the masks appear, begins with the New Yam Festival in late August or early September, when the new yams are harvested and eaten. The rains are then upon the village-group. Immediately after this festival the various Afikpo villages carry out, in turn, the four-day Rainy Season Festival *(iko udumini)*. Not long afterward the secret society in each village becomes active and the masks are seen. Initiations, plays, and dances continue until late February or March, although the society technically remains on the scene until June or July. There are major masquerades at the Dry Season Festival *(iko ɔkɔci)*, another four-day event carried out in turn by the villages in November and in the first half of December. At this time and into January and February many of the masked plays are held.

During the farming and fishing period persons may sing and even dance a bit at work or elsewhere, but the core of Afikpo aesthetic life is not found at the farms or on the river, but in the village commons and surrounding areas after the harvest begins. This ceremonial period is also the season when major readjustments in social relationships occur, for the secret society initiation and title-taking at this time create status changes among individuals. The wealth acquired in the previous period through farming and fishing is at least partially expended on raising one's social position, and that of close kin. Also, because men then have freedom from labor, they are able to settle disagreements. The elders spend much time resolving disputes over marriages and divorces, and over ownership of the farms to be used in the coming season—often matters that arose during the preceding work period. The ceremonial season is one in which social conflict and judgment are everyday affairs, and the Afikpo turn their productive energies to realigning and readjusting human social ties. The masked rituals are an aspect of this social productivity: they complement and reflect it, as well as having their own particular aesthetic aspects.

Thus the human cycle of the masked plays and dances ties in with the cycle of nature—the growth of plants and their maturation, the rise and fall of the level of the Cross River—and with the seasons of human labor and of social achievement and conflict. The masks and costumes, as the spirits of the masked players, lie at rest for six months of the year while persons labor. The fruits of that labor, and the frictions that arise during

that time, give rise to an artistic and religious awakening and to changes in social relationships during the ceremonial period, a time of public life as against the more personal and family-oriented activities of the period of work.

There is a rich and exciting variety of masquerades at Afikpo. The most popular one, and the best known to outsiders, is the ɔkumkpa. Different versions of this play are produced three or four times during a ceremonial season, each by a different village. Performed after the Dry Season Festival, the ɔkumkpa is Afikpo theater par excellence. Up to a hundred or more masked players play in the village common before an audience of men, women, and children, dancing, singing, and acting out a series of satirical and topical skits that are critical commentaries on the lives and affairs of real persons (see figs. 14, 23; pl. XI). The play sometimes lasts as long as four hours. Wooden masks are the only face covering employed, but almost the entire range of Afikpo mask styles in wood is found at one performance. There is a variety of costumes, but two predominate. One is the ɔri dress of dark raffia strands worn mainly by the older players, who also often wear the darker masks. Both costume and mask are considered ugly by Afikpo. Younger men and recently initiated boys, called akparakpa, wear the more feminine masks, thought to be more beautiful, and a costume that imitates the dress of girls. They dance about between the skits and songs put on by the older players. This is a rich and varied play, with some parts preset in form, while other sections are more flexible.

A quite different masquerade, njenji, performed at the Dry Season Festival, is a parade of the young village men through many of the communities of Afikpo. Many villages carry out njenji, often on different days from one another. The masked paraders walk in a line, arranged in an order of descending age. Many players are dressed in costumes that make them appear as females. Some walk side by side as couples, dressed as man and wife, frequently in European-style dress. Other paraders are costumed as scholars, priests, or as Muslims. The players are arranged by the type of wooden mask they wear, with most of one style grouped together (see figs. 2, 55; pls. XII, XIII). Accompanying the masked line are small groups of net-masked dancers in various raffia and leaf costumes who dance and prance about (see figs. 47, 48, 49; pl. XIII). Masked praise singers, hired for the occasion, are the only musicians. There is likely to be a smaller audience than at the ɔkumkpa as the players walk from the common of one village to that of another; the emphasis is on the quality of dress and the manner of movement rather than on acting, dancing, or singing, as in the ɔkumkpa.

A third play, oje ogwu, performed in only a few villages each year (see figs. 62, 63, 64; pl. XV), is usually seen in December or January. It is a net-masked dance of about thirty players accompanied by musicians also wearing net face coverings. The costumes are carefully prepared with elaborate and attractive headpieces; the dancing requires skill and precision. Played in the village common, the dance attracts a good audience.

Okonkwɔ is a dance carried out only once a year or so in Afikpo, toward the end of the ceremonial season. Only certain compounds of some villages and a few whole villages have the right to perform it. It is a dance of masked men, wearing certain of the light-colored, beautiful wooden masks, who circle the village common, moving to a xylophone played in the center of the common. The dancers dress as women and wear beautiful costumes, although they dance in male styles. There are a few pantomimes, but the more elaborate skits characteristic of the ɔkumkpa are lacking (see figs. 59, 60, 61; pl. XIV).

There are also masked events in some of the forms of initiation into the village secret society. The variations reflect the different historical origins and traditions of the Afikpo communities. In the initiation of a man's eldest son (if the father later takes the highest Afikpo title, omumɛ, he must put another son through this form), the calabash mask of Afikpo makes its only appearance (see pl. XV). In other initiation activities, wood or net masks are used.

At various times during the ceremonial season, men and initiated boys dress up in a variety of costumes with wood or net masks and gambol about, chasing one another. One popular form is logholo, employing a costume of long strands of fine, fresh raffia. These affairs usually occur in the village common (see fig. 66; pl. XV). And there are other masquerades in which the players chase after unmasked persons, frightening them and sometimes even flogging them a bit. One such masquerade, ɔtɛro, employs a net mask, and another, ɔkpa, a full net head and body costume (see pl. XVI).

At Afikpo masquerades are not seen every day, but they are not rare. Every good-sized village has hundreds of masks and costumes, which are familiar to everyone, for they are employed largely in public performances. Masks and costumes may be hidden from the uninitiated when not in use; but when worn, they are likely to be found in the village commons rather than in the secret society bush areas. Every Afikpo shares some knowledge of them; they are not a limited aesthetic experience, although feelings, understandings, and interpretations concerning them differ.

The Afikpo belong to the rich masquerade tradition of southern Nigeria and Cameroun. Why this full tradition? Jones's general suggestions for southern Nigeria (1945a, pp. 190-91) are of interest to our area of study. First, the Afikpo, and other

peoples in this region, have the well-developed habit of using a variety of iron tools in nonartistic woodworking and in preparing calabashes. Machetes, knives, and other implements are commonly employed for many purposes. The iron tool and woodworking tradition is basic to the system of productivity, in farming and fishing as well as in housebuilding, canoe construction and repair, and bridge work. The Afikpo traditionally made and used rope for many purposes, including fishing nets, so that net masks and net body costumes require little in the way of an additional technology.

Second, the absence of large-scale armies, conquests, and major slave raids probably prevented the destruction of large numbers of art and costume pieces. While there formerly was warfare at Afikpo and elsewhere in the Igbo country, it was generally localized and small in scale. A good deal of slave trading went on, but of a nature that did not usually lead to the destruction of whole communities. The isolation from Islam prevented the destruction of traditional art work, although Islamization does not always terminate an art tradition. Two local events, however, indicate how an art culture can suffer. In 1902, when the British conquered Afikpo, they burned Mgbom and Amuro villages; it is said that all of the art work and costumes except for two masks were destroyed and that an entire corpus of art in the village had to be remade (and borrowed from elsewhere). In 1958, when part of the Afikpo village of Anohia converted to Islam (S. Ottenberg 1971a), much of the village art was burned and the associated ceremonies abandoned.

These features may explain why a rich art tradition at Afikpo could exist, but they do not necessarily explain why it has come into being or what factors have spurred its development. Diffusion is one factor, of course, for Afikpo is well within the rich crescent of art productivity from the Guinea Coast to Zaire. However, Wolfe (1969, p. 14) has suggested, in a comparative study of selected African peoples, that richness of graphic and plastic artistic forms develops

in those societies where the men of the local community are divided by important social cleavages (and perhaps by intensifying affect, helps men to reach each other over these barriers). The data also suggest that the development of art is fostered by a nucleated settlement pattern and fixity of settlement. A related characteristic that has sometimes been considered important in the development of art—productive capacity—seems here to be more a by-product of nucleation and fixity than a determinant of art development itself.

These ideas are certainly valuable, if controversial, because they suggest that a search for functional explanations of the presence of a rich art tradition in terms of social features may be profitable. This matter will be taken up in my conclusions.

Jones (1945a) has suggested that there are three art traditions in southeastern Nigeria. One is

the Niger Delta mermaid or water-spirit play of the Ijaw, represented by masks carried upward on top of the head, symbolizing spirits living in the water. A second tradition is found in the Cross River area, mainly to the east of the river. Here the secret society plays a strong political role, and its plays have an important element of fear to them, as well as a religious quality. True wooden masks are not worn, and the older forms of public play consist of a "parade of a raffia-covered figure which was supposed to be either the embodiment of a local nature spirit or merely a familiar of a secret society. More elaborate plays had two figures, usually a fierce and a beautiful one" (p. 196). There are also wood pieces covered with skin which rest on the dancer's head or shoulders. Wood statues or statuettes are rare (Jones 1938, p. 108). The third tradition is the ghost play of the Igbo and Ibibio, where various face masks are worn and are employed in a considerable range of actions. The masks, originally ancestral spirits, have largely become mythological characters. Among the Igbo the *mmaw* performances of the Northern Igbo are one example of this tradition, as are the mask plays with comic and fierce characters, animal representations, and so on. The Ekpo society play of the Ibibio, as a terrifying production, with large, black masks, is another case in point. In Jones's third type, wooden and mud statues and statuettes are widespread. In most Igbo areas, in contrast to the Cross River region, there is less emphasis on magical and religious sanctions, discipline in the plays is slight, the secret society and initiation aspects are of less importance, and the religious elements are reduced. Display and artistic impression are stressed instead.

The Afikpo mask tradition appears to be a blend of Jones's Igbo-Ibibio and his Cross River styles. This mixture reflects the village-group's geographic position and its history. The Cross River influence is probably best represented at Afikpo in performances where raffia and net costumes, along with masks of wood or netting, are worn by small groups and individuals who either parade or dance about without much, if any, singing. These rites usually do not draw large audiences, nor are they directed strongly toward public aesthetic display in the form of a performance. The costumes often represent "familiars" or like spirits. Headpieces of wood, some skin-covered (characteristic of the Cross River style), are absent; but some Afikpo wood masks have headpieces attached to them rather than being placed directly on the human head.

The other tradition, the Igbo-Ibibio, is marked at Afikpo by the presence of large groups of wood-masked dancers and players, with substantial audiences, where the stress on display and aesthetic expression and the considerable use of voice in singing and in skits creates a strongly theatrical air. Here some of the white and

light-colored "beautiful" masks, often used to
portray females, are probably the result of Igbo
influence, while the darker, ugly ones, employed
to scare people or to represent ugly persons, are
an ancient Afikpo tradition, perhaps linked to the
Ibibio-Anang-Efik cultures to the south and
perhaps showing some Igbo influence as well.

The ɔkumkpa and okonkwɔ masquerades
best represent the Igbo-Ibibio tradition, for these
plays have large numbers of wood-masked
dancers and players and a substantial audience,
and are staged as theater. The njenji parade can be
seen as a blending of the Cross River and
Igbo-Ibibio traditions.

Two other features of the Afikpo mask
tradition should be noted. According to Nzekwu
(1960a, pp. 139–40), the head masks of the
Kalabari and Ijaw in the Niger River delta are
largely employed in masquerade performances to
represent animal spirits in association with myths,
dramatized in short and simple ways. The Afikpo,
however, are a particularly nonmythic people;
their masks are not employed to symbolize myths
or legends.

Second, Nzekwu, in the same article, suggests
that masquerading was directly tied in with the
secret societies of the Semi-Bantu peoples (Efik,
Kwa, Ibibio, Cross River groups):

Amongst them the greatest factor in masquerading
is its development into a most effective agency of
government. Ekpe, their principal cult, was a mysterious
overlord who became more significant than any king or
the community. Its messengers were masqueraders
who, to most of the people, became synonymous with
the overlord himself. These went about proclaiming
laws and enforcing them on behalf of their master. The
fear of Ekpe was exploited for their private ends by
officials of the traditional secular government, who
were invariably members of the cult. [P. 139]

At Afikpo the village secret societies have not
played such a strong political role, possibly
because of the important position of the Aro slave
traders there in the past. Although there are
elements of political and social control in the
secret eociety (S. Ottenberg 1971b, chap. 5), these
do not rest on the activities of masked men, but in
other spheres, and they are not as intensive as in
Ekpe. One might hypothesize that there was once
stronger masquerade control, and that the present
use of ugly, black masks to scare persons, and of
men and older boys dressed in raffia or leaf
costumes with wood or net masks who chase the
young, is a ritual remnant of an older masked
power. But at the present, these are games and
play, and speculation about the past must remain
just that.

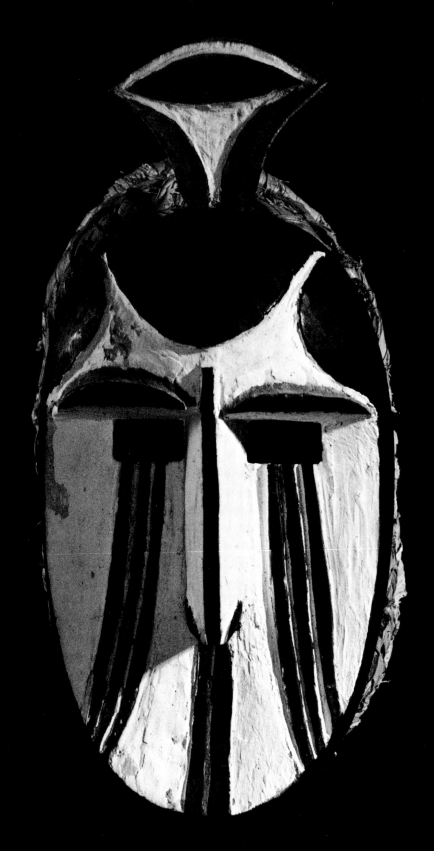

Fig. 1. *Acali* (no. 2, 1959-60)

The Mask Styles

In this chapter I shall discuss the major features of the twelve wooden mask types, the calabash form, and the net masks found at Afikpo. I also make some comments on the face coverings used by the uninitiated boys. The description of the general features of each form and their variants is long, but is a necessary prelude to the description and analysis of the rituals that follow. In many cases there are no clear-cut substyles of a mask but simply variations, and Afikpo do not usually say that one form is the major style of a mask while another is a variant; rather, they appear to see them all as ranges of a general type, expressing like or dislike for certain features in a particular mask. I find it hard, however, not to analyze out core features and to discuss variations of them. When I present "general features," I mean those elements that (1) are found in all masks of that type or (2) are quite common to that style. But it must be understood that these features are as I perceive them and not necessarily as the Afikpo would categorize them ethnoscientifically.

It should also be noted that the masks, as I viewed and photographed them in rituals, are not always in the same condition in which the carver produced them, for mask owners recolor them freely (but do not normally recarve them). While the recoloring generally follows the previous color pattern, there may be changes. For example, I suspect that a certain horned mask did not originally have a white head, and that a particular white ugly mask was formerly black. I am sure that persons have substituted modern paint for traditional dyes in some cases, with some effect on the mask's appearance. Even carvers who rent out their own masks sometimes recolor them a bit differently. What I describe, then, except in the case of the masks made for me by Chukwu Okoro, represents the work of artists plus some retouching by subsequent users and owners.

THE WOODEN MASKS

I list the twelve wooden face coverings alphabetically, since no single simple classification seems possible to me. Rather, a number of categories could be applied: ancient-modern, male-female, type of use, and age of wearer. These overlap one another and arrange the masks in different orders.

ACALI

Name. The meaning of the term is not known to me.

General features. The mask is about 9 inches high and 4 to 5 inches wide. It is one of the smaller and more lightweight Afikpo masks, oval in shape, with a high, narrow, rectangular, steep-sided nose with black on its ridge. The face is slightly concave, moving from the eyes to the chin. There is a sudden, nearly horizontal projection of several inches of forehead outward from the face to the same plane as the top of the bridge of the nose, a common Afikpo feature.

There are strong tear marks going from the eyes down the cheeks. The mouth, small and oval or triangular—if there is one at all—is not a focus of attention, as it is in some other Afikpo masks. There is a "beard" design, either full or a bit smaller, in either case going downward from the mouth area and represented by vertical colored lines and incisings. Sometimes there is instead a strong, single line dropping from the nostrils to the chin.

The top of the forehead is black, with variable colored designs on its lower section: these are usually curved and incorporate the brows, which are generally thin and only slightly curved. There is often a small vertical crest, several inches high, rising from the center of the head. In typical Afikpo style, ears are absent. The face is predominantly white, the black sides and underchin connect with the black forehead and black head top, so that the face is fully framed.

The sharp, straight lines of the nose, the beard or center line, the tears, and the break between forehead and face contrast with the rounded nostrils and curved features of the upper part of the mask, the rounded forehead and head, the curvatures in the forehead designs, and often the rounded surfaces of the crest. The straight lines of the face also contrast sharply with the oval quality of the mask outline (see fig. 1 and pl. I; and figs. 2, 11).

Variations. The crest may be in any number of curved or angular shapes (although on one mask I saw there was no crest at all).

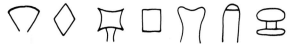

The crest decorations are quite variable (see examples), but usually consist of some curved lines and the use of more than one color. One mask has a small head instead of a crest. This head has a white, round face with a red, pouting mouth and circular black eyelids above and below the eyes, which enclose white eyes with black center dots. The nose projects out, going downward toward the nostrils, to a greater degree than is usual for Afikpo design, but it is decorated in the normal Afikpo manner, with a black nose ridge and nostrils. There is a black forehead, with a bit of white on top of the head and a white, curved line on the head's left side. This is the only example of a top piece in the form of a face that I saw at Afikpo, but Starkweather (1968, nos. 11-12)* collected two of this style. However, the Afikpo "queen" mask, *ɔpa nwa,* has a full figure on top of its head.

In the *acali* form, the top of the head is usually black, and the shape of the dividing line between it and the white forehead may vary as follows:

The eyes are often square, but sometimes they are ⊽ ⊽ or ⊽ ⊽ or rectangular.

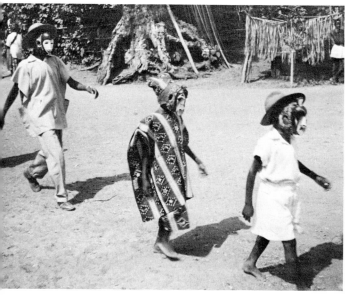

Fig. 2. Two small boys toward the end of an *njenji* parade line wearing *acali* masks

* This publication has no pagination. Here and elsewhere the numerals refer to his mask numbers.

Some *acali* have a bit more outward curvature from the nostrils to the chin than do others. One mask I have seen has white sides, but the face is predominantly yellow, black, and red, having a full, multicolored beard and only a little white in the upper cheek and on the underside of the projecting forehead. This carving has a darker, redder quality than most *acali,* which seems to go well with the dark costume the player was wearing in the Amorie village *ɔkumkpa* play. At the other extreme, another *acali,* worn at an Amuro village *ɔkumkpa* with a like costume, has a white face without a beard or cheek marks, and it lacks an elaborate forehead design. The whiteness of the mask contrasts sharply with the wearer's dark costume. In the darker-colored mask, the sharp lines of the lower face are lost in the coloration; but in the white form, despite the absence of bold-colored lines, the linear quality of the square eyes and rectangular nose stands out in contrast to the roundness of the whole. The differences illustrate what varying effects can be obtained from the same basic form, associated with the same type of costume, by altering the colors.

There do not seem to be any consistent substyles of this mask. Table 2 indicates that most of the features vary independently of one another. A full beard, for example, goes with a variety of mouth shapes, eye forms, crest shapes, and forehead lines. Whether the tears are multiple or single, wide or narrow, does not seem to correlate with any other single feature. This flexibility is, in fact, a common characteristic of many Afikpo masks. One carver may consistently use certain features together, but each carver chooses the design elements that please him.

Relation to other Afikpo masks. *Acali* has certain resemblances to *igri* (the mask of madness) and to the senior *ɔkumkpa* leader's mask, *nnade ɔkumkpa* (see the descriptions of these masks below).

Uses. The *acali* is often the first mask of the secret society that a young initiate wears (other than the calabash mask in the secret society initiation of some boys), and in many ways its small size and general appearance resemble the masks of the boys' imitation secret societies. Although occasionally worn by an older *ɔkumkpa* player, it is essentially a mask for the young.

It is one of the least common Afikpo masks, seldom seen in large numbers. Nevertheless, there is considerable stylistic variation to it. It is very popular with young boys because it usually has relatively big eyes (some forms also have large eyeholes on the raffia backing as well) and so it is easy for the inexperienced masquerader to use. It is worn a good deal by young boys after the *isiji* part of the seven-year initiation into the secret

TABLE 2
Variations in the Acali Mask

	Made by Chukwu Okoro, 1952–53 (pl. I)	Made by Chukwu Okoro, 1959–60 (fig. 1)	Starkweather (1968, no. 33)	Amorie ɔkumkpa 1952, dark face	Amuro ɔkumkpa 1952, white face	Amuro ɔkumkpa 1952	Double face, logholo, Mgbom 1952	Njenji, Mgbom, 1952 (1st in line, fig. 2)	Njenji, Mgbom, 1952 (2nd in line, fig. 2)	ɔkumkpa, Mgbom 1952	ɔkumkpa, Mgbom 1952
	1	2	3	4	5	6	7	8	9	10	11
Crest shape	◇	(drawing)	(drawing)	(drawing)	(drawing)	can't see	a face	(drawing)	(drawing)	(drawing)	(drawing)
Forehead line	(drawing)	(drawing)	low	(drawing)	low	(drawing)	(drawing)	(drawing)	(drawing)	(drawing)	(drawing)
Eye shape	□	□	□	□	□	□	□	?	(drawing)	□	(drawing)
Tears	single oblique	3 heavy, black lines	3 heavy lines	single but strong	none	single	single	single	3 lines	single wide	strong multiple
Nose length	short	long	medium	short	medium	large, flared nostrils	medium	long	short	short	short
Mouth	none	O	none	small or absent?	(oval)	none	none	△?	oval	none	oval
Beard	full	line	line	full	none	small	none	full	full	line	small

society, and it is used in the *logholo* "chase" play. In the *ɔkumkpa* it is usually worn by the smallest boy taking part, and often by a number of other young males who form part of the *akparakpa* dancers. If there are enough small boys, they form a separate dancing section, most of them wearing the *acali*. Small boys also wear the mask in the *njenji* parade, dressing as male scholars or Muslims (see fig. 2). The *acali* with the head on top was worn in the Mgbom *ɔkumkpa* in 1960 and in the *logholo* play in the same village.

Carving. The *acali* is one of the easier masks to make, and newly initiated boys starting to carve sometimes work on it first. Chukwu Okoro's older brother, Oko, made it as one of his earliest forms when he began carving secret society masks. Its greater similarity to some of the *enna* masks than most other Afikpo face coverings could be another reason it is carved early.

Opinions. Neither Chukwu Okoro, the well-known Afikpo carver, nor his brother Oko, likes this mask. They think that it has an ugly face, but it is unlike the ugly *ɔkpesu umuruma* group of masks, which are humorous.

Distribution. Starkweather (1968) lists three *acali* (nos. 33–36 and plate of 33) for Afikpo, but does not indicate that it is present or absent anywhere else. I do not know whether it is found in other Eastern Igbo areas or in other village-groups of the Ada. It does not appear like an Igbo or an Ibibio mask in form; it is possibly a Cross River type, for it is small like many of them and without the "beautiful" features of Igbo masks or the rounded distortions of many Ibibio ones.

Basis of analysis. Two masks made for me by Chukwu Okoro (fig. 1 and pl. I); one black-and-white photograph; eight different

forms in use on colored slides; and Starkweather 1968, nos. 33-36.

BEKE

Names. *Beke* or *mbeke*, the only names that I collected at Afikpo for this mask, mean "white person," or more generally any foreigner (which usually includes anyone not from the Ada village-groups and Aro Chuku, but can at other times mean any non-Igbo). The term is sometimes also employed to refer to Westernized Afikpo: one of my field guides was jokingly called *beke* by his friends.

General features. The mask is about 8 to 9 inches high and some 4 to 5 inches wide, with a red, oval, pouting mouth and black lips. The face has somewhat concave cheeks, oval eyes, and the large, bridged nose typical of Afikpo masks, with its blackened ridge and distinctly carved black nostrils, and sometimes a slight outward curvature going down toward the nostrils. There are no cheek marks. The black brows are gracefully curved and surrounded by the white area of the face; the head is black and usually undecorated. The dark coloring of the head often continues down along the outside edge of the mask and under the chin, framing the white face, as in the *acali*. There is a gently curved slope from the forehead to the eye area rather than an abrupt change of planes, as in the *acali* and *igri* masks, and the forehead and head are gracefully rounded. The mask thus has a light, delicate quality, with simple, curved lines and no decorations (see fig. 3 and figs. 11, 58; pl. XII; and Cole 1970, fig. 116).

Variations. The types of variations are similar to those in the closely related *nne mgbo* form: the degree of concavity of the cheeks, the extent of ovalness of the mask outline, whether the black nose line extends upward to the forehead and hairline, and whether it connects with the black eyebrows. There generally is not a white "drop" design or line on the forehead, as in some other masks.

Some variant forms are described in the following paragraphs.

1. My 1952-53 *beke* has a slight convexity to the ridge of the nose (see fig. 3).

2. One *beke*, used in the Amorie ɔkumkpa in 1952, has a long, lean face, greater concavity than is usual in the upper cheeks, and a flat, round, white piece on the top of its head, looking a bit like a little cap or a hair bun (see Cole 1970, fig. 116). A number of masks at an Mgbom ɔkumkpa in 1960 had a similar hair piece, one form having a bun nearly as large as the head portion of the *beke* mask itself, with a black line running around it near its base. Another form has a smaller, spherical bun raised up from the head:

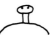

3. At the Amuro ɔkumkpa in 1952, there was a *beke* with thick, black lips, heavy, black eyebrows, a horizontal cut from the forehead back to the eyes, and a slightly pointed chin.

4. Another form (pl. XII) has a wider mouth than usual, narrow slit eyes, and an unusual curvature of the brows, appearing as

rather than

The face has a stern, serious look.

5. A mask used in the 1960 *njenji* parade has a mouth somewhat wider than usual, all in red. There are orange cheek marks, with a black vertical line down the side of each cheek, toward the back edge of the mask. The form has a different hairline, pointing down to the base of the nose, and again pointing down at the outside edge of each eyebrow. From there the line moves upward to the side of the mask. The face is thus not framed in black, for its sides and chin area are white. There is no decoration on the forehead; the nose is larger and wider than most other *beke*

noses. Although Chukwu Okoro considered it to be a *beke*, it looks to me like the face of the "queen" mask (ɔpa nwa) without the "child" on top. The hairline is similar; and the "queen" has tears and decorations on the side of the face, while the *beke* normally does not. This particular mask, then, is probably a "queen" in which the "child" has deteriorated, broken off, or was never made.

Relation to other Afikpo masks. It is similar to *nne mgbo*, except that the latter has a curved mouth and usually lacks the black lips. Its face is also the same as that of the major form of *mba* mask. Further, it has the basic color and shape of the "queen" form, although that type has teeth designs, tear marks, cheek and chin designs, and a differing form of hairline. The *beke* is thus a basic Afikpo facial type.

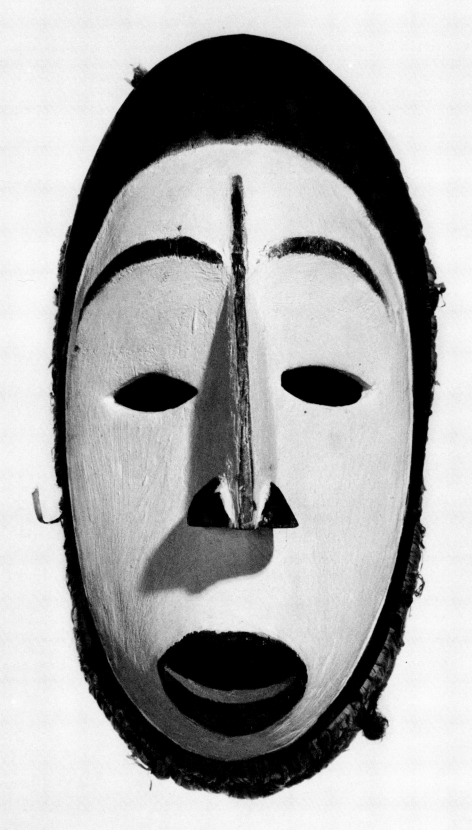

Fig. 3. *Beke* (1952-53)

Uses. The mask has a female quality by Afikpo standards and is employed in the same activities and in the same manner as *nne mgbo*—another indication of its similarity to it. In the *ɔkumkpa* the younger adult men wear it with the ugly, dark raffia *ɔri* costume. Actors use it in the skits to represent a woman or at other times a man, sometimes an African and sometimes a European. The *ɔkumkpa* musicians occasionally wear it, but younger boys do not use it in the play. In *njenji* it is worn by a wide range of ages, from children to young adults, always portraying males, who represent scholars, missionaries, businessmen, white men, men in modern Eastern Nigerian dress, and Muslims. *Logholo* players also wear this face covering.

Beke is a relatively common Afikpo mask. One sees quite a few of them at an *ɔkumkpa* play, but perhaps not quite as many as the related *nne mgbo*. Both types are found about as frequently at the *njenji* parade and are likely to be mixed up together.

Carving. One neophyte boy carver made it as one of his first masks. Like *nne mgbo* it seems to be one of the easier masks to produce, and it is also of light, porous wood, such as *okwe*.

Comments. None obtained.

Distribution. Like the *nne mgbo* it appears to be a simplified style of an Igbo white mask. I do not know its origin or distribution. Neither *beke* nor *nne mgbo* is considered by Afikpo to be an ancient form belonging to the Ego people. There is a photograph of a *beke*-style mask from Edda in Nzekwu 1963 (p. 26). He calls it the *ekumala* or *ikitikpoo* masquerade, where the player is accompanied by net-masked musicians. The hairline is unlike the Afikpo *beke* or *nne mgbo*, since it comes down to a point in the center of the forehead, but otherwise the mask is similar.

Basis of analysis. One mask carved for me in 1952-53 (fig. 3); photographs of some thirty-five different masks in use at Afikpo (see Cole 1970, fig. 116); Nzekwu 1963, p. 26.

IBIBIO

Name. The name refers to the fact that Afikpo consider it of Ibibio design and origin. The carving is both purchased by Afikpo in Ibibio and Anang country and regularly produced at home: it is considered no less valuable or useful a mask for being of foreign origin.

General features. It has a broader, rounder face and head than is usual in Afikpo masks; the general quality of roundness is perhaps its most characteristic feature. It has no tear marks and only occasionally is any facial decoration found at all. The face is predominantly of one color, either white chalk, shoe polish, or paint, although pink, orange, red, or violet paints have become especially popular in recent years. The painted forms sometimes look quite shiny, as if they have been lacquered over. The mask's eyes are oval and rimmed in black, with the usual black eyebrows. The nose is large and variable in slope, sometimes with an extensive and everted nostril area; at other times the nose is small and rounded, without flared nostrils. The projecting ears are colored, usually camwood or orange. It is the only mask at Afikpo to have projecting ears, other than the lobes on the "child" on top of the *ɔpa nwa*. The hair, black in color, is variable in style, but unlike other Afikpo masks it is built up in rounded forms on top of the head and without designs on it other than one or more white lines at the part or parts. In some masks the hair comes down in twisted strands, usually in front of the ears, but occasionally in back; these strands are not usually found in the *ibibio* forms with painted colored faces.

The *ibibio* is generally considered to be a female mask, and its hair arrangement sometimes represents female Afikpo styles, those of the Ibibio or Anang, or those found elsewhere in the old Eastern Region (see fig. 4 and pl. II, figs. 53, 54, 55, 56; pls. XI, XII; and Cole 1970, fig. 116).

Variations. I have not been able to synthesize any consistent substyles. Nose variations have already been mentioned. The mouth may have pouting lips; a small, oval opening; or a pouting, oval form. Some of the forms have white dots on a black bar across the lower forehead, or white and yellow dash marks. There is sometimes a small decoration on the cheeks: either a cross-mark (pl. XI) ✖ or dash marks ⟍⟍⟋⟋ pointing downward and inward on each cheek with vertical marks on the chin. Designs of these kinds are generally in black. Among the various hair styles, one consists of two bulbous portions with a white center line (Cole 1970, fig. 116), looking like this:

The two sections may be of differing heights and masses. Another form has a bulbous center portion, sometimes with white lines separating it from the remainder of the hair:

Still another form has a pointed center section with white lines on the side portions and a pink band beneath it (fig. 54):

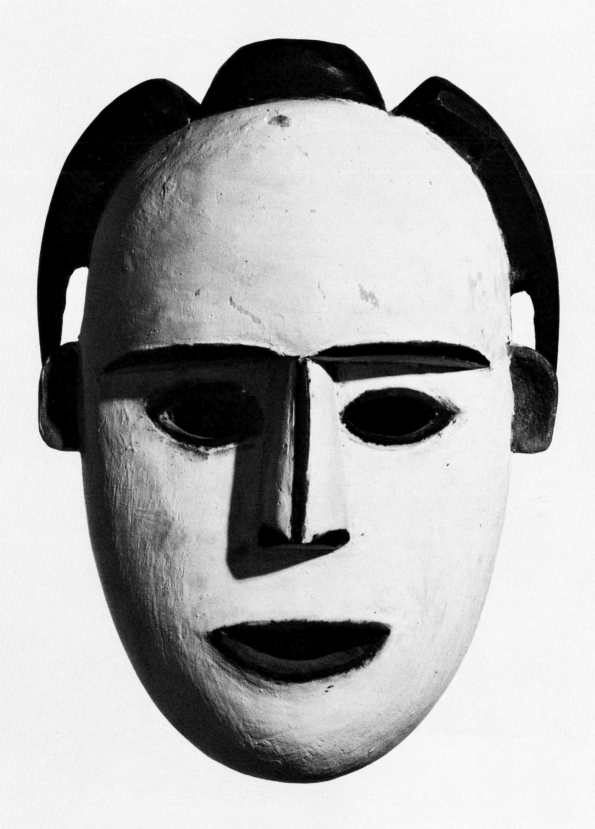

Fig. 4. *Ibibio* (no. 2, 1959-60)

A fourth type has three forward points coming from the forehead with orange vertical lines down them (pl. XII)

and a fifth form comes to a central crest with a red center section and a carved belt buckle across the whole:

A further hair style consists of three low crests of hair with white lines separating them, as in my 1959-60 *ibibio* mask (fig. 4).

Relation to other Afikpo masks. The carving on some *ibibio* forms, like my 1952-53 (no. 1) made by Chukwu Okoro (pl. II), is less rounded than on those produced in Ibibio and Anang country and it somewhat resembles the face of the "queen," *beke*, and *mba* masks. Afikpo carvers generally make the *ibibio* narrow-faced to resemble other Afikpo masks. While these masks do share some features with others at Afikpo, especially eye and brow shape, nose and mouth form, and a white face, they are otherwise unique.

Uses. In the *ɔkumkpa* play the *ibibio* is worn by adults using the dark raffia *ɔri* costume, but it is not worn by the oldest players, who prefer the ugly *ɔkpesu umuruma* masks (pl. XI). Players in the skits wear this mask to represent an adult woman or at other times a man, and *ɔkumkpa* musicians sometimes use it as well. It is not employed by younger boys or adolescents in this play. Both the white and colored forms are found, and they occur in good numbers.

In the *njenji* parade one mainly sees the colored *ibibio* (see figs. 53, 54, 55) worn by boys and young men, who costume themselves in modern female dress; it is not displayed by persons representing males. The *ibibio* is common to this play, and as many as twenty masqueraders wearing it may appear—very striking in their female dresses and brightly colored faces. The mask is not normally used in *logholo* or other chasing games.

I do not know whether this very common and popular Afikpo mask is used in the *okonkwɔ* dance, but it was not present in the one performance of this masquerade that I observed at nearby Okpoha Village-Group. At Christmastime one or more young boys, noninitiates into the secret society, may be seen in brightly painted *ibibio* masks and in raffia costume, accompanied by unmasked child musicians of like ages (fig. 29). The masqueraders sing and dance for the wealthy and educated Africans and for Europeans

in front of their homes and receive pennies as presents. I do not believe that the masks so used were made at Afikpo or have been employed in secret society ceremonies; such use would be a violation of secret society rules.

A simplified form of *ibibio* is also used by a chasing masquerader called *oke ekpa*.

Carving. *Ibibio* is often made out of a light wood, such as *okwe*, and it is not considered a difficult mask to produce.

Comments. Chukwu Okoro said it was "nice" and "good because it has a purpose. . . . The initiated boys [newly initiated into an age set] will dress like women [at *njenji*], put on frocks and shoes, and this mask makes them look like women. The nose looks like a woman's nose. The nose is so designed to make a woman look beautiful. A beautiful woman would have a nose like that!" He is referring to a nose of the style on the 1952-53 mask that he made for me, with some development of the nostrils.

His friend, Nnachi Enwo, does not like the *ibibio* form. He says that it is not supposed to be ugly or humorous. He thinks that it is ugly above the face, while the face itself is very beautiful.

Distribution. Neither Starkweather, Jones, nor Nzekwu describes this mask for the Ada group of the Eastern Igbo people. While it is evidently of Ibibio-Anang origin, the mask also has many Igbo features—its white face, the hair styles, its feminine qualities—that could relate it to the Igbo "maiden spirit" forms and other feminine Igbo masks. I am not sure that there is not Igbo influence at work here, if only in helping to create an attitude of easy acceptance of this mask in the Afikpo area. It is, of course, possible that the Igbo "maiden" forms are also of Ibibio origin and have been subject to Ibibio influence.

In 1952-53, when I first carried out field work at Afikpo, most of the *ibibio* masks were white; by the 1959-60 period there were many more of them and the majority in use were painted with bright colors, with oranges and reds predominating. They are a modern and popular Afikpo mask type.

Basis of analysis. Over forty different masks from photographs when they were in use (see Cole 1970, fig. 116); and two carved forms prepared by Chukwu Okoro, one in 1952-53 (pl. II) and the other in 1959-60 (fig. 4).

IGRI

Names. *Igri* is this mask's secret society name. In popular usage Afikpo recognize a similarity of shape by giving it the same name, *okonkpo*, as a slightly concave wooden tray, about three feet

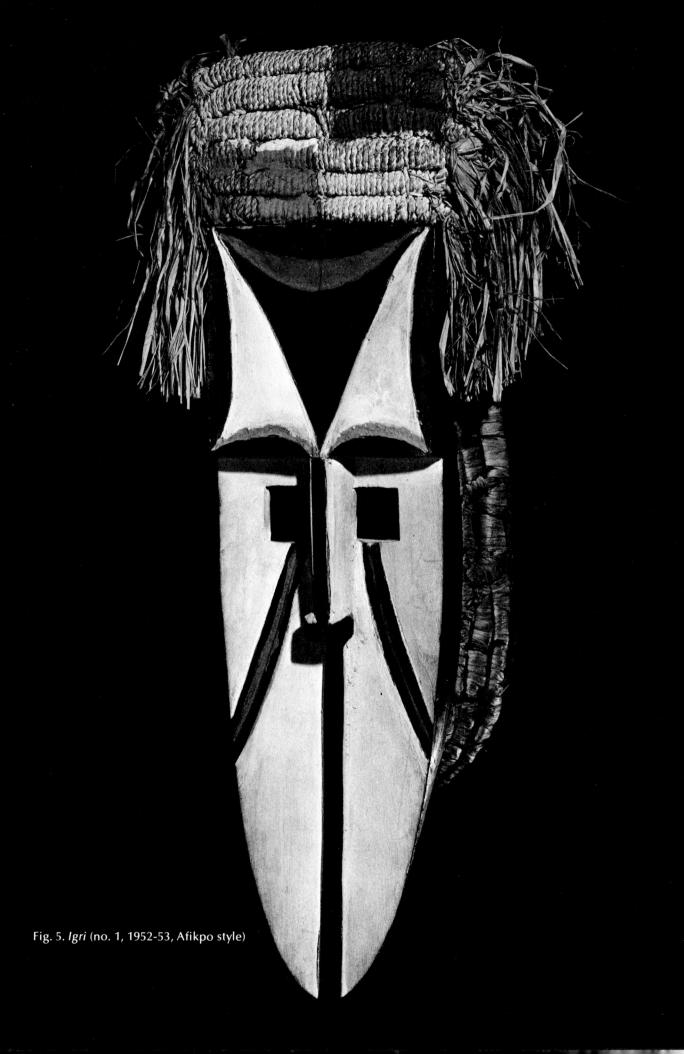

Fig. 5. *Igri* (no. 1, 1952-53, Afikpo style)

long, in which women carry fermented cassava and other foods from the farms. At Afikpo the *igri* masquerader is said to dance in eccentric ways, acting as if he is mad. At Edda Village-Group, where it is also found, Nzekwu (1963, p. 21) calls it *egede* and says that it is "a masquerade with a propensity for youthful exuberance." *Egede* at Afikpo is the term for a decorated sticklike construction that the *igri* masquerader holds in his left hand at the *njenji* parade. Starkweather (1968, nos. 13-21) calls the mask *okonkpo* and says that *egede* is a style with a taller forehead.

General features. The *igri* is a tall, thin mask varying in length from about 15 to 20 inches, and in width from around 4 to 5 inches. It has a lower, flattish section—the face—which is sometimes slightly concave from side to side, and which generally curls outward a bit at the chin. The upper part of the mask has a flat forehead, raised out beyond the facial plane as much as an inch or more by a sharp, horizontal brow line; this upper section is rectangular, sometimes narrowing a bit toward the top. In some *igri* this top part is slightly angled backward from a vertical center line down the forehead to the sides. At the top of the forehead is a raffia attachment, several inches high and usually about the same width as the forehead. This consists of horizontal bundles of raffia laid one on top of another, each bound with circled string, and with loose raffia at the sides. The bound portion is sometimes colored.

An examination of the raffia topping arrangement on my 1952-53 (no. 1) Afikpo *igri* (fig. 5) shows that it consists of six horizontally laid pieces of braided raffia, with loose ends, each braided piece wrapped tightly in a circular fashion with cord. The cord is attached to three wooden pegs inserted into holes at the top of the mask. This arrangement has then been colored in four equal sections: white in the upper left and lower right rectangles, camwood in the upper right, and yellow in the lower left, with no coloring on the loose raffia ends. My Edda Village-Group style of *igri* (pl. I) is constructed in the same manner except that a lighter, whiter string has been used to secure the six corded raffia pieces to the three posts. Its coloration divides it in two, camwood on the left and yellow on the right, and again the loose ends are uncolored.

The eyes are usually square or rectangular in this mask and are directly under the brows and up against the nose. In some masks they are placed slightly lower and out a bit from the nasal area. Sometimes the cut of the eyes is varied, as, for example, two intersecting sides of a rectangle whose ends are connected by an arc facing the cheek. The nose has sharp lines, with a flat, straight bridge on the same plane as the projected forehead, and straight sides, with little or no flaring at the nostrils. Some *igri* forms have tear

marks on the cheek, which are usually thin and move diagonally to the sides. There is much variation to the design of the forehead. The mask has no mouth, but there is often a black vertical line from the nostril area to the chin.

Variations. There are two recognized forms of the *igri* at Afikpo.

1. The Afikpo style is shorter, usually about 15 to 16 inches long, and has a good deal of white on the face and some on the forehead. The face is usually quite flat. Starkweather (1968, no. 13) pictures this style. See also the 1952-53 *igri* made for me by Chukwu Okoro (fig. 5; pl. XI).

The center line from the nose to the chin in this style varies in width. These *igri* also have the black line along the center ridge of the nose, so that there is a solid line from chin to forehead. All these masks of madness that I have seen have white faces (except for the black center line, the "tears," and the black nostrils), excluding one mask with camwood color in the upper cheeks, between the "tears" and the forehead.

These masks have either one or two design elements on the forehead. In most of them there is a central black triangle with concavely curved sides coming out from above the top of the nose. Sometimes complementary triangles in other colors are joined on either side, and there may be eyebrow marks over the eyes. Some forms have a triangle design in white, or with slightly larger top triangles, as in Starkweather 1968, no. 13.

2. The longer form of *igri*, 18 to 20 inches high, is a result of an increase in forehead length; the face size does not differ greatly from the first style, nor does the length of the raffia attachment. Afikpo still call this type of mask *igri*, but say it is from Edda Village-Group, although it is also produced at Afikpo (see pl. XIII). Darker than the Afikpo form, it has good-sized areas of black and camwood color, with a pronounced concavity from side to side in the lower face and a distinct outward curve of the chin. The nose is higher and larger, but it is still at the forehead plane, although the face is more depressed in the center than in the Afikpo style. These Edda masks lack the black line on the nose ridge; all but one that I have seen are without the center line from the nose to the chin. This one exception is the only Edda form that I have seen with the tear marks, and may be transitional between the Edda and Afikpo types. The absence of black in the tears on this mask is unusual; on the mask's right cheek the tear is red on the outside and yellow on the inside, while the

one on its left cheek is red on the outside and white on the inside.

In the Edda style there are either two vertical rectangles of color on the forehead, meeting at the center line, with each side slightly angled back from this line (pl. XIII), or there is some combination of long triangles on a flat surface, as in my 1959-60 Edda mask made by Chukwu Okoro and in Starkweather 1968 (no. 20).

 holes

Segy (1969, pl. 235) shows a mask from the "Afikpo district" which appears to be an Edda-style *igri*. It lacks sharply delineated brow ridges, and it has a curved headpiece design.

Relation to other Afikpo masks. See the notes on *nnade ɔkumkpa*, to which the *igri* has some resemblances—a similar face, but longer—and also on *acali*. The latter, with a forehead different in shape, lacks any raffia attachment.

Uses. This is not a common Afikpo mask form; the Afikpo style is more frequently seen than the Edda type. It is sometimes found at an *ɔkumkpa* play (pl. XI). It was absent from the one at Amuro in 1952; I saw two at the play at Amorie village in the same year, and one at the Mgbom *ɔkumkpa* in 1960. At Amorie both dancers wore large, floppy, wide-brimmed raffia hats and mat shirts, dressing somewhat as *ɔkumkpa* leaders do, although they were not the play's directors. At Mgbom the *igri* was worn by a musician with a khaki shirt and shorts, dress similar to that of the other musicians.

The mask is worn in the *njenji* parade by a number of players at the front of the line, going ahead of the main column (fig. 51), hopping and dancing about to announce the arrival of the line. I have never seen it worn in the main line of the marchers. The costume worn with it is also called *igri* (see the discussion of *njenji*, and also Nzekwu 1963, p. 20, for Edda Village-Group).

On the same day as the *njenji* parade, a few young men of the Afikpo villages of Mgbom and Amuro, wishing to test their strength and endurance, have a competitive run from these villages to Edda Village-Group and back again. During this race the *igri* is worn, but with a much simpler costume than in the *njenji* parade or the *ɔkumkpa* play. Other runners wear net masks.

The mask is not used in *logholo* or other chasing plays, according to Chukwu Okoro. Although I was told that it could be worn by boy

initiates into the secret society, I only saw it employed by strong adult men.

Carving. One young carver made it early in his career. My impression is that it is neither an easy nor a difficult mask to produce.

Comments. Chukwu Okoro likes it better than many other masks "because it is more popular, more common." It is, in fact, not common, although it is well liked and creates interest when it appears. Chukwu stated that "it makes a person act like they are mad when they put it on; even the dullest person will begin acting up when he puts it on."

Distribution. *Igri* is at least present at Afikpo, Edda, and Amaseri village-groups; Starkweather (1968, nos. 15, 21) lists two from Amaseri, and Nzekwu (1963, p. 20) shows it at Edda. It does not appear to be a usual Igbo type of mask nor to be from the Ibibio area. It reminds me most of some of the Ijaw carvings that are worn on the top of the head, particularly in its length—long for an Afikpo mask—and its tendency toward abstraction (Jones 1938, p. 105).

Basis of analysis. One Afikpo-style *igri* carved in 1952-53 (fig. 5) and one Edda *igri* carved in 1959-60 (pl. I), both by Chukwu Okoro, plus nine others from photographs of the mask in use at Afikpo; Starkweather's comments and two of his photographs (1968, nos. 13, 20); Nzekwu 1963, pp. 20-21; and Segy 1969, pl. 235.

MBA

Names. *Mba* refers both to a mask style and to a type of costume commonly used by the *akparakpa* dancers—boys and young men—at the *ɔkumkpa* play. The costume, which consists of a white singlet and white or khaki shorts, a colored cotton chest harness, a short raffia waistband and ankle rattles (pl. XI), is in evident contrast to the *ɔri* dress of dark raffia worn by the older players. Starkweather (1968, nos. 1-12) suggests that an explanation of the term *mba* "might be the fact that certain masks in this Eastern Igbo area are carved from a wood called *mba*." While Afikpo masks are often made from this wood, Chukwu Okoro did not feel that it was the source of the name, and in fact only some *mba*-style masks are made from it. Jones (1939a, p. 33 and figs. 1-3) calls these masks from Edda Village-Group *akpara oba* or *nwabogho*, which at Afikpo refer to the group of dancers, *akparakpa* (or *agbaragba*), discussed above. According to Starkweather (1969, nos. 1-12), the mask is called *amachiriri* at Amaseri Village-Group.

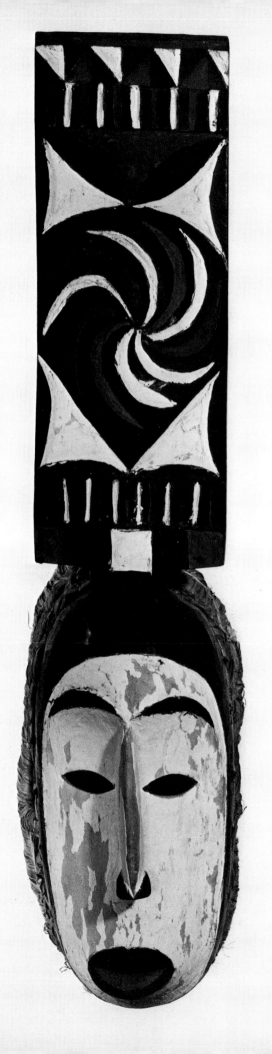

Fig. 6. *Mba* (no. 2, 1959-60)

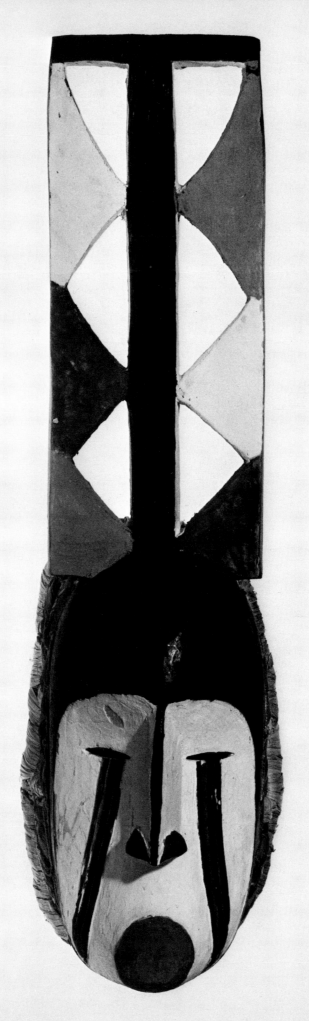

Fig. 7. *Mba* (no. 4, 1959-60, *mkpere* style)

General features. The face is essentially the same as the *beke* mask. At the top of the head is a flat board, rectangular in form, extending vertically as much as 10 inches above the head, 4 inches or so in width, and about 1/2 inch to 3/4 inch thick. In some masks the board is shorter and may taper in at the sides going toward its top. Starkweather (1968, no. 9) refers to one form where "the rectangle is reduced to a knob," but this may be a variety of *beke* mask. A curved triangular design is frequently found on the board, but straight triangles, squares, dash marks, and quatrefoil designs are also used. A center pinwheel form, swirling in either direction, is common (see figs. 6, 8, and pl. III; Bascom 1967, pl. 108; and Segy 1969, pl. 236). The back of the board is usually painted white but left undecorated. The top corners of the board may be rounded off. Sometimes designs are present on the forehead (Segy 1969, pl. 236).

The total length of these masks varies from about 15 to 22 inches, making it among the largest at Afikpo; the face is usually between 7 and 10 inches long (see figs. 11, 40, 66; pl. XI; and Bascom 1967, pl. 108).

Variations. There are two main variants from this general design.

1. One form (fig. 11), also called *mba*, has a face that resembles the "queen" mask rather than the *beke*. It is a very common variational type. There are tear marks on the cheeks, either in black or black and red. The face is not fully outlined in black and the hairline style, rather than being a single curved line, is similar to that in ɔ*pa nwa*. This points downward at the base of the nose, down again at the outside corners of the eyes, and goes upward to the outside borders of the mask. Sometimes the center point is rounded out (Starkweather 1968, no. 4) or it lacks the upsweep (ibid., no. 1).

The sides of the face and underneath of the chin are white. In the ear region on each side are one, two, or three black, circular dots; they are arranged vertically or, if three dots, occasionally in a

triangle. The other more elaborate decorations of the "queen" mask's face and forehead are missing. The board lacks the pinwheel design, but various arrangements of squares, rectangles, and triangles in red, orange, black, and white are found, as well as the white quatrefoil design.

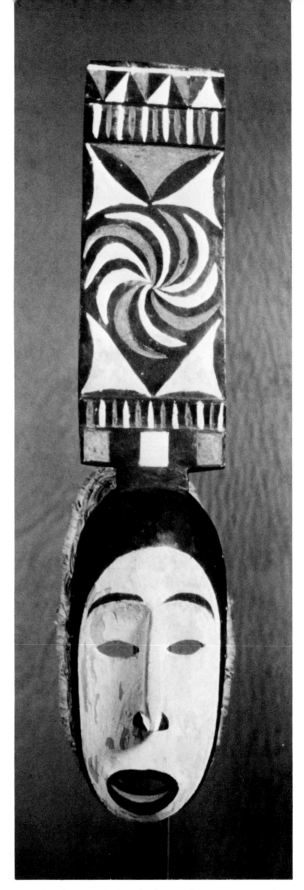

Fig. 8. *Mba*, made by Chukwu Okoro in 1959-60, now in Lowie Collection. Courtesy of Robert H. Lowie Museum of Anthropology, Berkeley, California

2. The second variant, *mkpere* (Starkweather [1968, no. 8] calls it *nkpere*), is not employed in the usual Afikpo plays but is used in connection with taking the highest Afikpo title and, it is said, in the funeral of an important man. I have never seen it worn. Chukwu Okoro made two of this form for me in 1959-60 (see fig. 7 and pl. III). The mouths are pointed to a bulbous red knob, rather than being oval and cut out. The eyes are narrow slits, there are no eyebrows, and there are strong tear marks. One mask is white with the usual black facial outline, the other black with a red diamond design incised on the forehead. The boards of the *mkpere* are composed of two vertical rows of variously colored straight-sided triangles whose bases are aligned along the outer edges of the board and whose tops touch a black, vertical line running down the center. The interstitial triangular areas are cut out. This carving feature is unusual at Afikpo. The board on the black-faced form is gently curved at the upper corners. Jones (1939a, pp. 33-34 and fig. 5) discusses and pictures a mask from the Ngusu Edda area, not far from Afikpo, with this type of board, but it has an *ɔtogho* mask style of face. He calls it *ufuocha* or *ikwum ocha*.

Relation to other Afikpo masks. I have indicated above the similarity of the face to the *beke* and to the "queen" masks. The face of the main type is also similar to *nne mgbo* except for the form of the mouth.

Uses. The main form and the first variant are worn by the older boys in the *akparakpa* group in the *ɔkumkpa* play (fig. 11; pl. XI), and occasionally by a musician at this masquerade. It is not worn by older men using the ugly *ɔri* costumes. I was told that there would be no serious objections to this, but that "it would just look funny." Actors in the skits do not wear *mba*; most of them wear *ɔri* costumes.

I have never seen *mba* in the *njenji*. It is not clear why it should not be present, since one sees the other masks worn by boys and young men, such as the *mma ji*, the "queen," and the *acali*. It is not usually used in the *okonkwɔ* play as far as I know, and it did not appear in the Okpoha Village-Group version of this play that I saw. It is employed in *logholo*. It is a common mask at Afikpo.

Carving. Chukwu's brother, Oko, first carved this form after his secret society initiation. It is not considered difficult, but neither is it the easiest to make, because of the board.

Comments. Chukwu, in making the nose of this form, once said he was fashioning it after my nose, which I take to be a joke, as the Afikpo style was set before my arrival.

Distribution. Starkweather (1968, nos. 1-12) indicates that it is present in Amaseri. Jones (1939a, pp. 33-34 and figs. 1-3) refers to variant forms at Edda, and Wingert (1962, p. xiv and pl. 19) indicates a mask that appears to be an *mba* which is in the Lagos Museum. He simply calls it an Igbo mask. It is probably a characteristic type of the Ada group of the Eastern Igbo, distinguished by its decorated boardlike projection. I was told by Afikpo that the *mkpere* variant is an ancient mask of the indigenous Ego people at Afikpo. It is apparently not a typical Igbo style, although the face has resemblances to Igbo masks.

Basis of analysis. Five *mba* carved by Chukwu Okoro, three of which are the pure white form, one made in 1952-53 (pl. III) and two in 1959-60 (figs. 6, 8). The mask pictured in figure 8 is in the R. H. Lowie Museum of Anthropology at the University of California, Berkeley (Bascom 1967, pl. 108). The other two *mba* from this carver are in the *mkpere* style. Some fifteen masks from the photographs at Afikpo; Starkweather 1968, nos. 1-12; Jones 1939a, pp. 33-34 and figs. 1-3; Wingert 1962, p. xiv and pl. 19; and Segy 1969, pl. 236.

MKPE

Names. The term *mkpe* means horn, referring to the horns on this mask. The major form is a goat *(ewu)*; Starkweather (1968, nos. 47-49) calls it "the 'he-goat' ram mask."

General features. The carving is about 12 to 16 inches long and some 4 to 5 inches wide (see figs. 9, 10, 11). The face and head are sharply angled forward from the sides to a center line that is not marked by special coloration. The sides of the face are slightly convex. This angled style also occurs in the junior *ɔkumkpa* leader's mask, *nnade ɔkumkpa*, but in that form it is interrupted in the mouth area. Well-delineated tear marks, usually colored camwood and black, curve out from the eyes to the sides of the face. There is no nose except insofar as the meeting of the two facial angles at the center line suggests one. The red camwood mouth has no lips and consists of two thin, lanceolate, diagonally placed incisions, one on each side of a pointed chin, which comes to a fine point at the tip of, or just above, the chin. Viewed from the front, the mouth looks like this: $\bigvee\!\!\!/$ There are the usual black brows over the typical oval eyes. The forehead, head, and horns are black; the hairline curves down at the center line to about where the base of the nose would commence if there was one. The top of the head is flattish. The horns rise out from the head's front and gently curve backward and a bit sideways; the ends of the

horns taper to points. This is the only Afikpo mask in which the wood projection sometimes reaches back beyond the head, sometimes going well into the plane of the raffia backing. In the *mma ji* mask it stops at a plane about equal to the back of the wooden part of the mask. Starkweather (1968, no. 48) has a nice photograph of this mask.

Variations. There are four variations of the *mkpe* mask style.

1. One *mkpe* from Mgbom village has a white forehead and head. There are no black brows and no hairline to separate the face from the head. The horns are black, but they are shorter and stubbier than the usual form. There is a dark, vertical center line from between the eyes to the mouth. This mask looks as if it originally had black brows and head which were later recolored white.

2. Figure 67 shows an adult wearing a usual-sized *mkpe* with a black face for a form of *logholo* chasing play called *ɔkwɵ*. The mouth is white, as is the tear on its left cheek. I cannot see the remainder of the mask in the photograph.

3. There is another Afikpo style similar in form to the usual mask but smaller, being about 12 inches long and 4 inches wide. Chukwu Okoro made for me a copy of one in Mgbom village (see fig. 9). It is rarely employed, and I never saw it in a masquerade. The carver claims that this is an ancient form of the goat mask, the larger white style being modern. The face, head, and horns are black. The mouth, colored orange, meets the center line at about an inch above, rather than at, the point of the chin, and it is cut differently than the usual Afikpo style, with a rather straight upper lip and a slightly outward-curved lower one. There are four orange tear stripes on each cheek. The oval eyes, being cut through at an angle rather than directly, represent an unusual technique at Afikpo. The center vertical line of the face is slightly convex rather than straight. The head is peaked in front, with the horns attaching at this point. These projections are thicker and shorter than on the modern masks. Although also rounded and tapering to points, they are parallel rather than flaring slightly sideways.

4. There is a rare type which I only saw once, at the Amorie *ɔkumkpa* in 1952, where the masquerader was wearing the dark raffia *ɔri* costume. I was informed that it is an ancient Ego mask, associated with the people believed to be early inhabitants of Afikpo. Amorie is partially an ancient settlement, and many of its ugly or *ɔkpesu umuruma* masks are also thought to be of Ego origin. I do not know what this horned form is called. It has a face about the size of that on the *mba* masks, with a large, pouting, dark mouth and a projecting lower face. The white face lacks the usual tear marks. The nose is small and dark, with a dark line running up to the hairline from the forehead. The mask has relatively large oval eyes

for an Afikpo form and lacks eyebrows. The forehead is white, and the hair mostly yellow. The horns are not curved, as in the usual Afikpo horned masks, but rise upward in a U-shape, their bases joining together at the top of the head. They are decorated with colored bands of white, yellow, and red.

The mask differs from others at Afikpo in the shape and coloring of the horns, the absence of brows, the short, dark nose, the somewhat larger eyes, and the yellow hair. Nevertheless, its general tone is not drastically out of line with other Afikpo masks, particularly in its relatively narrow face shape, extensive use of white, the pouting mouth, the general shape of the eyes, contours of the forehead, and the black center line on the forehead.

Relation to other Afikpo masks. The similarity of the angled face of the *mkpe* to that of the junior *ɔkumkpa* leader's mask has already been noted.

Uses. It is not a common form. I have seen it used by musicians (once in the usual form and a second time in the first variant form described) at several Mgbom village *ɔkumkpa* plays (see fig. 11). Occasionally it is worn by an adult *ɔri*-costumed player at this play, but not by the younger boys. Horned masks are also used in the *logholo* chase and related games. As far as I have seen, the wearer of this mask does not act the part of a horned animal in any of its uses.

Carving. It is usually made of *mba*, a strong wood, because of the horns.

Comments. Chukwu Okoro indicated, referring to the common type of *mkpe*, that he liked the horns best on this mask because they were well shaped. But they were hard for him to make. He believes that the goat mask is a serious one. "Does it not seem that it will pierce you if you want to catch it? Everything on the mask is fine. The red oblique lines running from the eyes are because it is crying." Why does the goat cry? "It is to add color to the face, to make it fanciful," he replies. "Whenever you see such lines on a mask, you know that it is tears."

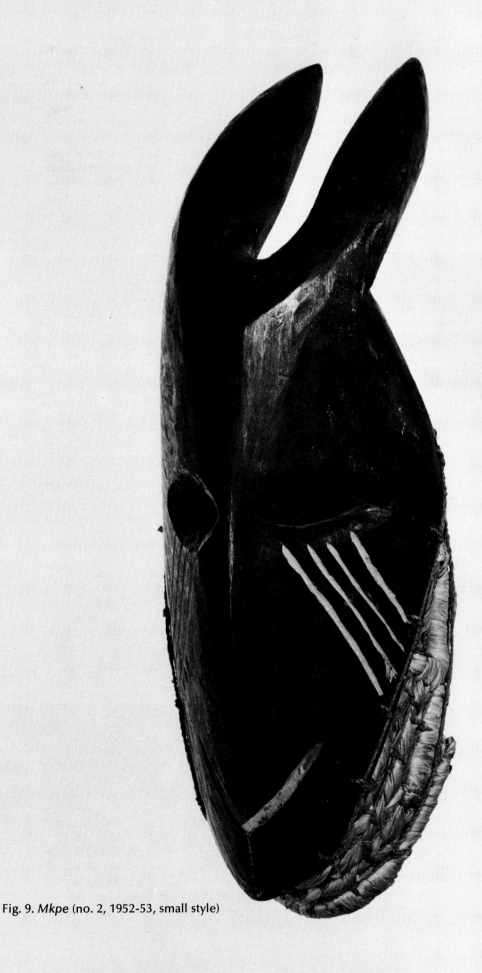

Fig. 9. *Mkpe* (no. 2, 1952-53, small style)

Distribution. Starkweather (1968, nos. 47-49) does not record its presence anywhere outside of Afikpo, but this is not necessarily conclusive. Jones (1939a, p. 33 and fig. 4) discusses a horned mask in the British Museum worn in "*lugulu*" (presumably the same as *logholo* at Afikpo), which is from Ngusu Edda, not far from Afikpo. It is a dark form, with large oval eyes encircled by white, white cheek marks, a very pouted mouth, and a dark forehead. It has thick, heavy horns, tapering toward the tips. It is a heavier, less delicate mask than the Afikpo forms, with larger horns and a different face style. I have never seen this Ngusu Edda type at Afikpo.

Horned sculptured figures, in the form of the *ikenga* spirit shrine, are common and well known throughout much of Igbo country, but not in the Eastern Igbo areas; none was found at Afikpo. Some forms of horned masks are probably ancient to the Ada group of the Eastern Igbo, but others are the result of a more recent Igbo influence. The fourth variational form at Afikpo is undoubtedly ancient, probably derived from the original non-Igbo inhabitants, while variation 3—the small, black type—is possibly an ancient form brought in by early Igbo settlers. The only village where I saw the latter is largely of Igbo origin and historically associated with Edda Village-Group.

Basis of analysis. One of the "usual" forms carved by Chukwu Okoro in 1952-53 (pl. VII); one of the small, black types carved by him in the same year (fig. 9); another usual form carved by him in 1959-60 (fig. 10), now in the R. H. Lowie Museum of Anthropology, University of California, Berkeley; Starkweather 1968, nos. 47-49; Jones 1939a; and photographs of six *mkpe* masks at Afikpo.

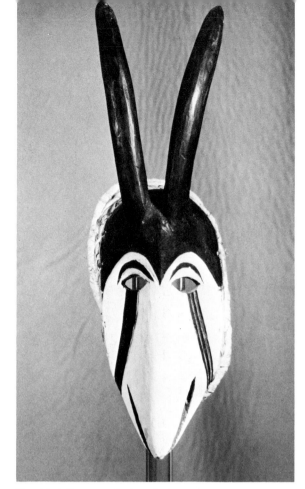

Fig. 10. *Mkpe*, made by Chukwu Okoro in 1959-60, now in Lowie Collection. Courtesy of Robert H. Lowie Museum of Anthropology, Berkeley, California

Fig. 11. View of chorus, Amuro ɔkumkpa, 1952. *Mkpe* mask is in foreground, with an unusual white ɔkpesu umuruma mask to its right rear. *Acali, beke,* and *mba* mask forms can also be seen

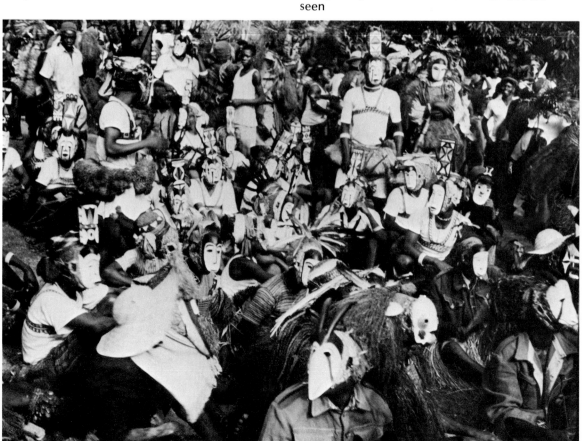

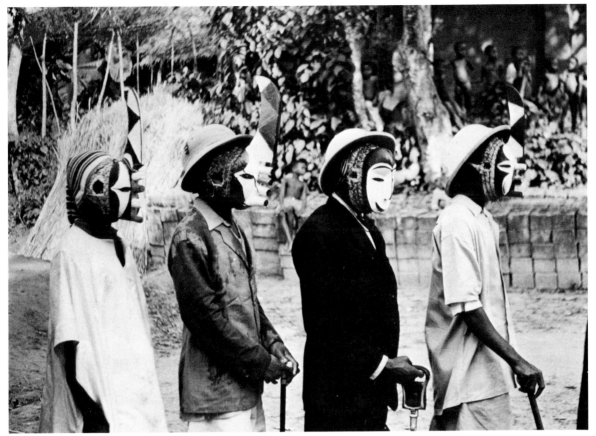

Fig. 12. *Njenji* players wearing the *mma ji* mask, except for the center one, who wears an *nne mgbo* and carries a shooting stick

MMA JI

Names. This is the best known and most characteristic Afikpo form. *Mmaji,* meaning "knife-yam," refers to the top piece, which has the appearance of a knife or machete. Afikpo also call it *mma ubi,* "knife-farm," a name that is used at Okpoha Village-Group (Starkweather 1968, nos. 23-32). I believe both terms are employed among most, if not all, of the Ada village-groups of the Eastern Igbo. In discussing one of these masks from Nkporo Village-Group, Jones (1939a, pp. 33-34, fig. 6) calls it *mba* or *ikwum* (see also Jones 1939b, pls. 3 and 4). *Mba* is sometimes applied to it at Afikpo and Okpoha, but *mba* usually refers to another mask at Afikpo. It is also the name of a costume worn with a variety of face coverings in the ɔkumkpa play, including *mma ji.*

General features. The face is a convex, rounded oval, a form quite unusual at Afikpo. Projecting horizontally outward from its center line are three or four cylindrical pegs, with flat ends, that lie in the same vertical plane and in line with the "knife." The "knife" curves back and tapers to a point somewhere above the raffia

backing region. The width of the "knife" varies considerably from front to back in different masks; in some it has considerably less curvature than in others (see pl. IV and figs. 12, 57, 59, 61; pls. XII, XIV; and Bascom 1967, pl. 109).

The mask has no mouth, ears, forehead, or head. The eyes are oval, often rimmed in black, and usually meet at the third peg from the bottom on a four-pegged mask and at the middle one on the three-pegged form. The mask is multicolored, as a rule, rather than black and white.

The face covering is abstract, not only in form but in design. Neighboring pegs are often of different colors—red, orange, and white, although not usually black—and may have dots of contrastive colors at their ends. The third peg from the bottom when there are four, or the middle one when there are three, often has a black line on both sides from the inner corner of each eye to the peg's tip. In one form (Great Britain 1951, pl. 19) this line is created by an incision rather than through color.

The face is decorated in various ways, often with the use of the white, concavely curved triangles so common at Afikpo. These form the dominant face marking, a pair to each side of the

face, with the base lines at the eyes. The rest of the face is usually black. These curved triangular lines, or sometimes straight ones, are often used to decorate the sides of the "knife." The front edge of this top piece may be decorated with an incised colored line or with dots or squares; the back is uncolored or in one color only.

The total length of this mask varies from some 13 to 22 inches, the major difference being found in the "knife" and not in the face length.

Variations. I have not been able to distinguish any substyles on the basis of design or form. However, those with only three pegs tend to have a thicker (from front to back), shorter "knife" section. A few masks have a double white circular face design rather than the curved triangles. This occurs in a mask from Nkporo Village-Group photographed by Jones (1939a, pl. 4) and one from Edda (Nzekwu 1963, p. 25).

 front views

At Okpoha and Amaseri village-groups a different style of this mask occurs (see fig. 61; pl. XIV). It usually has four pegs, but the third from the bottom is shorter and tapers at its end. The "knife" curves around to form a complete or nearly complete circle. Starkweather (1968, no. 29) and Plass (1956, pl. 18E, Amaseri Village-Group) show this style. The white facial markings form a single triangle on each side, with the longer side curved and the other two sides relatively straight.

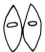

A round cap of wood or calabash, richly decorated, is worn on the top of the head and complements the mask in color and design. In Okpoha Village-Group the Afikpo-style forms also occur, sometimes with less curvature and a thicker "knife" front to back, but I have never seen the Okpoha-Amaseri style at Afikpo.

Relation to other Afikpo masks. No other Afikpo form is similar to *mma ji*. The *ɔtogho* also has outward projections from its face, but these are triangular and curved in shape and create quite a different effect than those on the *mma ji*.

Uses. The mask is a common form at Afikpo. It is worn at the *ɔkumkpa* play by older boys who wear the *mba* costume. I have also seen it worn by a musician at one of these plays, but never by adult men wearing the dark *ɔri* costume, or those taking part in skits. At the *njenji* parade it is worn by a range of ages, from small boys to adult men, who are costumed as schoolboys, school teachers, missionaries, Muslims, and Westernized Africans (see pl. XII). The mask is worn by the main dancing group at the *okonkwɔ* play, where a costume similar to the *mba* is seen (figs. 59, 61; pl. XIV). It is also employed in the *ikwum* form of secret society initiation.

Carving. It is one of the more difficult masks to produce and is usually made out of a sturdy wood, such as *mba*.

Comments. Chukwu Okoro once said that he likes it "because it looks fine to the eye." It is the second choice of his friend, Nnachi Enwo, the goat being the first. Enwo likes the *mma ji* pattern and form. "If one squints and lets his mind play, it looks alive," he says, and thinks that it looks like a bird, *iyɔrɔ*, which belongs to the swift family.

Distribution. I have seen it in considerable numbers at Okpoha Village-Group in the *okonkwɔ* play, especially with the closed, circular form of "knife." Starkweather (1968, nos. 23-32) has collected this mask from Afikpo, Amaseri, and Okpoha; and Plass (1956, pl. 18E) pictures one from Amaseri collected by Dr. Jack Harris in 1939. Jones (1939a, 1939b) shows it at Nkporo Village-Group, and Nzekwu (1963, pp. 19, 25) at Edda. Starkweather says that "these classical Eastern Igbo masks are not known in the balance of Igboland" (1968, nos. 23-32). I do not know whether it is present in the Aro Chuku and Abam-Ohaffia areas of Eastern Igbo country, but it appears to be a widespread ancient and typical mask of the Ada Village-Groups of the Eastern Igbo, and not a general Igbo form.

Basis of analysis. Two masks made by Chukwu Okoro for me, one in 1952-53 and the other in 1959-60 (see pl. IV); a third, made in 1959-60, which is nearly identical to the first, is in the R. H. Lowie Museum of Anthropology at Berkeley, California (Bascom 1967, pl. 109); in addition, some thirty forms from my photographs; Starkweather 1968, nos. 23-32 and fig. 24; Jones 1939a, 1939b; Nzekwu 1963; Plass 1956, p. 35 and pl. 18E; and Great Britain 1951, pl. 19.

NNADE ƆKUMKPA

Names. There are two masks, of different style but similar coloration, that are called by this name,

which means "father of the ɔkumkpa play." The longer form is worn by the senior leader, the shorter one by his partner, the junior leader. The two players largely stay together, forming a closely bound pair.

General features. The senior mask (see pl. V and figs. 14, 37, 44; and Cole 1970, fig. 109) is about 12 inches long. It is gently convex from side to side, with some outward projection in the chin area. Across the top of the forehead of the mask there is usually a black, rounded ridge. The forehead is in two colors, differentiated at the midline. There is a heavy, rounded, protruding, black brow ridge just above the circular eyes. The black nose is rounded, but without nostrils. There are tear marks and a small, round hole for a mouth at least halfway between the nose and chin. Black and white are the major colors.

The junior *nnade ɔkumkpa* (see pl. V and figs. 13, 14, 37, 44; Bravmann 1970, p. 58 and pl. 120) is shorter (about 9 inches) and slightly narrower. It is based on two slightly convex planes that angle out toward a vertical center line, this line thickening in the forehead and forming the nose below it. There are large, bulging upper eyelids, which nearly cover the round eyes. The center point of the two angled planes is cut out below the nose to form the mouth area, with a small hole for the mouth itself, and curves outward to produce a pointed chin. Again, black and white predominate.

Variations. The senior leader's mask takes various forms. I have seen five of these masks.

1. In one form, seen at the Amorie village ɔkumkpa in 1952 (fig. 14), the forehead is flat and black on its right side and red on its left. The mask has flat sides, a feature lacking in other senior leaders' masks. It is white on its right edge and the white continues down toward the chin. The right side of its face, the right side of its nose, and the nose ridge are red, the left side of the face is white. It has a rectangular nose with sharp edges, as in the *igri*, and no nostrils. Black coloring has been applied to its chin and up onto its right side. The mask as a whole has a dark appearance, as reds and blacks predominate. It is worn with a floppy, wide-brimmed raffia hat, a mat shirt, and a short raffia waistband; a towel hangs over the shoulders and onto the chest, attaching at the back of the head, and another towel hangs from the waist. This is a typical ɔkumkpa leader's costume. This Amorie version is said to be a relatively recent production, in imitation of some of the older ones at Afikpo.

2. At the Mgbom 1960 ɔkumkpa an assistant play leader wore a *nnade ɔkumkpa* mask (fig. 36; pl. X; and Cole 1970, fig. 116). There are usually two such assistants to the senior and junior leaders and occasionally one or both wears a *nnade*

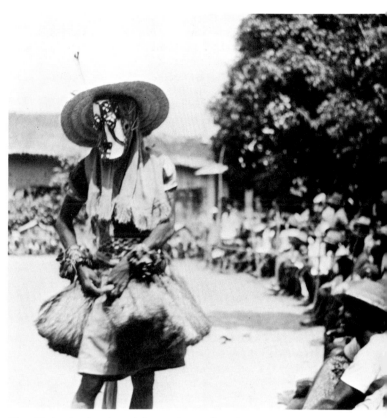

Fig. 13. Junior leader of the Mgbom ɔkumkpa in 1960 receiving a "dash" of money, which he is putting in his pocket

Fig. 14. The two ɔkumkpa play leaders at Amorie in 1952, wearing the *nnade ɔkumkpa* masks

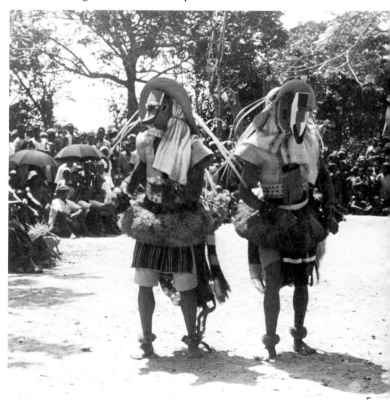

ɔkumkpa. In this particular case the other assistant wore a nne mgbo.

The mask is said to be an old senior leader's mask. Its curved forehead is white on its right side and red on its left, and there is a white line across the forehead just above the usual large, black brow ridges. Its face and nose are black, and it has red and white tear marks on its right cheek (part of the cheek has rotted away), but only white ones on its left. It has two mouth holes, one two-thirds of the way from the chin to the nose, and the other about one-third of the distance. Again, the masquerader wears a floppy, wide-brimmed raffia hat, with towels. He has a khaki shirt and shorts, white sandals, and dark raffia hanging from the waist.

3, 4, 5. The other three senior leaders' masks that I recorded are much alike: strongly black and white. The black has a rough texture and bits of eggshell are stuck onto it. This dark color is made from the oil of a small insect, okom, which makes a noise like a bee and, it is said, likes to get into a person's ear, although it does not bite. Its hive is cut off and drowned in water, and the oil drained out. Chukwu says that it tastes sweet like honey, but it is not the same; it is sometimes eaten. After rubbing it on the surface of the mask, Chukwu blackens it with a hot, metal blade and later adds the eggshells. It appears also to have earth or sand in it, as it has a rough, dull quality. This coloring is only employed in the senior and junior leaders' masks.

One mask seen at the Amuro ɔkumkpa in 1952 is said to be ancient. Another used at the Mgbom 1960 version of this play (Cole 1970, pl. 109) resembles the copy that Chukwu Okoro carved for me (see pl. V). In all three masks the right forehead is white, the left black. In the Amuro one the entire face is dark except for two heavy, white tears on each cheek. Eggshells are used more heavily than on the one that Chukwu carved for me. On the Mgbom 1960 mask, as well as on mine, the right half of the face is black, the left white. On my own the right cheek has an outer white and inner red tear, with only a red tear on its left cheek. There is a red line from the bottom of the nose through the mouth to the chin.

I have seen four junior leaders' masks. The Amorie 1952 masquerader (fig. 14) is costumed in the manner already described for the senior leader, and the mask resembles it in color. The chin and lower face area are black, sharply everted, and pointed; the lower part of the mask is cut away more deeply than in the other junior leaders' masks that I have seen. There is a short, orange nose with black nostrils, and the orange continues up to the forehead, which is red on its right side with a white line on its outer edge. The left side cannot be seen from the photographs. It is said to be a modern mask.

The Amuro 1952 ɔkumkpa junior leader's

mask, ancient like its senior partner, seems to be the prototype of the Mgbom 1960 ɔkumkpa form as well as of the one that Chukwu Okoro made for me (Bravmann 1970, p. 58 and pl. 120). All three are colored white on their right foreheads and left faces and black on the opposite positions. The ancient Amuro one has no tear tracks over the white on its left side, and the red left tear mark on the Mgbom form is heavier and more curved than the mark on mine. The Amuro mask also has an outer white and inner red tear mark on its left cheek, while the other two have only white marks. All three show considerable use of eggshells on the black surface. The junior leaders in Amuro and Mgbom wore costumes similar to those of their senior counterparts.

Relation to other Afikpo masks. The senior mask has something of the long quality of the igri, with a tendency toward abstract design and with a major division of the mask above the eyes at the brow level. But the nnade ɔkumkpa is convex, whereas the igri is flat in the forehead and ranges from flat to slightly concave in the face. The junior leader's mask resembles the ugly Afikpo mask, ɔkpesu umuruma, in its distorted, bulging eyes; but it lacks the rounded qualities of the other facial features found on the ɔkpesu umuruma.

Uses, comments. The masks are only worn by the senior and junior ɔkumkpa leaders, and occasionally by assistant leaders; they are not used anywhere else at Afikpo. They are said to be the property of all Afikpo, or at least of the villages that store them; however, they may be borrowed for use by other villages, for they are found in a few of them. The Amuro ones are of great antiquity: it is said that they were the only two masks in the village to escape destruction by fire at the time of the British conquest in 1902, and then only because they popped out from the ledge in the village resthouse where they were stored and became buried in the back part of the house. At Mgbom, while the leaders' masks are not very old, they are kept in the resthouse of one of the subvillages, Achara. In that resthouse is stored another leader's mask, so ancient that it is never taken out. Unfortunately, I could not arrange to see it. Chukwu says that "if it were worn, the wearer would not stop singing all the rest of his life—he would go mad." When someone wants to use either of Mgbom's two masks, he brings three uncooked yams and places them on the rack in the resthouse. These are to be cooked and eaten by anyone who goes there. The giver takes a mask and, holding it in his hands, carries it counter-clockwise in a circle around the original mask (a motion often made in other forms of ritual). This action allows the bearer to absorb power from the original mask in order to sing and dance well, but Chukwu Okoro could not say what

would happen if one did not do this. The leaders' masks can only be taken out on the day of the play. Chukwu has never touched them, although he has carved replicas of them for me.

The *nnade ɔkumkpa* are ancient in design and are associated with the non-Igbo people, Ego, who once formed a major population at Afikpo. The masks are believed to have greater power than others at Afikpo; they are feared, and persons will avoid getting too close to a player who is wearing one. The leaders prefer to use old ones (even though, like the Amuro pair, they are much patched up with glue) because the spirit of the secret society is alive in them; they are powerful and highly valued. Their ritual value is symbolized by the eggshells on their surfaces. Eggs are not normally eaten at Afikpo, but are placed in a variety of shrines as sacrifices and employed by diviners in preparing charms for themselves and for clients. The preparation of this form of mask is thus in itself akin to a ritual activity.

Carving. No information obtained.

Distribution. Starkweather (1968) does not record these masks, nor have I found any other information on them elsewhere. They do not seem Igbo or Ibibio in style, and I accept the belief of Afikpo that they are an ancient local type.

Basis of analysis. For the senior mask there is the one Chukwu carved for me in 1959-60 (pl. V) and photographs of four others in use (see Cole 1970, figs. 109 and 116); for the junior one, my 1959-60 mask carved by Chukwu (pl. V and Bravmann 1970, p. 58 and pl. 120) and photographs of three others as used by players.

NNE MGBO

Names and general features. The mask received this feminine name, meaning "mother of Mgbo," long ago in an *ɔkumkpa* skit when the wearer called himself *nne mgbo*, and it has remained as its most common name. At Afikpo, women are normally addressed by the name of a daughter, especially the first one. The mask is also called *nne mapɵ* ("mother of mapɵ") for much the same reason. Afikpo also sometimes say that it looks like a monkey (*enwe*), or even a chimpanzee (*ozo*), but it is not usually called by these terms. It is almost the same in basic coloration and form as the *beke* mask; but the latter has an oval, protruding mouth with black lips, while the mouth of the *nne mgbo* is wider, quarter-moon in shape, and often without any indication of lips. The *nne mgbo* is sometimes also called *beke* (white person) at Afikpo, and Starkweather (1968, nos. 50-51) refers to it by this term; but I was assured by Chukwu Okoro and others that this was not its true name and that it was a distinct mask form (see

figs. 15, 16; and figs. 12, 17, 36, 42, 56, 60; pl. XII; and Cole 1970, p. 47, fig. 97; p. 57, fig. 116).

Variations. Decorative designs usually do not appear on this mask, and its variations consist of only slight differences in form. Some *nne mgbo* are V-shaped, although not highly pointed at the chin, while others have a more oval quality. Some, such as my 1959-60 (no. 2) form (fig. 16), have more concavity in the cheek area below the eyes. There can be a wider, larger mouth, which sometimes is turned upward a bit at its outer edges. A few forms have a smaller, heavier, and thicker nose than others.

In terms of design, in some *nne mgbo*—for example, my 1952-53 (no. 1) mask (fig. 15)—the black line along the nose ridge stops at the base of the nose, while in others it continues up the forehead; in some cases it even connects with the black head and sometimes contacts the inner ends of the eyebrows. A fair number of *nne mgbo*, but probably not the majority, have either a white line or a white design in the shape of a drop that goes back on the head from the hairline at the left side of center. Some masks have considerably more white area in the forehead; in others the hairline comes down close to the brows and the brows may not be so curved. A few masks have black lips. All of these features seem to vary independently, as in the case of *acali*. A number of special variants should be mentioned.

1. In the Amuro 1952 *ɔkumkpa*, one *nne mgbo* had a heavier, less delicate appearance, with a larger nose than usual, a wider, longer mouth, and very little white on the forehead over the brows; the hairline on the forehead turned upward toward the sides before meeting the black border.

2. At an *njenji* parade in 1960 there was a form with a long mouth, upturned at the corners, and a heavy, black nose line that connected to long, black eyebrows. The hairline had a reverse curve from the usual form and it came about halfway down the side of the face. The side of the mask and the lower face were white; there was no black frame to the face. The outer ends of the eyebrows connected with this descending black line. The top of the head was flat, with a white "V" cut on it.

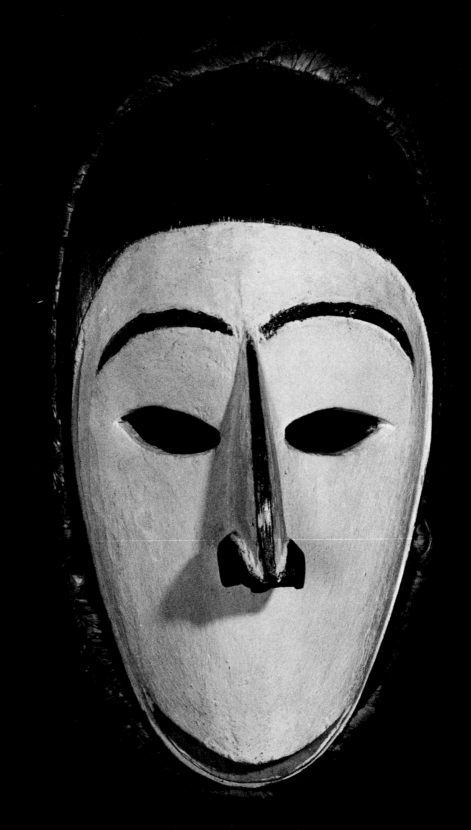

Fig. 15. *Nne mgbo* (no. 1, 1952-53)

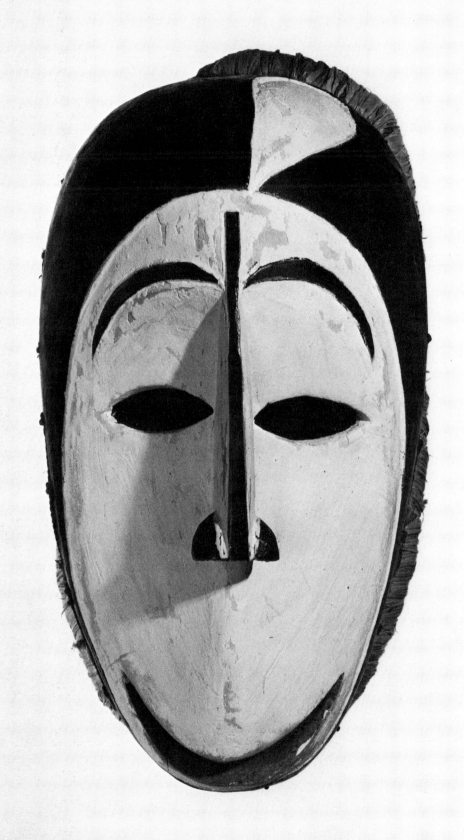

Fig. 16. *Nne mgbo* (no. 2, 1959-60)

3. At the Mgbom ɔkumkpa play in 1960 (fig. 36), I noticed a form with only a little white above the eyes; the hairline came down close to the brows in front, and curved off to the side of the face, so that there was no black border to the

middle and lower face. There was a wide, heavy mouth with black lips.

4. Another *nne mgbo* at this same play (fig. 17) had a wide, black mouth and a small design, black on a white background and about one inch in diameter, on its right forehead.

I cannot tell from the photograph whether there is any design on the left side.

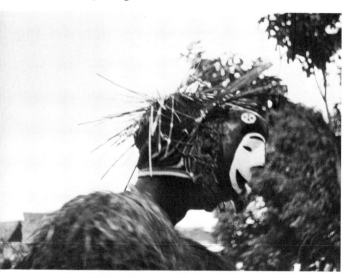

Fig. 17. ɔri dancer with *nne mgbo* mask, Mgbom village ɔkumkpa, 1960

5. Starkweather (1968, no. 50) pictures a crude mask from Afikpo with heavy black lines on the nose ridge, nostrils, and for the brows. There is a white "drop" design on the left side of the forehead and head, but its lines appear straight and not curved as is usual. White triangular areas are located on the forehead above the brows.

Relation to other Afikpo masks. The similarity to the *beke* form, except for the mouth, has already been noted. This mask also resembles the face of the common form of *mba*, except for the mouth, and it is similar to the face of the "queen" except for the latter's mouth and its facial decorations.

Uses. The color and general features of this mask place it among the group that at Afikpo are considered female and are employed with costumes of a feminine nature; its name also implies that sex. Yet, although it is occasionally worn at the ɔkumkpa play with the dark raffia ɔri costume to portray a woman in one of the skits, it is also one of the favorite masks worn by the younger adult males, in ɔri costume, who do not act a female part but come out and dance individually between skits and serve as an important and clearly male group (fig. 17 and Cole 1970, fig. 97). At one Amuro play (1952) it was also worn by one of the two assistants to the senior and junior play leaders (fig. 42). I have never seen young boys wearing this mask at this play.

In the *njenji* parade it is worn by males who range in age from young boys to adults. They are dressed as Muslims, lawyers, missionaries, and so on, but never in female dress, although other masqueraders wear female attire (see pl. XII). The wearers of this mask are sometimes mixed up with the wearers of the *beke* face coverings, leading me to feel that the Afikpo see these two mask forms as being closely related.

I do not know whether the *nne mgbo* is employed in the Afikpo okonkwɔ dance, as I did not see one. A variant form was seen in the form of play in neighboring Okpoha Village-Group. It is used in the *logholo* chasing plays at Afikpo.

Nne mgbo is a common Afikpo mask. It is not unusual to see ten or more of them at a single ɔkumkpa or *njenji* performance.

Carving. One boy who was starting to carve made it as his second mask. It is made out of light wood, such as *okwe*, and it is not considered difficult to carve, lacking decorations and projections.

Comments. Chukwu Okoro says that "it is neither a humorous nor a sad mask. Who has such a mouth as this? Look at its beautiful nose; it cannot be said that it is humorous or funny. It is so designed to imitate somebody's jaw. The mouth reminds me of somebody I know, a rascal man." Enwo, Chukwu's friend, does not like the female *ibibio* mask or this one. The *nne mgbo* looks like a chimpanzee to him, especially the curve of the mouth, and he does not like this animal's face. At another time Chukwu Okoro said that the mouth resembled that of a monkey.

Distribution. It seems to be basically an Igbo style, but very simple in design. It is present in Okpoha Village-Group, where I have seen it worn in the okonkwɔ play (1960) by the two xylophone players and two adult male dancers dressed as females (see fig. 60). The form there had a white face, more oval than those at Afikpo, and a peaked white center line in the forehead. A raised black

hairdo went from side to side across the front top of the head and down the upper portion of the sides of the face, with a white band laid over it. The mouth was ⌣ rather than ⌣. I do not know whether the people of Okpoha use the Afikpo name for this mask or if it is present in other Ada village-groups of the Eastern Igbo. Starkweather (1968) does not list it outside of Afikpo. I have no theory as to its origin.

Basis of analysis. My 1952–53 and 1959–60 masks, carved for me by Chukwu Okoro (figs. 15, 16); some twenty-five masks from photographs of it in use; Cole 1970, figs. 97 and 116; and Starkweather 1968, no. 50.

ɔKPESU UMURUMA

Names. The name, ɔkpesu umuruma, is used for a variety of ugly and grotesque masks that are generally worn by the older ɔkumkpa players and represent old, greedy men and sometimes elderly women. The term means "frighten-children," and the mask is designed to be upsetting. If one wishes to insult a person at Afikpo, one tells him he looks like an ihu ɔri ("face-ugly"), another name for this mask. The term ɔri also means "evil" at Afikpo, and evil is sometimes equated with ugliness.

General features. The mask is characterized by a great deal of variation in form, in contrast, say, to the ɔpa nwa, where the variation is largely in the surface design elements. There are design elements on these ugly masks, but these seem secondary to the form. The masks of this group range in size from about 9 inches long and 4 inches wide to ones with nearly twice these dimensions. They are usually black or dark brown, with only small colored lines, dots, and circles as designs. There may be masses of color—white, yellow, or red—on the surface, but the background is black. The face is often distorted, particularly in the eye, cheek, and oral cavity regions. The mouth is likely to project forward at a crooked angle and to have large teeth. The cheeks may be bulging and gross, sometimes out of line with one another; the eyes are large, colored, projecting circles, having heavy, bulging upper eyelids pushing in different directions. The forehead may also bulge. The nose often lacks the straight high-bridged quality of many Afikpo masks, but is flatter and broader, and it also may be distorted and angled. The bridge of the nose sometimes sinks in at the middle. Cheek marks and other incised colored designs occur, but sporadically and not systematically; if they are found on one side of the face or head, they do not necessarily occur on the other. Some ugly masks lack them entirely (see figs. 18-22 and pl. VI, and figs. 11, 23, 50; pls. X, XIII; and Cole 1970, fig. 116).

Variations. A number of distinct substyles appear.

1. One form is represented by three ugly masks made for me by Chukwu Okoro (see figs. 18, 19, 20). Here one finds round, colored, cut-out popeyes; bulging cheeks; a projecting or full forehead; and a toothed mouth. Figure 19, with the large tooth design, is explicitly recognized by the Afikpo as being from Ibibio. By those who are familiar with masks in Mgbom village, it is called imɛ ogerɛ, a woman's name, for when it was first used in the settlement it was worn by a man who sang about and acted like a woman of this name. Nevertheless, the mask generally represents a male elder. Starkweather (1968, no. 22) has a fine picture of this form.

2. Another variety, represented by figure 21, made by Chukwu Okoro, and a like form also manufactured by him and now in the R. H. Lowie Museum of Anthropology at Berkeley, California (fig. 22), seem to have come into Afikpo from Okpoha Village-Group. These masks display very few elements of distortion. They have the conventional oval eyes; a short, rounded nose; a bulging forehead; and a small, projecting mouth which is similar to that of the "queen" mask. A white band separates the forehead from the head above, and there is a white nose line. Short, white dash marks appear vertically under the eyes and horizontally at the center of the forehead; white and colored horizontal dash marks go down the sides in the region where the ears would be. This variant is sometimes called okpoha.

3. A third style (pl. VI) has a low, rounded forehead; a concave face with a flat, wide nose; and bulging upper eyelids. The slope inward from the forehead to the eye region is gentler than in many other ɔkpesu umuruma masks (see Cole 1970, fig. 116).

4. Another style has a small face and looks like a patched-up and deteriorating mask. It is hard to recognize any clear features on it at all. Probably these are ancient ugly masks.

5. There are numerous other types. One is larger than any that Chukwu Okoro made for me. It is well rounded in shape, with large, bulging eyes and a mouth of the same design. The bulge tapers out gradually on the outside to the opening of the eye or mouth, rather than being sharply cut as in the first variety discussed above. One of these masks has one side of its face colored white, the other black, with three bulging projections in camwood. In another (fig. 11) the projections are yellow-brown and the face is largely white—an exceptional feature on Afikpo ugly masks.

6. Another form seen at the Amorie ɔkumkpa in 1952 is a very large mask, slightly convex but with a rather flat appearance for Afikpo forms. It has a large, white quatrefoil design at the forehead and red eye openings circled in black, then in white. There are a small, red peg nose and a red,

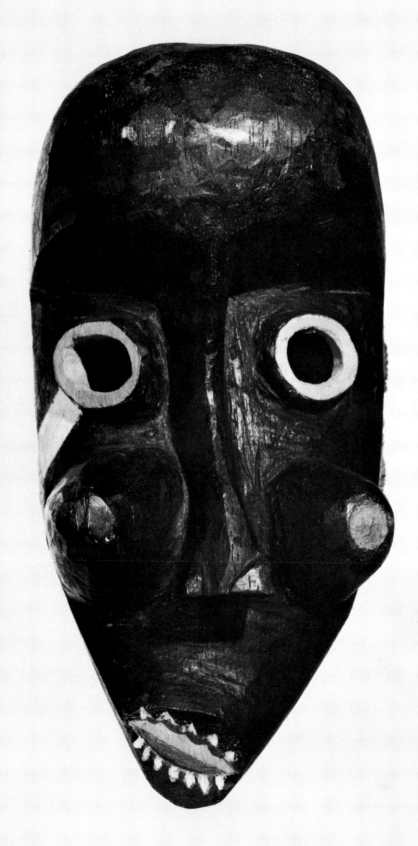

Fig. 18. Ɔkpesu umuruma (no. 1, 1952-53)

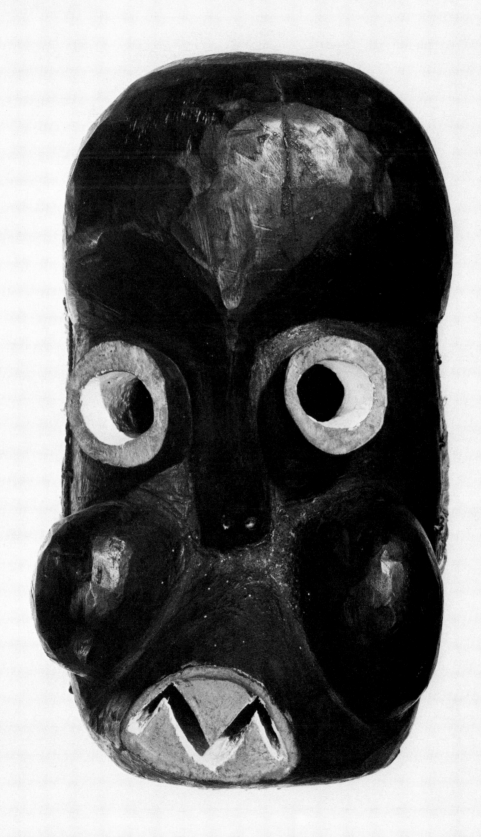

Fig. 19. Ɔkpesu umuruma (no. 4, 1959-60)

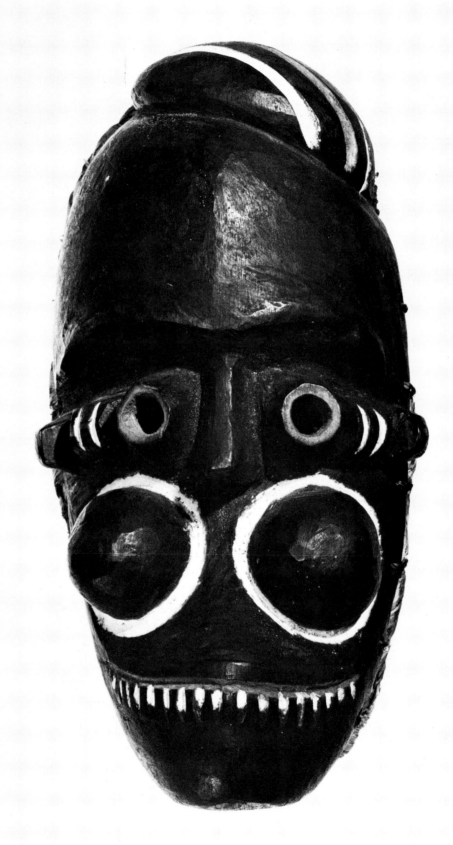

Fig. 20. *Ɔkpesu umuruma* (no. 5, 1959-60)

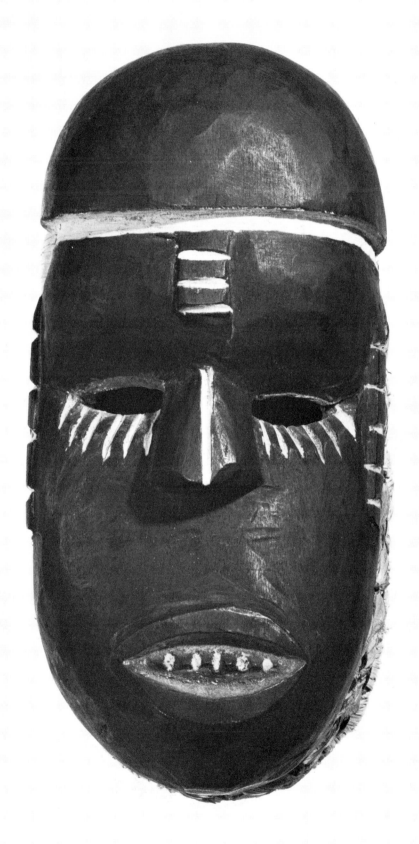

Fig. 21. Ɔkpesu umuruma (no. 3, 1959-60)

oval mouth; white lines go from under the nose and down toward the sides of the chin. A white circle appears on its lower right cheek, a symbol that often indicates Ego origin.

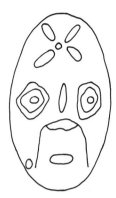

7. At one ɔkumkpa play at Mgbom there was a large distorted face in brown papier-mâché, which had been purchased by a friend of Chukwu's at Aba, a popular center for obtaining masks. It was fully accepted as an ugly mask and created a good deal of interest and excitement. Unfortunately, I did not get a photograph of it.

Ɔkpesu umuruma is a common form; and the first variety is perhaps the most frequently found. Because of its association with older males and its ugly qualities, it is respected and somewhat feared at Afikpo, even by adult men. It is taken much more seriously than some of the white-faced forms.

Relation to other Afikpo masks. The form contrasts with the white-faced, symmetrical masks of Afikpo. It is not based on abstraction, as the igri and the ɔtogho, but on distortion. The Afikpo see it as a highly distinct and most interesting type. Only the junior leader's mask, nnade ɔkumkpa, has some qualities of its style, particularly in its bulging upper eyelids and projecting mouth area.

Uses. Common to the ɔkumkpa play, the ɔkpesu umuruma is a favorite mask of the older players who, wearing the dark ɔri costume, dance individually between the skits and may also be actors. Ɔkumkpa musicians sometimes wear an ugly mask, and it is frequently used to represent an adult, or specifically an old male or female, in the skits. The mask stands for greediness and the self-interest of elders; the facial distortions seem to be regarded not as symptoms of physical illness, such as leprosy or yaws, but rather as signs of social illness.

In the njenji parade players in the line do not use it, but one or two players who gambol about wear it, completing their costumes with old, dark (often ex-army) shirts and pants, and often carrying a long gun and a full burlap bag (see fig. 50; pl. XIII). They represent Aro slave traders or persons sent from Okposi (a famous old slave-trading center northwest of Afikpo) by the Aro. At times they portray the slaves themselves. The ugly masks were not used in the okonkwɔ that I witnessed at Okpoha Village-Group, nor do I believe that they are so employed at Afikpo.

The mask is not found at logholo or other chasing plays, perhaps because younger men and boys perform these and the mask is for men of maturity. I have never seen it worn by young boys, even adolescents, at Afikpo.

Carving. This form is frequently made out of a light, porous wood. Chukwu Okoro says that it is the only secret society mask for which he does not explicitly copy existing masks, but feels free to develop his own style and variations. Some of his creations do seem quite like other ugly masks at Afikpo, although he may have carved some of the latter himself and simply copied his own originals. Perhaps, symbolically, the freedom of style here equates with the great freedom (and power) of the male elders at Afikpo. Chukwu enjoyed making this type of mask for me. The more difficult aspects of carving—complicated design elements and the shaping of long projections—are absent, of course.

Comments. Chukwu at one time said that he liked ɔkpesu umuruma "because of its purpose in plays, not because it is funny looking." He went on to say that it does not look like a person to him. Once when I asked him what he liked about it, he said that "everything is fine. Look at the teeth and the tongue; everywhere it is amusing." At a later date he stated that one of these masks that he was working on for me "looks like someone in Ezi Ukie," a compound of Mgbom village, and he thought that this was very funny—a mask with big eyeballs and protruding teeth.

Distribution. Some of the ugly masks at Afikpo are probably of ancient origin and are associated with the Ego people. Others are the consequence of contact with the Ibibio, who produce the well-known black, distorted, ugly-faced masks associated with the Ekpo society. They are found as well among the Anang and the Efik. The local ones are reduced in size to Afikpo mask dimensions and are worn with different-styled headdresses, but they possess a similar black, distorted quality. As we have seen, Afikpo also import and carve locally the white and colored ibibio masks. One mask (variant 2) with little distortion is explicitly considered to be from Okpoha.

On the other hand, ugly masks also exist in the Igbo tradition, although they are not as well known in the literature as are the white-faced mmaw funeral masks and the "maiden" forms. The darker forms are discussed by Cole (1969, pp. 33-38); Himmelheber (1960, pls. 54, 208, 209)

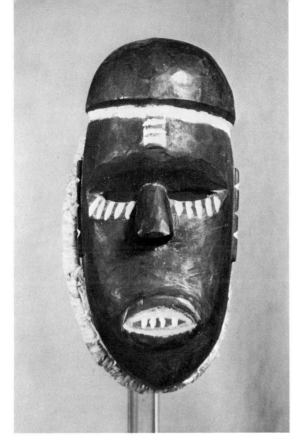

Fig. 22. Ɔkpesu umuruma, Okpoha style, made by Chukwu Okoro in 1959-60, now in Lowie Collection. Courtesy of Robert H. Lowie Museum of Anthropology, Berkeley, California

Fig. 23. Ɔkpesu umuruma masquerader, Amorie ɔkumkpa, 1952

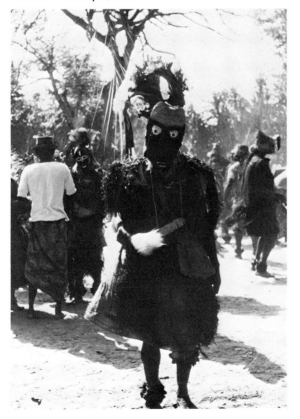

pictures a number of them. Starkweather (1968, nos. 121-24) mentions some from Ozubulu, about twenty miles south of Onitsha; Nzekwu (1960b, p. 76) cites an ugly form at Aguleri; Daji (1934) mentions them in writing about masquerades in the Isu trading towns in Owerri; and Boston (1960, p. 61) cites them for the northernmost Nri-Awka area. I believe that ugly masks, employed to scare and frighten people, are common among the Igbo, and it is likely that some forms came to Afikpo through Igbo invasions and contacts.

Starkweather (1968) does not discuss or report on this form in the Ada group of the Eastern Igbo outside of Afikpo. Jones (1939a) mentions a mask with a large, moonlike face, protuberant cheeks, and circular holes for eyes, which is probably from Edda, whose wearer spends most of his time miming and clowning. It is painted red with white spots.

Thus, the ɔkpesu umuruma at Afikpo probably represents a blending of an ancient, local, non-Igbo ugly face tradition tied into a Cross River aesthetic style, plus strong Anang-Ibibio-Efik influences, with some absorption from the Igbo tradition of ugly masquerades.

Basis of analysis. Six ugly masks carved by Chukwu Okoro in 1952-53 and 1959-60 (figs. 18, 19, 20, 21; pl. VI); another one carved by him in 1959-60 (Okpoha style) in the R. H. Lowie Museum of Anthropology, Berkeley, California (fig. 22); photographs of some twenty masks in use at Afikpo (see Cole 1970, fig. 116); Starkweather 1968, no. 22; and Jones 1939a.

ƆPA NWA

Names. The term means "carry-child" or "hold-child." Starkweather (1968, no. 38) suggests it translates as "she is carrying a child." It is also called agbɔghɔ ɔkumkpa (adolescent [girl]-ɔkumkpa play). In English at Afikpo it is often referred to as the "queen" mask.

General features. The face is that of a female, the mother of the seated "child" figure that she carries on her head. In fact, however, the "child" appears to be an adult and displays hair styles rarely worn by young Afikpo girls. This is the largest Afikpo mask, ranging roughly between 19 and 25 inches in height, although the width is within the usual range of 3 to 5 inches, and the mother's face is of average size. The mask is carved out of a single piece of wood. The shape of the mother's face is similar to the beke and mba, but it is much decorated. The lips are black and there are teeth. Cheek tear marks occur, and often black squares or other designs are found at the side of the cheeks—a common feature in both Igbo and Ibibio-Anang masks. The oval eyes are of the usual form, as is the long, straight, or

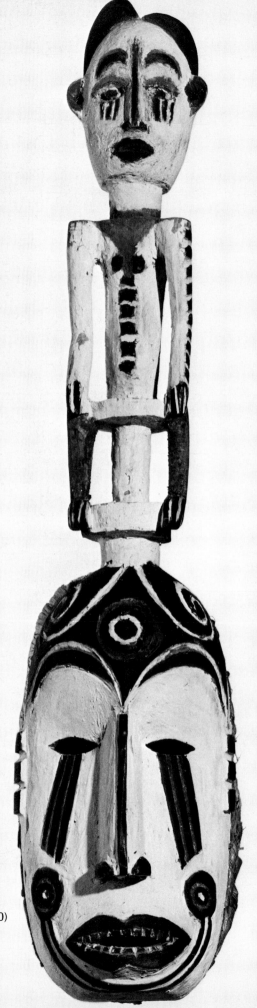

Fig. 24. *Ɔpa nwa* (no. 2, 1959-60)

slightly convex, nose, with its black ridge and nostrils. The hairline is of the pointed style.

The face is white, the forehead black; frequently the latter is decorated with one or more colored circles at its center, with "watch-spring" designs on each side, coming off of the front base of the

post holding the "child." The head is rounded. There is likely to be a circle or a star design at the lower cheek level on each side, which may connect with tears coming from the eyes and with lines running under the chin. The bottom of the chin is flat.

From the top front of the head rises a vertical post; the feet of the "child," a little over an inch above the head of the mother, rest on the edge of a circular platform on top of this post, the platform often being cut away in front between the feet. The lower legs of the "child" are colored orange or red with camwood. A second circular platform, also sometimes cut away in front, forms the hips and waist of the figure. There are no sexual organs. The arms rest on the knees. Toes and fingers are usually indicated, and there is often a design in black—squares or dots—going up from the protruding navel to small black breasts or nipples. The lower neck, shoulders, and upper chest of the "child" are colored orange, camwood, or yellow. The face has black lips and a red mouth, the typical forms of nose and brows, and a variety of black hair styles, sometimes with designs on them. The figure has projecting ears like those on *ibibio* masks, which are the only masks at Afikpo to display this feature. The statue's face is larger in proportion to the body than it would be in real life —a common trait in West African sculpture. The back of the figure is not elaborately decorated.

The mask of the mother and the "child" is predominantly white, while black is the next most striking element. The whole can be described as "decorated naturalism" (see figs. 24, 25, and pl. VII; and figs. 52, 53; pls. X, XI; and Cole 1970, fig. 112).

Variations. One type is simpler in decoration. For example, the *ɔpa nwa* in the Manchester Museum, England, mistakenly entitled *mba* (Fagg and List 1963, pl. 116b; Willet 1971, pl. 72), has no forehead decoration on the mother's face, no designs on the chest or stomach of the "child" or under the mother's chin. The face of the mother has two black circles at the side, a motif sometimes employed rather than small black squares, and the child has a projecting center-line

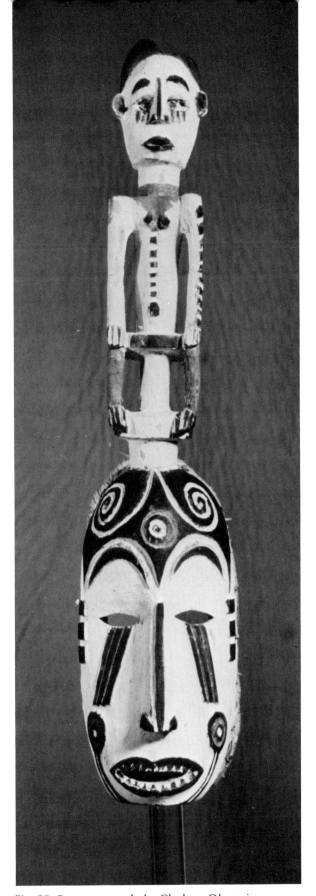

Fig. 25. *Ɔpa nwa*, made by Chukwu Okoro in 1959-60, now in Lowie Collection. Courtesy of Robert H. Lowie Museum of Anthropology, Berkeley, California

hairdo, a ceremonial style worn by married Afikpo women. I have seen similar masks to this specimen at Afikpo. Another simply decorated one, in Starkweather 1968 (no. 38), lacks forehead designs on the mother's face and the two black rectangles at its sides. However, the front of the seated figure is decorated. The hairstyle of the "child" is something like that of the one in the Manchester Museum.

Another form (fig. 53) has the "child" resting on a white circular element on top of the mother's head, such as is sometimes found on the heads of *beke* masks. Some Afikpo forms have only cheek marks on the mother, with no circular designs or chin lines. In one case the sides and underchin of the face are black and connect with the black hairdo; the whole face is framed in black. Here the hairline is a simple arc across the forehead. These features are also found on the *beke* and *nne mgbo* masks.

In some masks the mother's mouth is open, but no teeth are indicated. In any case the mouth is usually a single oval, but occasionally, as on my 1959-60 (no. 2) mask carved by Chukwu Okoro (fig. 24), it consists of two connecting ovals:

 In another mask made by Chukwu Okoro (fig. 25), now in the R. H. Lowie Museum of Anthropology at Berkeley, California, the mouth is

in half ovals, like this:

Many of the hairstyles on the "child" are either of the center-crest variety, or are J-shaped from a side view, large in front and smaller in back, with decorations, as in my no. 1, 1952-53 mask (pl. VII). I do not believe that there is a hairdo of this latter kind at Afikpo. Another style, found on the 1959-60, no. 2, and the Lowie Museum masks (figs. 24, 25), has a white center line at the base of the statue's head, with hair rising at both sides, more steeply on the head's right side. This closely resembles one real Afikpo hairstyle, and also reminds one of styles on *ibibio* masks at Afikpo.

Relation to other Afikpo masks. I have already indicated the basic similarity of the mother's face to the *beke* and the *mba,* and the unusual feature of the statue's ears, found otherwise only in the *ibibio* style.

Uses. It is said to be worn by only one person in the *ɔkumkpa* play, an older boy or young man who dresses up like a girl and, at the next to the last event of the play, comes forward to dance in imitation of a girl's style. However, in some *ɔkumkpa* plays the older boys in the *akparakpa* dancing group use this mask; others wear the

mba. I have never seen it worn with the dark raffia *ɔri* costume.

The mask is also worn, with very elaborate feminine costumes, by some ten to twenty-five young adults at the head of the *njenji* parade, following the gamboling *igri* players (figs. 52, 53; and Cole 1970, fig. 112). There is an elaborate headdress behind the masks, using mirrors and colored woolen string, and the masqueraders wear gaily colored European sleeveless shirts, plastic waistbands, and colored European cloths hanging from their waists. They are certainly proper ladies!

The *ɔpa nwa* is also worn in the *logholo* chase, but it is not used at *okonkwɔ.*

The mask is common, widely used, and much loved at Afikpo.

Carving. Chukwu Okoro and his brother, Oko, agree that it is the most difficult Afikpo mask to produce. It is usually made of a hard wood, such as *mba.*

Comments. Chukwu Okoro once remarked that he liked this mask best of all. "It is a girl and it is more interesting," he stated; later on he said that if one dresses like a queen—in a very fine manner—then he should wear a queen mask and not one that is worn with the dark *ɔri* costume.

Distribution. Starkweather (1968, nos. 37-41) indicates that this mask occurs at Amaseri Village-Group where, under the name of *nfuebulu,* the face part is crowned with the figure of an adult cradling a child. One might thus infer that the Afikpo "child" on top of the head may, in fact, be an adult without a child to cradle; indeed, the Afikpo "child" does not particularly look like a child, often having breasts and a female adult hairstyle. Further, the "child" is seated in a position that would allow it to hold an infant on its lap. It may be that the baby is an element that has been lost at Afikpo—nevertheless, persons there do refer to the statue as a child.

Jones (1939a, pl. 3) shows a similar mask at the Ofogu festival in Nkporo Village-Group. Forde and Jones (1950, pp. 51-54) include Nkporo in the Ada group of the Eastern Igbo, although the Afikpo do not seem aware of any particular connection with them. In Jones's example the mother's face is rounder than at Afikpo and it lacks cheek marks; the body of the "child" is dark, but its face is similar to the Afikpo style. The player, wearing white shorts, decorated waist beads, and a shoulder cloth, is with a group of masked musicians (some with net masks, others with the *mma ji* style mask) and appears to be shaking rattles.

I believe that the *ɔpa nwa* is found in all of the Ada village-groups of the Eastern Igbo. I do not know its distribution elsewhere. It is Igbo in appearance: the mother's face has a resemblance

to the famous Igbo *mmaw* masks of the Northern Igbo, and it is common for Igbo masks to have one or more wooden figures—either human or animal—on their tops. For example, Jones (1945b, pl. 5) pictures an Igbo beautiful mask, *nwanyure*, whose mother's face is something like the *ɔpa nwa*, with white coloration, a pouting mouth, and a similar nose and eyes. It is carrying two seated figures.

Basis of analysis. Photographs of some fifteen masks in use at Afikpo (see Cole 1970, fig. 112); those masks of Chukwu Okoro—one made in 1952-53 (pl. VII) and the other in 1959-60 (fig. 24)—in my possession, and another made by him in 1959-60 in the R. H. Lowie Museum of Anthropology, University of California, Berkeley (fig. 25); Starkweather 1968, nos. 10-12, 37-41; Fagg and List 1963, pl. 116b; Willett 1971, pl. 72; and Jones 1939b, pl. 3).

ƆTOGHO

Names. The term *ɔtogho*, used by secret society members, means "to peck like a bird," and the Afikpo say that this mask looks like a bird. Starkweather (1968, nos. 42-46) calls it *otogho kpo kpo*, commenting that *otogho* is the name of a woodpecker and *kpo kpo* is his pecking sound. The common Afikpo name is *obuke*, a dark-colored, wooden ceremonial machete sometimes carried by the *ɔtogho* masquerader.

General features. It is variable in size, some examples being quite small. The masks range from about 6 to 9 inches long, are roughly 4½ inches wide, and some 3 to 6 inches deep (excluding the raffia backing). The design is characterized by curved wood projections coming out of the top and bottom ends of the mask and nearly meeting at the front center as tapered points. The eyes are oval; tear marks sometimes appear and a mouth might be found on the outside of the lower projection.

Variations. Starkweather (1968, nos. 42-46) says that "considerable variation in shape and decoration is found in this type of Eastern Igbo mask." I have no photographs of it in use, but my two masks differ from one another considerably and from the one pictured by Starkweather (1968, no. 44) and one in the Lagos Museum that may be from Afikpo.

1. My 1952-53 (no. 1) form, made by Chukwu Okoro (pl. II), is a thick, relatively heavy mask for Afikpo. The projections are large, the lower one white on the outer and inner edges and black on the sides, and the upper one black except for a white inside and beveled outer edges colored in camwood. The projections have something of the look of the triangle with curved lines in three dimensions, the typical Afikpo design. The eyes

are oval, with a black raised outline around them. The triangular curved design is found also on the face above and below each eye in white, and the center part of the face is in camwood color above and below the eye level. The sides, top, and bottom of the mask are black, and there are figure eight ear designs in white on each side at the eye level.

2. The other mask, made by Chukwu Okoro in 1959-60 (fig. 26), is smaller and lighter. Roughly 7½ inches long, 4½ inches wide, and 3 inches deep (excluding the raffia backing), it is small in size, even for an Afikpo mask. The projections are thinner than on the first face covering, more sharply curved and flatter. There is a red mouth with white teeth on the outside of the lower projection, and above it a white triangle, enclosed on two sides by yellow borders. The upper projection has only two white stripes along lines corresponding to the yellow borders on the lower projection. The inside of both projections and the center of the face are white. There are black oval eyes, surrounded by white. The narrow sides of the face are black.

3. Starkweather's (1968, no. 44) mask is also small—6 inches high—and of chalk white, camwood, and black. Its projections are both alike in design, having camwood edges and a white stripe down a black outer surface. The projections appear to be thinner from side to side than in the other *ɔtogho* forms. The white face has oval eyes without other coloring around them, and there are tear marks on each cheek.

4. A specimen from the Eastern Igbo area in the Lagos Museum (see Beier 1960, bottom of pl. 6) has heavy, curved projections, a light-colored center, and black dots on the mid-sides. There are tear marks, and a mouth shaped like a flat-ended pear. The left side of the top and the right side of the bottom projections are dark; the reverse sides are light-colored. This design tends to suggest that either end could be considered the top, although tear marks, eyes, and mouth indicate the proper position. This feature is common to the *ɔtogho*; one must look carefully for which way is up or down.

Relation to other Afikpo masks. The form is quite distinct from other Afikpo types.

Uses. It is more limited in use than many other Afikpo masks being used in the *logholo* chasing plays. I have never seen it in the *ɔkumkpa* or *njenji*, but I do not know whether it is specifically proscribed from these activities. It was also absent from the Okpoha Village-Group *okonkwɔ* that I witnessed, and I doubt that it would be in the Afikpo variety. It is generally absent from the five Afikpo villages that comprise the Itim subgroup of Afikpo. Starkweather (1968, nos. 42-46) says that at Afikpo "it is used to act out

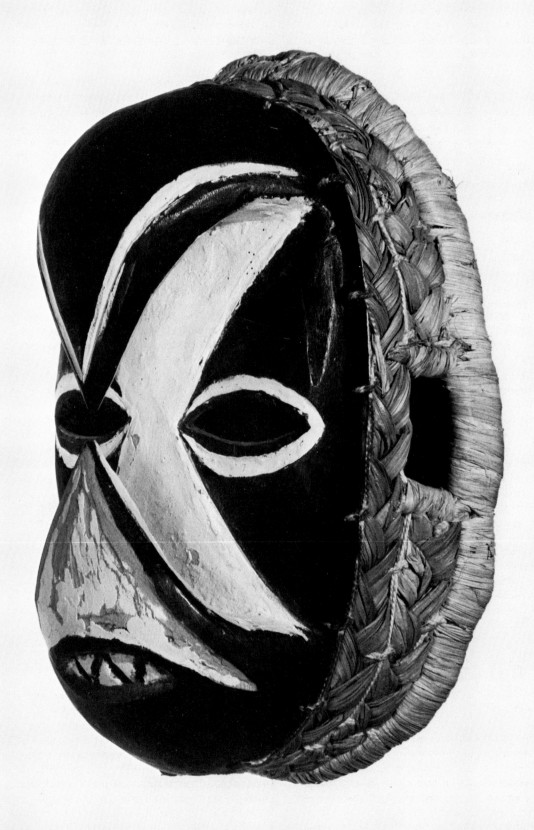

Fig. 26. Otogho (no. 2, 1959-60)

the man who is too boastful. It is a good example of how the Igbo masquerades can make use of an animal character from their folklore to depict human quality. The woodpecker appears in the play called *obu jaja*." I have been unable to identify this play at Afikpo. But in the *logholo* the wearer of this mask struts about, showing strength and quickness. At Afikpo the *ɔtogho* masquerader not only usually carries the wooden machete, *obuke*, special to this mask, but wears a singlet and a raffia, palm-leaf skirt. The face covering, wooden object, and costume together are called *ɔtogho* by initiates and *obuke* by noninitiates.

Carving and comments. It is not an easy mask to produce. I collected no comments on it.

Distribution. Starkweather (1968, nos. 42-46) indicates that it is an Eastern Igbo form, meaning presumably the Ada group of the Eastern Igbo. He says that "it is known as *otiekwe* at Amaseri. In Okpoha the carving of a full bird is projected on wire legs about a face mask to represent *ɔtogho*, which appears during the *Lughulu* dance in May."

Jones (1939, p. 33 and fig. 5) cites a mask from Ngusu Edda called *ufuocha* or *ikwum ocha*, which is used in a rich man's funeral. It has an *ɔtogho* face but a boardlike top piece in the style of the variant 2 *mba* mask of Afikpo, the form with cut-out triangles. No masks are employed in funeral ceremonies at Afikpo as far as I know. But clearly the bird motif, like the horn theme, is present, in one form or another, in the Ada group of the Eastern Igbo. I believe that it is probably an old style to the area; it does not appear to be an Igbo import and its association with the *logholo* and other chase plays using leaf and raffia costumes suggests a Cross River origin.

Basis of analysis. Two masks made for me by Chukwu Okoro (fig. 26; pl. II); Starkweather 1968, nos. 42-46; Jones 1939a; Beier 1960, pl. 6, from the Lagos Museum, which I have seen and photographed.

THE CALABASH FORM

MBUBU

Names. *Mbubu* has no meaning other than to refer to this mask. Even Chukwu Okoro, the carver, could not indicate what *mbubu* means. "It has always been called *mbubu*," he said. He does not know what the mask represented when it was first made at Afikpo; and does not think that it looks like anything in particular. In the southern Afikpo villages of Kpogrikpo and Anohia, the

mask, costume, and the form of secret society initiation in which it is employed, all of which are believed to derive from neighboring Edda Village-Group, are called *ɔkpɵ*. The form of ritual in these two settlements differs somewhat from that of the other Afikpo villages, where it is usually called *isiji*.

General features. The mask is made from an egg-shaped gourd, and it has a gourd top piece which is made from the "tail" of the plant, often attached, using nails or pegs, by means of an inner core of wood or some plant material stuck in the neck between the two pieces. The surface of the gourd is usually dark or black with abstract designs on it; often there are horizontal, colored rectangles and/or bars at its center and some curved triangular designs toward the sides. There are also lines cut completely through the face—horizontally at its front center and sometimes vertically elsewhere—but there is no attempt to indicate a nose, eyes, eyebrows, or other facial features. At best there is a slit that may represent a mouth. The top piece is often of one color, frequently yellow, although sometimes white. This lightweight mask ranges from 12 to 20 inches in length, 5 to 7 inches in width (see fig. 27 and pl. VIII, and pl. XV; and Bravmann 1970, p. 56 and pl. 114).

Variations. The *mbubu* at the Ukpa Village *isiji* initiation in 1959 (see pl. XV) have black faces with horizontal yellow and red, or yellow and white, bars at the center, and a white band around the "face" toward the mask's outside edge. The top piece is yellow, to match the color of the elaborate headdress in back of it, which is yellow with blotches of red. There is a colored vertical center line to the mask. One form has colored

triangles vertically arranged at its sides. Another form has a white angled outline. All the masks have the usual style of top piece.

In 1952 I observed the *ɔkpɵ* masqueraders at Kpogrikpo, but I was able to gather little information concerning their use of masks and form of initiation. The calabash is flatter than in the other forms. The face designs on the calabash mask are vertically oriented, although there are the usual horizontal cuts. In place of the curved calabash top piece is an extension of some unknown material, with a wooden frame backing, which rises several feet in the usual form. In the mask of the leader of the initiate's group, worn by

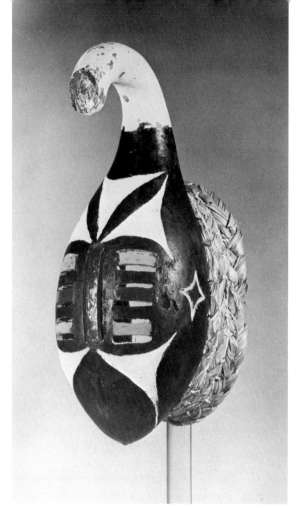

Fig. 27. *Mbubu* calabash mask, made by Chukwu Okoro in 1959-60, now in Lowie Collection. Courtesy of Robert H. Lowie Museum of Anthropology, Berkeley, California

the strongest boy, it extends some fifteen feet, and the wearer uses guide ropes to keep it straight on his head. There are side decorations projecting at intervals from these masks. The body costume consists of the usual raffia form used in the *isiji* initiation. Jones (1945a, pp. 195-96) has a photograph of this style, probably at Edda or Nkporo; but unfortunately it is taken from the back of the players.

Relation to other Afikpo masks. This is the most abstract of the Afikpo masks. It has the Afikpo quality of narrowness and relatively small facial size. The colored designs on it are not out of keeping with design elements on other Afikpo masks. While the gourd material cannot be handled in the same way as wood, the degree of abstractness is not required by the nature of the material.

Uses. The mask makes its appearance during the initiation of eldest sons into the secret society,

at a point in the ritual when these boys emerge from the secret society bush to dance in public in the village common. This form of *rites de passage* normally occurs only once every seven years in a village; although if a man is taking the highest Afikpo title, he must put a surrogate eldest son through the initiation (he will already have initiated his own eldest boy), and this ceremony is performed again, in any year.

The *mbubu* has sacred qualities and special power that extend beyond those of the ordinary Afikpo face covering. Although stored with other masks, it is not usually taken out, even to examine or to use in carving others like it, except for the *isiji* initiation. Its association with the most extensive form of secret society initiation at Afikpo, its use in one of the rituals of taking the highest Afikpo title, its production from a very unusual material for masks, and its abstract qualities all point to a special, prestigious place for this mask. It is not a common form, as one might infer from its rather restricted use.

Carving. This is discussed in Chapter 5, in the section entitled "Calabash and Coconut."

Comments. Chukwu once said that it was not fearful in appearance, but "pretty" (*nghɔ*) to look at.

Distribution. It occurs at Edda and Unwana village-groups, but I am not certain about other areas of the Ada group of the Eastern Igbo. I cannot find it mentioned by Starkweather or in other Igbo writings. I believe that it is a localized style of considerable antiquity.

Basis of analysis. One mask of my own made by Chukwu Okoro in 1952-53 (see pl. VIII and Bravmann 1970, p. 56 and pl. 114) and another by him in 1959-60, in the R. H. Lowie Museum of Anthropology, University of California, Berkeley (see fig. 27 and Bascom 1967, pl. 110); Jones 1945a, pp. 195-96; and some photographs of ten different ones in use at Afikpo.

THE NET MASKS

I know considerably less about the net masks than the wood and gourd forms. The net coverings are called ɔgbɵ, which also refers to fishing nets. These masks are apparently made by the looping of rough-textured twine made from raffia or other native plants, or nowadays sometimes from imported European string. The string fiber is one-eighth to one-quarter inch in diameter. The looping work is close, so that there is little visibility through the masks. Tied around the back

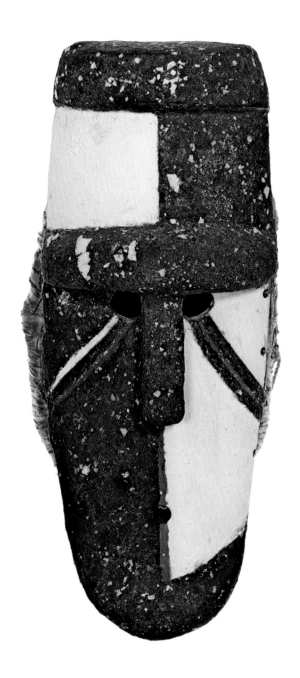

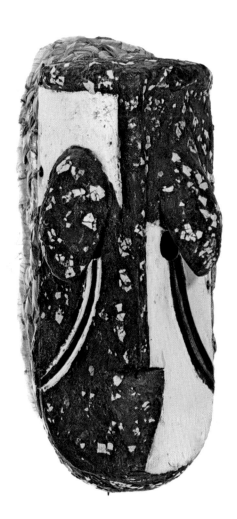

PLATE V

Nnade ɔkumkpa, junior leader's mask (1959-60)

Nnade ɔkumkpa, senior leader's mask (1959-60)

PLATE VI

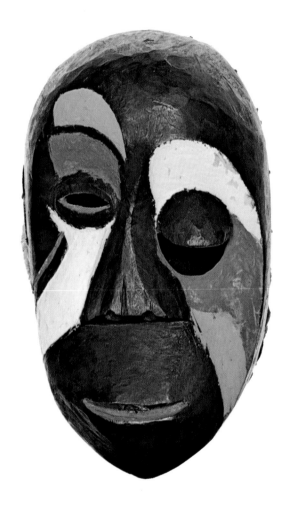

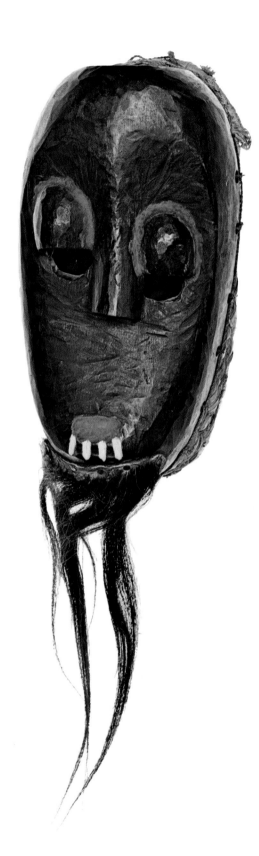

Ɔkpesu umuruma (no. 6, 1959-60)

Ɔkpesu umuruma (no. 2, 1952-53)

of the head, they cover the entire face side of the head and, hanging loosely, front the neck area. There is usually a string attached somewhere at the front center, which, when held out by the left hand of the masquerader, pulls the mask out from the face, enabling the player to see better without others catching sight of his face. The masks are usually brown or blackish, sometimes with white or light-colored bands going from the sides to the central midline. The coloring is usually done with chalk or charcoal (see figs. 47, 48, 49, 62, 69; pls. XIII, XV, XVI).

The net face coverings are not usually prepared by specialists but by the players themselves. In some forms of Afikpo secret society initiation, especially for a man's first son, the boys learn how to make them, and also how to prepare the native fiber. These masks are not difficult to construct. Unlike the wooden face coverings, they are often kept at home in a storage or clothes box; they must, however, be kept out of the sight and touch of females and uninitiated boys. More rarely they are stored in the village resthouses. They do not have the sacred quality of the wooden or calabash masks, yet they play important roles in some forms of secret society initiation and rituals.

The major variations in the net masks are in the coloration, the place where the holding string is attached, the length of the mask in front, and the degree of flatness in its fit to the face. There are two major types. *Aba orie eda* (secret society term–day of week–Edda Village-Group), or simply *aborie*, is a form deriving from Edda that is usually seen at Afikpo only on *orie* days. It is made from palm fiber. Its holding string is attached high up on the center line, tending to pull the mask out in the upper face region (fig. 48). It is sometimes associated with a raffia body dress and a knotted string hat with porcupine quills. In this case the costume is also called *aborie*. This type of net mask is found in various forms and with a variety of dress in the *njenji* parade; in a special running event, the Edda run; and in some forms of secret society initiation.

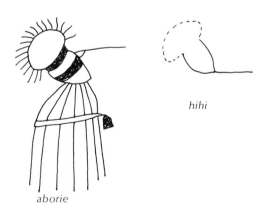

hihi

aborie

Another type, *hihi* or *hihihi* (fig. 69), is found in other secret society initiations, and a similar

form is worn in the chasing masquerade, *ɔtɛro* (pl. XVI). *Hihi* has a flatter face than *aborie*, and the holding string is at or near the front base of the mask. There are also other net forms that are simply called by the general term for net mask, *ɔgbθ*, or are known by the name of the costume that goes with them. Finally, another form, *ɔkpa* (pl. XVI), covers the whole body, not just the facial area.

The net masks more quietly blend with the body costumes than the wooden and calabash types, which become a strong visual focus of the whole dress. The net coverings are usually of dull colors, and their fibrous nature does not contrast with the body costume as much as the wood or calabash forms. Some of the net masks are of Edda origin, but others appear to be local and ancient. I lack sufficient information on their origin, however, although they seem widespread in the Ada area (Jones 1939b; Nzekwu 1963).

MASKS OF THE NONINITIATES

My insufficient knowledge of the *enna* masks allows only the following basic stylistic description, with something about how they are carved included in Chapter 5, on Chukwu Okoro's life and work. These masks, called *ihu* (face), are generally made in imitation of the adult society face coverings (also called *ihu*); but they are much more variable in form and style. They can be formed from a leaf, such as from the banana plant, from paper, cardboard, or a bit of cloth; and in such cases they are usually decorated with simple cut-out designs. Some are made from coconut shell and/or fiber from the bark of the coconut tree, and today, but not formerly, they are also produced from gourds. A wooden nose can be attached to the face with pegs or nails, but the whole mask cannot be made out of wood, as it would offend *egbele*, the spirit of the adult secret society. The uninitiated boy who makes or wears such a face covering is punished and a sacrifice is performed at the shrine of *egbele* to appease its spirit and to prevent illness or other harm from befalling him.

The raffia backing is similar to that used in the secret society masks. The coloring is also similar, including the use of paints today; however, the materials are likely to take colors differently than wood, and the decoration is not usually as elaborate or carefully done. The masks usually lack the sense of depth of some of the wooden ones in the adult secret society—deep carving is rare, for the mask materials are flatter—and the size is also often smaller (see fig. 68, and Cole 1970, fig. 59).

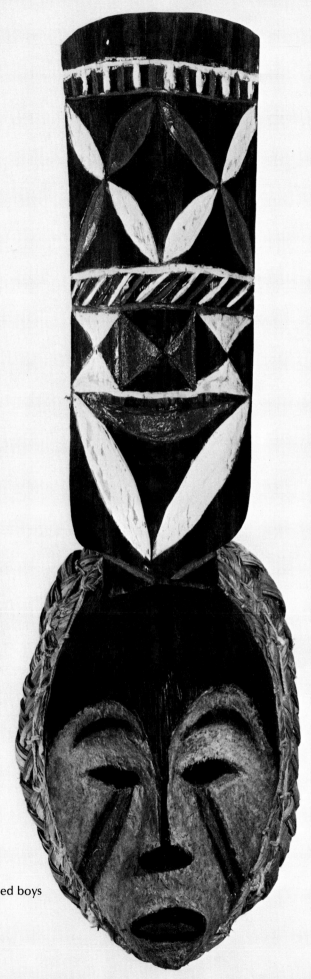

Fig. 28. *Mba* of the uninitiated boys
(no. 2, 1959-60)

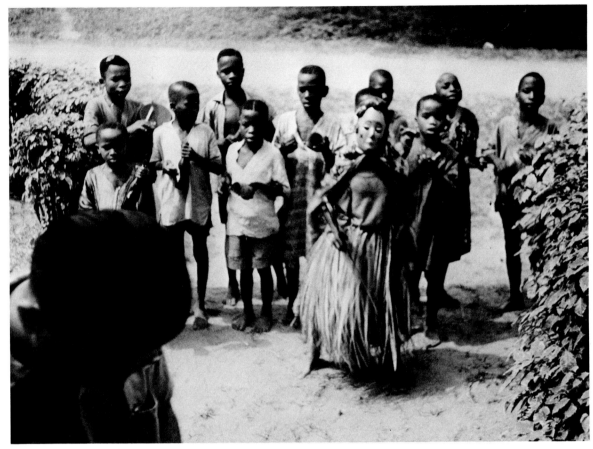

Fig. 29. Young masqueraders outside of author's home during the 1959 Christmas season at Afikpo. The mask is a modern *ibibio*, probably made outside of Afikpo

The boys make their masks in their own resthouses, which they erect in imitation of the ward and village resthouses, and store them in the ancestral resthouse of their compounds. The masks are usually only brought out and used during the ceremonial season, but are never taken off or put on in public. Jones (1945a, p. 199) shows a photograph of boys, somewhere in the Cross River area, who are apparently not initiates to the adult secret society, resting in public with their wooden masks up above their faces. This would be an unlikely occurrence at Afikpo; girls or even married women who saw such a thing would have to give eggs to the boys to sacrifice at their shrine in recompense for breaking a taboo.

At Christmastime at Afikpo I have seen one or more masked *enna*, accompanied by musicians of the same age who hit cans or bottles with sticks or metal pieces, visit the wealthy and educated Africans and the Europeans outside of their houses. The masqueraders, in raffia costumes, wore either coconut or calabash masks, or sometimes modern Ibibio forms.

All three *enna* masks that Chukwu Okoro carved for me are in the *mba* style. The first,

created in 1952-53 (pl. VIII), is of coconut trunk fiber, with a wooden nose attached by two nails through the back. The mouth is not the usual oval, but narrow and moon-shaped, and the face lacks a black border. Otherwise it is a typical *mba*, allowing, of course, for a different curvature of the face and top piece as a consequence of the material employed. The second (fig. 28) and third masks, both with faces made of coconut shell and with coconut fiber for the top piece, have the usual pouted mouths, tear marks, and the typical Afikpo designs on the board of the *mba*. Again, the face lacks a black border. These three masks range from about 15 to 17 inches in height.

At a *logholo* for the *enna* in Mgbom (fig. 68) I saw several coconut masks with black foreheads and nose ridges; the faces looked either like *beke* or *nne mgbo*. None was strongly colored, but each had the tear marks. There was one cloth mask, white on its left side and gray on its right, and several *ɔtogho*, with white faces and black angular and flat projections, one with a small top crest. These were made out of an unknown material. In addition, there was an *ibibio* style with a white face and black hair down the sides, probably made

of coconut; one long-faced *mba* with tear marks and a pointed, decorated top board; and several dark, distorted ugly masks. Finally, there was an *acali*-style mask with a black forehead and a white face.

There does not seem to be any style characteristic only of the *enna* masks. Generally they are imitations of the adult secret society masks, but occasionally a unique form is seen. At Christmastime one year a small dancer appeared with unmasked musicians wearing a brown, round calabash with triangular cut-out eyes, a curved mouth, and some facial features crudely painted on it in a dark color (fig. 29). This form does not follow any of those discussed on the preceding pages.

I did not investigate the distribution of these *enna* forms, but they are probably widespread in the Ada group of the Eastern Igbo, as the boys' society exists in all of these village-groups.

Commentary

There is considerable underlying unity to the masks of Afikpo. The commentary here is an overview based on the preceding descriptions. Comments on the uses of the face coverings are reserved for later chapters.

STYLISTIC FEATURES

Form and Design

The Afikpo mask is made of a single piece of wood, although there is no specific rule against joining two pieces together. The calabash form, of course, is in two parts, although usually from the same gourd. The Afikpo mask has a basically oval face, which at the back is about 8½ inches high and 4½ inches wide, regardless of the total size of the mask and whether or not it has projections.

The masks are generally smaller than most of those found in the Igbo and the Ibibio-Anang-Efik areas, and they have a characteristically narrow face. There are no movable parts and few attachments (one may find jewelry on the "child" on an occasional ɔpa nwa or a horsehair beard on a few of the ugly masks). The back inside of the mask is well worked out, and the back edge is flat and in one plane, with the back of the raffia in a parallel plane about two inches beyond. The type of raffia backing, which is discussed in the section on carving, varies surprisingly little.

When projections exist, as they do in about one-half of the mask types (acali, igri, mba, mbubu, mkpe, mma ji, ɔpa nwa, ɔtogho), they extend outward from the front of the face and/or upward from the head; there are no downward or sideways forms. Projections occur on both the ancient and the modern mask types. The rear sides of projections that extend upward from the face (on acali, igri, mba, mma ji, and ɔpa nwa) are generally unornamented: they are either of one color or uncolored, although decorated at the front and sometimes on the sides. The whole projection of the horned mask and the calabash form is colored but undecorated, except in the case of the ancient and rare Amorie village horned mask. The area in back of the projections on all these masks is likely to be covered with headdresses of porcupine quills, feathers, and false hair styling, so that it is not

very visible and any decoration would not be noticed. However, there is no effort on the part of the masqueraders to present only the front of the face to the public: they move rather freely in many directions, and the audience often surrounds them on all sides.

The eyes of the Afikpo masks are generally oval cut-outs, although square, round, and other shapes are found. The eyebrows are black and gently curved; the nose is high-bridged, often straight and narrow. If the face is white, the nose often has a black line along its center ridge, and its nostrils may also be black. Tears are a predominant element on many masks, although facial scarification is not a feature of traditional Afikpo life. The head is usually dark and only rarely is it extensively decorated. The mouth is frequently oval and pouted, sometimes with teeth distinctly indicated. The area under the chin is rarely decorated or specially treated. The cheek areas are often slightly convex; and this convexity, combined with a bulbous quality to the forehead and a projecting mouth and chin, makes, in some types, for a mild concavity in the shape of the face from the forehead to the chin. The face, generally narrow, is nicely linked to the forehead by the nose ridge, which is usually at the forehead level; there is little or no indentation at the base of the nose. Most forms have no projecting ears, although in some types a simple design occurs in the ear region.

As a rule, no more than four colors are used on a mask. Black and white are traditional, and most frequently employed; there are also an orange-to-red and a yellow. It is mainly in the *ibibio* forms that modern paint colors are employed. Where colors border one another, the color change is usually sharp rather than blended. Color differentiation is generally associated with carving: whenever there is a cut on the surface, there will be a color change—or, put the other way, whenever there is a color change, there will be surface carving, either raised or indented. There are a few exceptions to this rule: for example, in the masks made for me by Chukwu Okoro, color changes occur without surface alterations on the colored triangles of the *mkpere* style *mba* masks (fig. 7 and pl. III), on the face of one of the ugly masks (pl. VI), in the yellow or orange coloring above the black brows of the two

acali masks, on parts of the "child" on the ɔpa nwa, and on the center face of the calabash mask. Extensive cuts without color change exist on the side hair and ears of one of the *ibibio* masks (pl. II). But the strong relationship of incision and color, most evident perhaps in the cheek tears, suggests that carving and coloring are seen as different aspects of one process of design and decoration, rather than as two separate elements.

The strong nose suggests a tendency to divide the face into halves; design elements on one side of the face rarely carry over to the other between the eyes and the nostrils, tending instead to be alike on each face side. The lower mouth area and the forehead are not usually divided. Many masks have a strong brow ridge line. The masks often appear to have four sections: two cheek areas, a forehead region, and a mouth-chin area.

Or, sometimes they can be seen as a "U" divided by a nose and having a separate top section.

In some cases the center ridge line of the nose is extended down to the chin and up to the forehead, dividing the mask into two sides. This division is occasionally effected by the use of projections, as in the case of the pegs on the *mma ji,* or by angling the face planes, as in the *mkpe* and the junior leader's mask.

The most characteristic abstract design element —the concave triangle—is found on both ancient and modern mask forms. Here all three sides of the triangle have concavely curved lines, often coming to sharp points at their junctures; the

design is often in white: Straight-edged

triangles, dash marks—usually two or more together—and straight and curved lines are all common. Small rectangles, squares, or circles occasionally occur, often in black; but these elements are not extensively employed on Afikpo masks. Ovals and quatrefoil designs are also present.

Variation

In going through the masks made for me by Chukwu Okoro and the photographs of others from Afikpo produced by diverse hands, I am impressed with the amount of variation that exists in any mask type, most conspicuously in the design elements. When a good deal of design is

employed in a given type of mask, there is considerable playing with design from mask to mask; a single rigid and static conception of decoration for a mask form does not exist at Afikpo. Most of the variation in the *form* of sculpture is in the ɔkpesu umuruma masks, where large masses are manipulated and treated in various ways. Here there is little decorative design.

Variation in one design element can occur independently of variation in another design element on the same type of mask. I have worked this out in some detail for the *acali* (see Table 2), but it seems to be a general principle at Afikpo. For example, in the ɔpa nwa, there seems to be no relationship between the type of design found in the ear region on the "mother" and the type of design on the "child." Since different elements of a mask vary independently of one another, there are few clear-cut substyles of masks at Afikpo; rather, for each mask type there is a range of variations.

There seem to be no strict rules prohibiting variation; instead, the carver himself regulates the variation according to his own sense of tradition and aesthetics. Just as the masquerade costume is sensitive to and reflects change, so that now we have shorts, singlets, shoes and sneakers, mirrors and plastic bead bands, so should we expect a freedom of expression in mask design. Yet, the variations do seem to have limits: forms that do not have ears do not usually develop them, those without projections do not grow them, and certain colors (blue, green, brown) are not employed as a rule, although they are now available in commercial paints at Afikpo. This principle is exemplified by the fact that most masks at Afikpo are quite easy to classify.

WEARING

The Afikpo masks are worn far forward on the face (see Jones 1939a, fig. 6, or Jones 1939b, fig. 4), a feature characteristic of the Ada group of the Eastern Igbo, in contrast to the Ibibio-Anang-Efik and to other Igbo styles, where the mask more fully encloses the face and even the head of the wearer. The Afikpo forms have a smaller face and no large side areas.

The masks are tied to the back of the head with string from the side holes, or with cloth attached to these holes with string. There may also be a hat with attachments, such as porcupine quills. In any case, there is always some cloth or other covering for the head in a wide variety of shapes and materials. Sometimes a towel or leaves are attached at the top of the head. The color of a cloth frequently contrasts to that of the mask, adding to the attraction of the whole upper part of the body. Attached leaves, porcupine quills, or other materials bend and sway about as the player moves, accentuating his motion.

NAMING

The problem of names for Afikpo masks is most aptly explained by Starkweather (1968) in the introduction to his section on Afikpo:

The names for these masks were acquired from the carvers who made them, and in some cases do not match those published elsewhere. Obtaining names can be a confusing undertaking. Custom provides that certain masks be made from the wood of certain trees. When asking for the name of a mask, you may receive the name of the wood. Some masks may have a name of their own, but in certain cases a mask can be used with different costumes to produce different masquerade characters, each with a different name. (Until we know more about these things it is dangerous to generalize.) The name of a mask may indicate that it is a female. Our conclusion might be that she must enact certain female roles in skits or pantomimes. In reality the mask could be worn by the drummers. Even the Afikpo themselves may not be able to explain why each masquerader wears the specific kind of mask he does.

My own data make several points clear. A mask may have one name used by secret society members and another by nonmembers (igri); the term for the mask may refer to what human or animal form it represents (mkpe, ɔtogho, beke, nnade ɔkumkpa); it may indicate some particular feature of the mask (mma ji, okonkpo for the igri); the name may be that of the costume usually worn with it (ihu ɔri for ɔkpesu umuruma, mba); the term may refer to a character once successfully portrayed (nne mbgo); or it may be a word with no apparent meaning (acali, mbubu). The name may suggest the effect desired in wearing the mask (igri) or the reaction of the viewer (ɔkpesu umuruma). The name may allude to the place of origin (ibibio and the ugly form called okpoha). Terms for a mask may vary from village to village and between those more familiar with masquerading and those less acquainted. This flexibility of terminology may be related to the lack of association of specific mask styles with elaborate traditions or myths or with sacred and powerful supernaturals; the presence of these features might tend to restrict terms. There does not seem to be any correlation between the degree of variation in naming and the age of the particular mask form.

HISTORICAL CLASSIFICATION

The mask styles that appear to be ancient to the Afikpo area, and that are probably also characteristic of the other village-groups of the Ada peoples of the Eastern Igbo, are acali, igri, mbubu, some mkpe forms, mma ji, nnade ɔkumkpa, some ɔkpesu umuruma masks, and ɔtogho. They are either masks that Afikpo claim originated with the Ego, one of the ancient non-Igbo peoples in the area, or they are early Igbo styles associated with the older movements of persons into Afikpo, particularly from the Aro Chuku and Ohaffia areas. These ancient types are characterized by considerable abstraction, limited use of white, and a tendency to be strikingly multicolored, with the use of red, yellow, and black. They tend to employ sharp angles and changes of planes rather than featuring gentle curves. Among them are the most sacred and respected of those found at Afikpo: the mbubu of the eldest son's initiation, the leaders' masks in the ɔkumkpa play, the ugly ɔkpesu umuruma, and the igri mask whose wearer acts as if mad. Except for mma ji and ɔkpesu umuruma, these ancient Afikpo forms are found in only small numbers at Afikpo, although representing about half the mask types there. The ancient types seem quite varied from one another in form and design.

The masks that are more probably of recent local development and/or from external contacts include beke, ibibio, some mkpe, nne mgbo, most of the ɔkpesu umuruma, and ɔpa nwa. These tend to be more naturalistic, even if they have facial distortions as in the ugly masks, and they make considerable use of rounded and curved forms. Each mask has one dominant color, which until very recently was either white or black, although now the ibibio forms are painted in other colors. This modern group includes the least sacred of the masks, for example, ibibio, beke, and nne mgbo. Some of these forms clearly show Igbo or Ibibio influences, while others, such as beke and nne mgbo, and the white-faced, angled, horned form (mkpe) may represent a local evolution from earlier indigenous forms. The masks in the modern group are popular and most are found in considerable number; they have less of a religious quality than the more ancient carvings.

I have omitted mention of the mba style since I am most uncertain whether it is ancient or modern. Its facial features and colors classify it as a recent form, but its headpiece of decorated board is unusual for Igbo masks. It may, in fact, be a composite of an ancient and a modern type, as it certainly has characteristic Afikpo and Ada features.

There are, of course, exceptions to the general distinction between ancient and modern types. For example, the ancient horned mask from Amorie village is white and naturalistic, and the more modern ugly masks also have sacred qualities. Further, the interpretation presented here is based solely on statements made by Afikpo and on my own comparison of Afikpo forms with those from other areas of the former Eastern Nigeria. It is not based on a full examination of mask forms of known antiquity, if, indeed, these can be found today. Nevertheless, this general classification seems to fit the available evidence as well as any.

Carvers

The Afikpo employ two terms for carver, *omenka* (perform-art) and *ogbukpɔ* (cut-noise: one who cuts something). Both terms also signify a carpenter, a person who makes doors, chairs, tool handles, and does other woodwork not particularly aesthetic in quality. The Afikpo perhaps believe that even a carpenter is likely to carve or make designs at some time, though Afikpo do not have carved wood doors or house posts as do the Awka and some other Igbo, and only seldom do they decorate tool handles.

I did not take a census of the number of carvers in the twenty-two villages of Afikpo. I know of no village that has more than one well-established carver, and in some there are none. I believe that there are six or seven established workers at Afikpo and two or three times that number of young initiated boys and men who are experimenting with carving.

No Afikpo carver works full-time or even half-time at the job. Carving is occasional work, and in some years the craftsmen may not have anything to do at all. Carvers therefore may farm, fish, trade, or engage in any other of the traditional Afikpo occupations, such as the practice of native medicine or carpentry. The latter work is likely to include the making of hoe, knife, and machete handles; *ocici* bowls for the hot pepper to use with kola nut; the smaller *ocici* for farm use; drums; and also doors, chairs, and stools. The carpenter may derive a greater income from making these objects than masks.

Up until the last fifteen or twenty years before 1960, when the uninitiated boys' secret society was quite active and when lads were not initiated into the real society until late adolescence or early adulthood, these *enna* had plenty of time to develop carving skills. They made masks for their own plays and dances, which were face coverings of coconut materials, calabash, net, and leaves. After initiation some boys continued working, and these are the carvers of today. However, boys nowadays are initiated into the village secret society at an earlier age and the boys are not so skilled before they join the adult society.* Chukwu Okoro believes that the carving skills at Afikpo

have consequently declined, as boys must start making the society's masks without having first worked on the simpler *enna* forms, where the carving is easier and there seems to be greater variation in style and quality. Today an interested boy member of the secret society experiments pretty much on his own and then takes his masks for examination to a known carver, who will make suggestions; in addition, the boy may just watch him work a bit. Established carvers work with several boys in this informal, easy-going, noncontractual type of relationship.

Carvers can come from any patrilineal or matrilineal grouping at Afikpo; but, as in the case of diviners (S. Ottenberg 1971b, pp. 208-9), if a man is a carver, there is a tendency for at least one of his sons to take up the profession. Chukwu Okoro's family has certainly followed this pattern, although there is no rule in this matter.

The carver, as a member of the secret society, can work only during the season when this group is active, from September or October to May or June. However, he may cut wood and store it for future use during the rest of the year. It is only during the secret society season that he can take masks from their storage places in the village or ward resthouses, or elsewhere, to observe and compare with his own work. And the calabash mask is brought out only at the time of the *isiji* initiation.

The carver works in secrecy and isolation from females and uninitiated boys, either in a special shed in a secluded, wooded area or in a part of his house where others do not enter freely. His wife or wives may prepare colors for him, especially the red camwood and the yellow *odo*, by grinding them into powder form, but they are not supposed to know what these are used for (they have other purposes as well). In fact, I believe that they sometimes know but pretend not to, for undue familiarity with secret society business invites spiritual contamination and possible illness or barrenness. Unfinished masks are stored in the house or shed of the carver, or sometimes in the ancestral house of the major patrilineage; but the tools are not specially

* The earlier initiation and the consequent decline in *enna* masking and plays and dances can be attributed to the European educational process and Christianity, which have directed boys' interests elsewhere, and to the greater wealth at Afikpo, which has allowed fathers to put their sons through the expensive secret society initiations at an earlier age.

segregated or ritually handled and can be employed for everyday work.

Carvers make masks on request for a small fee, which has varied in recent years between 5s. and £1, partially depending upon the complexity of the mask involved. There is no standard rate as far as I can determine. Many carvers also produce masks to be stored away in the village or ward resthouse, or in their ancestral shrine house, until they are needed for rental. A person who is going to take part in a particular ritual will request a suitable mask from the carver and pay a fee of a few pennies, a shilling or two, palm wine, or some tobacco. A good carver with numerous masks will have many visitors of this kind before a major performance. Carvers are known to the males of the village—it is not a secret activity within the secret society—and a person has little difficulty in locating one, although he may not always be able to rent the kind of mask he desires. There are no residential restrictions: the carver may carve masks for and rent to persons in any of the villages. The renter or buyer should be an initiate of the society and aware of how to store and use the mask, but carvers sell to Europeans and Americans, who belong to another world and who take the face coverings away.

A carver's masks, like the masks owned by other persons, ideally are supposed to pass to his eldest son upon his death, but actual practice varies, depending upon whether the son wants them or not. If not, some other son takes them over. Tools are passed on in the same manner. There does not seem to be any matrilineal association involved in the carving craft, although double descent is prevalent at Afikpo.

Merriam (1965, pp. 460, 464) suggests that the musicians of Basongye are little respected, yet the recognition of their necessity exists. Something of the same attitude is applicable to carvers at Afikpo. Carvers clearly do not make much money: I know of no carver at Afikpo who even begins to make a living by selling or renting masks, and only a few who have made substantial sums from selling to non-Africans in recent years. Clearly then, mask-making is not a lucrative activity or a means of attaining economic prestige. The mask carver, in fact, is often considered a person who is foolish or silly; he is doing a "funny thing" but nothing very serious. Chukwu Okoro said that Afikpo believed carving to be "lazy man's" work and that a carver's wife was liable to give birth to a baby looking like one of her husband's carvings. Yet, of course, masks are necessary for some of the important secret society rituals, and the Afikpo clearly recognize this need. They are also aware that certain carvers have considerable skill, and their masks are sought after for purchase or as rentals. But the carver holds no specially recognized status or rank even within the secret society, and he has no special formal relationship to its priests or ritual leaders. He works mainly for pleasure and for the little income that he receives.

It may be that carving is not technically beyond the skill of ordinary men (Merriam 1965, p. 461; Messenger 1958) and that any adult male, because of his general familiarity with tools and woodworking techniques, could turn out a fair mask. If so, perhaps there is not much money or prestige in mask-making because it does not involve an ability that is in short supply. One would find it hard to test this theory. While it seems true that Afikpo carving does not demand the specialized training of some Western arts, and that there are few "great masterpieces" at Afikpo —rather, numerous well-executed ones—still, I sense in the Afikpo wood and calabash masks a unique and particular craftsmanship, and the Afikpo seem to feel this also.

The idea of foolishness associated with the carver may derive from the fact that it has been young, uninitiated boys who first carve, albeit usually not in wood, as members of their *enna* societies, and that to continue carving as adults is to carry on in some way as a child—the masks and plays are childish things, not to be taken too seriously. I have argued elsewhere (S. Ottenberg 1972a) that the masked ɔkumkpa plays, as social critiques and documentaries, are treated lightly in order to prevent frictions that may arise from social criticism. It may also be that in the light of years of Christian influence at Afikpo, and of the attitude of some educated Afikpo and other Africans (who consider carving and traditional secret society ceremonies as "that *juju* stuff" tied to "paganism and superstition"), Afikpo explain their traditional activities as being foolish in an act of cultural apology. However, I tend to discount this last argument. (The matter is further discussed in Chapter 8 in terms of psychological considerations.)

There appear to be no restrictions on the quantity, quality, or style of the masks produced. The artist is permitted freedom of design and coloring. Artists or carvers have formed no counterpart of the diviners' guild at Afikpo (S. Ottenberg 1971b, pp. 209-10). This guild regulates working conditions, insists on an extensive apprenticeship with an established diviner, fines members for malpractice, and can even force them out of the guild, with the backing of Afikpo's elders. While carvers also exist scattered through the Afikpo villages, although in smaller numbers, they have apparently never organized and they do not usually work together. In fact, some of them do not seem to know of the existence of others in other Afikpo villages. The absence of a carvers' union relates to the casual nature of their work and their low pay in contrast to the diviners' situation. Divination is seen as serious business, affecting peoples' lives, while carving is not.

The carver at Afikpo also lacks the patronage

of a centralized authority, or even of the village or village elders, as an incentive for his work; but he does not, on the other hand, suffer from their controls. He sells and lends mainly to the young adult and the middle-aged. In the achievement-oriented, individualistic way of life at Afikpo, he is free to carve as he chooses, regulated merely by his own strong sense of tradition.

The only specific controls pertain rather to the secret conditions under which he may carve, the seasonal limitations on his work, and his responsibility for storing his products out of the eye and reach of the uninitiated. If the carver violates any of the rules of secrecy, he is required to carry out a ritual sacrifice to the secret society spirit; he may be fined by the village elders as well. However, I have never heard of such a case at Afikpo.

PORTRAIT OF AN AFIKPO CARVER

Chukwu Okoro, also known as J. C. Okoro (he is pictured in fig. 33 and pl. IX; S. Ottenberg 1971b, opposite p. 79, upper right-hand plate), was born and lives today (as of 1960) in the small compound of Ezi Ume, Agbogo (Amebo) ward, in Mgbom village, one of the largest Afikpo communities. There have been a number of carvers in his family. In 1960 he was a little over fifty years old and had just become a junior elder of Afikpo following the ceremonial upward movement of his age group. He has three wives and thirteen children, a relatively happy family man blessed with numerous offspring. His children are still young, with only two girls married as of 1960. He has only one living brother, Oko Chukwu, who is somewhat older and lives at Ezi Ume with one wife and a daughter. The carver had another brother, Akpani Chukwu, between himself and Oko in age, and a half-brother, Igwe, both of whom are dead. He has two living sisters, both married. One lives in another Mgbom compound and the other at Kpogrikpo, the southernmost Afikpo village, some seven miles south of Mgbom. A number of other sisters are dead. Chukwu's mother, one of the oldest women alive in Afikpo, lives in his compound, although she is weak and sometimes a bit forgetful. Of his two married daughters, one lives with her husband in another Mgbom compound and the other resides at Ibadan, as the wife of a younger brother of Nnachi Enwo, a good friend of Okoro's who is a politician and a "progressive" in the community. Her husband is educated and in the army.

Like other Afikpo, Chukwu has many other relatives. His matrilineal grouping is average in size and geographic distribution, being composed of about thirty-eight living members; but his patrilineal organization is smaller than many in Afikpo, and thus so is his compound. The carver's family and kin ties are not unusual for Afikpo,

except that it is rare for a man of his age to have a mother living and to have such a relatively tranquil domestic life.

In 1960 Chukwu was making a living largely by farming. He was not desperately short of land for growing his major crop, yams, but he did not have a lot of it and he had a good-sized family. He also controlled a palm wine grove not far from his compound, which belongs by inheritance to a son of one of his wives. He did not tap the trees himself, as he is not an expert tree climber, but rented them to palm-wine tappers.

In addition to farming, his main source of income is the little money that he makes carving hoe, knife and machete handles, stools, and *ocici* bowls. For a good many years he derived a substantial income as a food contractor for the Government Prison at Afikpo.

Childhood

Chukwu's father died when he was a year old and his mother remarried shortly after that. Both his father and stepfather were farmers. Chukwu believes that as a young boy he was "ordinary." He liked to fight and wrestle. He and his friends caught crickets and grasshoppers, pulling off their wings and roasting them or making grasshopper stew; they also caught and cooked rats and mice. They built miniature playhouses, played in the boys' house (*ulote*) in the compound, and took part in various children's games. Chukwu never went to school, as it was quite unusual for anyone other than the sons of prominent "chiefs" or village leaders to receive an education.

When his mother remarried, she moved to her new spouse's home at Ezi Ɔkpa Ɛnyum, in Amɔzo ward of Mgbom, taking most of her children with her. Chukwu's older brother, Oko, continued to live at Ezi Ume, although he came over for his meals, and Chukwu used to go and stay with him at times. At his new home, Igwe, his half-brother, was born and subsequently died.

When a small boy, Chukwu joined the imitation secret society, ɔhia ɵmɵ enna (bush-children-uninitiated), whose membership is composed of small boys of a single compound or of two or more neighboring ones. Such societies have no fixed home, and Chukwu's group met in a clump of banana plants behind the homes, in the compound ancestral shrine house (*mma obu*), where small boys often play, or in the bush. (It is only the older uninitiated boys who have a set place to meet.) These small boys made masks of large leaves or sometimes of cloth, and imitated what they saw older boys and men do in the activities of the village secret society, such as the ɔkumkpa play or the *logholo* game.

When Chukwu was about eleven, the usual age for transition, he moved into the older uninitiated boys society, also called ɔhia ɵmɵ enna.

With a friend he joined the one derived from his real father's ward, Agbogo, and not that of his stepfather's ward, Amɔzo, for he had an evident attraction for his dead father's people. His stepfather was angry at him for so doing and refused to pay his fees required for joining this advanced *enna* society; his mother and his older brother, Oko, paid instead.* Oko, as senior living male in the direct line, was to help Chukwu in other ways a number of times in his life.

The advanced *enna* group is divided into junior and senior sections on the basis of both age and skill. It builds and maintains its own resthouses and sacrificial shrines, and the boys carry out a variety of plays and rituals, again largely in imitation of the adult secret society. Chukwu was in this *enna* group some seven or eight years.

During this time he took part in the *enna's* imitation ɔkumkpa plays, some of which were as well done as, if not better than, those performed by the actual secret society, according to Afikpo informants. He also joined in the masked chasing play, *logholo*, wearing raffia palm leaf costumes. Each boy made his own dress; but while some boys—one other boy in particular—tried their hand at masks for this and other plays, Chukwu claims that his products were the most popular. He produced a variety of masks of coconut fiber or coconut shell, and sold each to other boys at a price of three medium-sized yams. He did not make calabash masks at that time, as they were not then used by *enna*. For carving he used several small knives, one made in imitation of those used by secret society members. He colored the carvings with white or light pink chalk, camwood, and *odo* yellow, charring portions of the surfaces black, as in the adult masks. He also made skin drums several feet high, one of which he still has today. After his first son was born, he brought it out, made a new skin head for it, and gave it to the child to play with; his son used it until the head went bad.

In this imitation secret society Chukwu also joined in the ɔtero chasing play, when young boys wear a cloth over the face or large leaves with slits for eyes. Some of the boys also wore banana-leaf body costumes. The ɔtero chases girls, and also smaller boys, all of whom are easily frightened by the masquerade. When he was a bit older he wore, along with the other older boys, the coconut-bark mask colored red with camwood, which the player raises a bit in order to see out in the direction of the ground. They also wore

* There is often a real conflict over where a boy such as Chukwu will live as an adult, whether in the compound and patrilineage of his stepfather or his true father. Generally each group will wish such a male child to join them, for it increases their size. In fact, the boy has a choice as he approaches manhood, and many of them return to where they were born.

banana leaves around the body, with a belted rope or towel around the waist from which bells were strung.

Chukwu and his *enna* friends also engaged in whipping contests, in imitation of those of the secret society, as well as in wrestling and other sports. He was a strong boy and did well in these, as well as in *logholo* and ɔtero.

Away from Home

By the time Chukwu was ready for his initiation into the secret society in his late teens, both his stepfather and half-brother had died. His eldest brother, Oko, wanted to pay for his initiation, as frequently occurs when the male parent is dead; but according to custom, he had first to initiate Chukwu's older brother, Akpani Chukwu. It is not desirable that two full brothers be initiated at the same time, and there were not sufficient funds for both, so Chukwu's initiation was delayed. The search for money to pay for his own entrance into the adult secret society led him to go in 1924 to the Enugu area, the developing capital of the Eastern Region, and later to Makurdi, in the north, looking for work. He was away from home for over five years.

At Enugu he sold and helped to make loaves of bread for a small company run by some Afikpo. Then he worked for a contractor, carrying bricks. Later on he was employed on construction projects for the railway not far north of Enugu, carrying sand for making bricks and hauling the finished bricks for the building of the Emele railway station. He also worked at other nearby railway projects.

After more than two years away from home he moved to Makurdi in Northern Nigeria, where there were a small number of Afikpo; here he labored at construction on railway buildings and a railway bridge. Then for six months he worked as a garden boy and house servant for a European.

He was assisted in finding work at both Enugu and Makurdi by an entrepreneur from his native compound, J. A. Idume, who was later to found the first store at Afikpo. When he returned to Afikpo from Makurdi to take up the contract for supplying food to the local prison, Chukwu also returned and worked for him, traveling to neighboring markets to purchase food. Later, and at the time of my first field trip in 1952-53, Chukwu held the contract to supply meat to the Afikpo prison, moving between Afikpo, Amaseri, and Owutu Edda markets by bicycle on different days. By 1959 he had lost this job and was doing no contracting at all.

Adulthood

Upon his return from Makurdi to his compound in Mgbom, he was initiated into the

village secret society, and about a year after his return he married his first wife, a year later his second, and some ten years later his third. He is considered a successful family man by his fellow Afikpo, one with little "wife palaver" and a large number of children.

Sometime after he was initiated, he started carving secret society masks. His father had been a carver but had died long before Chukwu was old enough to learn from him. All of his father's masks had been destroyed in the fire during the British invasion of Afikpo in 1902. Chukwu, then, combined his past experience at carving as an *enna* with what he learned from his older brother, who helped teach him. In fact, he had learned many of the primary techniques of mask carving (but not in wood or calabash) and of coloring when he was an *enna*. Many boys at that time try their hand at the work. During that period he was unaware that his older brother, Oko, who was already initiated, was carving secret society masks, because members of the secret society do not reveal this fact to nonmembers, even in their own family. Similarly, his eldest brother did not know that Chukwu was making *enna* masks, for members of these *enna* groups are also secretive to outsiders about their activities. For the noninitiate, then, the stimulus to carve comes not from older persons—elders or professional carvers—but largely from the criticisms and rewards of age-mates. Chukwu's carving skills were basically learned when he was a child. When away from home in the Enugu area and at Makurdi, he apparently did no carving, but acquired considerable skill in the use of Western-type carpenter's tools, which undoubtedly contributed to his later success as a carver.

Chukwu received guidance and advice from his elder brother, Oko (pl. IX), but he did not work as an apprentice under him. The first mask that Chukwu carved was *mba*. Then he carved another *mba*, and went on to an *acali*. The *mba* is a common form of *enna* children's mask, very popular with them, and the *acali* is also employed by them and used by small-sized initiates into the secret society. It may be that he carved these first out of familiarity with them. He considers the "queen" mask (*ɔpa nwa*) the most difficult to carve, and it was not until 1952 that he produced one, a nicely carved piece made for me.

He enjoys the work and is also pleased to receive a little income from it. He had not carved for several years before I contracted with him in 1952, as there was a sufficient number of masks about the village. He carved regularly from then on until I last saw him in 1966, partially stimulated by his own return to work, but also by the purchases of a number of Peace Corps volunteers as well as local persons.

Neither Chukwu nor his older brother knows how their father had learned to carve, but he made masks, wooden mortars and pestles, hoe and knife handles, and other wood objects. In addition, the father carved the large male and female figures standing in the back part of the main resthouse of Agbogo ward, the main Mgbom ward, possibly the most unusual carved figures at Afikpo (S. Ottenberg 1972b). Oko was largely a self-taught carver, having learned before his father's death only how to make hoe handles.

The father had two good friends of his own age from his village, now deceased, who were also carvers: Alu Orie of Ezi Ukwu compound, and Nwachi Akpo of Ezi Itim. In 1960 Nwachi had one son alive, who was a mail runner and did not know how to carve. Alu Orie's second son used to make hoe handles and pestles, but he never learned how to make masks; and Alu's first son does not carve at all. However, one of Alu's sons was an *ɔkumkpa* play leader in 1960, and he and his children, including daughters, all sing very well, so there is a continuation of an artistic tradition in the family, a fact that Chukwu Okoro finds very pleasing.

Chukwu's deceased older brother, Akpani Chukwu, also used to carve. Chukwu Okoro remembers that he made the *igri* mask. Another relative of Chukwu's, his senior sister's son, Enyi, who is living in Ezi Ume compound with Chukwu and his brother Oko, also carves masks. He was born into Ezi Agbo compound in the village, where his mother still lives, but housing there is scarce and there are empty houses in Ezi Ume, so he went to live with his mother's brothers. Enyi was self-taught, although the two brothers believed that he "learned" from their dead father, for Chukwu and Oko learned through divination that their father was one of the two spirits reincarnated in Enyi. Skills are sometimes believed by Afikpo to pass down through reincarnation. Chukwu is a reincarnation of a former secret society priest, Ɔkpani Ukie, from another compound in Mgbom, Ezi Abagha. While this man was not a carver, his association with the Mgbom secret society again puts Chukwu within a special group of ritual experts.

Thus there are three carvers in Ezi Ume compound, two from the same father and one related by marriage. This seems to be an unusual concentration for Afikpo. Of the three, Chukwu Okoro is the most active.

The Carver in 1960

In addition to masks, Chukwu also makes *ocici* bowls (fig. 30), stools, diviner's trays (fig. 31), and knife and hoe handles. Oko only assists Chukwu a bit in carving masks; he does not make them himself, although he still produces other things such as doors, hoe handles, farm *ocici* bowls, and *amoma*, a stamper used in making the earth beds in the homes of the Afikpo. About 1960

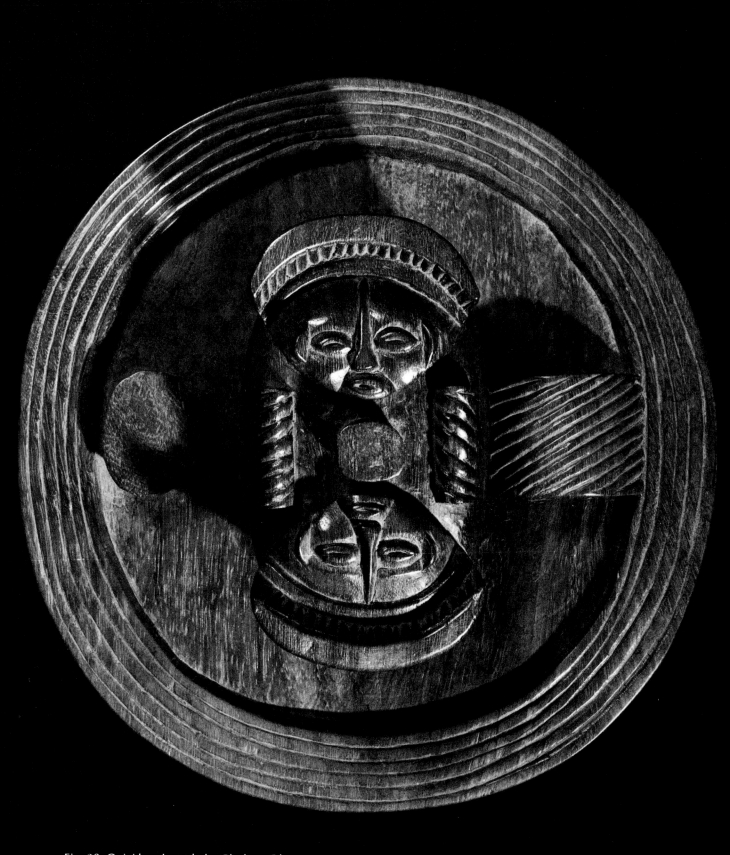

Fig. 30. *Ocici* bowl, made by Chukwu Okoro

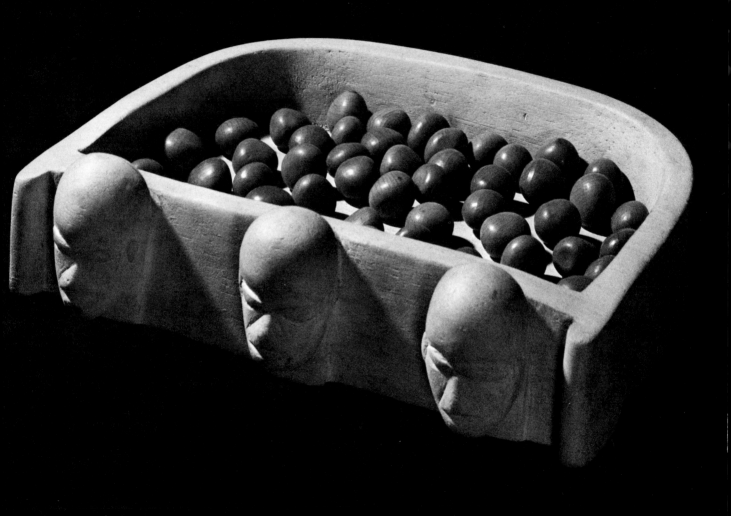

Fig. 31. Diviner's tray, carved by Chukwu Okoro

Oko made the door to Chukwu's house, one for his own rebuilt home, and one for the ancestral resthouse in another Mgbom compound. Oko also farms and is an expert at breaking boils, extracting teeth, and removing things that get in the body, such as fish bones stuck in throats. He is an elder now and, even though he is a fine craftsman, feels it is not quite right to carve masks, as a person of his age should turn his attention to other things. He says that there is no rule forbidding him to continue carving masks. I suspect that this attitude is commonly held, for the few Afikpo carvers that I know of are all younger than Oko. This fits the pattern that older men do not take a direct part in the plays and dances of the secret society.

Both Oko and Chukwu are members of the ritual group within the Mgbom secret society, called nde erosi (S. Ottenberg 1971b, chap. 5). Carvers are not required to belong, but the fact that these two men come from a compound that has produced some of the priests of the village secret society may weigh heavily in their interest.

Chukwu has not taken the highest secret society titles. It is not necessary for a carver to have done so, although he normally takes the lowest ones, as every new initiate does while young. Nor is it necessary to have taken them all to be a member of the nde erosi group: this inner clique is rather a voluntary collection of interested individuals of various ages within the secret society.

As members of the nde erosi, Chukwu and his brother take part in virtually all of the major rituals of the society, help prepare a magical salve used as a medicine in the village, and join in the important sacrifices to the society's spirit, egbele. Chukwu is also considered an expert dresser of persons for the various plays, and he is often seen in the bush or the dressing house sewing a costume onto someone or advising a person how to wear his dress. His skill in the use of raffia strands, netting, rope, and other materials used in dressing is considerable. He is likely to perform such services for a friend in return for some palm wine, tobacco, or the like. He does not make net masks, however.

In addition, Chukwu knows a great deal about herbal medicines and sometimes treats relatives or acquaintances, although he is not a professional herbalist. His knowledge of the properties of various woods used in carving is vast. He can also repair calabashes (used to hold water or palm wine), sewing the broken or cracked parts with string and making the joint solid with sap. In a sense, he is a skilled craftsman in a general way.

Chukwu is essentially a traditionalist, despite his experiences away from home, his work as a food supplier for the Afikpo prison, his friendship with a "progressive" politician in his village, and his ability to speak and write English fairly well (which he acquired while working away from

Afikpo rather than through school). And he is a traditionalist with considerable knowledge of Afikpo ritual. Nevertheless, he has given his own children, particularly his sons, as much schooling as he can afford, and most of those of adolescent age speak and write English well.

Chukwu has never been active in politics at Afikpo. He is capable of speaking effectively on a subject at a meeting, but in general he is a quiet person to whom the political fight, the dialogue of the politician, and the indulgence in "palaver" do not appeal. In fact, I know of no Afikpo carver who is active in politics.

None of Chukwu's children has so far followed in his footsteps as a carver or woodworker. In 1952 he expressed a desire to have a younger person learn from him, but indicated that it was not necessary for a carver to have one. In 1960 he was advising several boys. One, about twelve years of age, was a secret society initiate who had been away from Afikpo working as a servant for a sailor in Calabar, and who had returned in 1958 to begin school. By 1960 he was in Standard II. This boy, from Ezi Itim compound in Mgbom village, started carving after he was initiated, and claims that he began by just imitating the finished masks stored in the village men's resthouse. However, Chukwu indicated to me that the boy had watched him making the igri mask, although when he came to doing his own carving he did not use Chukwu's patterns in his work. He had made two igri, a beke, an acali (his first carving), and a nne mgbo. The acali and nne mgbo were a little crude and a bit cracked, but they have been used in plays and dances and are considered acceptable at Afikpo.

Another young boy from the same compound as the first, a carpenter's apprentice, also was making masks as a beginner in 1960.

Chukwu is a quiet and nonabrasive person in a society in which a good many men love to talk and argue and give forth with oratory. He lives in a small compound, distinctly separate from others in the village, that is itself a peaceful place, lacking the bustle of some of the larger compounds. He likes to eat and drink, and he enjoys the feasting activities connected with his various ritual activities as much as anyone.

Working

Chukwu works in a small booth (nto) in a bush at the outer edge of his ward (fig. 33). The shed is not far from the carver's compound, but it is not visible from the village, and should not be, for carvers work in secrecy from noninitiates.

His nto is about five feet square, roofless, and has loose wooden fencing around it, covered haphazardly with leaves. There he sits on a wooden stool and carves. He leaves the unfinished masks in the nto, wrapped up in leaves or burlap,

PLATE VII

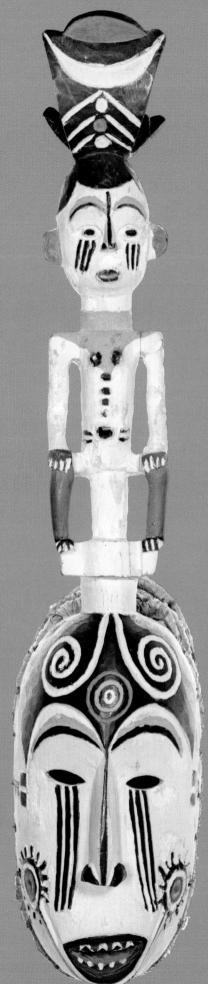

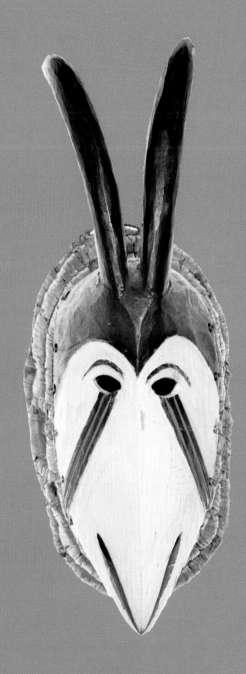

Mkpe (no. 1, 1952-53)

Ɔpa nwa (no. 1, 1952-53)

PLATE VIII

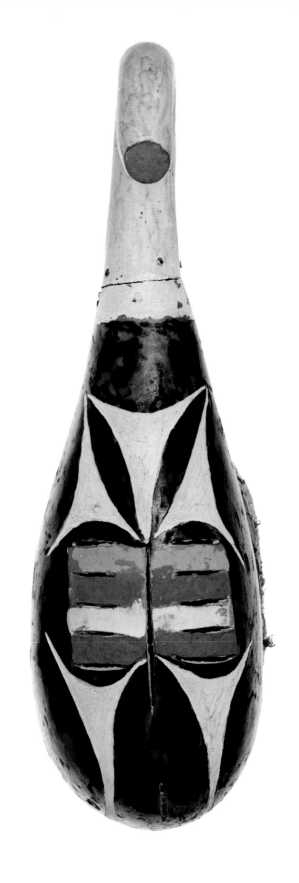

Mbubu (1952-53)

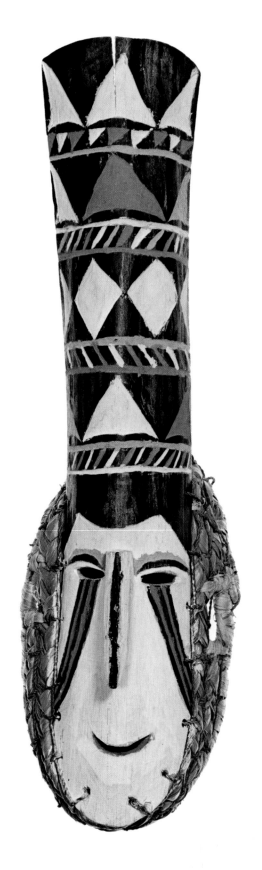

Mba of the uninitiated boys (no. 1, 1952-53)

Fig. 32. Chukwu Okoro dressed as an elder, shortly after he joined the Afikpo elders' grade

or he may keep them at the shrine house of the secret society. He works in his free time, when he is not farming or doing other things, and whenever he feels like it, perhaps a few hours a day during the rainy season. Since the *nto* lacks a roof, he does not work when the weather is bad. This structure is cut down toward the end of the dry season—in 1952 it was in July—in the general clearing of the bush about the village. He could not have a shed after this time, for not only would it be visible from the village, but the secret society season would be over and he would not be permitted to carve.

Before carving a mask, Chukwu makes paper cutouts representing portions of masks, such as the side of a face, the top piece, or the horns of a goat mask. These are taken from other masks of his own or ones belonging to other persons, generally those stored in the main resthouse in the village or in the secret society priest's shrine house. He says that such patterns were not used in his father's time, and I attribute his employment of them to his experience away from home as a carpenter. As he works on a mask, he checks it against the cutout and tries to approximate the pattern, although he does not seek exactness; it is merely a guide. Similarly, to attain the right proportions, he uses pieces of reed or of grass cut to the correct length of certain areas as measured from existing masks. For most of the masks he makes, he tries to create a replica of an existing form, although he may vary the coloring. For the ɔkpesu umuruma masks, however, he carves as he pleases, without following any model or measurement guides. Since Chukwu, or any other Afikpo carver, does not attempt to make any totally original masks, much of his sculpturing originality lies in his production of the ɔkpesu umuruma. His masks in this style are popular and well thought of by other Afikpo.

Sometimes his friends, or other secret society members, hear him working in the bush, so they come and sit with him and watch him carve. They give him advice, telling him how to carve, even if they themselves do not know how. He is not offended by their suggestions and says that he does not mind having persons watch his work, that it does not affect his ability to carve. I felt, myself, that he rather enjoyed the company, as he apparently also enjoyed mine. After my first visit to his carving shed early in February 1952, he said that my coming to see him work had pleased him very much, that he had "gotten into the mood" and had carved longer than he usually does—on that occasion some three hours.

He works in a relaxed and competent manner. When Afikpo visit him, they freely gossip about people and events; we talked in a like manner. I sometimes pursued a line of questioning on something ethnographic that I was interested in, but, alas, rarely on aesthetic matters. I

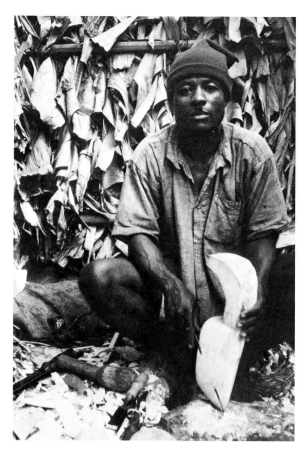

Fig. 33. Chukwu Okoro in his carving shed in 1952, working on an *mkpe* mask

remember that he once carried on an extensive conversation about something with me while he worked away with a machete at the general outlines of the horns of a goat mask, carving that is difficult because of the possibility of overcutting and ruining the horns. Yet he did not seem bothered or distracted by the discussion. He has always seemed at ease, an efficient craftsman: no artistic *angst* ever appeared on the surface, no disturbance over creativity, no struggle. There were sometimes technical problems, say when the coloring did not hold well, or the wood or calabash was cut a little further or more deeply than he had planned; but these he solved in time without much disquiet.

If an uninitiated person sees his masks in process or his carving activity as a result of Chukwu's own carelessness, Chukwu must sacrifice a dog at the shrine of the secret society. This sacrifice, standard for a noninitiate who sees or touches anything having to do with the secret society, is made to prevent illness, death, barrenness, or other misfortune from occurring to the offender through action of the angered spirit of the secret society, *egbele*. It is the carver's responsibility not to be careless. Chukwu did not mention being involved in any such incident, and I believe that he was always careful to respect the

society's rules. I was able to see his masks and to visit him in his shed while he was working the year before I was initiated, although my wife of that time was forbidden to do so because of the very strong feelings toward exclusion of females from any secret society activities. In my case it is not clear why I was permitted entrée, except that it must have been thought that *egbele* would not affect me, or that as a white male stranger I was not involved, for Chukwu indicated that he did not care what I did with the masks when I was out of the Afikpo area or back in America. Then I could hang them up on the wall or leave them about, and that would be all right; while living at Afikpo, however, I was to keep them out of sight. They were brought to me, or I procured them from his carving place, in a burlap bag.

In 1952, the day after I had taken to my house at Afikpo the "queen" and *mba* masks that he had made for me, he asked me whether I had shown them to my wife. In fact I had, but I said, "No, but she may have looked at them when I was not looking." He laughed and said that he did not believe me, and his friend, my field assistant, confessed that I had indeed shown them to her. Chukwu then quoted a proverb, which is summarized at Afikpo by saying "*εgugɔ mvodu*" (deny-cricket): "The cricket denied that he was under the ground but the dirt on his face showed that he had lied." The carver actually was very much interested in my wife's reaction to them, and pleased that she had liked them. Since he was a member of the secret society ritual group, *ndε εrosi*, of his village, I cannot believe his attitude toward all of this was an act of carelessness, but rather that it involves a conception that the rules for the masks only work fully for Afikpo.

Other data reflect the sensitive distinctions between permitted exposure and forbidden actions. I took a number of photographs of Chukwu carving (now unfortunately lost) and gave him prints of some of them. He put one of them up in his house, claiming that since "they were only prints," the head priest of the secret society would not be offended and it would be all right for his wives to see them. Yet, on another occasion I had to burn ritually in front of the secret society shrine house some negatives of photographs showing the priest and the assistant priest in special dress (although not masked) at a secret ceremony that I had thought was public. On another occasion I had shown several married females negatives from an *ɔkumkpa* play, using a small battery-operated viewer, and they responded by refusing to acknowledge what they had seen, even though it was clear that they comprehended. The pictures were of a public performance, but as adult women they did not wish to reveal knowledge that they did not feel they should have had. Possibly Chukwu's wives and uninitiated children would also not

acknowledge the significance of my photographs of him carving, as his wives would not indicate that they were aware of why he asked them to prepare colored dyes for him.

The question of foreignness and the rules for the carving of masks comes up in another case. An individual from the southernmost village, Kpogrikpo, who had a reputation for being a "rascal man," had hanging on a wall in his house a mask that he had purchased northeast of Afikpo, in the area of the Mbembe, a non-Igbo people (see Harris 1965). At that time my field guide, Nnachi Enwo, said "that this was all right since it had never been used in a dance or play, but if it had he would have had to keep it wrapped up as any Afikpo mask." Later, both Enwo and the carver, Chukwu, said that it was wrong to hang it in this way, for no mask, even a foreign one, should be so treated, and that he could get away with it only because other persons did not know about it. Its owner, they both concluded, was a rascal man.

One final case. In 1952 I saw a chalk wall-drawing of one of the tall *isiji* initiation masks, the style with a calabash face that is used only in the southern Afikpo villages of Kpogrikpo and Anohia. A child had made the drawing at the head of the bed of a prominent leader of Kpogrikpo. Since females and uninitiated boys entered the room, I presume that a distinction is made between the drawing of the mask on a wall and the mask itself. Possibly the same principle is involved here as with Chukwu's photographs— they are seen as drawings and not as true objects.

Selling and Renting

Chukwu has some thirty masks of his own making that he keeps for rentals. Nowadays neither he nor his elder brother takes part in masked rituals, considering themselves too senior. Chukwu stores his rental carvings, wrapped in palm leaves, by placing them in or hanging them from the rafters of either the priest's shrine hut or his own ancestral shrine house in his compound. He occasionally keeps some masks in the men's village resthouses, where other villagers do, but he has better control over them if they are stored elsewhere.

When someone wants to rent one, he makes arrangements a few days before the ceremony in which he will use it. Chukwu has a boy in the compound—a secret society member—who receives a small commission for assisting when he is not around. Persons usually ask for a specific type of mask. For example, a member of an age set playing the leading role in *njenji* will come and ask for a "queen" mask, which he is expected to wear. Chukwu usually does not tell them what to bring in exchange for the rental, only "something" if they ask, and he seems reluctant to put the

matter on a strict cash or contractual basis. Nevertheless, his standard charge for a large mask, such as ɔpa nwa, is 1s. 6d., and somewhat less for smaller ones. One time in 1960 when a boy, obviously unfamiliar with the arrangement, asked for a "queen" mask, Tom Ibe, my field assistant and Chukwu's friend, told him to go back and bring either palm wine, tobacco (Chukwu smokes a pipe), or "something else." Chukwu is pleased if given either tobacco or wine. He takes the renter to where the mask is and points it out to him; the client may then take it, wrapped up, or leave it until he is ready to use it. There is no ritual of handing over, no blessing the mask when it is rented out, as there is none for a mask when it is completed. Chukwu may advise the person who rents it how to recolor it, if he thinks he does not know how; but Chukwu rarely does the recoloring himself, and persons do not seem to expect a fully colored mask when renting. A face covering is normally hired only for a few days and for use in one specific event or festival.

Chukwu would not reveal how much he charged Afikpo to make a mask, saying only that he used to charge 7s., but that now the fee was higher. I paid him £1 each on each field trip, which he considered a good price, higher than what he could get from Afikpo. Again, there is no ritual for handing over a new mask to its owner; the mask in this case, of course, is well colored before delivery.

Wood

When Chukwu knows that he will be carving, he cuts his wood in advance. For example, he began to collect wood in April 1952 for masks that he would be making the next carving season, starting in September or October. After he locates and cuts pieces of suitable size, he brings them home and soaks them in water. When the wood has been thoroughly wetted for some time, he lets it dry out. He believes that this procedure both softens the wood for carving and prevents it from splitting, in that if he were to leave it outside after cutting it would split, become hard, and be difficult to carve. He prepares his wood with care: none of the masks that he made for me has cracked seriously; only a few have minor splits, although some of them are now twenty years old and have been through all sorts of climates.

Chukwu says that he usually uses two types of wood, mba and okwe. The latter is a light, porous wood, possibly *Ricinodendron africanum* or Erimado (Irvine 1950, pl. 192; von Wendorff and Okigbo 1964, p. 7). In 1952 he used okwe to make the beke, ɔkpesu umuruma, ibibio, and nne mgbo masks. He uses this wood for masks without major projections and ones in which there is a good deal of surface rounding. *Mba* is a stronger and heavier wood, better for making and maintaining the top

pieces and projections. It is possibly the wood of the native rubber tree, *Funtumia elastica* (Irvine 1950, p. 188). In 1952 he made the ɔpa nwa, mkpe, igri, acali, mma ji, ɔtogho, and an mba of this wood. The carver can select any wood that he wishes, according to his taste. And, as with other aspects of the technique and aesthetics of mask carving, the secret society has no specific regulations concerning wood selection.

I did not keep track of the woods that Chukwu used in carving during my second field trip, but from examining the masks that he made for me I believe that he followed much the same system of choice, although the two variant 2 mba masks (nos. 3 and 4, mkpere) and the ibibio (no. 2) appear to be of heavy wood.

A scientific analysis of the wood of some of my masks was made by Jorgo Richter, a wood products chemist, for Samuel James Kemp, who was comparing the carving styles of my masks with those of Kwakiutl Indian carvers. The findings suggest that Chukwu's masks were made of three woods: Obeche (*Triplochitou scleroxylon*), Okha (*Ceiba pentandra*), and Kondroti (*Bombax brevicuspe*), all woods of low specific gravity, short, and parallel fibers (Kemp 1967, p. 4). Okha is a variety of the silk cotton tree, a type common to southern Nigeria. It has soft wood which is commercially valued, as is its cotton fiber (von Wendorff and Okigbo 1964, p. 6). *Ceiba pentandra* "is soft and wooly and has to be cut with [a] sharp tool edge to produce a clean surface," according to von Wendorff and Okigbo (p. 6), who indicate that Obeche "is fairly soft but relative to its weight it is strong" (p. 8) and that it seasons easily and fairly rapidly.

Tools

In Chukwu's father's time the iron carving tools were largely locally made by male members of patrilineal lineages of blacksmiths living in a number of compounds in Mgbom village, as well as in compounds in other Afikpo villages. These workers used either iron brought in from ores mined in other Igbo areas, as none was excavated at Afikpo, or iron rods imported from Europe during the slave trade and post–slave trade period and brought north from the coast by Aro traders (S. Ottenberg 1958).

The tools used when Chukwu's father was carving are:

1. A small adze called atɔ, short for atufu (to burrow out), a term used for a range of carving tools. This one had a wooden handle and was employed for general shaping and rough work.

2. A U-shaped blade of iron with wooden handles at both ends, also called atɔ and used to cut out the insides of the masks.

3. A long iron chisel, without a handle, again called atɔ, which was employed to carve out eyes,

mouth, and other parts by being hit with a rock or a piece of wood.

4. A long, thin rod of iron, about 10 inches long and ¼ inch to ½ inch wide, called *ahia* (borer), which was heated in the fire and used to bore holes for the raffia attachment and for other purposes, as well as being used heated to blacken small surface parts of the mask.

5. A wide, flat piece of iron, or a machete, also heated in the fire and used to blacken larger surfaces.

6. Another machete was used to cut the original block of wood and for rough work on the mask.

7. A leaf, *anwɛrɛwa*, which is used when fresh, acts like sandpaper, being fairly fine-grained.

8. An iron needle, *ntutu*, about 3 inches long, for sewing up the raffia on the backing of the masks.

In 1952–53 Chukwu was using modern European tools except for the iron needle. He carved with the following equipment:

1. Chisels of various lengths—¼ inch, ½ inch, and 1 inch—roughly equivalent to the small adze in use in his father's time.

2. A small plane, which he called a "cockshaver," used to smooth flat and rounded surfaces. This partially replaces the U-shaped *atɔ* of his father's day.

3. A modified *atɔ*, J-shaped, with a wooden handle, to round out the backside of the mask.

4. A penknife to cut out fine parts and to make straight small or gently rounded cuts, such as eyes or fingers. He also used it to smooth out surfaces.

5. A ½-inch penknife blade, very much shortened in length, embedded in a piece of wood, which he employed in cutting out the very finest details. This worked better than the iron rod (number 4 of the traditional tools, above).

6. A machete for the original cutting of the log and the gross shaping of the mask.

7. The iron rod with a wooden handle for boring holes and for blackening, as in his father's time.

8. The flat iron blade for blackening larger surfaces.

9. Sandpaper, instead of the leaf, *anwɛrɛwa*.

10. A wooden mallet with which to hit the chisels.

11. *Ntutu*, the 3-inch iron needle, as before.

In addition, in 1969–60 I saw Oko, while assisting Chukwu, use a small rip saw to cut spaces in the hairdo of an *ibibio* mask. During this later period Chukwu also used a wood-handled, slightly bent iron rod, as well as the straight one, for making holes for attaching the raffia backing. He sometimes employed a double-handled plane.

Carving tools are not sacred. They can be used for other work, and noninitiates can see them away from the place of carving.

I took no detailed notes on Chukwu's carving techniques. It is interesting that a graduate student at the University of Washington, who had learned from expert Indian carvers how to make Kwakiutl masks, was able, using modern Afikpo-style tools, to make several Afikpo masks (an *igri* and an *ɔkpesu umuruma*) in poplar wood, which has some of the characteristics of the lighter, softer Afikpo woods (Kemp 1967). While he encountered some difficulty in adjusting from the Kwakiutl tools and carving style to the tools and techniques of the Afikpo, he was able to turn out masks that I believe would be acceptable to the Afikpo. He did so partly by examining the type of cuts in the wood on Chukwu's masks and then trying to duplicate them with Afikpo-style tools. He felt that the chisels were the most versatile of the Afikpo tools, and he used them for hollowing out the backs of the masks as well as for carving the face. Interestingly enough, he could use the Kwakiutl tools, which differ somewhat from the Afikpo ones, in carving Afikpo-style masks, though not with the ease of the Afikpo-type implements.

Raffia

After the carving has been completed but before the mask is colored, the raffia backing is put on. In the *igri*, the raffia attachment at the high end of the top piece is attached at this time as well. Backing, called *ɔkpukpa* (weaving) or *ɔkpa* (weave), on a mask makes it easier to hold and to handle while applying coloring. Two types of raffia are used: a heavy form, *ɛkwu ɛgwu* (leaf-raffia), for the inner core and a finer type, *ɛgwu* (raffia), which is wound around it. Chukwu could buy raffia at the Afikpo market during the ceremonial season, although my impression is that it is not easy to find there. Once in 1960 he purchased a bundle for 2½ d. at Oreatchi, a market on the road to Abakaliki, while we were visiting there.

To prepare the backing, Chukwu first braids the rougher raffia and then wraps the fine raffia around it at right angles to its length, so that the inner core cannot be seen. Then he attaches the length to the mask with string through the already prepared side holes in the wood. He starts attaching at the top of the back frame and usually continues in a counterclockwise direction as one faces the back of the mask. He goes around three times, to make three widths of coil as backing, ending up in about the same position on the mask as he has started or sometimes a bit further along, at the top. On a few masks (*acali* [pl. I], *mma ji* [pl. IV], *nne mgbo* [fig. 16], *mbubu* [pl. VIII]) he has gone clockwise, starting and ending at the top; and on two masks (*igri* [fig. 5], and *ɔtogho* [pl. II]) he has started at the bottom and ended there, moving counterclockwise. I know of no particular reasons for these variations. Formerly the coils were secured with local fiber, but now

any sort of light, strong European string seems to do. There are a number of types on the masks he has made for me.

The raffia is generally uncolored, although the *nne mgbo* (fig. 16) mask has bits of orange raffia by the eye holes and a bit of green raffia at the end of the outer coil at the top. Chukwu had been making some raffia things for his children for the school, he said, and had colored bits left over. In some of the masks, the end of the outer coil is doubly secured by tying it to the next coil with raffia; occasionally the beginning portion is similarly secured to the coil outside of it. About one-half of the masks have the fine raffia wrapping around the outer coil only, which has contact against the human face—thus assuring a softer touch. Most of the other masks have the finer wrapping throughout the coils. The second (fig. 28) and third children's *mba* have no fine raffia wrapping at all. The variation in the masks is probably a function of the availability of the finer raffia, which is not always easy to secure. The variability in the two children's *mba* may be simply part of a tendency toward greater variation in the *enna* masks. These two are the only ones of my Chukwu masks to have red paint in the design, other than a 1960 *mbubu* now in the R. H. Lowie Museum of Anthropology at the University of California, Berkeley (fig. 27 and Bascom 1967, pl. 110).

From an examination of the raffia backing on my masks (see figs. 34 and 35), I would conclude that most of them were secured in the following manner. With the mask facing upward, Chukwu guided the string into one of the holes on the mask's side and then pierced it back outward through about the top half of the first coil of raffia. Looping the string around itself, he continued to the next hole and repeated the process. He followed the same procedure when the second coil was reached, this time piercing into the bottom one-third of the first coil instead of the holes in the mask in order to secure the second coil to the first. The third coil is attached in the same manner, and the string is finally tied off to itself. The piercings for the raffia on the second and third layers of coil are not usually in line with the holes on the mask. This seems to be Chukwu's basic tying method, although he uses some variations.

When the coils are in place, he cuts holes on the raffia sides, between about 1/2 inch and 1 inch long, making a square or a rectangular eye hole. He then sews up the loose ends with a fine raffia, using the native needle, *ntutu*. The openings, called *enya* (eye), allow the mask wearer to see out of the sides of the mask as he moves along.

Chukwu says that if the eyes on the wood mask are large enough, he does not bother to make side raffia eyes; he omitted this feature on the *mbubu* (pl. VIII and fig. 27), *mba* of the noninitiates (fig. 28), and the *ɔkpesu umuruma* (fig. 18). The *mbubu* has no eye holes on its calabash part, but it does have enough slits on the face to see through; at any rate, the *mbubu* masks that I saw used in the *isiji* ceremonies often had the raffia part covered up by the headdress. Chukwu Okoro is not always consistent, for one of his *ɔkpesu umuruma* (fig. 20) has large eyes in the wood, yet it also has raffia holes. On some masks at Afikpo the raffia openings are oval and point down a bit toward the front of the face. Some give greater vision than Chukwu's.

The raffia backings on all of the masks that Chukwu produced for me are still in excellent condition. The braiding, coiling, and tying have been securely done.

Color

After the raffia is attached, the mask is colored. Chukwu enjoys doing this very much: he stops to look at how his mask is progressing as he colors it, often smiling at the effect he is creating. Perhaps part of the pleasure rests in the fact that he is allowed more freedom in this aspect of mask-making than he is in choosing shape and form. For example, once in 1952, while working on an *ɔkpesu umuruma* (fig. 18), he was trying to decide what color combination to use on its eyes and left cheek, choosing between coloring its right eye and left cheek red and its left eye yellow, or its right eye and left cheek yellow and the left eye red. He finally elected the first design, but he felt that he could have done either.* Such choices are possible with most Afikpo masks.

Chukwu prefers to color a group of masks at once, putting one color on a number of them before going to another color. This saves time in preparing and using the coloring materials. He indicates that the basic colors at Afikpo are: *odo* (*odo* bark), yellow; *uhie* (camwood), red; *nzu* (chalk), white, and *oca*, also a term for white; *ojii*, black or dark (sometimes *ndu* is used instead, a term that in some other Igbo areas is used for green); *manə manə* (oil-oil), deep brown; *ɛkwɔ ɛkwɔ* (leaf-leaf), green; *ɛlu igwɛ* (sky), blue. He does not consider the last term a proper color word, but he uses it as one. Note how green or brown is signified not by a specific word for the color itself but by the duplication of a term that, taken singly, denotes a thing *colored* green or brown. Other related colors are distinguished by sight, but are expressed through the use of the above basic

* Note that in either case the color contrast is between right eye and left cheek on the one hand and left eye on the other.

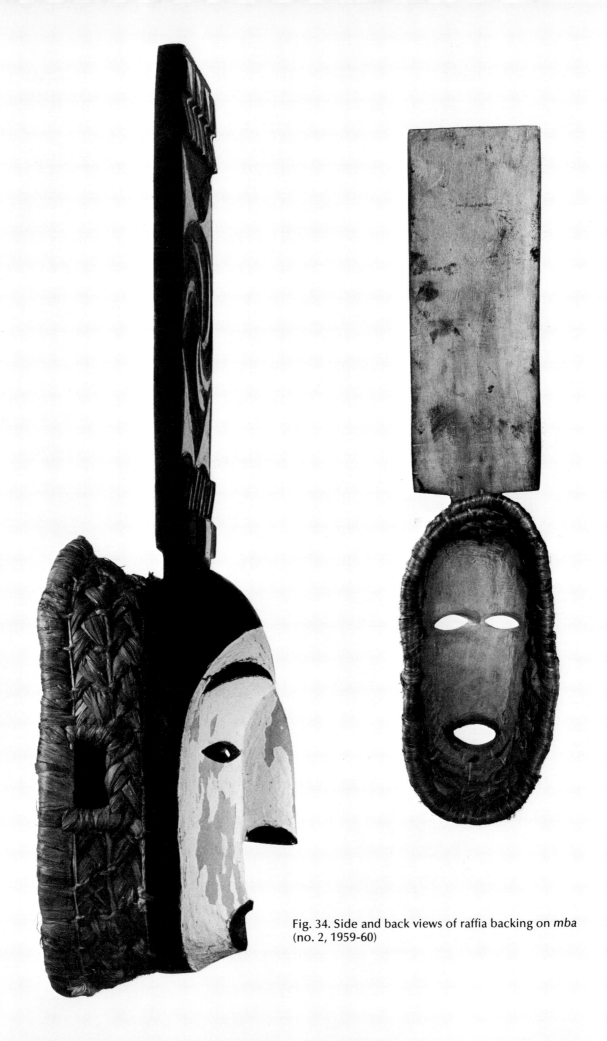

Fig. 34. Side and back views of raffia backing on *mba* (no. 2, 1959-60)

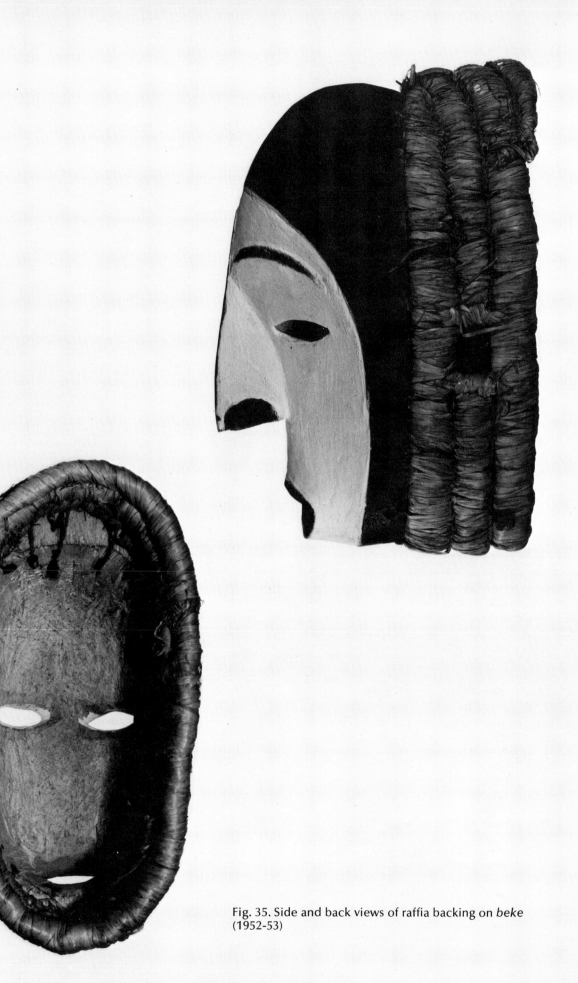

Fig. 35. Side and back views of raffia backing on *beke*
(1952-53)

terms. For example, a light gray is called *oca* and a dark gray *ojii*, as are the darker blues. Purple and orange are both *uhie*, unless the latter is closer to yellow, when it is called *odo*.

Until recent years the colors on the masks were exclusively black, white, yellow, and a reddish orange, and were made with native materials. Nowadays various shoe polishes and paints may be used exclusively or mixed with traditional coloring. Formerly feathers were used as paint brushes, being trimmed to the proper size for a particular task. Any suitable feather could be used. Sometimes thin sticks of wood or wood shavings were also employed in coloring. Today, small paintbrushes are likely to be used instead of, or in addition to, these traditional brushes.

Black. The traditional way to achieve this coloration is to blacken the surface with a very hot iron rod, a flat iron piece, or a machete. If the oil from a few roasted palm kernels is applied to a surface that has been blackened by searing, it becomes darker. Chukwu disapproves of two other techniques of blacking sometimes used by carvers, or by mask owners, in retouching the face. One is to rub on fresh egg white with a feather; the egg white shortly darkens, but Chukwu feels that it invites wood rot. Some persons use charcoal ash, *inyiri*, but not often, because it does not last. *Inyiri* is also used by masked dancers imitating females, especially the *akparakpa* dancers in the *ɔkumkpa* play, to blacken their fiber hairpiece.

White. Traditionally *nzu*, a chalk mined at Afikpo, is used to add white to a mask. It is also produced in considerable quantities in nearby Edda Village-Group, from where it is traded to Afikpo. Slightly pinkish, it is much used on the body at Afikpo. It comes in cake form, is soaked in water on a leaf, piece of pot, a calabash, or perhaps now a dish, and is applied with a feather. Another white chalk sometimes used is *nzu ɛja*, which is mined at Afikpo. Although prepared in the same manner as *nzu*, it is not as smooth and fine. White shoe polish may now be employed, either in the original production of the mask or in recoloring it. Meltonian, a white powder cake used on shoes and canvas boots, is one variety, and Blanco, a liquid polish, is another. Neither seems to penetrate the wood as well as chalk, forming a thicker surface which tends to crack and peel off easily. Occasionally white paint is also employed, mainly in retouching masks.

Yellow. This coloring is traditionally made from the yellowish bark of the *ɔkwoghɔ* tree (possibly *Terminalia superba*; see Irvine 1950, p. 193, and von Wendorff and Okigbo 1964, p. 23). The color, the bark, and the powder from it are all called *odo*. The bark is rubbed on a moist, flat stone, *npumɛ odo* (stone-*odo*), usually by women, and a substance comes off that dries into a powder and is kept in cake form. It is used in the same manner as the chalk, and it is also employed as a body paint. Today yellow paint is sometimes used on the masks instead.

Red and orange. The *uhie* color is traditionally made from camwood (probably *Baphia nitida*; see von Wendorff and Okigbo 1964, p. 50; and Irvine 1950, p. 185) by rubbing its wood (not its bark) on a moist, flat stone, *npumɛ uhie*, and collecting the powder, which is stored in cakes. Sold in the Afikpo market in wood form, it is generally prepared by a woman after purchase. Applied in the same way as chalk and *odo*, it produces a reddish orange color. The term *uhie* is used for the color, the camwood tree, the wood, and the powder. Nowadays carbolic red, which gives a deeper red tone, may be used alone or mixed with camwood, for the latter is no longer so easy to come by. Red paint is also sometimes painted on now, particularly in place of white on the face of *ibibio* masks.

Other colors. The *odo* and camwood (and even the carbolic red) are often mixed to produce colors ranging between red and yellow. Pink, purple, red, and orange paints are now also used on some masks, especially the *ibibio*, and sometimes in recoloring older masks originally painted with local dyes. Chukwu claims that he does not like to use paints; he feels that the traditional colors are easier to recolor, as they sink in and do not crack, break off, or produce an uneven surface.

Despite this ideal, he has often varied his own procedures. In 1952 he was using *odo* for yellow, but a prepared mixture of red carbolic and camwood for red, claiming that camwood was hard to obtain. In making the *mkpe* (pl. VII) he added *odo* to tone down the red, applying this to the tears and mouth of the mask with a stick. For white he used Meltonian, scraping about a tablespoon of it into a piece of coconut shell and adding water to thin it; he applied it with a 1/2-inch brush with a 2-inch handle. He often uses a larger brush for white than for the other colors, as the white surfaces on the Afikpo masks are often more extensive. It is not clear why he did not use chalk, as it is plentiful at Afikpo. His whites from this period have a creamy appearance today. In 1952 he mixed the white, the red, and the yellow colors in separate coconut shells; water was kept in an old army canteen, which he was still using in 1959–60. At the earlier time he was blackening by searing with a heated iron or a flat iron piece and then rubbing on a combination of charcoal (from the bottom of cooking pots) and vaseline. This mixture, he felt, made the black stand out beyond what the charring had done. He

usually colored the black areas before applying the other colors, for if they spilled over onto the black it was easy to rub them off. For the other colors there seemed to be no particular order of application.

In 1959–60 he was using Meltonian, *odo*, and blackening in much the same manner, although there is apparently more ash and less oil in the black on some masks, so that they have a flat, dull look rather than a slightly shiny surface (for example, *ɔkpesu umuruma*, fig. 21). Further, the whites are more intense and less creamy than before. In 1959–60 the two children's *mba* masks and an *mbubu* that he produced were decorated with red paint instead of camwood. He used camwood on some of his other masks at this time, either directly or in mixture with *odo*, but claimed that it was hard to find because it was seldom employed for body painting any more and was not much in demand. He did not ask any of his wives to prepare it, for he said that they would want to know why he wished so much camwood. He arranged for a woman at Ezi Agbo, the neighboring compound to his in Mgbom, to grind it for him. She was not an old woman, and in fact was nursing a child and had some free time. Chukwu said that she "still follows the old ways." He told her that he needed it in making sacrifices. Although Chukwu's wives ground camwood and prepared *odo* for him in 1952–53, my suspicion is that during this second fieldwork period it was not so much a matter of keeping something concerning the secret society from them, but rather that he did not wish them to know he was carving a series of masks for me. If they did, they might demand some of the money he earned from the work.

Chukwu, and others at Afikpo, consider it important to recolor the masks, whether traditional colors are used or not. It is not good for a mask to be shown with poor or faded coloring. The carver once asked me whether I would "keep the masks up by recoloring them," and I agreed to do so.

Calabash and Coconut

The nonwood masks carved for me by Chukwu Okoro deserve special mention. He used the same set of tools as for the wood forms, although clearly the heavier tools are not of any help in preparing the *mbubu* calabash masks or the *mba* forms of coconut materials. The raffia backing is roughly similar to those on his other masks with like face colors, except for the use of red paint on two *mba* masks and one *mbubu*.

In order to prepare the 1952-53 *mbubu* (pl. VIII), he looked around for a suitable gourd, but could not locate one. It was difficult to find one

with both a properly shaped body—rather long and thin—and a well-shaped "tail."* Finally he was able to purchase one at the Afikpo market for 1/2d. He considers this mask difficult to carve, for if one slips and scratches the surface, it is not easy to cover it up or to patch it by further carving, as one can with wood. This is a particular hazard when carving out the mask's surface in order to put on the white coloring. Chukwu feels that the calabash takes the camwood, orange, and white coloring better than wood; however, I am inclined to disagree, especially in the case of an unworked surface. He also indicated that this mask was harder to blacken with hot metal, as the tool slipped about on the surface.

In 1952 I wished to have some *enna* masks carved by uninitiated boys, but we could not find a child to do so, possibly because the ceremonial season was over. Finally Chukwu Okoro agreed to make me two *mba* of the *enna* type out of coconut fiber. This was at the end of July, when he technically should no longer be carving at all. But he agreed to go ahead since the children's society, while in imitation of the adult one, is not strictly bound by rules regulating its season—anyway, he was no longer a member of it. His work shed had been cut down about a month before in the general bush clearing and he felt that he could not work on them in the open where women and uninitiated children would see him; he must work in private, according to the regulations of the boys' secret society. He made one mask secretly in his house. At one time he thought of working at my home, outside of the village, as he needed a fire to blacken parts of the face. He makes no fire in his own home and did not wish his wives to know what he was doing by using a fire of theirs. Eventually he arranged for a private fire in his village.

One night after he had agreed to make the masks, he was drinking at the house of his friend, Nnachi Enwo, who lives in the same village. While imbibing with his friends he began to think about carving the mask and suddenly decided that he would look for the two coconut fibers. He went home and took his ladder, to the considerable astonishment of his wives, who wished to know what he wanted it for in the middle of the night. He told them it was none of their business and with his friends went out looking in the dark for a suitable tree. They had some difficulty in finding one, as Chukwu says, because there was a coconut tree blight and many were in bad shape, but perhaps the darkness was also a factor! Finally they found one and he climbed it, cutting off a fiber. At this moment some persons came by on a nearby path. Chukwu became frightened that they would think that he was stealing coconuts and he dropped down quickly, taking the ladder and fiber but losing his penknife. He and his friends fled home. He recovered the knife the next day, but

* Probably the common West African bottle gourd, *Lagenaria vulgaris*. See Irvine 1950, pp. 130–31, 189.

carved only the one fiber mask at that time. He felt that he should not get the fiber in the daytime when women might guess what he was doing. He kept the mask, until finished, under the raffia roof of the ancestral resthouse of his compound, where small boys could not find it and take it for their own use. I believe that he felt a little silly, as an adult man, carving a child's mask, considering it a humorous affair.

Attitudes

Chukwu feels that the *nne mgbo, beke, ibibio,* and *ɔkpesu umuruma* masks are the easiest to produce. He usually makes these, of course, with the softer, lighter *okwe* wood, and they involve large curvatures. For him the horned mask and the *ɔpa nwa* are the most difficult, because of the horns of the goat and the many elements on the queen mask.

At various times Chukwu, his brother Oko, and his friend Nnachi Enwo made comments about the masks. I have indicated these above in the discussion of each type. I very much regret that I did not question them more fully, as it is difficult to comment in detail on their opinions from the incomplete data I have. I feel that Chukwu was not conscious of specific meanings attached to parts of the masks, such as tears or the high-bridge nose; rather, these were simply design elements used on Afikpo masks, parts of the mask that one could explain as "tears" or as being like Ottenberg's nose, or as one wished at the moment. I feel that he saw many of the masks, or parts of them, as representing humans— sometimes real persons—rather than as abstractions. This is true of one of the ugly masks, of the mouth of a *nne mgbo,* and of the nose of an *mba.* I sense that he searches for human equivalents rather than seeing the masks simply as design.

Chukwu, Oko, and Nnachi Enwo view certain masks, or perhaps all of them, directly in the context of their use in plays and dances, and as part of a total costume. The quality of the mask— fine, ugly, or however they may express it—relates to the type of activity with which it is connected and the type of costume associated with it.

Further, masks are "beautiful," meaning that they are carved with fine lines, are white, and are female, or they are "ugly," in which case they are humorous (excepting *acali*) and not so finely carved. The ugly ones stem from earlier times at Afikpo; the beautiful ones are more modern. Such classification is not applied to all masks, such as *acali* or *ɔtogho,* but it reflects a view of a mask as a whole rather than a concentration on its parts.

While the comments of Oko and Nnachi Enwo are quite brief, when taken together with Chukwu's views, they can take on more meaning. Here are three persons from the same village, two middle-aged and one a bit older, two of whom are carvers and a third very familiar with carving and the related rituals, who as individuals like different masks, dislike some different ones, and seem to apply somewhat different standards of taste. One can only surmise, then, that there is not a strong emphasis on uniformity of views about the Afikpo masks beyond some general concepts of what is beautiful or ugly.

Change

There are some differences between the masks carved by Chukwu Okoro in 1952-53 and those produced in 1959-60, but they seem minor and do not suggest that he had gone into a new style or "period" of carving. Chukwu's brother helped him on the second occasion and not on the first, but I do not attribute the changes to Oko's contributions. Rather, Chukwu, while just as interested in carving, was busier and more rushed in the work he did in 1959-60, turning out a larger number of masks for me in a shorter time. On some of the masks from the second trip, such as the "queen" (fig. 24), the *acali* (fig. 1), and the *ɔtogho* (fig. 26), the carving lines are less clean and sure, the flatter surfaces are rougher. Some of the masks of the second period have a much thicker layer of white coloring and also lack a sense of woodiness, as the black does not have the same luster and dark brown quality as before. At the time of my second visit he was using some carbolic red and the reds were deeper, whereas on the first occasion the camwood was almost orange. However, there is also some very fine carving and coloring to be found in the 1969–60 group, as on the *ibibio* (fig. 4) and the *igri* (pl. I), and I would not say that Chukwu's basic technique had degenerated. Nor do I feel that in the six-and-a-half-year period between the two field trips there was any general decline in the quality and quantity of mask carving at Afikpo.

A PLAY

CHAPTER VI

Ɔkumkpa

I have, up to now, discussed the masks as static elements, largely separated from the context in which they are used. This treatment was necessary in order to set forth basic information—to classify them and to learn how they come into being and are maintained. But the masks do not stand alone. They are only one aspect of the rituals, which involve full costume, movement, music and song, talk, drama, dance—combinations of masqueraders arranged in various ways and sequences. In this larger perspective the masks become only one of many elements in the masquerade, and in the discussion of the masked ceremonies at Afikpo in the chapters to come, less attention is paid to them than before.

Yet their significance should not be minimized. The wearing of a mask by an individual at Afikpo automatically leads to (1) the presence of certain symbolic elements; (2) secret society involvement; (3) special behavior associated with the *mma* spirits; (4) an awareness that one of a number of recognizable and identifiable masquerades is in progress; (5) attitudes of voluntary suspension of belief as to who the actual player is; (6) physical movement; and (7) some quality of emotion, whether fear, laughter, pleasure, or some other feeling. The mask, then, becomes the crucial element for an understanding of what is going on, with the other elements dependent on it.

There does not appear to be any general term popularly used at Afikpo for the masquerades. However, the expression *ihie ogo* (something-secret society) is used to refer to any event in which persons dress up in masks and costumes, be it during an initiation or at a dance or play. It is not an expression employed for other secret society activities.* The term *igwu rεgwu* (play-to play) is also used for masked rites, but it is a more general term, also meaning dances, elaborate second funeral rituals, and dances associated with wrestling.

* Jones (1939b) refers to a play called Ifogu, which appears to be something like a simplified form of the Afikpo *njenji*, which derived from Unwana Village-Group and spread to Nkporo, Abiriba, and Item. The "h" is commonly used at Afikpo where the "f" is employed in other Igbo areas. However, this is not the term for a specific masquerade at Afikpo.

With these comments in mind we now turn to the most elaborate masquerade found at Afikpo Village-Group. Ɔkumkpa is the most popular and well attended Afikpo masked ritual. It consists of a series of skits, songs, and dances presented by masked players in the main common of a village during the course of an afternoon or evening. Every Afikpo village can put on its own performance. The play is closely associated with the village secret society; all players are society members, and all wear wooden masks and costumes. Such plays apparently exist throughout the Eastern Igbo area and among the Ibibio people (Messenger 1962, 1971).

In reality, only three or four Afikpo villages are likely to produce the play in a given year. For example, in 1960 Amuro, Mgbom, Ibi, and Amamgballa put on the ɔkumkpa. A village does not necessarily perform it every year, but may present other plays or none at all. Before their productions in 1952 Amorie had not staged the ɔkumkpa for some fifteen years and Amuro not for about three years. Some villages do not seem to put it on at all. It is my impression that the play is most frequently seen in the larger Afikpo villages, where resources in skilled personnel are more likely to be found. In the past a village ward would sometimes produce the play, especially in the larger villages, but nowadays there is not a sufficient number of young men about to do so.

The play is a creative and aesthetic event. It is not the sort of ritual that can be produced simply on the demand of the elders, but requires the strong leadership of a single person, generally a young or middle-aged man, who has singing and organizational talents as well as a fine imagination. He seeks out a fellow villager and they form a team, the senior and junior play leaders, respectively. They are called by the same name as the masks they wear, *nnade ɔkumkpa* (father-the play). Often one or both have led the ɔkumkpa before, if not in the adult society at least in the form given by the boys' imitation secret society.

The two men are likely to begin preparations as early as nine months before the play is to be given, working on the songs jointly and separately. They try out new verses when they are alone and cannot be overheard, such as at the farms or in the village men's resthouse. Much of the interest of the play is in the novelty of the lines. The senior

leader has ultimate responsibility for the choice of the vocal and the skit material.

A play leader is not usually a person of high social status, as the skills used in leading are not those usually associated with prestige or wealth at Afikpo. The ability to speak well and to handle oneself in disputes and the possession of physical strength are rather more important general attributes at Afikpo. In fact, play leaders, like mask carvers, are often looked upon as foolish or funny persons. It is said of the leaders that they "have buried their own nonsense," meaning that they put time and effort into an inconsequential thing. If persons want to scorn a man who gossips and makes fun of others, they call him a leader of the ɔkumkpa. Similar attitudes exist toward other individuals who preoccupy themselves with taking part in these plays. Yet the skill of the leaders and players is much admired, as is the work of a good carver. Some leaders, such as Okewa of Mgbom, have gone on to become prominent in the village later, but none has been a play director and community leader at the same time.

Occasionally there is a second set of persons in a village preparing to give a performance. If so, the elders decide which is the best prepared, and the other one disbands completely or postpones its efforts for a year, for a village never puts on more than one production of the play in a season.

The village elders, in fact, can refuse to allow the play to be given at all if they do not feel that it will be well done. They are concerned that the play be a fine one in comparison with those performed in other villages and in other years; there is some intervillage rivalry here. The elders also approve the date on which the play is to be given. The performance is in the dry (ɔkɔci) season, usually in January or February, normally on the Afikpo market day (ɛkɛ) that falls on a Sunday, for this encourages the largest possible turnout of players and audience. If it is raining on the day of the play, the performance is postponed either for two or four days.

Two villages do not give their plays on the same day. If several communities are preparing the play, they coordinate their performance dates through their village elders and play leaders. The village that is furthest along with its rehearsals goes first. Each village likes to have as large an audience as is possible, and the plays are often well attended by persons from many parts of Afikpo. Some individuals like to view all the productions given in a single year.

The presentation of the ɔkumkpa must also be coordinated with the performances of other major plays in the village. First to be given is the njenji masked parade, presented at the Dry Season Festival, iko ɔkɔci; then come the net masked dance, oje ogwu, the okonkwɔ dance, and finally the ɔkumkpa. Neither oje ogwu nor okonkwɔ is as frequently performed at Afikpo as is ɔkumkpa.

I will first indicate the general features of the play and then present information on an actual performance. I was able to see two of these plays in 1952, one at Amuro and the other at Amorie. I also saw one in Mgbom in 1960 and the first half of the Amuro play in the same year. What follows is based on these observations, on interviews with the 1952 Amuro play leaders, and on other data gathered during the course of ethnographic research.

REHEARSAL

Some weeks before the play is to be given, the two leaders start recruiting persons to take part. Crucial to the success of the play is their selection of two assistant leaders, the musicians, the principal singers, and the actors. These are located among known performers in the village, as well as among friends and relatives. Knowledge that a play is to be performed soon spreads among the village men, and some volunteers come forward. The senior and junior leaders can also look outside of the village for assistance, although most of the players come from within it. External help may be necessary in the case of musicians, particularly drummers, for not every village has high-quality musical performers. Persons recruited by the leaders are often offered small amounts of money to attract them; but the musicians, singers, and actors obtain their major rewards through gifts ("dashes") given them by friends and relatives during and after the performance.

The village elders usually issue an edict that all secret society boys and young men belonging to certain of the younger village men's age sets (S. Ottenberg 1971b, chaps. 3 and 4) should take part. This ensures a large group of players, often over one hundred, and a substantial number for the boys akparakpa dancing group, for the younger players do not usually take acting roles.

About two weeks before the performance the players begin to meet for rehearsals—every other evening or night, on Afikpo's major and small market days, ɛkɛ and ahɔ. They meet at a clearing away from the village so that they cannot be seen or heard, although the sound of singing and drumming is sometimes noticeable miles away. Interested persons go along to form a critical audience.

In December 1959 I attended the first rehearsal for the Mgbom ɔkumkpa. About nine-thirty at night persons began to gather in the main village common in response to the wooden gong, ɛkwɛ, beaten by one of the musicians. No one was in costume, although many were warmly dressed, as it was a chilly night. After about half an hour we passed in single file through the special path leading to the initiation bush of the village, but cut out before reaching it to a clearing near the road south of Mgbom. This is the traditional

rehearsal spot. The players kept a bonfire going there, and some of them had bush lanterns or flashlights. One hunter brought a carbide head lamp; several times he fired his gun for the pleasure of it. Rehearsals have a pleasant and comradely air.

The players were grouped together in a circle by the two leaders, who stood in front of them, with the audience to the back. This arrangement is similar to a regular performance of the play. The audience, separated from the players by sticks laid on the ground, was not permitted to cross over. If someone did so, he would be considered one of them and would have to sleep that night in the village common or the men's resthouses there, along with the players. This cloistering of all players who take part in the rehearsals and the actual performance symbolizes the separation of the sacred activities associated with the secret society from ordinary daily life.

On this occasion some fifty players came out to practice, with an audience of about twenty-five experienced and interested middle-aged men and some curious schoolboys home on holiday. Of course, only secret society initiates can watch. The leaders went through the entire play, paying particular attention to the songs, already learned by some performers, who had been working closely with them. The interest in the words of the songs, which were original, amusing, and satiric, was high. The leaders passed a ruling, more or less followed, that if a person did not know the words he should keep quiet until he heard them thoroughly and learned them. Between songs persons came out and practiced dancing as the musicians played. The leaders also tried out men for parts in the skits, explaining what they wished them to do and having them act out the parts. Some actors had been chosen already; in other cases the leaders made decisions on the spot whether to accept an individual for a role. A person passed over usually joined in the play as a singer and dancer.

The senior leader was experienced. With a friend he had already put on three ɔkumkpa for his village, but he had stopped out of sorrow when his partner had died. Then some years later he decided to try leading again and he found a new junior partner. The two had been preparing songs for some nine months before the rehearsals began.

The rehearsal that night lasted until about two o'clock and was repeated every other night up to four days before the performance. The usual final rehearsal two nights before the play was canceled because one of the leader's voices was weak and he wished to save it for the performance.

EVENTS JUST BEFORE THE PLAY

During the days immediately preceding the performance each player seeks a proper mask and costume for the role he is to take in the play. It is his responsibility; no one does it for him. Some persons own the right kind of costume; some borrow one from friends or relatives or else make part of it. Some individuals have a proper mask; others borrow or rent one from an owner or a carver. Neither the mask nor any other part of the costume has to come from the village giving the play. It is at this time that Chukwu Okoro, the Mgbom carver, has a steady stream of visitors. During the days before the play men borrow strings of colored plastic waist beads, cloths, bangles, and porcupine quills from various sources —sometimes from their wives. Unmarried boys and men, and even husbands, obtain these things from a girl they like; such a female will be glad to lend them to a male in whom she is interested. She is not usually told what it is for, but she frequently knows or guesses. These matters are likely to be complex, for if a man shows an interest in one woman but borrows items of dress from another, the first will feel insulted. If a female lends something to a man, it does not mean that they are lovers, but as one Afikpo said: "It is better if they are." Sisters, mothers, and other female relatives may also lend costume articles.

During the two or three days before the play is presented the village resthouses are crowded with boys and men busy at recoloring masks, preparing raffia, repairing and sewing costumes, bangles, and so on. As the masks are painted, they are hung unwrapped on the inside roof of the resthouse to dry. Their placement here hides them from outside view and also indicates that they are being used by someone, for persons without masks sometimes use unclaimed face coverings found in the resthouse to avoid renting one.

It is a rule, according to some Afikpo, that the presentation of a costumed play associated with the secret society is not announced beforehand. Everyone's preparations are supposed to be a sufficient sign. It is believed that if the information is publicly given forth, the secret society spirit, egbele, will be offended and make the leaders and some of the players fall ill. Events connected with the secret society do not have to be announced; they just take place. Yet I have heard the date of an ɔkumkpa given out beforehand at a meeting of the village elders, and the day of the performance is often common knowledge in the village-group. And in January 1960 at seven o'clock on the morning of the Mgbom play three dancers wearing nne mgbo masks, one of whom was beating on a wooden ɛkwɛ gong, came to my house and woke me up. They said that the play would start at eight (in fact, it began about noon). They would not leave until I had given them a "dash." The desire for a large audience at these plays requires some announcement regardless of the ritual rule.

But the religious aspects of the play are

expressed in other ways. The players are expected to refrain from sexual intercourse the night before the performance. It is believed that if persons have sexual relations, they will become weak, their voices will fail, and they will dance poorly. The same proscription applies to priests the night before important sacrifices. In fact, major ritual activities associated with the secret society are commonly kept free of sexual contacts in order to avoid contamination.

The two leaders usually sacrifice to the spirit of the secret society on the morning of the play, and sometimes again just before it begins, when they are fully dressed. During the play, especially if one of their voices is growing hoarse, they will call out to egbele to keep them strong and will throw bits of kola nut to the ground in the name of this spirit. Sometimes they tie a small live chick to each of their headdresses, another sacrifice to egbele; such animals are often placed alive in shrines, particularly ones associated with the Aro Chuku oracle, ibini ɔkpabe (S. Ottenberg 1970, pp. 41-44). The older dancers, wearing the dark raffia ɔri costume, sometimes also carry chicks to bring them strength, but the younger players usually do not.*

The leaders often wear a charm on one of their fingers. In the Mgbom play of 1960 each wore a large one tied with a string. Such magical pieces are prepared by the secret society priest or a diviner. And the players as a group may make a sacrifice to a village shrine to ensure their success, as they did to ibini ɔkpabe before the 1960 Mgbom ɔkumkpa.

These ritual steps are designed to ensure good voice and skill in dancing, singing, and acting, against the reckoned power of egbele to ruin the performance if this spirit is annoyed. Afikpo say that during the Amuro ɔkumkpa of about 1949 one of the leader's voices failed because he had offended egbele, although no one knew quite how. Whatever the beliefs may be, four to five hours of almost constant singing on the part of the leaders and players leads to a number of cases of strained voices.

In the past, each player in the ɔkumkpa, as for other masquerades, was expected, according to secret society rules, to provide two balls of yam fufu with soup, prepared by a wife or mother, for men sitting in the commons to eat before donning a mask. If this was not done, the player ran afoul of the law and could be fined by the elders if he

ever, at some other time, tried to eat such food himself. This practice has disappeared today.

In the Itim subgroup of Afikpo villages the masqueraders generally wear a braided leaf arrangement (aso) tied to the left wrist and the right foot, or somewhere on the costume. Composed of yellow and green palm tree leaves braided in with another leaf, ekɔrɔ, which is much used in Afikpo costuming, this is not for magical protection, but is a sign that a person has been through a form of secret society initiation called isubu eda (see Chap. 3).

Each of the five Itim villages has a special dressing place for masquerades called an ajaba. These are roofless structures with wood and stick walls, erected one to a ward for the ceremonial season. On the morning of the performance the village common is closed to females and noninitiates and the costume materials are taken from homes and the village resthouses in the commons to the ajaba. Male friends and relatives often go and help the players costume themselves. Skilled dressers, such as Chukwu Okoro, are quite busy on the morning of a performance, for the materials have to be tied and pinned on properly; mirrors are not used.

There are special rulings associated with the ajaba. A dresser must leave the ajaba before the person he has helped prepare for the play. A player performs a small rite, called rie mma (eat-spirit) or oriri mma (eating-spirit), upon entering the ajaba. He touches his mouth to the sacred abɔsi tree found in the ajaba and thereby receives mma, the spirit of egbele, within himself; the spirit is not in the mask itself. A helper must be careful not to touch the tree or the ajaba walls or to put anything in his mouth while in the dressing house or else he is considered to have performed the rite and must dress up in a mask and costume. However, on leaving the ajaba the dresser clears himself of spiritual forces in a rite called mɛrue onwɘgi (spit-yourself), by touching the tree with his hands and spitting on the ground. The masked player does not do this, for he wishes to retain the spiritual forces of the ajaba within himself; he leaves the dressing place as a masked spirit, mma. If a player is missing part of his costume when in the ajaba, he does not go out himself, but sends a helper to get it for him.

The ajaba of the Itim villages derives from nearby Edda Village-Group. In most of the other Afikpo villages there is no ajaba. The players prepare for the play with the help of their friends and kin in the closed village common, behind a specially prepared fenced enclosure in a bush area near the village, or around the village latrine. Here the transition to spiritual form is not as ritualized.

STAGES OF THE ƆKUMKPA

Afikpo see the ɔkumkpa as comprising some

* In the 1960 Mgbom ɔkumkpa the chick came untied from the headdress of one of the leaders and fell to the ground. The leaders were unaware of this and several dancers nearly stepped on it, creating considerable anxiety in the audience until an elder among the viewers picked it up. The leader did not wish to bother to tie it on again (indicating that he felt strong), so the elder took it to the ajaba dressing house and tied it there for him.

eight or nine stages. Each is marked by a particular type of action, and most stages are identified by name. Stages may be separated by a pause in the music, dancing, or acting, but generally flow rather directly to another. These features vary from play to play, as does the length of each stage. Creative variation within a general framework, rather than the rigid adherence to a pattern, is a characteristic of the ɔkumkpa, allowing the leaders the chance to develop their own style.

Stage 1

The first stage, called *oga lozo* (walk along-road), finds the newly dressed players joining together in a central common. In some plays they gather in the dressing house as a group and come out together, in others they move out individually. In some of the Afikpo villages females and uninitiated boys cannot come out to watch until the players are grouped together; in others they are allowed to sit beforehand. Initiates who come to view the play can come whenever they wish.

Upon joining together, the players, directed by the two leaders and the assistant leaders, sing while they walk through the commons of the main wards of the village, with the musicians playing in front (fig. 36). The song is called *nde ɛgwu ale* (people-song-ground), a term that also refers to the players as a whole, minus leaders and

musicians—that is, the group that acts as a chorus throughout the performance. The song announces that the players have come. The music is usually the same in a village each time the play is performed, but the words differ. In the ɔkumkpa put on in Mgbom village in 1960, the song concerned a man from that settlement who had killed a fellow villager with a machete and also someone from Kpogrikpo village who some years before had committed the same crime. The leaders and chorus sang that in the olden times these men would have been killed for their actions, but nowadays they go to court and are not done away with. Then they sang another verse concerning a land case between Mgbom and another Afikpo village, Ugwuego. Mgbom men would not let members of Ugwuego go to their farms along the narrow and deeply cut farm path that passes through the Mgbom forest area. Now, however, "it is civilization," and they can pass. "A man who has not got his hands, who cannot feed himself, cannot harm Mgbom," they sang.

This first stage is an impressive sight, with some one hundred or more masked and costumed men moving en masse. The leaders and assistant leaders hold iron or wooden canes in their right hands; these are often used by other players.* The

* Both in the 1960 Mgbom and Amuro plays the two leaders did not appear until the singing and walking about was well under way. Before they came out the two assistant leaders directed the group.

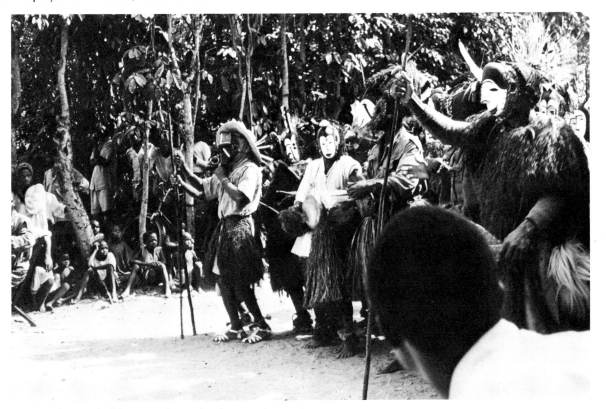

Fig. 36. Players, led by an assistant leader, coming out to village common for the Mgbom ɔkumkpa play in 1960

music and song, by signaling the start of the play, bring out the rest of the audience. At the Mgbom 1960 ɔkumkpa, a junior elder of the village arose in front of the audience after the dancers had first passed by and shouted the traditional Afikpo greeting, "unuka," several times to the viewers. He then said that there was to be no talking, that they were there to listen to what was going to be sung, and that there was to be no fighting or crossing the wooden barrier (erected to keep the audience back). He indicated that any violators would have to pay £10. There were no fines levied that day, although the audience at these plays is not always quiet.

After some fifteen minutes to half an hour of singing and moving about, the players return to the main common, where they go immediately into stage 2 without a break. However, at this point it is desirable to say something concerning the various categories of performers.

The two leaders, ɔkumkpa odudo (ɔkumkpa -leaders), are in special dress. They are usually the only ones to wear the powerful, generally ancient and sacred nnade ɔkumkpa masks (figs. 13, 14, 37; Cole 1970, pl. 109). They each wear a floppy, wide-brimmed mat hat; a raffia mat, sleeveless shirt; a dark raffia waistband; and khaki shorts. Towels or pieces of narrow-strip native cloth (made in the Okposi-Uburu area) dangle from their waists or shoulders. Sometimes they wear the skin of a deer or some large animal on their backs. Like the other players, they use ankle rattles made from the seed of a plant from the Ikom area; but they are usually the only ones to wear wrist rattles made of the same material. The leaders are easily identifiable amongst the players by their dress and actions. They do not sit down, as do the other players, but usually remain apart from them and do not usually dance about.

These two men are responsible for indicating the end of each stage, for starting a new one, and for directing the music, singing, and dancing. They must keep the players seated in orderly fashion and check the tendency of some of the older players to come out in the middle of an event and to start dancing and begging "dashes" from the audience.

The main leaders are aided by two assistants (fig. 42), called odudo ɛgwu ale (leader-song-ground), who are dressed as the leaders but less elaborately. They occasionally wear a new, less sacred leader's mask or one of the types of masks worn by the ɔri players, to which general category they belong and in which age group they normally fall. The assistants sit near the front or at the sides of the masked chorus during the play, keeping it orderly and leading it in singing. Sometimes they jump up to quiet the audience, waving their arms at them. They are usually expert dancers and put on individual

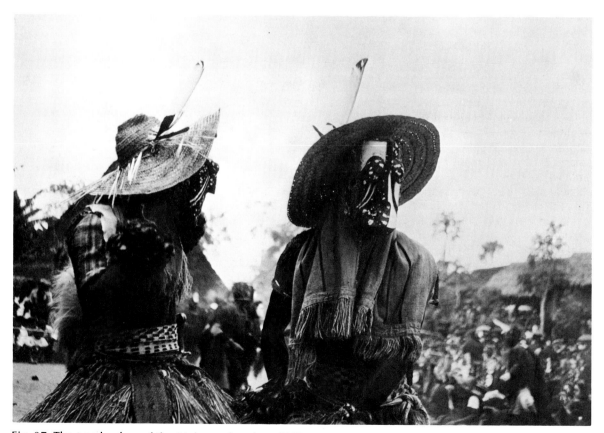

Fig. 37. The two leaders of the Mgbom ɔkumkpa, 1960

dancing displays between some of the events, along with other ɔri.

About one-half of the players—some fifty or so—wear the dark raffia ɔri costume, which covers much of their bodies; underneath they usually weak khaki shorts and an undershirt of some kind. The raffia dress, *ukpu egwe* (weave-raffia), is also worn newly made by the boys during certain forms of the secret society initiation, after which it is stored in the resthouse of the owner's ward for use in the ɔkumkpa. The costume is readily borrowed and there are usually some in the resthouse that lie about unclaimed. Occasionally at the play a bright orange raffia costume is seen; this is its color when it is new and indicates that it was only recently used in an initiation.

The ɔri are the principal actors in the skits. They also come out and dance as individuals between some of the events (figs. 17, 38; pl. XI). Some of them are highly skilled dancers and they draw many "dashes" from the viewers. The ɔri are also active singers in the chorus. As the older players, often middle-aged, they are likely to wear the ɔkpesu umuruma, *mkpe*, or *ibibio* masks, the *beke*, and *nne mgbo*, or more rarely an *igri*, an *acali*, or a leader's mask. They are experienced players, as a rule, having taken part in previous performances, and they are generally volunteers selected by the play leaders, for the village elders usually demand participation only from younger men and boys, not men of their age. The success of the play depends to a large extent upon them.

In contrast are the *akparakpa* dancers, who form the other half of the chorus. The term comes from *epia akparakpa*, a kind of music danced to by these players in a characteristic fashion, in which they shake their waists from side to side. These boys and young men wear the *mba* costume, consisting of a light-colored raffia waistband, a white singlet, shorts of white or khaki material, and a colored wool chest halter called *nwea ɛrɛ* (shirt-breast). The halter, usually in blue and red with a little white, comes down the shoulders and connects near the front center and the back center to a band of the same material that goes across the upper chest and back. It is a style of dress found in other masquerades, such as *njenji* and *okonkwɔ*.

The *akparakpa* often also wear the *mba* headdress, like the ceremonial dress of unmarried girls but exaggerated. On the players this consists of five elaborate black projections representing standing braids, some ten to fifteen inches in height, with one for each corner of the headdress and the fifth in the center. They are connected at their tips by pink yarn. Sometimes the players also wear one or more plastic waistbands composed of strings of thin, flat, round plastic disks that are usually pink but sometimes other colors. These are commonly worn by girls on ceremonial occasions and are a substitute for strings of cowrie shells formerly used in the masquerades and by

the girls. These plastic bands feature in the *okonkwɔ* and *njenji* masquerades as well.

With this costume are usually worn the *mba*, *mma ji*, and *ɔpa nwa* masks, with the youngest player, and sometimes several other young boys, wearing the *acali* with hats or caps rather than the more elaborate girl's headdress. Only one boy in stage 5 and another in stage 8 who wear the *mba* costume actually take part as actors in the skits.

The *akparakpa* sing as part of the chorus, and at set intervals in the play they come out and dance counterclockwise in a circle around the remainder of the chorus. They imitate female dancing in an impressive fashion, much enjoyed by the audience (fig. 39; pl. XI). While the ɔri dancers appear quite male, the *akparakpa* are dressed to represent young, unmarried females, even though the costume has mixed male and female features. These young men love to dance in imitation of the female style. If there are sufficient *akparakpa*, they are divided into two separate dancing groups by age, each one appearing in turn. If there should only be a few, some ɔri sometimes come out and dance with them.

One of the young boys is dressed in more elaborate feminine style than the others and wears the ɔpa nwa mask. Colored feathers are attached to his head or mask and he has more plastic bead waistbands than other *akparakpa*. Sometimes he is found hidden in the center of the crowd of

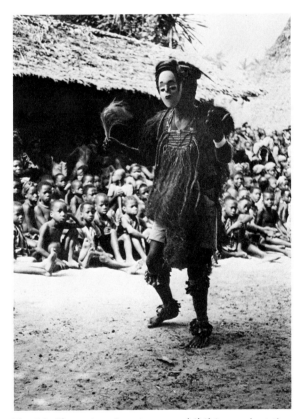

Fig. 38. Player in ɔri costume and *ibibio* mask at the Amuro ɔkumkpa, 1952

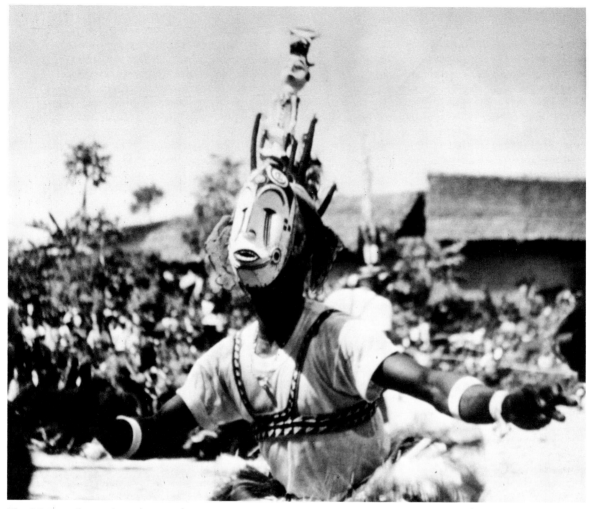

Fig. 39. Boy dressed as *akparakpa* player with *ɔpa nwa* mask at the Mgbom *ɔkumkpa* in 1960

players, or in the men's resthouse in the commons, but toward the end of the play he emerges as the "queen," *agbɔghɔ ɔkumkpa* (girl-*ɔkumkpa*).

Lastly there are the musicians (*nkwa*), who remain together as a group (fig. 40; pl. X). They do not sing, dance, or take part in the skits, but remain seated during the performance at the front of the chorus. They usually wear a shirt and shorts, sometimes with some raffia covering, and a variety of masks: *beke, ibibio, igri, mba, mma ji, mkpe, nne mgbo, ɔkpesu umuruma*. There are generally three drummers playing the relatively small, skin-headed wooden drum (*ikpirikpɛ*), sometimes in different sizes; one player of the small, conical basket rattles *(ahia)* covered with brown raffia, one to each hand; a musician with a small wooden gong (*ɛkwɛ*); and one with a small, single-element iron gong (*omomo*).* The latter is hit with a short wooden stick, as is the *ɛkwɛ*, while the skin

drummers use their hands and fingers. The musicians bring their own instruments to the play.

The musicians are not necessarily all from the village producing the play, nor do they have to be a team that always plays together. The drummers are the most crucial to the performance: their skill in coming in at the end of a song helps to keep a sense of movement in the play, and their playing cues the dancers in and out and through their steps.

The attitude toward the musicians is not much different than toward carvers and play leaders. It is well summarized in an early report on Afikpo Division: "It seems that a musician is a respected but not necessarily highly-honored member of the community: he is regarded as a jolly fellow, as a jongleur rather than a minstrel, and though he may receive popularity and presents, is not leader of the town" (Anon. 1927, pt. 7).

Since the players, as *mma* spirits (the plural in Afikpo is *nde mma*, meaning people-spirit) or "fairies," have a general connection with the spirit of the secret society, females and uninitiated boys

* See Okosa 1962, pp. 6-7, for a photograph of the kind of rattles and wooden gong played at Afikpo (although Okosa calls them by other terms).

are expected to believe in them and to respect them. Any unusual noise in the evening, such as secret society drumming, singing in the bush, or shouts, is believed caused by *mma*. It is said that if a wife is troublesome, her husband may hide near her at night and talk in a light, squeaky voice. She will think it is a *mma* and quiet down.

Women are well aware who the players are, and they spend quite some time trying to recognize husbands, sons, brothers, lovers, and others at the ɔkumkpa. Of course, they may see some of their own clothes or other costume elements on the players. While they may discuss this among themselves as they sit together in the audience, they do not reveal to men that they know the identity of any of the *mma*. They may give a player who is a relative, a friend, or a lover a small gift after a play for "something fine" that he has done, but they will not admit directly what this is; the receiver knows what is meant.*

Females nevertheless fear the dancers, largely

because of their association with the powerful secret society spirit. I have seen a hostile male dancer come up very close to a seated woman at a play and try to touch her "accidentally"; the woman, even though she knew who the dancer was, drew back in fright. Any such contact means that she may fail to produce offspring and at any rate should perform a sacrifice to *egbele* to purify herself. Men, of course, know who the *mma* are, whether they take part in the play or not; but they also fear *egbele* and thereby adhere to the ritual rules of the play concerning such things as dressing, undressing, and sexual activities and they will not remove a mask during a performance no matter how hot or uncomfortable they become.

Stage 2

In the second stage, called *obubu εgwu* (fall in or line up-sing),† the leaders and players put their canes and walking sticks on the ground to one side and group themselves at the center of the main common, facing the seated elders. They either remain standing for a while or all but the two main leaders sit down. Then the *akparakpa* come out from the group and dance around it

* Since I was offered the chance to take part in the play once in Mgbom (I now regret my declining this offer), the attempt at concealment on the part of men can hardly be very serious, for my height, white-skinned arms, long legs, and musical ineptness would surely have given me away to everyone.

† *Egwu* also means to dance.

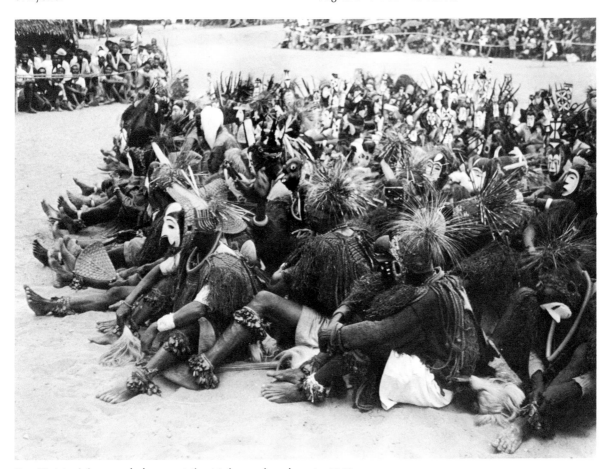

Fig. 40. Musicians and chorus at the Mgbom ɔ*kumkpa* in 1960

counterclockwise some three times. They are often arranged by height, from the tallest to the shortest, dancing in their characteristic style to the music, their upper body somewhat bent forward and their arms out in front of them, with the waist wriggling as they imitate females. They face the group or one another in line, with no particular attempt to face the audience. The members of the audience freely criticize and comment on the ability of these dancers; the *akparakpa* form an early test of the quality of the play.

While the dancing is going on, the leaders and chorus sing a song honoring the former play leaders in the village, in which they are called by name and asked to come out and to see what is happening on this day. Usually only the living are called, and in no particular order. Leaders in neighboring villages may also be so honored. In some plays the naming of former leaders occurs at another place in the play and there may be some other song here, often a listing of names, perhaps of elders who are foolish or selfish. One or two other bits may also be sung. For example, in the 1960 Mgbom play the leaders and chorus sang about a calabash, out of which a dish or cup is made, and asked for persons to "put wine in the cup for me"—a reference to expected "dashes"—as a reward for a good performance.

If the group stands during the dancing and singing, they sit down as soon as these are over. The musicians are in front, facing the elders, with the *ɔri* in back and to the sides of them, and the *akparakpa* toward the rear (Map V, and fig. 40; pl. X). The two assistant leaders as a rule sit toward each side. The large seated group of masked and costumed figures presents a colorful array (figs. 11, 42, 43).

The elders and more prominent male members of the audience sit in the shade of a tree or in the men's resthouse in the main common. Women and children sit elsewhere, often in the hot sun. During an act the two leaders go about in front of the audience explaining what is occurring. They may ask the audience whether they are following the skit and if the audience says no, as it often does, the leaders explain it. They may repeat sections or phrases of songs for the same reason. The acts themselves are carried out in the space between the musicians and the elders, a distance of some fifteen yards.

By this stage the audience is well formed. Its members are likely to dress up in good clothes, but some wear more ordinary clothes; there is no dress regulation and it is not an occasion for women to do up their hair in ceremonial style. Drinking among the audience is rare, as is eating. Persons bring out stools or chairs to sit on, or simply sit on the ground.

Chatter among the viewers often makes it difficult to hear the words of a song. Members of the audience move around and talk to one another. Children start to move up toward the players, even sitting in front of the elders, and may be chased back by an annoyed male member of the crowd. At some plays bamboo poles are placed on the ground, or upright posts every six to ten feet, to mark the line beyond which the audience should not sit. *Ogirisi* leaves may be attached to the standing poles to indicate that a rule has been made that members of the audience should not move in front of them.

The watchers comment and criticize freely to their neighbors. If they do not enjoy the performance, they will leave; there is no pressure to stay to the end, and at a poor production half of them may be gone by the end of the play. Approval of an action or song is given with a high warbling shout repeated at short intervals. Disapproval is indicated by a similar sound, but louder and lasting a longer period. In these features the *ɔkumkpa* differs little from the way audiences behave at other Afikpo plays and public performances.

Between the acts, and also between other sections of the play, men in the audience go out and give "dashes" of small coins to the dancers, to the leaders, and to the musicians. Rich and prominent men as "patrons of the arts," are more or less expected to do this, but others do so as the mood strikes them. The main leaders and musicians sometimes make considerable sums in this way, as there is no sharing and each keeps what he is given. For the musicians this is a form of pay. The leaders and others may receive traditional gifts also, such as brass rods and yams. A leader usually gives his gifts to a few friends or relatives in the audience to hold for him, for they become too cumbersome for him to carry about.

Stage 3

The third stage, *ɛgwu akɔ ye* (sing-salute), consists of three or four satirical and topical songs sung by the leaders with the masked seated players as chorus, but without drumming or other musical accompaniment. This part of the play is characterized by an intricate call-and-response pattern between the two leaders on the one hand, who stand in front of the group and face it, and the chorus. The chorus, here as elsewhere in the play, sings as a group, not in separate vocal sections.

If a song is thought well done, members of the audience may shout to have it repeated. The words are particularly important and should be highly original, although the music does not have to be. Popular songs from this stage—sometimes all of them—are likely to be repeated later in the play, renewing the good feeling that they have engendered, and they may be sung by Afikpo for years afterward.

I was told that if these songs are poor, the

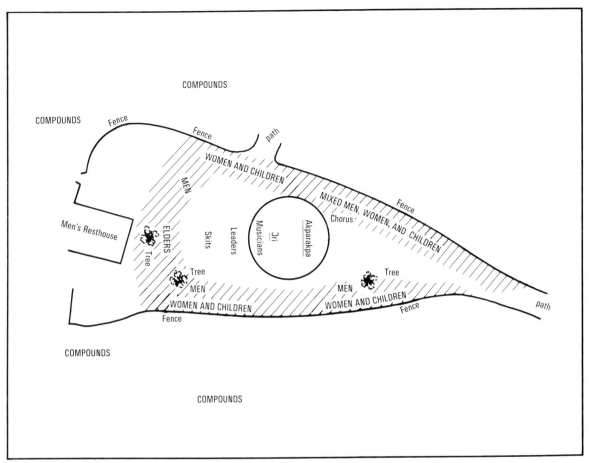

Map V. Arrangement of Players and Audience at Ɔkumkpa Play in Main Common of Amorie Village, 1952

play will be considered a failure and many persons will leave; however, I have not seen this occur. In some plays, during the last of the songs or at the end of this stage the leaders turn to the elders and other male members of the audience and ask whether the play should go on. The audience shouts its approval to continue.

In the 1960 Mgbom play the first song suggested that some villagers are only interested in making trouble in the men's resthouse through quarreling and making "palaver." The song goes on to say that anyone who wants to make a case should hire a lawyer and go to the Magistrate's Court, where he will get justice (a satirical comment). The song names Mgbom persons who are causing "palaver," and after each name it asks that someone bring the person to his senses. The song then indicates that those who go to the ogbo shrine in Edda Village-Group to swear innocence in a case or a dispute are lying. They then "dash" the priest to get special protection (from being made ill or from dying as a result of lying to the shrine). Again, names are given.

This was followed by a satirical song about how the junior elders at Afikpo like to fine persons. If members of this grade decide to fine

someone 30s. or £5, he must pay. They are like flying ants and are "very brave" (satirically sung).

A third song said that Islam is very new at Afikpo, but that there are only a few leaders who are not Muslims at Anohia village (where the conversion was occurring—see S. Ottenberg 1971a). Everyone else there uses Hausa rather than Afikpo kola nuts for rites. This song refers to the mass conversion to Islam of most members of this southern Afikpo village a few years earlier. The converts became hostile to the secret society and its activities and by 1960 there was a great deal of friction over these matters.

The leaders performed the fourth and last song alone in this particular play. They asked first the elders, and then all secret society initiates, whether they should go on with the Ɔkumkpa. After approval was given, they sang that women had become more interested in the secret society than men and they wanted to know whether they should hand it over to them. Then they reminded the women that it was man's nature to carry on with the society, not woman's.

This song was followed by dancing, during which the two leaders received "dashes." The songs were then all repeated, the first and fourth ones being the audience's favorites.

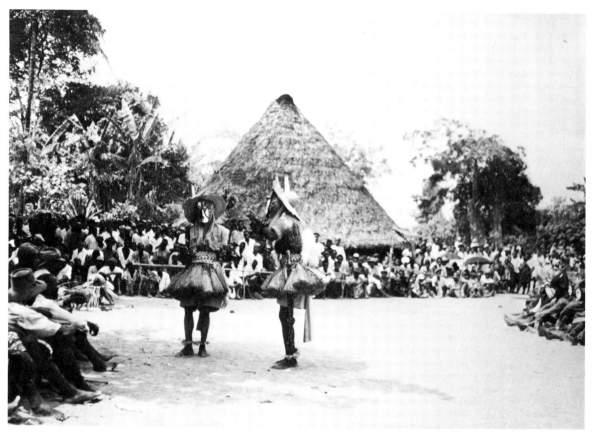

Fig. 41. The two leaders of the Mgbom ɔkumkpa in 1960 explaining a previous skit to the elders in the audience

Stage 4

The fourth stage is a major section of the play, both in activity and length of time. It has no special name and may simply be called ɔkumkpa. It consists of some five to eight acts (ɔkɔye), usually with explanatory songs. The exact number of acts and songs depends upon the leaders who prepare the play. Sometimes several consecutive skits will have only one song that ties together the meaning of the several acts. The ability to produce such a song is much admired at Afikpo, and one ɔkumkpa leader from Ukpa village is famous for possessing this particular skill. Between some of the acts other songs are sometimes heard. And one or more of the popular songs from stage 3 are likely to be repeated in this stage as the leaders sense the interest of the crowd. Such decisions are made on the spot, usually by the senior leader.

Between most of the acts there is a break in which the ɔri players come out and dance, sometimes begging money from the crowd, and men bring out "dashes" for the players. Somewhere toward the end of this stage, between two acts, or an act and a song, the akparakpa dancers appear for the second time, again dancing

in imitation of female styles. Their performance may sometimes follow an act or song ridiculing women. The young dancers are glad to be up and about, as they have been sitting since stage 2, perhaps for two hours. Their appearance marks the mid-point of the play, and it is also a time when some members of the audience get up and stretch a bit.

The actors in the skit may occasionally stop and explain what they are doing, for the large size of the "theater" makes it hard for everyone to hear and see the actors. In other cases the leaders go around in front of the audience describing in a sing-song chant what the players are acting (fig. 41). Shouts of "aiy, aiy, aiy" in loud, high voices by members of the audience indicate that they cannot hear or see what is going on and that the leaders should come and inform them. If the audience is large, it may take some time before the leaders get around to all sections of it, for audiences of a thousand or more persons are not rare. Most of the calls of approval, disapproval, or demands for the leaders to come and explain what is going on come from the men in the audience. Women are

quieter, laughing and chatting but rarely shouting.

The "stage" for the skits is not marked out in any special way by edges or barriers, nor is it raised; it is simply the ground about halfway between the chorus and the senior male members of the audience. The actors, usually dressed in the ɔri costumes, come out for a given skit at the beckoning of the leaders. Sometimes they act in pantomime and sometimes they use dialogue (fig. 46); but in the latter case most persons in the audience cannot hear them, as they do not speak loudly enough. There is little attempt to develop the "stage voice" of the modern Western theater. The leaders do not take part in the skits, although the assistant leaders sometimes do.

The actors may add certain elements to their basic masks and costumes as required by their roles in the skits. For example, a cloth over the head plus body cloths indicate a Muslim (see pl. X), a pith helmet indicates a European. These are worn from the beginning to the end of the play. Props are also employed. Sometimes one sees a crude wooden animal made out of a piece of log with four peg legs and something to represent a head. This can be used for a goat, a sheep, a horse, or a cow. Other props may be a pot, drinking cups, a horn, a gun, a small log to represent a bench or the village gong, money, or a small rack with a yam or two tied to it to represent the yam

racks (ɔba) between the village and farms where the yams are stored (fig. 45). These props are kept with the players until they are employed.

The actors in the skits represent specific persons from Afikpo, and they attempt to move and to talk as they do. Great weight is placed on the ability to imitate a person's movement, such as his walk or the manner in which he uses his hands and arms, and skilled actors are much admired, well rewarded, and complimented after the play. Voice imitation is also attempted, but not many of the audience hear the actors clearly.

The actors' masks often contribute to this character portrayal. An adult woman is likely to be indicated by an *ibibio* mask, a male elder by the ugly ɔkpesu umuruma form. Names of persons being portrayed are given out directly and reiterated by the leaders in song and explanatory speech. All the characters in the skits, as in the songs, are real persons at Afikpo. Afikpo do not create roles or characters out of their imaginations in this play, nor do they invent imaginary situations. The events that they depict are believed to have occurred, although they may be represented in exaggerated or distorted form. The creative art lies in presenting real situations in a humorous and satirical manner.

If a person hears that he may be sung or acted about, he may refuse to view the performance.

Fig. 42. An assistant leader standing in front of the chorus at the Amuro ɔkumkpa in 1952

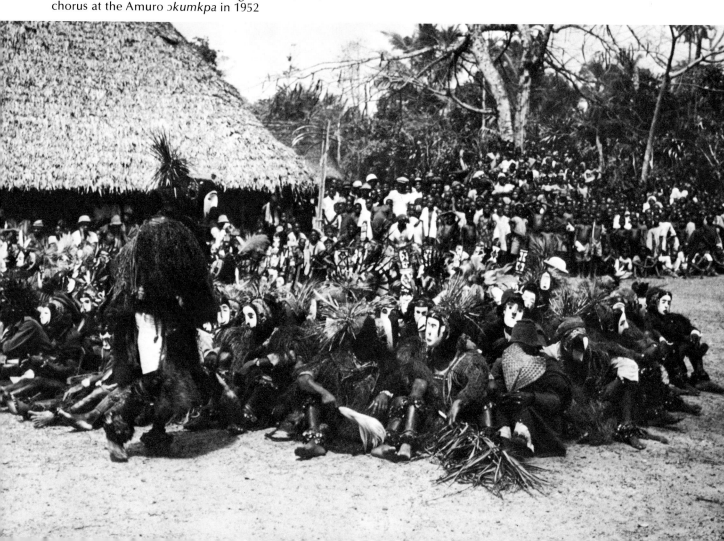

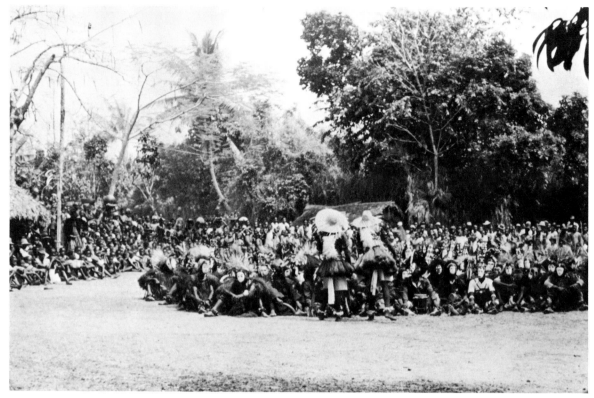

Fig. 43. The two leaders singing to the chorus at the
Amuro ɔkumkpa in 1952

Thus, secrecy at rehearsals is desired, if not always achieved. If he views the play, he is expected not to show anger, but to take it in good humor. Many eyes will watch his behavior at this point. He is expected to go out to the stage area and give the leaders and actors small "dashes" to show that there are no hard feelings—even if he feels otherwise. I suspect, in fact, that some persons, particularly some elders, enjoy being satirized publicly; it is, after all, a recognition that they are of some influence. I also believe that some persons suggest topics to the leaders for skits or songs concerning a rival in order to "put him down" publicly. The leaders are free to satirize friends and relatives and sometimes do so. Much of the skill in creating the skits and songs involves the manner in which persons and groups are ridiculed.

Sometimes, however, an individual represented in the play will become disgruntled and bear a grudge afterward. One prominent Afikpo leader, who was a good friend of an ɔkumkpa leader, refused to have anything to do with him after being ridiculed in a play. Sometimes a person made fun of may attempt to get a leader pushed off some farmland via friends and relatives, or hinder the person in some other manner. Acts of revenge must be carried out discreetly, for any negative reaction, even after the play, is considered bad form and indeed a

confirmation that the qualities depicted about the individual are really true.

In one case a man in Ukpa village built one of the first two-story houses in Afikpo. He said that he would keep it for himself, but in fact rented it out. The Ukpa ɔkumkpa play leader, a famous and much admired director, sang that the man had sold the second story to his mother. This is an insulting reference, of course, for who sells anything to his own mother! The man, angered, rose up at the play and shouted that this statement was false and that he was going to keep the five shillings he had been planning to "dash" the leader with. The man also reminded the leader that he still held some of his land on pledge and suggested that the leader should think of redeeming it—although he probably did not have enough money to do so.

In another ɔkumkpa a leader accused a man of not taking any of the numerous Afikpo titles even though he had the money. It is considered improper behavior to refuse to acquire them if you can afford to do so, for a man with money should be generous. He should give it out in redistributive ceremonies such as title-taking, through marrying more wives, and by putting his children through the *rites de passage* in grand style. The accused man in this case did not react at the play, but afterward he met the leader and pointed out to him that he himself had taken no titles. Friends of

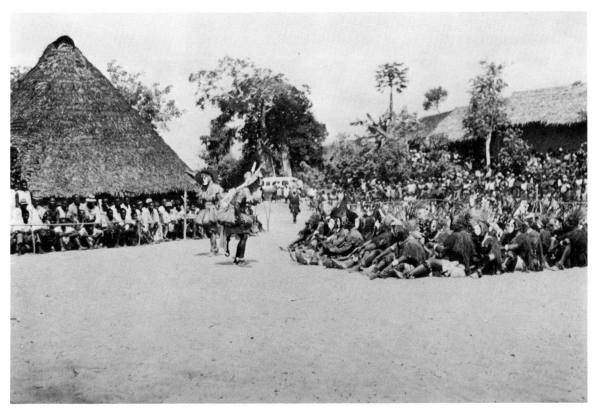

Fig. 44. ɔkumkpa play leaders singing to the chorus at Mgbom in 1960

the ridiculed man, as well as others, then used to sing whenever they met the leader: "Are you preparing to take ɛbia yet?" Ɛbia is the lowest Afikpo title.

Afikpo say that a good leader will avoid excesses of insult in the play. He treads a thin line here, for it is not always possible to predict how the satirized person will react. If the ɔkumkpa leaders win acclaim for their skills, they almost always make some enemies. Here the senior leader is most involved, for he is held chiefly responsible for the success or failure of the play, as he is the play's major creator and organizer.

Following are some materials from stage 4 of several plays, which will indicate their quality and the range of topics involved.

In the 1952 Amorie ɔkumkpa there was a skit concerning a dispute between the northern Afikpo villages of Ozizza and a compound in one of these communities, Ezi Ezuko, in Amorie village. The people of Ozizza decide to boycott this compound and will not even wrestle with them. The compound decides to appease the rest of Ozizza and asks the leaders what they should do. They are told that the matter will be settled if they deliver a cow, a goat, and a horse as recompense. This is a heavy fine, and at the last moment the compound refuses to pay it. Ozizza says that it will not "beg" the compound to make peace again. This skit was acted out with group discussion and

the imitation of wrestling, using as props a wooden cow, horse, and goat.

The two leaders immediately begin to sing to one another in a call-response pattern about a man, noted for his eavesdropping, who was responsible for the dispute. He goes about in the night and tells lies about the two groups, suggesting what each should do to the other. The leaders sing that he is a "spitting cobra," that he has now gone away from home to tell more stories, and that he should be punished.

The first skit of the 1960 Mgbom ɔkumkpa concerned a prominent Afikpo leader, Chief Isu, a member of the most important Afikpo elders' grade, the ɛkpɛ ukɛ ɛsa, who is often satirized in Afikpo plays. He converted to Islam at the first wave of Muslim influence in Afikpo (S. Ottenberg 1971a), although he did not come from the village involved. The skit explains how he became very poor and decided to give up his Muslim status. In the performance he consults a diviner as to how to improve his position. He tells the diviner that he has been a court messenger, a court clerk, a teacher, a chief, and now he is a member of the elders' grade. But despite these achievements he is always having to look for money. When the Muslims came to Afikpo he thought that he would be rich, but now he is poorer than before. He set fire to his land, to clear it for farming, before the date set by Afikpo custom and the Afikpo elders

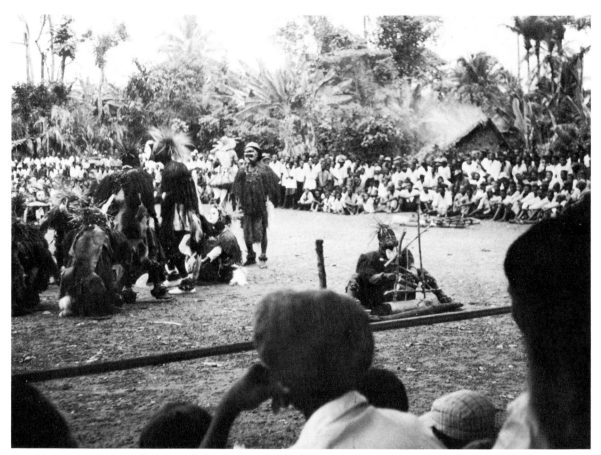

Fig. 45. Masquerader taking yams from yam racks during skit in Amuro *ɔkumkpa* of 1960

fined him £5. He is helpless now. If anybody has a dispute to settle, he wishes that he would come to him for help and with money to pay for that help; perhaps in this way he will become rich again. He tells the diviner that he wants results that day, not the next, or else he will pour petrol on the ritualist and set him afire.

In the skit the diviner is sitting on the ground, with the chief in front of him jumping around nervously. The man playing the chief is very good at imitating his postural stance. The diviner wears an orange *ibibio* mask, the chief a black ugly one. The diviner tells his client that anyplace he farms he will get good yields. But the chief says no, he wants money, nothing else. (This draws considerable laughter from the audience.) The diviner rattles around with his instruments again and he says that Chief Isu will get plenty of money if he plants rice (a new cash crop at Afikpo). The chief says no, he wants money now. (There is further laughter from the audience.) He wants to stand for election, feeling that all of Afikpo should give him a chance to be in the House of Representatives (of the Eastern Region). He needs the money to run for the election.

At this point somebody who has a dispute

interrupts the chief and asks him to represent him in the case. He says that he spent £150 on a girl, but somebody else married her and he wants his money back. The chief says that he can take on the case but he needs £10 for meat that he has just bought, and £20 to pursue the case. The man, who is very anxious, gives him £30. The suitor then gathers his own people and asks them, along with the chief, to get him back two-thirds of his courting fees (not an unreasonable request by Afikpo standards). The suitor and chief go and tell the mother of the girl that the former had spent £150 on her. She denies it, admitting that he worked hard for her but saying that he never spent a penny. In fact, she claims that he and a friend of his ate ten bags of groundnuts and owe her the cost of this food! The audience was greatly amused by this turn of events. The gathered elders discuss the matter while the chief sits alone. They decide that the woman should be given the cost of the groundnuts; but the chief insists that she must pay the former suitor money. The suitor faints when the decision is made to give nothing to him. The actors drag him back to the chorus and the skit is over.

The tale of the inept, money-hungry chief is

then sung by the chorus as the leaders go around the audience counterclockwise explaining it. They add that whatever persons do nowadays, there is always bribery involved. In earlier times there was no bribery and persons made fair judgments. This is what they should be doing now.

Another skit in this play explains that a number of "progressive" men from Mgbom and Amuro villages were sent abroad to collect money in order to build the primary school for these two communities. They went to the cities of Port Harcourt and Victoria and other places where persons from these villages were living and collected some £500, but before reaching home all but £200 of the money had "finished." Why? Because they took an airplane part of the way home. The skit goes on to explain that the school should still be built and if anyone in Mgbom tried to make a case over the money, the work would be stopped. Then the leaders go about explaining the skit in song.

The next skit in the same play began with some ɔri players dancing as if they were women imitating men dancing. This role interchange was skillfully done, particularly by one small man with an ugly mask who portrayed a woman imitating a

male doing the dance at the initiation of an eldest son into the secret society, the so-called *isiji* dance. There was a great deal of interest in him because he moved gracefully, and he received much acclaim and a lot of "dashes."

The ɔri actors and the leaders then sing that nowadays women are doing what men do; furthermore, they have drink and fine food and enjoy themselves while men do not. The leaders go around the audience singing the names of men whose voices women have "taken from them," including that of Chukwu Okoro, the carver. They meant that women were imitating good male singers—the names spoken were those of singers from the past. The ɔri dancers who have been imitating women dancing as men then go to the *ajaba* dressing house and bring out the *agbogho* or "queen" player, who will dance toward the end of the play. They place her in the center of the chorus, where she sits until her turn comes. Then the *akparakpa* dancers come out in two groups, one of small boys followed by one of older boys. One small boy dances with the older group, and members of the audience admire his good performance.

One last skit from this play concerns a

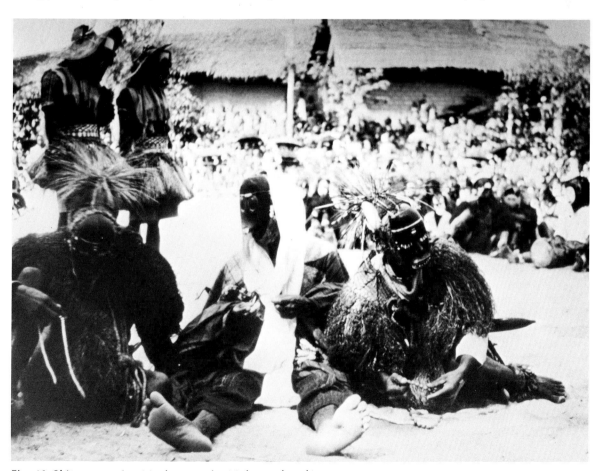

Fig. 46. Skit concerning Moslems at the Mgbom ɔkumkpa in 1960. The actors are wearing ɔkpesu umuruma masks. The two play leaders are in the background

prominent, middle-aged Mgbom man, a forceful and influential person. When the priest of the secret society dies, Okewa thinks that he should be selected as his successor. He gives away all of his firewood to his wives, since the priest is not allowed to use certain kinds of wood. His wives are surprised at their husband's generosity. But the man's older brother claims the post by right of seniority. Okewa replies that he is better qualified and that he farms a good deal. (In fact, he is a fine farmer and probably a more intelligent man than his older brother.) The two brothers take to quarreling and neither one gets the priesthood.

Carefully acted out were the scenes in which Okewa gives the firewood to the wives and the two siblings argue. The leaders then sang about the skit and, delighted with the performance, danced about a bit—an unusual occurrence in an ɔkumkpa. As the leaders passed in front of persons in the audience they vocalized about them, too. When the leaders came to Chukwu Okoro, they sang that he liked to sing at home—when he went home from an ɔkumkpa, he put on his own ɔkumkpa in his house. They would make him go through the initiation again! There was considerable laughter from the audience, and also from Chukwu, at this song.

The Amuro play in 1960 contained another skit about Chief Isu. He was fined £5 by the elders for becoming a Muslim. Since he now wishes to withdraw from the faith, he calls in the Afikpo seniors and objects to the fine. They insist that he pay the £5 and feed them in addition. His wife prepares the food, the elders eat it, and he pays the fine. His fellow elders divide the money amongst themselves at the gathering, as is the custom. The chief's wife begins to cry because they did not include her husband in the sharing, even though he is a member of the grade. She cannot understand why he got nothing. This skit ridicules the chief for becoming a Muslim for opportunistic reasons, and his wife for thinking that he should have a share of the fine because he is a member of the group that fined him! This was a well-acted skit, particularly on the part of the masked man representing the chief's wife.

Then the leaders went about explaining the skit to the audience in the usual manner. At this point an ɔri player started to come out and dance. The audience shouted at him to sit down, and the assistant leaders tried to get him to go back, but he just went on. Soon the musicians started to play, as the "explanation" was over, and other ɔri came out to dance. One of the two leaders went to the secret society priest's house for a brief moment, but no one knew why—perhaps to perform some brief rite. Players received "dashes" —one of the leaders was presented with a yam, which the giver took back to hold for him. One leader got a metal rod, a traditional form of money, which he gave to a friend to hold. A

famous, wealthy, and powerful Amuro diviner, looking colorful in a bright cloth, came out and "dashed" members of the chorus and the musicians with small sums of money.

Then the leaders sang a song in front of the chorus, naming those men in the village who had only one wife and those who had no house but had to go to the men's resthouse in the common to sleep. They were ridiculing the failure of these men to carry out their role as males.

There was also a short skit concerning an event in neighboring Mgbom village that involved Okewa, the man who thought he would be selected the secret society priest. At another time he had wanted to join a title society in his village. One member said that the fee was £200, but Okewa objected and the price finally was settled at £100. He did all the customary things, providing food and drink as well as the money. One title member, whose name was stated, drinks a good deal at the ceremony. He goes to the men's pit latrine and falls in. This action draws considerable laughter from the audience. He struggles and yells and the title members come and pull him out of the deep trench by his hands and feet, then clean themselves off disgustedly. There is much excitement among the viewers. The leaders have been explaining the skit to the audience as it was being acted out, but clearly not much needed to be said, as it was so well performed. The leaders continued to sing about the event after the acting was finished, and then the chorus took up the song while the leaders went about restating the plot in their chant style. Finally the ɔri players came out, the drums started, and the individual dancing began.

By the end of stage 4 some of the players are beginning to show fatigue. They have been out in the hot sun for some three hours or more, sitting in the middle of the common, an area not usually shaded by trees. The players are forbidden to remove or lift up their masks to obtain fresh air. They may leave to urinate, but they cannot defecate while masked, as this would insult the secret society spirit. If they become ill, they may remove themselves or be taken to the dressing house or the men's resthouse until the play is over. It must be particularly difficult for the musicians, who remain seated throughout the play, as they do not dance, act, or come forward to beg or to receive "dashes," which are brought to them instead. It is the ɔri players, who come out to act, to dance about as individuals, who have the greatest freedom among the chorus.

Stage 5

The fifth stage, called ɔkɔkɔ ɔdawa (break-one who falls) or odidi ale (fall-ground), consists of one act and one accompanying song about someone who is ill or is knocked down and later

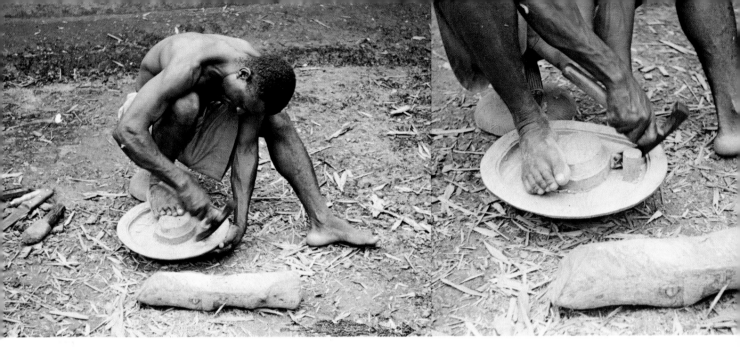

PLATE IX

Chukwu Okoro carving an *ocici* bowl, 1952

Oko Chukwu, older brother of Chukwu Okoro, sitting
in front of his residence working on a hoe handle

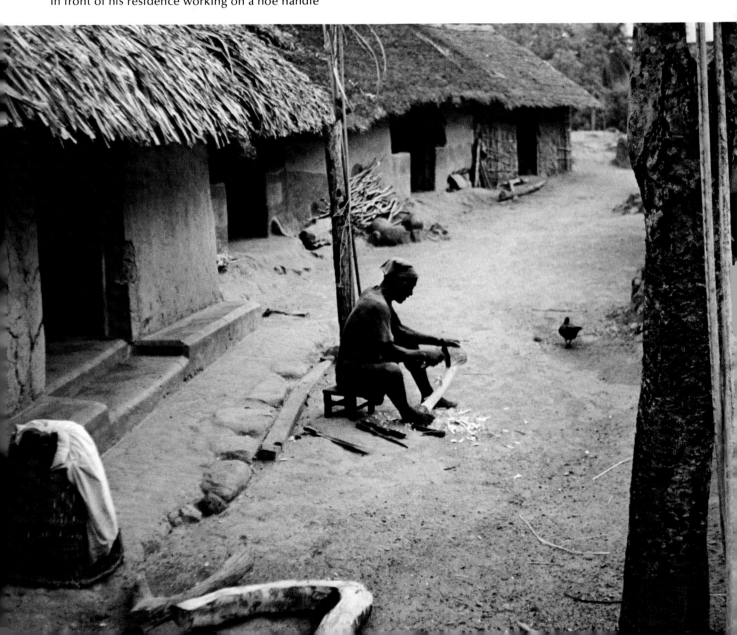

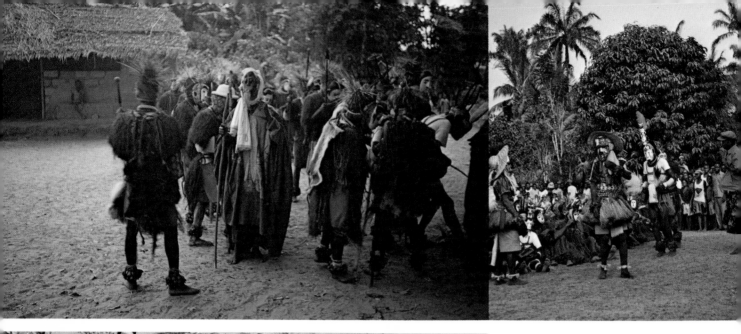

PLATE X

(Above left) Ɔkumkpa players milling around as they first appear in the Mgbom village common in 1960. The player at the center with the ugly mask and the stick is dressed as a Moslem

(Above right) Skit of the girl who refuses to marry in the 1952 Amuro ɔkumkpa play. The player is wearing the ɔpa nwa mask. His "mother" is just in back of him, the two play leaders are to his right. The father of the man playing the girl is approaching him from his left to give him a "dash"

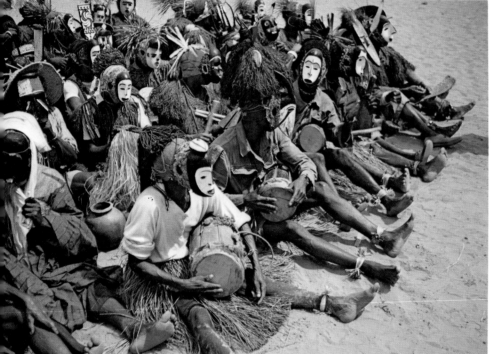

(Left) Musicians at the Mgbom ɔkumkpa in 1960. The water pot was used in one of the skits

Ɔkumkpa musicians and chorus, Mgbom village, 1960. A painted ibibio form is at left front. At the center is a fine ugly mask, and in back of it, to its left, is an old leader's mask being worn by an assistant leader

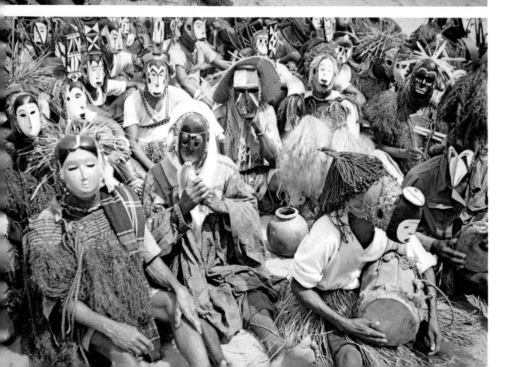

recovers. There is usually some person or persons who treat the unfortunate individual, who is often a young boy wearing the *akparakpa* costume. After he gets well, he dances about a bit. The story involved is frequently humorous, sometimes with a moral. It was not particularly funny in the 1960 Mgbom play. Here a small boy, wearing the *acali* mask and dressed as an *akparakpa*, is pushed down by another. He becomes ill and nearly dies, but a diviner cures him, waving his arms about while the boy kneels on the ground. The boy then rises up and dances, as does the diviner, who is in the ɔri costume. The entrance of the ɔri dancers signaled the end of the skit.

Stage 6

In some ɔkumkpa plays stage 5 is followed by a part that has no regular name but repeats one or more of the most popular songs from stage 3 or stage 4. Sometimes the audience shouts out what songs they would like to hear. In other plays songs from stage 3 have already been repeated in stage 4. They may or may not be repeated here.

Stage 7

Called ɔpopa nja (carry-soup pot), this portion of the play is often created by the ɔri players. An ɔri comes out, gives his name, and in speech or song explains why he is the most foolish man of all. Usually his statement is not accepted by the other ɔri, and one or two others come out after him and go through the same procedure. The last to do so is accepted and he gets the prize for being the most foolish person. He takes the soup pot, which is on the ground in front of the players, and dances about with it. The explanations of foolishness usually have to do with some domestic matter. Sometimes the leaders and chorus conclude this stage by presenting a song about yet another foolish man.

At the Mgbom play in 1960 the first ɔri player to come out sang that he was the most foolish of all. He is Obeni of Mgbom village and is having trouble with his wives: some of his wives wanted him to chase away another wife. He refused but left home in order to escape the "palaver."

This talk of a man foolish enough to let grumbling wives drive him out of his home was not accepted by the ɔri, so another man came out. He says that he is a hard worker and that he has collected many yams from his farm. He was placing the yams in the yam racks when he became weak from hunger. He went home to get a calabash of water for wetting the ropes to tighten them around the yams, but at home he fainted from lack of food. His wife cooked him a nice meal and he recovered. After a short interval of music, he continued his story. Following the meal he had a fight with his wife because she refused to

go to the barn to assist him. For this quarrel the village elders fined him £5. The next day he carried many yams to the market from his yam racks to sell in order to pay his fine. He again fainted from hunger, but nobody knew what was wrong with him until his wife arrived. She bought *gari* (ground-up cassava) in the market, added water to it, and fed him. He was so hungry that he ate with both hands at the same time. This story of a man so preoccupied with his yams was accepted by the ɔri as being more foolish than the first tale. The man took the soup pot and danced around to the music. In telling this tale the man used some pantomime, but mainly he was chanting rather than truly acting or singing.

The two leaders followed with a song concerning a foolish father who was trying to initiate a son into the secret society but lacked funds to complete it. The son asked his age set to help him finish and they did. The son sang to his father that if he had not been able to complete his rites, he would have hung himself or gone away to Akpara (a non-Igbo group southeast of Afikpo, on the other side of the Cross River). The story reminded everyone how important it is for a father to take responsibility for the important events in his children's lives. This was followed by music and the dancing of the ɔri before beginning the next stage.

Stage 8

Stage 8 signifies that the play is coming to a close and it is looked forward to with keen interest by the audience. Called *otite okomɛ* (dance-native harp),* it begins with the drummer's playing the music of a woman's dance. The young man dressed up as the "queen," with the *akparakpa* costume and the ɔpa nwa mask, comes out and starts to dance about as a girl. He is sometimes accompanied by an ɔri dancer playing the mother of the "girl," who follows her and brushes her off with a handkerchief as she dances about. The leaders and chorus sing a short song, using a real village girl's name, indicating that many persons ask to marry her but that she refuses. An ɔri comes out representing a man who wishes to marry her, but the mother rejects him; another man comes up and she finally agrees. This ends the action.

The skit portrays a beautiful village girl who refuses one man after another as a husband. It is always an honor for a female to be so portrayed. It is also an honor to be chosen by the leader to play this role. The person selected should be a skilled dancer who can imitate women. If he does well, he receives many presents and is long remembered. In two of the three performances that I saw, the "queen" danced poorly, and persons rushed out to stop him, thus signaling the

* This harp is not present at Afikpo today.

end of the play, except for a short last stage. The role of "queen" is much coveted, and some Afikpo claim that persons bribe the leaders in order to play it. In any case, it does not always fall to a good dancer.

Stage 9

At this point the audience is already starting to move away, especially if the "queen" has danced poorly. The senior leader comes out in front of the elders and talks to them, then the junior leader does the same. One mentions something bad that is happening in the village concerning men, the other concerning women. Sometimes these are totally or partially sung.

In the 1960 Mgbom ɔkumkpa, the senior leader sang that a small boy held something edible very tightly in his hand to prevent the hawk from coming and taking it away. A hawk has taken something from the old people because they like to carry everything home; they are too greedy to share with anyone as they should. The implication is that the elders should not act like a small boy, who has every reason for holding something tightly in his hand. This song verbalized a common complaint against the Afikpo elders, that they "chop" (eat) all the village food and wealth in rituals, feasts, and palaver and do not share these with others.

The second leader then sings that the women's pots are not well fired these days, so that they crack and break. Women are defying custom and indulging their pride by wearing cloths and shoes when they fire their pots. Also, when they are ready to eat, they should rub their hands in the ground to cleanse them, according to tradition, and not use soap. Women formerly were forbidden to wear cloths and footwear while firing their pots, but they commonly do today. Afikpo men frequently criticize this practice in songs performed at other times, as well as here in the ɔkumkpa. Afikpo pots are famous, being sold down the Cross River as far as Calabar and bringing substantial income to the women who make them. The men's criticism may reflect jealousy as well as concern with a change in custom.

Sometimes, as this stage comes to a close, the drums beat out the first song of stage 1. In any case, the players retire to the dressing sites to refresh themselves with water, some receiving more "dashes" as they move toward these places. The play is over.

Postplay activity

If two villages are paired or closely linked together (S. Ottenberg 1971b, pp. 199–200), the play is repeated in the neighboring village shortly after it is finished at home—as, for example, in the case of Amuro and Mgbom. The players remain in their dressing area for only a short while before going to the second community and recommencing. They do not add any new skits or other materials; in fact, as a result of fatigue and the arrival of nighttime the play is often shortened by the leaders. Plays usually contain material about persons in neighboring villages so that there will be interest in it the second time that it is given. And persons who missed the first performance can catch the second one. After the Amorie play in 1952 the players did not present it again anywhere but walked, masked and in costume, through the other northern Afikpo villages (Ozizza subgroup), gathering up "dashes" as they passed by. The play is never given more than twice, as far as I know.

The dancers end up at their village and undress in the place where they dressed, according to the custom of the village. If they are in the ajaba, the players spit on the ground or on the abɔsi tree as they touch it with their left hands before leaving in order to remove the mma spirit from them. Villages that have this ajaba also have a priest's house with a like tree in front of it. These two trees symbolically connect the ajaba and priest's house, and in this way the spitting ritual is linked to the secret society and its spirit. The players then go to the common, where they return the masks and the sacred parts of their costumes to the men's resthouse for storage.

In some villages the players perform certain acts before taking off their costumes. In Mgbom they run through the secret society shrine house and then go to every compound entrance in the main part of the village. They can give no explanation of this ritual other than they learned to do it when they acquired the secret society in ancient times. However, the act seems to symbolize the players' unity with the whole village and their return to it. Other villages have other procedures. The players must spend the night eating and sleeping in the village commons, out in the open or in the men's resthouses. Food and water are brought to them by men from the compounds. The commons are closed to women and uninitiated boys after the play. The players wash there and they often stay up late talking about the performance. They can leave the next morning, but only after they have seen a woman walking through the common.

The procedure of remaining in the common at night is also followed after the short one-day form of secret society initiation and some other rites of the secret society. The persons involved are believed to be too closely associated with the spiritual world to return immediately to the compounds. Since on these occasions the commons are closed to females and uninitiated boys, the separation of the secret society members from others and the distinctiveness of the sexes are reinforced. The first woman seen in the

morning reunites all symbolically.

The leaders each receive anywhere from a few pounds up to considerable sums of money in "dashes" during and after the play. They really do not, however, receive a great deal of money, considering the extent of their efforts, the energy and time that they have put into the play. Yet the gifts are warmly received, symbolizing friendship, kinship, love, and other ties, as well as admiration on the part of some of the viewers. It is clear that the leaders enjoy being praised and noted. A day or two after the play the senior one, or sometimes both leaders together, feasts the players, those who helped to dress them, and those who gave advice during rehearsals, to thank them for their participation. It is a jolly event in which aspects of the play are recounted and contrasted with other ɔkumkpa held at Afikpo.

If the leaders wish, they soon begin creating new songs and skits, thinking of a play for the following year. It seems rare, however, for a village to hold two in consecutive years. The leaders do not themselves usually sing their old songs again after a play (although a senior leader did so in going over a play for me). If they sang them, it would be viewed as boasting or attempting to put on the same play again. It is also said that if they continue to sing the old songs they will not have time to make up new ones. Other men, however, commonly sing the old ɔkumkpa songs.

DECLINE IN ɔKUMKPA AND THE ENNA PLAYS

It is my impression that the ɔkumkpa used to be given more frequently earlier in this century than it was in the 1950s and early 1960s, and that since there are more young persons away from Afikpo now, it is more difficult to organize the event. Yet when it is presented, it is popular and well attended. It is certainly clear that twenty or thirty years ago the societies of uninitiated boys, the enna, used to put on many of these plays, sometimes by wards, sometimes by compounds, and sometimes at the village level. Some of them are said to have been better than the adult plays of today. The enna rarely perform the ɔkumkpa today because their societies are not well organized as a result of time spent in school and because youths are initiated into the adult society at an earlier age.

I saw only one enna ɔkumkpa at Afikpo—in January 1960 at Mgbom—although others were held while I was carrying out research there. It was performed by the uninitiated boys of Ezi Ukie, a good-sized compound in the village, and it involved ten players. Two boys played skin drums, and there were two leaders wearing large straw hats and very good imitations of the leaders' masks. A "queen" with plastic waist beads and a boy dressed as an akparakpa did their characteristic dances. As in the adult plays, the boys acted out events and sang. The leaders told about a boy who was given a "dash" and refused to share it with other boys. The "queen" danced in proper female style, rolling his hips well. The leaders asked for "dashes" now and then from the adult females, girls, and small boys (as well as the anthropologist) who comprised the audience. There was much laughter from the small audience at the players' actions. After the performance the boys returned to their own ajaba house in back of the compound. Such children's play is not common today, but it must be remembered that most of the present-day adult players were involved with enna productions when they were young and they undoubtedly influence the manner in which they perform today.

An Ɔkumkpa Performance

The ɔkumkpa that I will describe in detail was presented on the ɛkɛ Sunday afternoon of 13 January 1952 in the main common of Amuro village and repeated in the evening in nearby Mgbom. Amuro had not performed the play for some three years, although Mgbom had produced one the previous year.

First, however, a note on the data presented here. I watched the full play, taking some movies and a few slide photographs. The next day I briefly discussed the play with its senior leader in the main resthouse of Amuro in the presence of the village secret society priest and other men, including Nnachi Enwo, my field guide. Between 13 May and 22 July I held six long sessions at my house with the senior leader and my guide. The leader went through all of the songs, singing them for me while I took them down in Igbo. He then did much of the translating and explanation of the text, with the help of Nnachi Enwo. The Igbo text was carefully checked through. At the time, I indicated the tones in my notes, but I am not satisfied with them and I have not used them here. There are probably errors in the Igbo, for I claim no linguistic skills. However, I believe that the song texts are adequate.

Amuro is one of the larger Afikpo settlements, with a population of over one thousand in 1952. The village is a member of the Itim subgroup of Afikpo, deriving its secret society form from nearby Edda Village-Group. Thus it has the ajaba dressing houses for each of its wards and a central secret society shrine house with a priest. Being some distance from the Cross River, it is composed mainly of farmers rather than fishermen. Its location near the main Afikpo market attracts more strangers to its plays than do some other villages, since the ɔkumkpa is usually held on a market day. As already noted, Amuro and Mgbom are closely paired neighboring settlements; the play is really for and about both villages.

The play leader, Ɔto Ɛzɛ, indicated to some fellow villagers that he would like to try putting on the ɔkumkpa, since there had not been one in the village for some years. The elders agreed to let him proceed, promising to cover whatever small costs he might incur in producing it. He is middle-aged, speaks English fairly well, and is both a photographer and a farmer. He has a small shop in the Number 2 settlement at Afikpo, the little shopping center between Ukpa village and the Government Station. Known as a good singer, he has taken part in other rituals where singing occurs. Men greet him, as they do some other play leaders, by calling him "ikwughuhughu abalisi" or "owl of the night." He responds with "ɔno anaghada ji" (mouth-cannot be-quiet), meaning that "the mouth of an owl cannot be quiet." It is interesting that the owl at Afikpo is often associated with evil. The bird is considered a bad spirit in folklore and in belief, and if a person hears it at night he sometimes believes that it is haunting him, especially if he is ill or having other problems. While the play leaders are not really seen as evil persons, they are, in a sense, diabolical like the owl.

Ɔto Ɛzɛ claims that while his voice is not the best, the gods have given him its quality and the ability to memorize long parts. "It is not something one can learn at school," he indicates. He does not believe that there is much prestige attached to being a leader, except for the praise he receives for his work in the play and the honor given him at future plays, when he and other former leaders are named in song. Persons who have led the play do not have a special seat at a new ɔkumkpa, nor do they find it any easier to contract a marriage, take titles, or join other societies.

Although an expert singer and a player of drums, Ɔto had never led the ɔkumkpa before. His junior leader had been the senior leader in two uninitiated children's ɔkumkpa plays, in which Ɔto had played a drum.

Ɔto suggested the idea of doing a play to another village man and together they worked for about nine months on the songs and skits, sometimes with the help of friends. About two weeks before the play was to be given, when rehearsals were ready to begin, they had a falling out for some unknown reason. Each leader decided to present the play, gathering together his own actors and working out the play's details. Each chose a junior leader. Ɔto selected a member of his own age set who was a patrilineal relative, having the same grandfather but a different father, and living in the same compound. The two took palm wine, yam fufu, and rice to a group of Mgbom musicians, whom they felt were better than Amuro's, and asked them to take part for a group fee of 5s. This was not much of a

remuneration, but the musicians agreed, knowing that they would receive much more in "dashes" at the play. Likewise, the actors selected to take part settled for the small sum of 2s., which they divided amongst themselves.

The dispute between the two groups of players simmered for some days. The age set of each senior leader in the village sided with their man and tried to influence the elders to agree that their group was the best one to present the play. Four days before the date set for the ɔkumkpa by the elders, these senior men said that they would view the performances of both groups at night in the bush two days later and select the best one. Each group rehearsed extensively, using the same musicians. The elders selected Ɔto's group. The village leaders had previously ruled that all those of certain age sets in Amuro, the more junior ones, should take part or else pay a fine of 10s. There were no fines. The ages included men about forty years old and younger. Some older ɔri dancers and actors also took part, but voluntarily. The dispute was not mentioned in the play, for it was important to present a face of unity during the performances.

STAGE 1

In the oga lozo stage the Amuro players dress in the ajaba and pass quickly through the priest's shrine house, where they are blessed. (In Mgbom they go to the shrine in the evening after the performance.) Then the men move through the village commons, from south to north and back again, with the musicians playing enthusiastically. It is only after they have moved once through the village that females are allowed to enter and take their seats, although many men are already seated.*

The players continue to move about the main common for a while as a group. The leaders, wearing the sacred, ancient leaders' masks, are in front, followed by the musicians, who are given plenty of room so that they can play freely. The chorus comes last, kept close together by the two assistant leaders. The members of this group are not sorted out by ɔri or akparakpa as they will be later when they are seated on the ground.

While moving about, the players sing to a characteristic type of drumming that is always used at this stage in the Mgbom and Amuro plays. But the words differ for each play.

Two Leaders
1. Ɔkpanɛ dare mba na ozo Ɔgbo
 Ɔkpanɛ fell faint in road Ɔgbo

* An exception was made for my former wife and her female field guide, who were permitted to enter just before the dancers began to move through the commons and were allowed to sit in the men's section.

2. unu cita ɛga nayɛ jɛjɛ Ɔgbo
 you take hammock we will-go Ɔgbo

Chorus
3. ojɛri Ɔgbo darɔ mba bɔ di Ugo Mba
 went Ɔgbo fell faint is husband Ugo Mba
4. Ɔkpanɛ Eko ɛriyɛ bɔ ahɔhɔ
 Ɔkpanɛ Eko eat is suffer
5. Ɛgwɔ Igbo Okochi Uyɔ nde asɔghɔ egwu duyɛr(yɛ) Ɔgbo
 Ɛgwɔ Igbo, Okochi Uyɔ people are-not ashamed sent-him Ɔgbo

Explanation
1. Ɔkpanɛ fell faint on the road to Ɔgbo (a village in nearby Edda Village-Group).
2. The people of his compound should take the hammock and go to the man.
3. He who went to Ɔgbo and fainted is the husband of Ugo Mba.
4. Ɔkpanɛ Eko suffered much. (The expression ɛriyɛ bɔ ahɔhɔ commonly indicates suffering; it does not mean "to eat.")
5. Ɛgwɔ Igbo and Okochi Uyɔ were not ashamed to send him to Ɔgbo.

The background is that a person, curiously unnamed in this tale, was taking a title and, assisted by Ɛgwɔ Igbo and Okochi Uyɔ, asked a fourth title member, Ɔkpanɛ Eko, to get the palm wine at Ɔgbo, famous for its fine wines. It is foolish for a man taking a title to ask a title member to get the wine; he should get a younger man or men instead. It is also ridiculous that Ɔkpanɛ should have agreed to go, and his fainting is an extra disgrace, calling the matter to public attention.

These first five lines establish the theme of the play: foolish behavior. But the song continues. While the chorus is singing lines 3-5, the two leaders sing one line, from any of those below:

6a. ale ogo dim uvu na onwughu oku
 ground secret-society is honorable is can't-catch fire

Anything connected with the secret society (ogo also means village) is honorable, but one cannot easily see the good in it. Take the Amuro secret society shrine house, for instance. It looks like an ordinary place, yet inside of it there are a lot of things. One should see fire in it to tell you that it is an honorable place. The reference is apparently to the sacred fire associated with the secret society shrine house.

6b. okara ge gɛbɛ nti ma izɔro olu
 women [secret society term]-you listen ear so-that hear voice
 Women should keep quiet so that they may hear the voices of the song.
6c. okɛ nnɔnɔ ghi ɔzara wa nɛzi

big bird from bush return village
We are the big birds who have been in
the bush, practicing the play, and now we
have returned to the village.

6d. *Alɛ Oga cɛri ugbo na orighi nka omumɛ*
Alɛ Oga watched shrine did not long-life
Omumɛ
Alɛ Oga, former priest of the Amuro
secret society, did not live long. *Egbele* (here
called *omumɛ*), the spirit of the secret society,
was responsible for his death. He must have
offended it. The singers are addressing the
present priest, reminding him that there was a
former priest who did not do what he should
have and thus did not live long.

6e. *igbo-nde-anoma-ugwu ɛjunu ogo*
Afikpo-people-of-certain-race fill-up
village
Afikpo people have today come and
filled up the village to see the play. The first
four words are an expression for the Afikpɔ,
who otherwise call themselves ɛhugbɔ.

The whole song is then repeated from line 1 a
number of times. The sixth line is variable.
Sometimes both leaders sing the same sixth line
together, sometimes one sings alone to the
audience, sometimes each sings a separate line to
different sections of the viewers. While most of
these sixth lines are already made up, a leader may
improvise one, perhaps to praise a person he sees
in the audience.

STAGE 2

In the *obubu ɛgwu* stage the chorus stands in
the center of the common with the musicians,
facing the elders to the south. The *akparakpa*
come out and dance three times counterclockwise
to music. There are enough of them so that no ɔri
dancers are needed to fill up the line. While they
are moving about, the two leaders together face
the chorus, standing in front of the musicians, and
sing a single line to which the chorus responds
with another line.

Two Leaders
1. *Okɛwa nwa Idumɛ Ɔgo biyano na ɛbo nzi mɛmɛ*
 igbo ɛkɛrɛfurum enya
 Okɛwa son Idumɛ Ɔgo come you are head title
 Afikpo open eye

Chorus
2. *iwɛɛye woo haa haa igbo ɛkɛrɛfurum enya*
 iwɛɛye woo haa haa* Afikpo open eye
 The two leaders call on Okɛwa, a middle-aged

* Certain Igbo terms are repeated in the translation
like here, and elsewhere, because they cannot be
translated into English. For a comment on these
sounds, see "Aesthetic Considerations" in Chapter 8.

prominent man of Ezi Akputa, Mgbom, to come
out because he was a former senior play leader.
He should see what is happening today, that
which the Afikpo will watch.

Both lines are repeated some fourteen times,
on each occasion with the name of another former
senior leader. They are mainly from Amuro and
Mgbom, but one person is from Ukpa and another
from Ngodo, both nearby villages. The individual
called does not actually come out, although he
may give a "dash" at the end of the song. There is
no special order in which the names are given, nor
do the leaders feel bound to call all living former
leaders. That only senior leaders are named
indicates their primary role in this play.

Then everybody sits down. The two leaders go
about in front of the audience repeating all of
these lines using the same names, the senior
leader taking the first line and the junior one the
response. No music is played during the entire
song, except for the rattles (*ahia*). This is called a
"quieting song," as it acts to settle the audience
for the events to come.

By this time there are about five hundred
persons in the audience, plus some one hundred
players. The arrangement is shown on Map VI. The
only unusual feature is the tendency for educated
persons to sit together to the left of the elders. I
have not seen this at other ɔkumkpa plays.

STAGE 3

This stage, called ɛgwu akɔ ye, consists of four
songs, sung by the leaders and chorus without
musical accompaniment. The songs of this section
are often eight lines long, as they are here,
although the last line of the fourth song is very
long and sung rapidly, without pauses.

In the first three songs the senior leader takes
lines 1 and 5, the second leader lines 3 and 7, and
the chorus lines 2, 4, 6, and 8. This pattern is
typical for this stage in plays at Amuro and
Mgbom, but the leaders are free to depart from
this form if they wish.

First Song

Senior Leader
1. *Nnale nwa Ɛgwo Akpo biyanɔ tiye ɘlu*
 Nnale son Ɛgwo Akpo come put voice

Chorus
2. *ɔbɘ mumu onogho doye oka*
 he-is dumb he-cannot talk word

Junior Leader
3. *onye biyanɔ tiye ɘlu ayɵɵɵɵɵɵɵɵɵɵ Ɛgwo nwa*
 Igboke biyanɔ tiye ɘlu
 person come put voice ayɵɵɵɵɵɵɵɵɵɵ Ɛgwo son
 Igboke come put voice

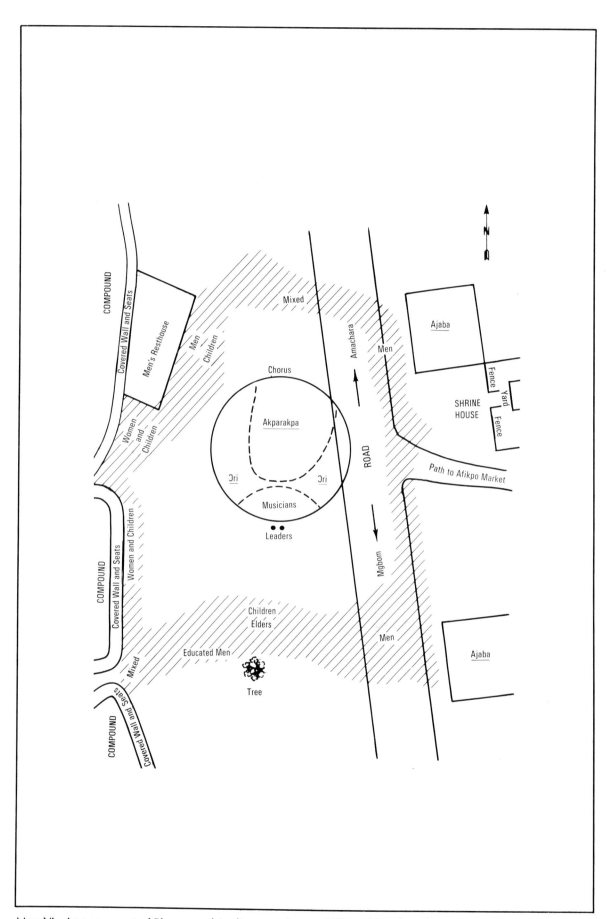

Map VI. Arrangement of Players and Audience at Amuro Village Ɔkumkpa, 1952

Chorus
4. ɔbɘ mumu onogho doye oka
 he-is dumb he-cannot talk word

Senior Leader
5. Repeat of line 1, with the substitution of
 another name

Chorus
6. ɔbɘ mumu onogho doye oka
 he-is dumb he-cannot talk word

Junior Leader
7. Repeat of line 1, with yet another name

Chorus
8. ɔbɘ mumu onogho doye oka
 he-is dumb he-cannot talk word

Explanation. They call Nnale, from Amuro, to
come and speak, but he is "dumb"—shy and
slow of speech—and does not respond. They
likewise call other persons for the same
reason. The singers are ridiculing individuals
for not speaking up in public. When there is a
quarrel, these persons are not able to express
themselves, even though they have no
physical defects.

Second Song

Senior Leader
1. *Okoci nwa Ci Oyɔ biyanɔ tiye ɘlu ɔnwa
 ririmeeeeeeeee*
 Okoci son Ci Oyɔ come put voice this eat-up
 [drawn out]

Chorus
2. *ande nde ande aghame*
 they-are they-are they-are enemy [literally,
 war-my]

Junior Leader
3. Line 1, with the name of another man

Chorus
4. *ande nde ande aghame*
 they-are they-are they-are enemy

Senior Leader
5. Line 1, with the name of yet another man

Chorus
6. *ande nde ande aghame*
 they-are they-are they-are enemy

Junior Leader
7. Line 1, with the name of a fourth man

Chorus
8. *ande nde ande aghame*
 they-are they-are they-are enemy

Explanation. The term *ririm* in the first line
means that someone has "eaten me up" or
"consumed me." It refers to the covering up
of bush land with water. The first line and its
repeats call the names of four men to come
and have a say, as a certain matter has "eaten
up" the people of Amuro. The reference is to
an event that is well known in the village,
although not directly stated in the song. A
certain man had a banana tree, and a second
man wished to make a fence near it. The tree
owner told him not to do it, but the second
individual did not take heed and put up the
fence. When the tree owner saw this, he in
turn called on the four men in the song; but
they would not come to help him because
they did not think the fencemaker would
heed them. In the second line and its repeats
the second word, *nde*, is shortened for
euphonic purposes. This word is sung in a low
tone, the first and third ones are high. The
leader believes that this makes the line sound
smoother than three like words in a row. The
meaning of this second line is not fully clear
to me, but seems to refer to the state of
tension that the dispute has caused. The song
criticizes the weakness of the banana tree
owner for calling in four persons after the
fence was built instead of first trying to settle
the dispute directly. Note that as in the earlier
song concerning titles (stage 1) the name of
the principal person is not given; but it is
generally known in the village.

Third Song

Senior Leader
1. *Nwa Odoma bɘ ebiri ebiri gɛre keni
 mɛ onwoghu ka bɘ imaghɘ ihie ologho
 awaooooooo eyewoooooooooo*
 Nwa Odoma is Ebiri Ebiri look-at how do
 yourself like is don't-know something
 god-of-secret-society came [drawn out] yes
 [drawn out]

Chorus
2. *hɘɘɘ hɘɘwa hiyɘ wɘ hɘɘɘ ha hɘɘɘ ihɘɘɘya
 Nwa Odoma ri gburu Mgbom sɛ nawɘ bɘ oke
 ɛka ya wɘ iye
 hɘɘɘ hɘɘwa hiyɘ wɘ hɘɘɘ ha hɘɘɘ ihɘɘɘya* [no
 specific meaning]
 Nwa Odoma eat killed [death] Mgbom say
 are-they is big hand he they follow

Junior Leader
3. Line 1, with another name, that of Chief Isu
 Egwole of Ngodo, frequently referred to in
 these plays

Chorus
4. Line 2, with Chief Isu's name

Senior Leader
5. Line 1, with another name, Agbo of Ukpa
 village

Chorus
6. Line 2, with Agbo's name

Junior Leader
7. Line 1, with the name of Okoronkwɐ, the Native
 Authority Court member from Ukpa

Chorus
8. Line 2, with Okoronkwɐ's name

Explanation. The first line and its repeats tell Nwa
Odoma and others of the Ebiri people to note
how they are pretending not to know something.
But the god of the secret society is working on
Nwa Odoma. All the lines refer indirectly to a
well-known dispute between Mgbom and
Ugwuego villages, in which Nwa Odoma of
Amuro sided with Mgbom. He claimed that his
decision was based on Mgbom's large size, but
the song implies that he was bribed with food
and money. They then refer to other leaders who
acted in the same manner.

The Ebiri are an ancient and possibly non-
Igbo people at Afikpo, believed to have played
a role in the founding of Amuro. The song
portrays leaders who like to make palaver. They
support a side in a dispute for personal gain,
although always claiming that it is for other
reasons.

Fourth Song

This song is about Otɔdi, a native of Amacha
village, who at the time of the play is performing
the important Afikpo title, *uhie ci*. He has an older
brother, Mbɐtɔ, of the same father but a different
mother, who lives in Amuro. Mbɐtɔ left home at a
very early age and did not return, so that people
thought he was dead. When he finally did return,
his father had died and he was a wretched man,
just like a prodigal son. He started to sell and to
pledge away his father's property. The younger
brother was very upset about this and went about
crying, "Why is my brother behaving like this?"
The junior brother sings the first two lines through
the medium of the singers.

Senior Leader
1. *ele owurum eyeeeeeeeeeeeeeeeee*
 ah! sorry my yes [drawn out]

Chorus
2. *ehaaaaaaaaaaaaaaaaaaa*
 aha! (or yes!)

Junior Leader
3. *Otɔdi nwa Egwo Ɛke bɐ Ebiri nɔ za*
 Otɔdi son Egwo Ɛke is Ebiri he answer

Chorus
4. *ehaaaaaaaaaaaaaaaaaaaa*
 yes!

Senior Leader
5. *Ɔmeri Mbe nɔ bɐ di Osue Ekɛ*
 Ɔmeri Mbe he is husband Osue Ekɛ

Chorus
6. *Mbe di Osue Ekɛ nɔ bɐ Ebiri nɔ za*
 ehaaaaaaaaaaaaaaa
 Mbe husband Osue Ekɛ he is Ebiri he answers
 yes

Two Leaders
7. *enyi egoghu akwa be dubughe ogo Ebiri*
 elephant cross-does-not bridge come lead-over
 village Ebiri

Two Leaders and Chorus
8. *ojeri ibɔzo ejighi afu ɔ-wa-tajɛ ginɛ na Ebiri ase*
 nimaghe na Ebiri anagha amɔ nwa ingerɛ, Otɔdi
 nɔ na ekwa, ekpe nna kpatare deberi ayi, oke
 Mbɐtɔ apare yɛ rie, ha mo na nnayi zare oribe
 ogbom biarɛ omume ingerɛ, igbo unu
 kwajigheje itim gwɐ unu narabɐzum enya onye
 rɛri ale cɔrɛ ɔnwɐ
 one-who-went another-place has-not half-penny
 he-come-go [he is coming] what? in Ebiri
 it-is-said you-don't-know in Ebiri cannot deliver
 child(ren) foolish, Otɔdi is in cry, wealth father
 got put us, big Mbɐtɔ took it sell, leave me that
 father-our answered one-who-"eats"-Afikpo-
 people [an important man] my-namesake
 came perform foolishness, Afikpo you play-as-
 you-like Itim-people you [used to call
 attention to someone] you wink eye one-who
 sell ground want death

Explanation. In lines 1–4 Otɔdi, who is the son
of Egwo Ɛke and is of Ebiri background, is called.
He answers, "Yes." In lines 5–6 Ɔmeri Mbe, an
agnatic relative of the title-taker, Otɔdi, is one of
those criticizing the senior brother, asking along
with Otɔdi, why he is trying to sell his father's
property. Line 7 says that the senior brother,
when he was leaving Amuro, was as fat as an
elephant and was too big to cross the bridge.
When he finally returns he has been away so long
he does not know his way and calls for people to
come and lead him to his village of Amuro. The
man referred to actually was a big, heavy person
on his return.

The long last line says that the one who went
away returns without a halfpenny. What is he
going to Ebiri (Amuro) for? It is said that he does
not know that the Ebiri do not deliver foolish

children (a man who returns poor is a foolish man). The younger brother is crying (because of the foolishness of his older brother). He cries that the wealth that their father had for them the senior brother has taken to sell. "Leave me," the junior brother wails, "for our father was an important man" (implying that the older brother is not). The junior brother continues, through the voices of the singers, that his brother is a foolish man, that Afikpo are happy (kwajigheje) because his brother is foolish, and that Amuro people are making fun of the junior brother. He who sells land is looking for trouble.

There is no reference in the play to the fact that the junior brother is in the process of performing the various ceremonies for the important uhie ci title, but by implication the senior brother should be supporting his younger sibling in this expensive endeavor, rather than acting against him.

As the song ended there were many shouts of approval and requests for its repetition. Then the first leader took both leaders' parts and the second one became the chorus, as they walked around near the audience. The third stage ends and is followed by a break, during which the musicians play and ɔri dancers move about. "Dashes" are given out by members of the audience.

STAGE 4

This section begins with a long song in two parts concerning a dispute over a large palm tree grove that has been going on for over thirty years between the villages of Ndibe (Mkpoghoro) and Anohia Nkalo (S. Ottenberg 1971b, pp. 288–96). In this dispute Amuro sides with Anohia Nkalo, which belongs to the same Afikpo subgroup, Itim. Persons in Amuro believe that Anohia Nkalo was a very early settlement with prior claim to the groves and land involved, and that Ndibe grew in power and tried to take the property away. The case has been in the courts many times. This is one of the few topics that has been used in other ɔkumkpa plays; but each time the players try to give it a new twist.

The senior and junior leaders sing the first part of the song alone, without the musicians. They then go around to the audience repeating it a number of times. When they come to the chorus, the song is turned over to that group and sung over again with music playing. Here the two assistant leaders take the part of the senior leader and the chorus the junior leader's voice. As this is going on, the two leaders move about in front of the audience. They stop and ask: "Do you know what the song is about?" The audience, whether they know or not, usually shouts "No!" and the leaders explain the action to all parts of the audience.

First Song

Senior Leader
1. *Ɛgwo nwa Idume Ɛgwo biarɛ ughɔgho okwu na ɛhugbɔ*
 Ɛgwo son Idume Ɛgwo come false palaver in Afikpo

Junior Leader
2. *owue nna cekwe na okwu dɛ na Mgbom*
 sorry father wait in palaver is in Mgbom

Senior Leader
3. *Isu Ɛgwu Oriɛ biarɛ ughɔgho okwu na ɛhugbɔ*
 Isu Ɛgwu Oriɛ come false palaver in Afikpo

Junior Leader
4. *Isu Ɛgwu epiyeyɛ ma ekpehgiɛ nanni ɛnohia alewo na okwu adeghɛ mma*
 Isu Ɛgwu tried or not-tried give Anohia-Nkalo land-their for palaver is-not good

The first leader sings line 3 again with another name and the second leader replies with either line 2 or 4 at his discretion, putting in this same person's name. This is done for the names of about fifteen persons involved in the dispute from all over Afikpo.

Explanation. Line 1 mentions Ɛgwo, a prominent and wealthy Mgbom trader, who makes false palaver in Afikpo. In line 2 Ɛgwo says: "Wait, father, there is no palaver in Mgbom," pretending that there is no trouble at all. Line 3 is like the first line only it gives the name of another palaver man, Chief Isu of Ngodo, who has already been referred to several times. Line 4 says that no matter whether Chief Isu does or does not try the dispute, he should give the land to the Anohia Nkalo villagers, as it is their land.

The lines refer to leaders and elders known for their inclination to arbitrate. Among those included are Okoronkwɔ, a Native Authority Court member from Ukpa, who has been mentioned in the third song of stage 3; Okɛhihie, who is the most prominent leader of Ukpa and is known as a "big palaver man"; Okoro, a chief, former school-teacher, and once a Native Authority Court member who is from the southernmost Afikpo village of Kpogrikpo; Onya Odo from Amuro, an elder who encouraged the leaders to stage this part of the play even though he knew that he would be sung about; Okoce of Mgbom, a senior man who had an early education and an unusual career; and Ekuma Owum, the Native Authority Court member from Ugwuego.

The second part of the song begins with the two leaders singing lines 5 through 12.

5. *igbo-nde-anoma-ugwu na agha abia*
Afikpo-people for war come
6. *igbo-nde-anoma-ugwu na agha abia*
Afikpo people for war come
7. *unu ahoa agha eejighi mma na agha eejighi egbɛ*
you see war does-not-hold knife and war does-not-hold gun
8. *unu ahoa nde unu riri nna owɔ abia ɛgwa imɛri na barɛke kunu eekwuruwɔ ukwu*
you see people you eat father their come revenge things in barracks you-did not-speak word
9. *Idume Ɛkwokwɔ nkɛ ale ayi rɔro kɛlaki na ɛne onye cɔruya Okoroje gire ntɔ ba cɔruya ka igbo eyewɛriyɛ iwe*
Idume Ɛkwokwɔ of land our work clerk in N.A. who drive-him Okoroje used trick came drive-him and Afikpo didn't-vex vex

10-11-12. Line 9 is repeated three times, each with a different name replacing Idume Ɛkwokwɔ at the beginning.

Explanation. In line 5 (and line 6) the leaders point out to the Afikpo that there is a war. The first four words of this line are a colloquial expression for the Afikpo people that have been used before in this play. Line 7 roughly translates that this is war but it involves no machete and no gun. Line 8 makes it clear that the Anohia Nkalo and Ndibe land dispute is not the subject of the song but something else. It says, in effect: "In the Government Station area and the Number 2 settlement you have seen African 'strangers' whose fathers you killed in warfare. They have come to revenge now, but you have done nothing." These "strangers" are the Africans in the administrative sector of Afikpo, mainly other Igbo, whom the Afikpo used to fight in pre-European contact times. Now they are doing things to the Afikpo and nobody objects. Line 9 explains that Idume Ɛkwokwɔ worked as a Native Authority clerk (actually the Native Authority treasurer), and that Okoroje (a "stranger" Native Authority clerk) drove him away by a trick. The people of Afikpo did not make palaver over it. Lines 10–12 refer to three other Afikpo persons who were driven out of the Native Authority service by Okoroje (or more generally by stranger Africans). These are Agha Uce, an ex-Native Authority treasurer; Egwu Mbɔ, an ex-Native Authority clerk; and Okoce, who worked in the Native Authority in Aro Division. The song reflects the deep suspicion that Afikpo have of government by other Africans, and also a sense of resentment that Afikpo people did not react to these affairs.

The song continues, returning to its original theme of the land dispute.

Two Leaders
13. *Isu Ɛgwu Orie bɔro ɛze ogo na ale Ngodo ajuwa ka omɛri gɛni na ale Ngodo*
Isu Ɛgwu Orie was chief village in land Ngodo asked what did thing in land Ngodo

Senior Leader
14. *Abagha nwa Ɔta Mgbɵ lare ɔnwo ike*
Abagha son Ɔta Mgbɵ went death strength

Junior Leader
15. *ɔbare ikpɛ ɛnohia ya lare ale owuwɛyi*
because case Anohia-Nkalo he went ground sorrow

16–33. Lines 14 and 15 are repeated some nine times by the senior and junior leaders, respectively, but with different names.

Two Leaders
34. *igbo-nde-anoma-ugwu nejije jakpɔ ɛnwa nawo sɛ ji dɛre igbo dɛre Nkalo na nke Nkalo karie ɛka nawo bɵru ikɛngɛ wo nawo bɵru ozo bia*
Afikpo-people went to-bless bless [noun] they say yam should-be Afikpo should-be Anohia-Nkalo and their Anohia-Nkalo over hand they first right-hand their there first road come

Two Leaders
35. *Akparakpa nwa Ibe Urɔ lare na ulo tiye nkpɵ unu hɔro ibe ɔko ghakɔro ulo jadoa obiogo Amɔzo na Mgbom kantutu akwaha obube ɔko ya bɔro okwu cekwɛ na ihie okwu nɛme adeghe mma*
Akparakpa son Ibe Urɔ went in house shout noise you see where fire left house burnt men's-resthouse Amɔzo-ward in Mgbom many refused separate fire it is palaver wait in thing palaver does not good

Two Leaders, with only a very brief pause
36. *ɛhugbɔ nja na sɛ berɛme ɔnwa ihie mado nwɵ nanasiyɛ nikɛ*
Afikpo what is say don't-do this thing person own don't-take-from-him force

Two Leaders
37. *epiyeyɛ ma ekpeghiɛ nanni ɛnohia alewo na okwu adeghe mma*
tried or not-tried give Anohia-Nkalo land-their for palaver is not good

Then the first leader sings line 3 again with another name and the second leader replies with either line 2 or 4, putting in this same person's name. This is done for the names of about fifteen persons involved in the Anohia Nkalo–Ndibe palm grove disputes, individuals from all over Afikpo.

Explanation. In this part of the song Chief Isu is again referred to. The singers ask, "What did he do

there? What improvements did he bring to his village?" (They are implying that he did nothing.) In the next line the senior leader sings that Chief Abagha of Anohia Nkalo died while his sun was still high. It is said that he died a "strong" death, that is, he died before his time. Line 15 states that he died because of the land dispute between Anohia Nkalo and Ndibe and it is a pity. In lines 16–33 other prominent men are mentioned who died during the dispute. It is felt that they died either through worry, by poison, or through some other cause connected with the palaver. Among those mentioned are *"Enwo di Ugɛnyi"* (Enwo, husband of Ugɛnyi), who was a former warrant chief from Mgbom; Ɛkɛjɛ Ɛkwu, who was a leader in Ngodo; and Okata Ori Ɛke, a prominent man from Ndibe.

Line 34 indicates that the leaders believe the palm grove and land belong to Anohia Nkalo. It says that there should be yams at Afikpo, and there should be more in Anohia Nkalo because its people are the "right hand" of Afikpo, the first to come. This claim is based on the fact that the original yam priest for Afikpo came from Anohia Nkalo and his patrilineal line still holds this office; but Ndibe has claimed its own yam priest and gives him priority (this is also part of the same dispute). The singers clearly feel that Anohia Nkalo is on the right side of the dispute and should win it. Line 34 is long and the leaders are out of breath by the time they get to its end.

Lines 35–37 tell the story of Akparakpa, the leader of Amɔzo ward in Mgbom, who went to his house and cried because fire had burned the men's resthouse in the ward common. It did not destroy any homes. How could a fire start at the resthouse when no one was using it at the time? There are no houses nearby from whence it might have come. The leaders sing: "What can I say? It is because of the palaver. Well, Afikpo, you see what palaver can do! Do not take anybody's things by force. If the case is tried or not, give it back to Anohia Nkalo, it is their land." Line 37 is actually a repeat of line 4 without the opening name.

Then the second part of the song (lines 5–37) is taken up, to music and drumming, by the assistant leaders and chorus. The assistants sing the part of the two leaders together, and in lines 14–33 each of the two assistants sings four names of his choice for the first line, and the chorus, with the second line, whatever names individual singers there wish to give among those already mentioned.

The insertion of the commentary concerning stranger Africans at Afikpo (lines 5–12) in the midst of a song about the Anohia Nkalo–Ndibe dispute, and about the problems that palaver causes in general, suggests that "palaver men" are being equated with stranger Africans at Afikpo who act against Afikpo's interests.

As the lines are being sung by the two assistant leaders and the chorus, the drumming becomes strong and the ɔri dancers start to dance and "beg" for "dashes." Meanwhile the two leaders go about in front of the audience, explaining the song. Then the singing and speaking cease and for about ten minutes there is only dancing and the giving of presents. After this the two leaders return to a position in front of the drummers and put their hands down toward the drums as a sign to stop. The music ceases and the dancers return to the chorus. The song has been so well received that the leaders go over it again, but without the two assistants and the chorus singing their part.

The First Acts

The leaders then signal the actors to come out in front of the chorus. They go through their roles while the leaders go about explaining to the audience, without song or music, what is going on.

Chukwu Agbam from Amuro is taking the *ikwe mise* title. Oko Ɔyare of Amuro, popularly known as Oko Amaseri, has recently joined this title society himself. As a new member he is not entitled to a share of the title money, but he can eat and drink with the others. He comes late, while the members are already feasting. They ask him where he has been and he says that he had to go somewhere. He is asked to have some palm wine. Because he is late he tries to catch up by drinking a great deal. He is reminded by others that any title member who gets drunk at a title meeting pays three bottles of native gin to the others. Nevertheless, he keeps on until he is drunk and he "goes to the latrine" in his clothes. The offense is now double: Oko Amaseri came late to an important title event and then he became drunk and defecated in his pants. The title members are offended and begin to take him away to his home. While carrying him they try to think up the best song to sing about him. They play with words, but none is good enough until they make up a tune which they hum and which ends in the word *nfa*, which sounds like a person breaking wind.

This act is followed immediately by a series of skits where one or the other of the leaders calls out the name of a man and his wife. Two actors appear from the chorus and play out a scene indicating some weakness on the part of the husband. Such henpecked men are called *nde nye wo nakwe ihu na ɛkwu* (people-wife-their-washes-face-in-kitchen), that is, husbands whose wives can drag them into the kitchen and make them work there. In a society where the division of family and other activities is very great (P. Ottenberg 1959), a man doing woman's work is considered weak.

Skit 1

A leader calls for Uce Ɛdam and his wife, Nne Ɛdam, of Amuro, and actors representing them come out. The wife calls her husband and he comes to her. She takes one of her shrines, *ci ɔwɔkɔ* (*ci* shrine found in back of the house), represented by a shrine pot (S. Ottenberg 1970, p. 46), and holding it in one hand and an egg in the other she says: "If there is any title taking in which you are involved and if you have not finished preparing soup for me before you go, this god will kill you." The husband bends down and she sweeps the egg around his head, puts it in the pot, and walks away.

The movement of the egg around the head is done in a number of sacrifices at Afikpo. Normally, of course, a husband does not prepare food for the house. Afikpo say that it is a foolish, weak, and stupid husband who allows himself to be so ordered by a wife. Nor does he permit a woman to perform a sacrifice over him.

Skit 2

The two actors return to the chorus and a leader calls out Nkpɔdu and his wife, Nne Odo, from Amuro. An *ɔri* representing the wife carries out a pot to signify the three stones on which her cooking pot is placed in her home for preparing meals. Called *ekwu*, the pot here has ashes in it to represent the fire. She calls her husband and asks him to kneel down. He does this and she states: "If there is ever a title society of which you are a member and you do not finish grating this, my cassava, and frying it and measuring it, before going to the title feast, this *ekwu* will kill you. If you fail to tell me the exact cost of the cassava and what will be my profit, or after having done these things I go to the market and sustain a loss on it there, this *ekwu* will kill you." She waves an egg over his head and drops it into the pot. They both walk away, returning to the group.

Cassava preparation and selling is exclusively women's work. It is a main source of income for wives.

Skit 3

Oko Abagha and his wife, Nne Oko, from Amuro, are called and actors appear to represent them. The wife takes *ɛgɛro*, a women's personal shrine for health, good crops, and general welfare (S. Ottenberg 1970, pp. 45–46), here represented by a pot, and calls her husband. She tells him that if he does not remain in the house to tell her all about his property, where he keeps it, and all about his personal secrets before going to enjoy the title feast of a title society to which he belongs, *ɛgɛro* will kill him. Again, she waves an egg over his head as he bends down; they then return to the group.

This skit contains several elements of ridicule.

No man should let a woman delay his going to a title feast. And no husband tells a wife all about his personal property or secrets, as sex roles are too distinctive.

Skit 4

Oko Alo and his wife, Nne Akpot, of Amuro, are called by a leader. The wife takes the *ekwu* pot referred to in skit 2 and calls her husband. She says to him that if he goes to a title feast and is served with soup, the *ekwu* will kill him if he first tastes the soup without returning it to the house. She waves an egg over his head, puts it in the pot, and they walk away. It is not uncommon for a man to take all, or part, of his soup and yam fufu home and eat it there, but it is not obligatory, nor does he necessarily share it with anyone.

A number of other skits of a like nature are carried out following the same pattern and involving persons from Amuro.

Second Song

The skits are immediately followed, without music or dancing, by a second major song for this part of the play. It begins with two leaders walking about in front of the audience and singing, with musical accompaniment. The first four lines are a sort of prelude; some of them are recalled later on. The song consists of single lines about individuals, either praising or satirizing them.

Senior Leader
1. *Ɔku nakpa nganga na ulo*
 Ɔku behaves joke in house

Junior Leader
2. *Oko amoghe ihie onye Amaseri*
 Oko does-not-know thing one Amaseri

Senior Leader
3. *Urom Aliji ya kpɔru ulo gba-ɔlɔ omume awarote*
 Urom Aliji he enter house repeat [again] secret-society-spirit returned

Junior Leader
4. *iyogowogowo eyawo Oko amɛghe ihie*
 iyogowogowo eyawo Oko does-not-know something

Senior Leader
5. *Nnale nwa Egwo Akpo bɔ enyitɛ abalisi ologhɔ awarote*
 Nnale son Egwo Akpo is rabbit night secret-society-spirit returned

Junior Leader
6. *iyogowogowo eyawo Oko amaghi ihie*
 iyogowogowo eyawo Oko does-not-know something

Senior Leader

7. *Eze nwa Akama Eze ge sue egbe ye ngbɔ*
 omume awarote
 Eze son Akama Eze you load gun put bullet
 secret-society-spirit returned

Junior Leader

8. *iyogowogowo eyawo Oko amaghi ihie*
 iyogowogowo eyawo Oko does-not-know
 something

Senior Leader

9. *Uce Akpo tɔro Ogenyi mgba tayɔdaghaye isi kə*
 na ale ka iriri eruenre
 Uce Akpo knock Ogenyi wrestling turned-over
 head knock in ground like eat nightjar-bird

Junior Leader

10. *iyogowogowo eyawo Oko amaghi ihie*
 iyogowogowo eyawo Oko does-not-know
 something

11–16. The last two lines are repeated several
 times, naming other persons in the first of the
 two lines.

Two Leaders

17. *eleee akpam oka zɔla iyɔra kamagɔsere Eze*
 women's-call I-say word forget swallow-bird
 did-not-sing Eze

Two Leaders

18. *Eze Jimafɔ Chukɔri onye rari ukeya ɔzo*
 Oko Aja bə ibe-akante Eze nwa Akama Eze
 bə enyi-enyum, Oko Mbe bə ibe-mgbiri-ma,
 Urom nwa Aliji bə ibe-ugɔnya, uwa legbue
 onwɔm onye nɔndo ciduare ihie dia na eka ike
 eze nnɔ na egbu nagbare onwue nkpə Urom
 nwa Aliji wε sε nɔbo gε seri ɔnwa bəkwu
 Eze Jimafɔ Chukɔri one leads his-age-set run
 Oko Aja is matriclan name Eze son Akama
 Eze is matriclan name, Oko Mbe is matriclan
 name, Urom son Aliji is matriclan name, life
 die myself who alive take-all thing is in hand
 molar teeth is in jaw run itself alarm Urom son
 Aliji they say you you draw this matter

Explanation. Line 1 explains that Ɔku wants to
be an *ɔkumkpa* leader, but instead of staging it
he keeps singing and playing the songs and
acts in his house. The second line refers to Oko
Ɔyare, whose popular name is Oko Amaseri.
He is the man in the first skit of the first act
of stage 4 who came late to the title ceremony
and became drunk. The lines here say that he
is a foolish man, that people consider him an
Amaseri. Afikpo look down upon persons from
Amaseri Village-Group, who are their neighbors
to the west and with whom they often dispute.

The third line praises Urom, who entered
his own house twice to bring presents for the
players when watching an *ɔkumkpa*
performance. Urom is known as a generous
man. The line suggests that the leaders hope
others will be as free with their presents on
this day. The fourth line refers to Oko Amaseri
again. The junior leader takes great delight in
the initial syllables that are sung in a descending
scale. The line is repeated a number of times
later (lines 6, 8, 10, 12, 14, 16), thus reiterating
the song's theme of foolish men.

Line 5 states that Nnale is a rabbit of the
night, a man of sinister habits who works
always at night. Now that the play has come
and *egbele* has returned, he must be prepared
to hear something about himself. Note the use
of the term *ologhə* for the secret society spirit
here in this line, and the term *omume* in line 3.
These are but two of the numerous ways of
referring to *egbele*.

In line 7 the senior leader asks Eze, who
is actually his own father, to load his gun and
fire it because the play is on. There is no criticism
of the father in the line; it is a statement of the
leader's pleasure at the performance of the
play.

Lines 9, 11, 13, and 15 refer to persons
who are weak in wrestling. Wrestling is an
important sport for boys and young men at
Afikpo, being considered a major test of a
person's strength and character. A person wins
when he throws the other to the ground. In
line 9 Uce knocks down Ogenyi and thereby
wins. But Ogenyi, instead of stopping, turns Uce
over, a foolish and weak thing to do after losing.
Ogenyi is like the nightjar, a bird of the night,
a weakling that flops around the roads in a
halting, irregular flight. He also represents
persons who, when they lose a dispute, do not
drop the matter but try it again instead of
accepting defeat.

Eleee is the sound that women make when
entering the commons of the village during the
secret society season in order to warn society
members that they are coming. In line 17 it is
used to call attention to what follows. The
leaders sing that they have said some things,
but that they have forgotten to sing like the
swallow bird of Eze. The last line of the song
states that Eze leads his age grade in running
competition. His matrilineal clan affiliation is
given. Then follow the personal and matrilineal
clan names of important and influential
individuals in a sort of prelude to naming the
person to be discussed here, Urom, the
generous man of line 3. The line says, "I
entered into life. Who has ever lived to eat all
he has before he dies? A molar tooth remains
where it is planted. It stays in the jaw as the
hand sends food to it and it chews the food."
This is a way of describing Urom, as a molar
tooth to whom people bring something all the

time. He and his four sons are all traders and are rich. There was a time when, having quarreled with the people of his village of Amuro, he was ostracized for some five years and lived alone. Eventually he was reconciled. The song is praise for him: he is a strong, independent man, strong as a molar and not affected by ostracism. This sort of independence, when coupled with an ability to acquire wealth or power, is much praised at Afikpo.

The song is not quite over, however. The two leaders together sing the fourth line, moving to face the chorus, which picks up the end of this line. The assistant leaders and chorus then go over portions of the song, taking the parts of the senior and junior leaders respectively. The two assistants take turns singing any senior leader's line they choose, the chorus responding to each line with the fourth line of the song. Each assistant leader chooses four lines in this manner, in any order that he wishes. While this is going on, the two play leaders go about in front of the audience explaining what has been stated in the song. Then the two leaders sing the last line again to close the song.

When the singing finally ends, the ɔri dance and beg to the music for about ten minutes, when the leaders signal the musicians to stop.

The Second Act

Each ward in a village has its own men's resthouse and common, but one ward and common are considered central to the settlement. In this ward the ɔkumkpa is played and in the resthouse the sacred wooden slit gong (ikɔro) of the village is found. There is normally only one of these gongs to a community. Sacrificed to before being played, it is used to announce deaths and important events in the village, although not the ɔkumkpa. Being hollowed out of a tree trunk, it is usually large, some six to ten feet long (S. Ottenberg 1972b).

Amuro comprises three wards. About 1950 a prominent man of Ezi Onya compound, Onya Odo, goes to the main resthouse, which is in his ward, and notes that the large wooden gong is in very bad condition. It had been damaged, in fact, many years before in a fight between Amuro and Mgbom.

Onya Odo decides that it is time to make a new one. Instead of consulting the people of Amuro, as he should have done, he goes straight to a well-known gong maker in nearby Edda Village-Group and discusses the price with him. The craftsman asks £5 for the job. Onya Odo suggests that he charge the people of Amuro £10 and that he and the instrument maker should split the extra £5 between them. The latter agrees.

Onya Odo returns to the village and puts the question of a new gong to the men of Amuro. Ɛzɛ Akama (who is the father of the senior leader of the play), a prominent leader from Ezi Aja compound, the largest one in Amuro and one of the three largest compounds in Afikpo, objects, suspecting some foul play. He questions whether Onya Odo should have gone alone to bargain without consulting the rest of Amuro, and argues that the people should not collect £10 to pay for the instrument. The meeting develops into a dispute, with Onya's compound, Ezi Onya, desiring the gong, and the rest of Amuro refusing to pay this sum. The people of Amuro finally tell Onya Odo to go get his own for his compound, that Amuro will have its own at whatever cost.

Onya Odo's supporters pay £10 for the gong and bring it to the resthouse, replacing the damaged one. The rest of Amuro sends representatives to the same instrument maker and have him make them a gong for £5—a better one, representatives to the same instrument maker and have him make them a gong for £5—a better one, it is said, than the first. It is paid for and a day set to drag it to the village. But an argument arises over which of the other two resthouses in Amuro it should be placed in. The people of Ezi Amɛlu claim it as theirs, as do the people of Ezi Aja. When the young Amuro men drag it to the village, a tug-of-war results between the people of the two compounds and for a while the gong does not move at all. Eventually Ezi Aja wins out and forces it into their resthouse, where it is set up. But Uhyum Alogho Ude, considered a troublemaker in Amuro, has gone to the police and they come and arrest some of the leaders in the dispute.

A day is appointed for settling the matter through discussion in the traditional style. The leader of Ezi Aja, Ɛzɛ Akama, goes to Okɔ Ogo, the leader of Ezi Amɛlu, and says to him: "We are to get a new court member to replace the one who is now in, Onya Odo, who still desires to be selected again. I am putting up your son Ɛzɛ Oko and I will get Amuro to vote for him." He is referring to the Native Authority Court of Afikpo, and Onya Odo, the present court member from the village is, of course, the same man who started the whole business.

Okɔ Ogo agrees to this proposal, which constitutes a double political maneuver for Ɛzɛ Akama: it hits at the incumbent, and also gives Ɛzɛ a good bargaining position over the gong, which he expects to get in his ward's resthouse in return for this support. In actuality, Ɛzɛ Akama probably knew that the selection of Ɛzɛ Oko had already been approved by the native authority councillor from Amuro, the Native Authority Council as a whole, and the district officer, and that the village election would be a mere formality. But apparently Okɔ Ogo was unaware of these facts when he agreed to the arrangement.

On the day that the district officer comes to

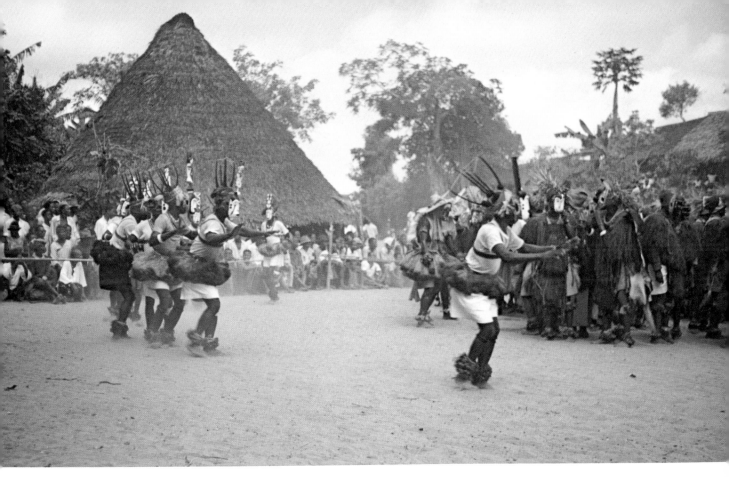

PLATE XI

Senior group of *akparakpa* players at Mgbom ɔkumkpa in 1960

An *igri* mask, worn at the Amorie ɔkumkpa in 1952

An *ibibio* mask at the Mgbom ɔkumkpa in 1960. The masquerader is wearing a pink plastic necklace made up of numerous disks strung together and a porcupine quill headdress

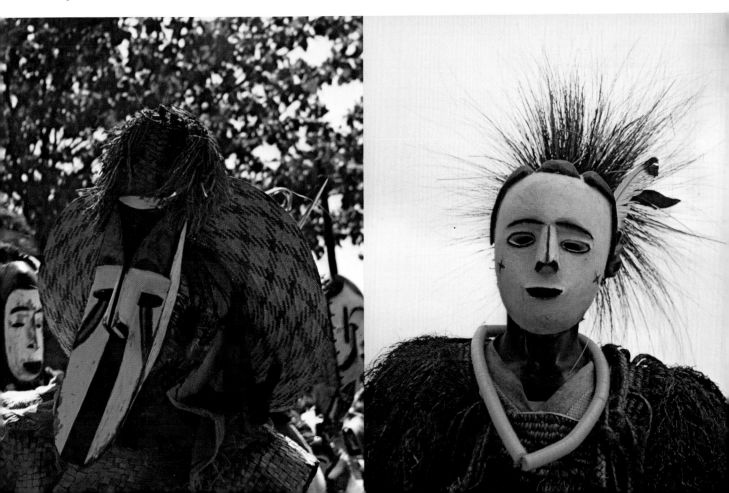

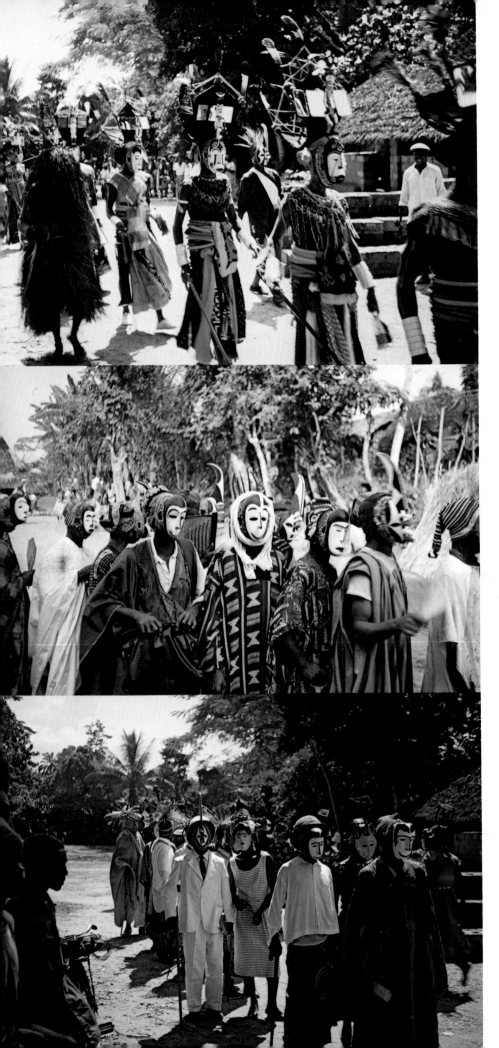

PLATE XII

The "adolescent girls," *agbɔghɔ mma*, at an *njenji* parade. At the left is a raffia-hooded praise singer

Njenji players dressed as Moslems, wearing *mma ji*, *beke*, and *nne mgbo* masks

Njenji players dressed in European clothes or as Moslems, wearing *nne mgbo*, *ibibio*, and *mma ji* masks

"select" the new court member from Amuro, the incumbent, Onya Odo, goes to the *iye ci* village shrine and makes a small sacrifice in which he promises to pay it a ram if he is re-elected. But the vote goes to Ɛzɛ Ogo, as already arranged. After the decision is made, Ɛzɛ Akama tells Okɔ Ogo that since his compound now has the court official, Ezi Aja should therefore have the gong, as they had agreed. He goes on to say that on the day when the two sections of the village are to decide which should have the instrument in its ward resthouse Okɔ Ogo should absent himself by going to the farm. "I have done you a favor. You should do me one now," he says. The rest of Amuro knows nothing of this agreement at the time.

The day before the meeting to resolve the issue, Nnachi Ɛdam, a leader of Ezi Amɛlu compound, goes to the same *iye ci* shrine and promises it a fowl if the gong is put in his compound's resthouse. The next day Okɔ Ogo, the leader of this compound, goes to the farm, as he has agreed to do. Elders come from the neighboring village of Amachara to decide the dispute, as it is the custom for a village troubled by a major internal conflict to ask senior men of a neighboring community to help settle it. They decide that the gong should be in Ezi Aja. When Okɔ Ogo returns from the farm, the people of his compound rebuke him for going there on such an important day. He says that it is not important where a gong is located; what is important is that everybody in the village can hear it. The play ends with this statement.

This play was acted out from the first arrangement of Onya Odo with the gong maker to the final decision concerning the placement of the second new one. A small log is used to represent the gong.

Note how the presentation is much like muckraking in a newspaper. The motivations behind decisions are revealed and are found in part to be selfish ones. Not everyone, in fact, knew this full story before it was revealed here.

The Third Act

Another act follows without a break. The people of upper Amuro, in need of a new log to sit on in their ward common, fell a tree in the Government Forest Preserve without permission. Uhyum, a troublemaking man from lower Amuro (see the song that follows and the next act), reports the incident to the forest guard and tells him that he should collect £10 from each of the three leaders of upper Amuro. Uhyum then suggests that the guard should give him part of the money after it is collected.

The guard comes and arrests four persons. One offers to pay £3, another £2, and a third £3. They also agree to give yams, goats, and fowls.

Then the guard stamps the log as approved for use. The fourth arrested man cries out that he will pay nothing, that he will not be able to reap the yams he planted this year, and his dead mother will have to come and harvest them (as he will be imprisoned). The reference for the mother is an attempt to insult the guard. The forest guard lets him go.

A small log is used to represent the bench. The dragging of the log away from the forest is acted out, as well as Uhyum's talking to the forest guard, the arrest, the payments for the offenses, the stamping of the log, and the cries of the fourth arrested man.

The Third Song

This song connects with both of the preceding acts. The skill of relating one song to a number of acts is highly regarded at Afikpo. The last line of the song refers to the end of both acts, the "nneleeeeeeeeeeeeeeeeee" representing crying and distress, *nne* being the word for mother. The song is sung without music, while the two leaders move in front of the audience.

Senior Leader
1. *ngu jeɔɔɔɔɔɔɔɔɔɔɔɔɔɔɔɔ*
 sing I? [drawn out]

Junior Leader
2. *okwɛ ilu kwejɛoooooooooooooooo*
 answer song to-answer-on [drawn out]

Senior Leader
3. *Ɛzɛ nwa Akama Ɛzɛ nidi nayaoooooooooooooooo*
 Ɛzɛ son Akama Ɛzɛ you-are in-it [drawn out]

Junior Leader
4. *gɛ mari wo kujɛ woooooooooooooooo*
 you know them call them [drawn out]

The senior leader then sings the third line with another name and the second leader follows with either the second or fourth line, as he chooses. The leaders do this a number of times, mentioning different persons involved in the two preceding acts. Then there is a long explanatory line sung through without a stop.

Two Leaders
5. *ogbomlɛɛɛɛɛɛ agam jɛse ogbɔrigɛ nsɛtɛ ogbɔrigɛ, mam debiɛ na ihu ogo, elu nwɔ ɔgo wo ɛseri ogwe wo bedɛbɛ na ihu Uhyum Alogho Ude nɔri nɔfis nde pɔlis erutɛ Okɔ Ogo nkɛ Ama Ɛlu nɔ di aya Ojɛ Ubi nkɛ Ezi Amɛlu nɔ di aya unu ahoa onye ike kwɔro ɛnyum udu di Odo Ewa sɛ gɛ wɛri oka gɛ kaghɛjɛ Okɔ bɔ nwa Ologwu nɔbiam nɔwam abia, bia tie nneleeeeeeeeeeeee unu ahoa ji nkɔro ahunwa erighimua*
 friend [drawn out, the leaders referring to each

other] I-want draw along drawn along, I keep in face [middle-of] common, up own fight they draw bridge [log] they kept in face [middle-of] Uhyum Alogho Ude is office persons police come Okɔ Ogo part Ezi Amɛlu-compound he is it Ojɛ Ubi part Ezi Amɛlu-compound he is it you see one strength bail-out-water river rainy-season husband Odo Ewa say you take matter your talk about Okɔ is son Ologwu he-come just come, come shout mother [drawn out] you see yam plant this-year don't-eat

Explanation. In line 1 the senior leader asks, "May I sing?" The junior leader replies, "Sing on!" The senior leader replies to this in line 3 by saying that Ɛzɛ Akama is in the song that is to be sung. The junior leader responds with "If you know them, call their names"—referring to the persons involved in these two previous acts.

These first four lines and their repeats form a sort of prelude to the last line, the longest and most interesting. Here the two leaders address each other as friends. They sing that they want to drag the bridge (the term can be used for any log like this) to the middle of Amuro's common. The people of Ezi Amɛlu have drawn their gong (a mockery, as they did not finally get the gong for their resthouse). Uhyum has gone to the government office to bring the police to quell the dispute that has arisen over where the newly dragged log should be placed. The police come and take people who were involved in the matter, including Okɔ Ogo, Oje Ubi, and another (the husband of Odo Ewa), who is a strong man, strong enough to bail out a river in the rainy season, and Okɔ. The latter shouts: "My mother. You see the yams I planted this year? I am not going to eat them." He means that he is being taken away by the police and will not have the opportunity to dine on them.

The assistant leaders then alternate in singing the third line of the song, putting in specific names as they like. They each do so four times. After each such line the chorus responds with either the second or fourth line, both lines being sung at the same time by different individuals. The tune for these two lines is the same. Then the two leaders sing the last line again to end the song.

The musicians come in at the end of line 5 as sung by the two play leaders, and they continue to play while the assistant leaders and the chorus sing, at which time the ɔri players are out dancing and begging and the two leaders are going around the audience explaining the song in speech. The dancing and music continue after the singing is over. After a short while the leaders return to the musicians and motion them to stop, for another act is to begin.

The Fourth Act

Uhyum of Ezi Ogɛnyi, a subcompound of Amuro, who is referred to in the previous song and two acts, wanted to take a title, *ewu anɔhia*. In order to become a title member, he normally would call together the title members in his compound and feast them and give them the title fee, which they share amongst themselves. But he is not on good terms with the people of his compound, as they consider him a dishonest man. They had fined him over some matter, but he refused to pay, and so the compound ostracized him. Among other things, ostracism means that he is not permitted to take any titles because they involve other members of the compound. But he is required to take this title before his sons can join the secret society, and he has two of them he wishes initiated.

In the morning Uhyum takes a goat into the resthouse in the compound (not the same as the ward resthouses previously referred to) and calls on his fellow compound members who are about (most are at the farms) and tells them he is taking the title and that they should take part. They tell him no, he is ostracized, and they will not join him. So he calls together his sons. With their help he kills the goat and starts to boil it in the compound resthouse, as is the custom in this title. An old, sickly man who stays a good deal in the resthouse objects and takes the pot outside the house. Uhyum returns it, the man takes it out again; this happens several times. The old man is trying to stall him off until the men return from the farms, but he is too weak. He forces the man to cook outside of the house, however. Uhyum feasts his sons with the meat and he brings out the title price money and calls the names of the eldest men of the compound, all of whom have taken the title. Of course they are not there, so he gives the funds to his children in their place. He then collects the money back from them and goes to his house. All of the title ceremony is acted out, as is the next event.

Uhyum then wants to initiate his two sons into the secret society in Amuro, but the village elders will not let him do so. So he goes to the secret society priest at Mgbom and asks him whether he can initiate his children there. It is permissible to initiate one's sons in a village other than one's own, although this is not normally done for the eldest son. The Mgbom priest replies that it is not his custom to make inquiries; if children come, they will be initiated. By this he means that the question of whether the children are eligible or not is a family, compound, and village affair in the home village and it is not up to him to judge the matter. The two sons take the Mgbom initiation. That evening they return to Amuro and enter the resthouse in the common where only initiates are allowed. When the Amuro people see

this, they are surprised; but the father shouts out that anybody who tries to kill or harm them will have to deal with him, and nothing is done.

It is the custom for a man who wants to take a compound title when there are no living title members to call the sons and grandsons of deceased titleholders living in the compound and give them the food and money as if they were the title members. But they are not really titleholders, and the next person in the compound taking the title only feasts the first man and gives him the title costs. In effect, Uhyum performs a modified version of this procedure; but because of his ostracism, he is trying to create his own title society, where one actually already exists in the compound. Others view his actions as an attempt to make his own compound in the midst of another—a foolish, humorous, and hopeless undertaking. But one senses that there is also some underlying admiration for the man's ability to persevere without punishment and to reach his desired ends.

The senior leader thinks that the funniest part of this act is when the old sickly man tries to stop Uhyum from cooking the goat in the resthouse. "He showed his strength by stalling him off," he says.

The Fourth Song

The song that follows the act refers directly to it. There is no break between the two for music or dancing. It is first sung by the two leaders without the musicians playing.

Junior Leader
1. *nde Alazo sɛ na Uhyum ɛmeghe jɛ nyɔ medue jɛghe*
 people Alazo say that Uhyum can't-go he after-all went

Senior Leader
2. *akatomeeeeeeee owɛ ghɛ yo, iyo oo owe aha ho*
 secret-society-spirit [drawn out] *owɛ ghɛ yo, iyo oo owe aha ho*

Junior Leader
3. *hagha owe ghe yo Uhyum Alogho nyɔ medue jɛghe*
 hagha owe ghe yo Uhyum Alogho he after-all went

Senior Leader
4. *nyɔburo na Agbago nɔwa, ale nde Alazo ehuhuwo*
 if that Agbago is, ground people Alazo lost

Junior Leader
5. He sings either the first or third line, as he wishes.

Senior Leader
6. *Udetɛ nnɔ na ulo nahɔ ji ka ojijɛ je me ole na obiogo*
 Udetɛ is in house roast yam what going to do which in resthouse

Junior Leader
7. He sings either the first or third line.

Senior Leader
8. *nyɔburo na Okwe Alo nɔwa, ale nde Alazo ehuhuwo*
 if that Okwe Alo is, ground people Alazo lost

Senior Leader	*Junior Leader*	*Two Leaders*
9. Oko Ɛzɛ Igbo	Ɛgwo Igbo	ezɛene umɔroma!
Oko Ɛzɛ Igbo	Ɛgwo Igbo	old children!

Two Leaders
10. *ogbom retajekwe ihie ayi kpare na obu ayi Oko Abagha fotare ihu ezi Uhyum Alogho ge weri nkegi rige bθ ewu na nyɔoni acɔkɔgho bθ ewu. Oti nwa Ɛreke fotare ihu ezi Uhyum Alogho ge weri nkegi rige bθ ewu na naya acɔkɔgho bθ ewu. Udetɛ fotare na ihu ezi tie nkpu Uhyum Alogho gwɔ nwa Alogho Ude gwθ ɔhaka ezi ogɛnyi bθ ihie ejicikɔta je owue na nkata. Ema vuta ike adeghe*
 friend remember thing we said in compound-resthouse our Oko Abagha came-out face [middle-of] compound Uhyum Alogho you take your eat is goat that he-himself doesn't-want is goat. Oti son Ɛreke came-out face [middle-of] compound Uhyum Alogho you take your eat is goat that we don't-want is goat. Udetɛ came-out in face [middle-of] compound shout alarm. Uhyum Alogho oh! son Alogho Ude oh! as big Ezi Ogenyi is thing put-together go put in basket. Lift carry strength not

Explanation. In the first line the people of Uhyum's patrilineal group, Alazo, say that he cannot go to initiate his sons; but he has gone after all. By calling on the secret society spirit, the second line is praising it and reminding persons that this is a secret society play. The tune of this line is used again later in the song by the senior leader. The third line repeats that Uhyum was able to have his sons initiated after all.

The fourth line states that Agbago (Uhyum's deceased father) would not have let the land of Alazo people be lost if he were alive, meaning that if Agbago were alive, Uhyum would not have been permitted to take the title and thus usurp rights in the compound and patrilineal group. The line implies that Agbago would have had the strength and courage to check his son's actions. Line 6 refers to Udetɛ, the old man who sits and roasts yams in the resthouse, which is his house. What is he going to do?

He is an old man, so what can he do in this matter? The eighth line recalls another man, Okwe Alo, who, if he were alive, like Agbago would have prevented this event from occurring. And line 9 names two old men, referred to as foolish children, who tried to side with Uhyum in his actions.

The last line begins with the two leaders referring to one another. They say that they remember what they talked about in the resthouse (where they used to practice the play they are now staging). One man, Oko Abagha, came out and said to Uhyum that he did not want to join him and eat his goat. Oti then came out and told him to eat his own goat, they would not join him. Udete came out and shouted "Oh!" at Uhyum. "A compound as big as Ezi Ogenyi" [referring to Uhyum's attempt to create a separate compound by taking the title alone]. "You are trying to create and put in a basket and lift and carry on your head something that you do not have the strength to do."

As the singing ends the musicians begin to play. Then the assistant leaders alternately sing the fourth line four times, putting in names as they choose, each line followed by the chorus singing the first and third lines as individual chorus members desire. Then the two leaders sing the long last line again. The song ends here and is followed, as usual, by the ɔri dancing and the giving of "dashes." While the group and the two assistant leaders are singing, the leaders explain the song to the audience and occasionally sing bits of it to aid their presentation. They then go back in front of the chorus and stop the music, and the dancers return to the group.

At this point during stage 4 a branch of a tree suddenly falls down in back of the ajaba dressing house toward the south of Amuro. The viewers rise quickly, shout out, and start to run in various directions. It is some ten minutes before everyone returns to his seat. In the meantime the more enterprising children have secured better places for themselves. My field guide, Nnachi Enwo, at first thought that the falling branch was a good sign, indicating that the play was going well, but later he was not so sure that it had any meaning at all.

During the play the two assistant leaders, one holding a green tassle in his hand, the other a yellow one, keep the players grouped and seated properly, and help to keep the audience from crowding in too much by swooping down on certain viewers and waving their arms at them, making the watchers retreat a bit.

During stage 4 men dressed in the masked logholo costume (see Chap. 10) were coming from and going to the main village resthouse. They do not chase children while the play is on and take no part in it, but play about during the day.

It should also be noted that it is a mark of skill for the drummers to come in at the closing notes of a song by the two leaders and take the music away from them, thus moving the action without a break to singing by the chorus and the assistant leaders, or into the ɔri dancing period.

Fifth Act and Fifth Song

The act, the song that follows, and the associated dancing of the akparakpa all have to do with females and can be viewed as one integrated section.

The act is based on a women's society that flourished at Afikpo at this time. Called ovu ɛjo (carry-head pad or head tie), the society is made up of wealthy females (mainly traders) and Europeanized Afikpo women. The founder and leader of the group is a well-known Amuro midwife, Nne Afi Azo.

During the secret society initiation in Amuro, there is a time when the new initiates who are doing the additional part of the initiation deriving from Edda Village-Group go to the bush and dress in a special costume, ikpem mbe. They then return to the village common one by one. Until they are all out in the common, women are not permitted to come out and greet them. However, initiated male relatives and friends who have helped to dress someone as ikpem shout "yeeeee ibuzɔ mɔa" (ah!-first-my) meaning "First!" as he appears. This is done as each initiate returns to the village, although of course only one of them is actually first. But the midwife, whose house is close to the common, counts their number by the shouts without looking out. She totals some forty-five new initiates. This is acted out at the start of the skit.

That evening the midwife sends for another Amuro woman and says to her: "Didn't you hear what I heard? There are about forty-five ikpem! If we call their mothers to collect money from them, don't you think that it will be very big money? Let us start it!" There was a custom, at that time practiced in Mgbom village but not at Amuro, whereby on the evening of the initiation day village women came out and collected money from the mothers of the newly initiated boys. Nne Afi Azo desires to start this practice in Amuro.

The other woman says that this would be a nice thing but wants to know who will organize it. The midwife replies that she will. As the mothers and their newly initiated sons are rejoicing in the village common, the midwife comes to where the women congregate, spreads out a mat, and calls on the mothers to pay something, naming no specific sum. When she mentions something about there being forty-five initiates, some men hear her and ask her how she obtained that information. She admits that she has heard the initiates return. They ask her to name them, and

although she can list most of them, as she pretty well knows who has been initiated, she is reluctant and refuses.

The men tell her that she has gone beyond bounds, that she should not know what is going on, and that she should not introduce this system of payments to Amuro. The village elders and secret society priest fine her a goat and a dog and prevent her from collecting any money. She pays and laments what she has done. She calls the members of her women's society together to sympathize with her, serving them palm wine; they in turn "dash" her something to help pay the fine. The women end by singing and dancing.

Then the two play leaders together call out, "εlia ovu εjo" (group-carry-head pad), referring to the women's society, and the akparakpa come out to represent them in dancing. They line up in a circle, the music commences, and they dance around counterclockwise, imitating female dancing, with the characteristic bending of the body forward and backward in a much exaggerated fashion.

While they dance, the leaders go to the chorus and say, "Give them a song," and the chorus sings lines that are supposed to represent what the women sang, only with modifications in the tune and words. The assistant leaders sing the lead parts, the seated group—now only the ɔri and the "queen," as the akparakpa are dancing—is the chorus.

Two Assistant Leaders
1. *Nne Afi Azo nekwε egbele na ulo*
 Nne Afi Azo sing secret-society-spirit in house

Chorus
2. *iiiiiiyooooo hεleeeeeeee iyooooooooo*
 wiyoooooooooo εlεεεεε ololo mayi
 iiiiiiyooooo hεleeeeeeee iyooooooooo
 wiyoooooooooo εlεεεεε [no specific meaning]
 bottle wine

Two Assistant Leaders
3. *enyim Ugo Ɔkwa nekwε egbele na ulo*
 my-friend Ugo Ɔkwa sing secret-society-spirit in house

Chorus
4. *eyeyeee eyeyeee eyeyeee ololo mayi*
 eyeyeee eyeyeee eyeyeee [no specific meaning]
 bottle wine

Explanation. In line 1 the midwife sings of the secret society spirit while in her house, which she is forbidden to do. The women at the party at her home call for a bottle of wine in the next line, and the third line refers to another woman, a friend of the midwife, who also sings secret society songs in the house. The fourth line repeats the meaning of the second line.

The assistant leaders continue to sing the first line with a different name each time, singling out women who were at the midwife's party and females in Amuro and Mgbom who are interested in secret society affairs that are none of their business. The chorus replies either with the second or fourth lines as individuals choose. As this is going on, the two play leaders go about in front of the audience singing the same song, though not necessarily together with the assistant leaders and the chorus. The first leader sings the first line, giving names as he wishes, and the junior leader responds with either the second or fourth line as he desires.

This continues, with more and more names being sung, until the senior leader feels that it is beginning to tire the audience. He motions with his hand for the musicians to stop, and the players sit down again. This is a very popular section of the play and the men love it. In this ɔkumkpa it marks the end of stage 4.

STAGE 5

This act and related song, ɔkɔkɔ ɔdawa (break-one who falls), concerning someone who falls down or is knocked down, here connects with the previous stage by dealing with Uhyum of Amuro, the man ostracized from his compound. Although he is represented by a young akparakpa boy, the portrayal is of Uhyum as an adult.

When the act begins, Uhyum's compound is enjoying a feast. Uhyum comes by and greets the feasters, who are, of course, his agnatic relations. They are angry at his behavior, for he is ostracized, and they beat him down. I was told by the senior play leader and one of my field guides that this is not an uncommon practice toward an ostracized individual. Uhyum's wrist is broken and he goes to the police and starts an action against those who attacked him. He becomes sick and three native doctors come in turn at his call to treat him, but they all fail to cure him. Uhyum then suggests that he be taken to the Catholic hospital at Afikpo. Several persons assist him in reaching the place, a few miles from his village. An ɔri player, representing a Catholic father, who is wearing a white Ibibio mask, holding a prayer book in his hand, and mumbling in English, comes walking to where Uhyum is lying on the ground and starts to talk to him. The father asks him what he will give him if he cures him. Uhyum says 1s. and he starts to pay it, but the father says: "No, you will have to pay £5." Uhyum tells the father that this is contrary to the mission's doctrine: "You come to help the poor and now you want money." There is a discussion between the two and eventually the father agrees to accept a cock as payment. The man prays over him and Uhyum is cured, but he lies there on the ground while the leaders sing a song, without musical accompaniment.

Senior Leader

1. *Uhyum Alogho Ude bə oke ago nɔciri ozɔ*
 Uhyum Alogho Ude is big leopard stands way

Junior Leader

2. *ɔno gho okwu ezi wo ɔno gho okwu ɔha ogo ja*
 nɔwa ahr fathr wic aht hevin bə mkperi
 hear don't language compound their hear don't
 language group village went hear our Father
 which art heaven is prayer

Explanation. The first line says that Uhyum is a
wicked man, like a big leopard, who stands in
the way and does not live peacefully with
others. The second goes on to indicate that he
no longer (after being cured) hears the language
of his compound or his village. He only hears
"Our Father, which art in heaven."

The music starts and the boy actor rises up
and dances about to show that he is well. The
assistant leaders alternate in singing the first line
of the song, each immediately responded to by
the chorus with the second line. Meanwhile the ɔri
dancers are out dancing and receiving dashes and
the leaders go around the audience a number of
times singing the song again. Thus stage 5 ends.

The act once more emphasizes the
foolishness of an ostracized man who does not
make peace with his people. He drives himself
into further isolation by his actions, so that he is
no longer one of them. In fact, Afikpo have come
to consider him odd, spurning the ways and the
aid of his people, and having recourse to an
outside means of faith and cure. Uhyum was in the
audience, but did not give any pennies to the
leaders as a "dash" to show that he was not vexed;
for this he was considered a poor sport.

Also interesting is the depiction of the
Catholic missionary as a mercenary person. This
view of persons at the Catholic hospital at Afikpo
is commonly held.

STAGE 6

Here an earlier song is repeated. The leaders
sing the second song of stage 4, which they
consider the most popular song of the play so far.
It is again well received, and allows those who
come late to the performance to hear it. The song
is appealing probably partly because it concerns a
number of foolish persons.

STAGE 7

This act, in which the most foolish person gets
the pot, ɔpopa nja (carry-soup pot), is organized,
as usual, by the ɔri.

The first leader brings out a very small pot
and places it on the ground in front of the group.
The two leaders separate, each going to a different

part of the audience and saying: "Do you know
what that pot is?" They do not speak in unison. The
audience says that they do not, although they
know full well what is coming, for each leader in
turn says, "It is the pot of foolishness." The
drummers start playing wrestling music, which is
not the usual ɔkumkpa music, to rouse people.
One of the ɔri jumps out and says: "I understand
that this is a pot of foolishness. I am the most
foolish man." He dances a wrestling dance and
then stops the drums. He asks the chorus whether
they know his name, and they reply, "No!" He
tells them that he is Oko Akpo Ikwe. The wrestling
music is played for him again and he dances
about. But the leaders and ɔri make him sit down.
In fact, his actions have not been planned at all:
he is considered to be a bit crazy, and this is not
the sort of foolishness that is meant. His behavior,
however, accentuates the point that the man who
gets the pot is really very foolish indeed.

Then another ɔri comes out and goes through
much the same routine. He says that his name is
Ɛjim and, facing the chorus, he tells them why he
is the most foolish of all. For nine years he had an
intended bride. But he paid nothing to the future
mother-in-law, although he worked at intervals on
her husband's farms. He hoped that by doing this
that her parents would give him the girl for
nothing, without the usual bride price. After nine
years he asks them to let him have her in marriage.
The mother-in-law says that he should pay cash for
some labor that he has not yet done. He agrees, if
there is to be no bride price in addition. But she
has forgotten about this and then says he should
pay it, too. He objects, but he finally does so and
marries the girl.

Some time later his mother-in-law asks him to
take her by canoe down the river to a certain
market. After they have returned, he asks her to
pay for the work he has done of transporting her.
She does so but remarks, "It is bad of you, my
son-in-law, to take money from me for helping
me." He replies that he has paid her some money
as a substitute for work never done for the
father-in-law when he married her daughter.
"Now I have worked for you. You must refund it.
Get out." He pushes her out of the canoe. He asks
the chorus: "Is that not sufficient enough to take
the pot?" They shout, "Yes," and one of the
leaders gives it to him. It is getting late, evening is
falling, and the players move quickly to the next
stage.

The humor, of course, is in the man's
niggardly attitude about the bride price and then
his charging for transporting his mother-in-law,
work he ought to do freely as her son-in-law.

STAGE 8

In this stage, otitɛ okomɛ (dance-native harp),
the drummers start playing a female dance and the

"queen" (an *akparakpa*) and her mother (an *ɔri*) stand up in the middle of the chorus.

Senior Leader
1. *Ugo Agha nwa Agha*
 Ugo Agha daughter Agha

Chorus
2. *haaaaaaa yeyeeeeeeeeeee ase ge lorɔ di ine*
 sem lorɔ di nde dema biam ayeeyeeeeee
 haaaaaaa yeyeeeeeeeeeee if-said you marry
 husband you say marry husband people fine
 coming *ayeeyeeeeee*

Explanation. Ugo Agha, daughter of Agha, when men come and ask you to marry them you refuse, saying: "Are those people fine men?"

Then the girl and her mother come out. The "girl" starts to dance, but so poorly that the *ɔri* and leaders, and even some of the male audience, rush in and stop him right away. He cannot imitate female dancing. The senior leader had, in fact, given the part of the "queen" to a man who was not a good dancer, as a reward for helping with the organization of the play from the very beginning. He denied to me that bribery was involved in this case.

STAGE 9

In the last stage, *eko aka* (say-opinion), persons are already beginning to leave. As usual, the senior leader commences, speaking to the audience without music. "The reason women are not getting pregnant anymore is that when they go to *ahoma*, they sing the *egbele* songs and shout the *egbele* shout. To be good again, and pregnant, they should not do this again." This last line is addressed to the women in the audience. The *ahoma* fishing pond is a swampy area near the Cross River that is used for public fishing on a certain day each year. At that time women are permitted to sing the secret society songs and to employ its shout as they fish there. Nevertheless, the senior leader is telling them that they should not do this.

Then the junior leader addresses the males. "Men die young because nowadays many people go outside of Afikpo and bring back medicines that were not formerly used here. The medicines have restrictions and duties, one of the most common being to offer a coconut sacrifice while using it. When men bring them back, they do not always follow the rules for them and they die. The medicine is left about the compounds and kills the coconut trees. This is why many of the coconut trees die. People should not bring in these medicines again so that persons, and also the coconut trees, will not die."

There has been, in fact, a coconut tree blight in the Afikpo area. The comments here reflect a traditional suspicion toward outside medicines, that they are strong but poisonous and must be carefully controlled.

The drums beat out the first song in stage 1 of the play and the players break away to the *ajaba* to drink water. The play is finished.

POSTPLAY ACTIVITY

After about a half hour's rest, the players went to Mgbom where they gave a shortened version of the play from out 3:30 to 7:00 P.M. They then returned to Amuro for the night.

After the play the senior leader was given presents of 12s. 6d. by his friends, a group of comrades who live mainly in the southern villages of Kpogrikpo and Anohia. He said that his total "dash" was about £4, and that of the second leader somewhat more, since he knows more persons. The senior leader indicated that his own older brother was away and therefore could not help to hold his "dashes" for him during the play. He gave his presents to various persons to hold and, as he said, "Those who were honest returned it; some did not."

The leader says that after the play neither Chief Isu nor Mr. Idume, the trader, would speak to him. They both regard him as wicked for the references to them in the first song in stage 4. Chief Isu was also upset about a number of other references to him in the play.

Some days after the play the senior leader called all those who had helped to make the play a success and feasted them. He thanked them for helping him. He then rested several days before starting to work again on his farms and with his photography. He took no pictures at the play nor did he arrange for others to do so. It is not forbidden to take photographs, although I have never seen one of an *ɔkumkpa* play at Afikpo other than my own.

By the middle of May the two leaders and the most active members of their group were already beginning to prepare for another play for the next season. By 25 June the senior leader had already worked out six new songs.

CHAPTER VIII

Analysis of the Play

Discussion of this play and other ɔkumkpa is divided into three frames of reference: sociological, psychological, and aesthetic. They do, of course, overlap and complement each other, but I believe that they can profitably be distinguished.

SOCIOLOGICAL INTERPRETATIONS

The ɔkumkpa, a play of wide interest and broad concerns, is traditional in outlook and fully sanctioned. The players and audience together constitute the total local community, at least at the first performance of the play. Further, the roles played by the performers represent a range of ages, both sexes, and some animal forms (through certain masks). The variety of topics covered in the play is wide. The players speak with an authority that derives from the secret society, the elders who have sanctioned the performance, and customary norms associated with the ɔkumkpa. The presentation of the play in the main village common also gives it status.

The masks and costumes, the theatrical nature of the play, and the belief that the players are a type of spirit, mma, all serve to protect the players and to give them freedom to perform. It is the masks, especially, that turn humans into mma spirits (S. Ottenberg 1972a). The element of make-believe acts as a screen, allowing players, who are viewed somewhat as foolish persons, to act out this quality in the performance. Using artificial secrecy provided by the masks the players, whose identities in reality are also not very secret to at least some of the audience, can reveal secrets about persons in the village and at Afikpo. The essence of the play is the direct ridicule and satirizing of real persons and topical events, clothed in ritualized and superficially religious terms.

The content of the play falls into three broad categories: (1) the ridicule of persons who have acted foolishly, (2) the criticism of leaders who do not lead properly, and (3) the maintenance of the relative roles of males and females. They are not mutually exclusive elements.

Ridicule of Foolish Persons

The first consists largely of commentaries on single individuals who have misbehaved by Afikpo notions. In the play just presented I found fifteen references to such persons:

1. Title member obtaining palm wine (stage 1 song)
2. Banana tree incident (stage 3, song 2)
3. Man who returns home poor and sells his father's land (stage 3, song 4)
4. Man who becomes drunk at a title ceremony and defecates in his pants (stage 4, act 1, first part; stage 4, song 2, ll. 2, 4, 6 and its repeats)
5. Henpecked husbands (stage 4, act 1, skits 1-4)
6. Man who wishes to be ɔkumkpa player but sings in his home (stage 4, song 2, l. 1)
7. Man who is a "rabbit of the night" (stage 4, song 2, l. 5)
8. Men who do not wrestle properly (stage 4, song 2, l. 9 and its repeats)
9. Uhyum's conniving with the Forest Guard (stage 4, act 3 and song 3)
10. Uhyum's taking a title and initiating his sons in spite of his ostracism (stage 4, act 4, and song 4).
11. Foolish men who side with Uhyum in above incident (stage 4, song 4, l. 9)
12. Man who is really foolish (stage 7)
13. Man who is stingy in marriage and with his mother-in-law (stage 7)
14. The "queen" who is considering marriage (stage 8)
15. Men who die young because they bring in foreign medicines and do not control them properly (stage 9, second part)

I have excluded here comments about foolish persons who are leaders when their leadership is suggested or indicated, as they belong in the next section. For example, Uhyum is mentioned a number of times, but not in connection with leadership, so I have included him; but Nne Afi Azo (stage 4, act 5 and song 5) is excluded here because she is a prominent female in Afikpo and leader of an important women's organization.

The range of situations of ridicule is wide, from title members who do not act properly, to henpecked husbands, to men who have wrestled improperly. The emphasis of the play is on individual foolish men; females are more likely to be criticized as a group. The play thus speaks a

good deal about male personal morality and norms. Significantly, virtually all cases listed above concern residents of Amuro. Those criticized from outside of the village are prominent leaders and are discussed under that category. The incidents thus reflect local morality, which is also felt to apply elsewhere at Afikpo. Although three of the situations (numbers 3, 9, and 15) suggest foreign contacts and influences, even these cases are concerned with maintaining traditional norms; they do not suggest that deviancy is a consequence of social change as much as individual peculiarities.

The frequency of references to persons who have acted foolishly at title-taking (numbers 1, 4, 5, 10, and probably 3) reflects the strong concern over personal achievement at Afikpo. Titles are generally open to any male who has the money and other necessary resources. If a man has wealth, he is expected to join many of the title societies. Although there are only a few titles for females, the same principle applies to them. The references here suggest that Afikpo are easily bothered by persons who do not follow the usual achievement patterns and who act foolishly over titles or at title ceremonies. One incident concerning Uhyum (number 10) is interesting, for while there is ridicule of his forming his own title group, there is also admiration that he was able to do so and to use this as a basis of initiating his sons into the secret society. He has, after all, achieved his (and Afikpo's) goals, if not in quite the proper manner. Other ɔkumkpa plays at Afikpo reflect similar achievement values.

The commentaries on the leaders are fewer in number, but some are extensively drawn. They include:

1. The cautioning of the secret society priest (stage 1, l. 6d)
2. Elders who should but do not speak up (stage 3, song 1, ll. 1-8)
3. Leaders ridiculed in Mgbom-Ugwuego land disputes (stage 3, song 3)
4. Leaders ridiculed in Anohia Nkalo–Ndibe disputes (stage 4, song 1, ll. 1-4, 14-37)
5. Failure to protest against actions of stranger government workers at Afikpo (stage 4, song 1, ll. 5-12)
6. Chief Isu's failure to help his village (stage 4, song 1, l. 13)
7. Dispute over the Amuro village gong (stage 4, act 2 and song 3)

The main themes are that leaders should not act against the interests of their own people, especially for personal gain in the form of bribes or other devices of self-aggrandizement. The foolish behavior of leaders results in their deaths, as well as misfortune for the community. The Afikpo are most vague as to the mechanism behind these deaths: they say that "dispute kills men," and if an active leader dies, the cause is usually traced to some dispute. If pressed further, Afikpo will suggest that the death came from poison, sorcery, or some unknown medium. But there seems to be no institutionalization of these beliefs; as there is no public ritual of investigation followed by accusations and a trial of a supposed provocateur. However, comments that the leaders act against their people's interests are often heard in everyday speech. And it is widely believed that leaders act in many ways for personal gain against the interests of their communities.

Elsewhere I have raised the question of whether corruption exists to any extent in traditional societies (S. Ottenberg 1967, pp. 38-39). The criticisms in the ɔkumkpa suggest that it is a part of Afikpo life. Most of the cases in this play occur within the traditional sector at Afikpo rather than through modern government contacts. I argue that they probably also occurred in the past, and that the play reflects essentially traditional criticisms of corrupt behavior.

Leaders from many parts of Afikpo are mentioned, although criticism is certainly also leveled at heads of the village in which the play takes place. The larger disputes and events at Afikpo are seen as influencing village life. Certain leaders' names appear again and again: at the village level Uhyum is the object of a variety of comments; and on a wider level Chief Isu of Ngodo frequently puts in an appearance. In fact, the latter crops up in many Afikpo plays: he is the prototype of the foolish leader, a prominent man who fails to follow the proper norms. I suspect that he is portrayed so frequently because, while he has the image of a "palaver man," he rarely succeeds in his endeavors and is often "broke" and inept in his operations. He thus becomes a natural symbol of corrupt and foolish practices. On the other hand, Uhyum represents the stubborn man who goes his own way regardless of the consequences. He runs to the police, or to the forest guard, in order to gain his own ends, a form of behavior highly despised at Afikpo. He could be considered the protagonist in the play, if there is one at all.

Two elements in the above list (numbers 2 and 5) criticize persons who do not fulfill their obligations to lead and be active. Afikpo believe that a person who has money should take titles and marry many wives, likewise, a man who is of the proper age and in good health should speak out and act vigorously. Passivity is seen as being unhelpful to the community.

While persons who are capable should be active, the "palaver man" should not step out of line. Leaders should not become too strongly independent, too "big." If redistribution of wealth through title-taking and marriage is the norm, so is a leveling of power among leaders through cooperative action toward a desired end. In a society that stresses individual achievement

equally as much as cooperative behavior in decision-making, it is no wonder that the ɔkumkpa returns again and again to cases of leaders who break out from the delicate balance of this contradiction for individual gain.

The comments concerning leaders in the play are of the kind that are commonly gossiped about in the Afikpo villages, but rarely publicly made outside of the ɔkumkpa. In the first place, age and authority are closely related (S. Ottenberg 1971b), so men rarely criticize their elders directly in public in the manner that they do in the play; the closest they come is through oblique reference or implication. A direct approach would lead to a severe fine and to loss of status and influence. Deferential behavior according to age is the rule, and the players are too young to be members of the councils of elders that control the village and its compound. Middle-aged and young men attend elders' meetings, but they must be circumspect in speech, generally saying little at all unless called upon.

The unusual nature of the criticisms of the elders made in the play is indicated by the general interest shown in them by the audience, including the elders themselves. It is also attested by the rules prohibiting revenge against players for their actions, and by the anger that some leaders feel at being satirized. It is further suggested by the Afikpo's belief that the play is after all only a funny affair of masked men pretending to be "fairies."

The criticisms of the elders, as well as other aspects of the ɔkumkpa, present an interesting study in role reversal. The players become elders, the elders in the audience come to act like younger men. It is the players who are active, who develop and initiate and create. The elders and others in the audience are relatively passive, more or less accepting the comments of the players, whether they like them or not, as younger persons do of actions of the elders in everyday life. It is the players, rather than the elders, who are the moralists, commenting on individual behavior and the violations of norms. The players now are surrounded with an aura of secrecy and supernaturalism through their costumes and masks and their associations with the secret society, while normally it is the elders who have the greatest religious contacts and controls, act as intermediaries between the spirits and the living, and control the secret society.

Why do the elders sanction a performance of what is in good part a series of satires about themselves? Elders like to see other elders satirized, as well as other persons. Some elders seem to enjoy being depicted or sung about, for it is a mark of their power. And the play asserts traditional norms and beliefs thereby supporting traditional leadership and its values. The players are not asking for a social revolution, but rather the proper execution of traditional leadership patterns.

Further, the authority structure amongst the players reflects traditional standards. The leaders are older players and control the play because of seniority and personal skills. The ɔri, who are older players among the chorus, dominate much of the acting, singing, and dancing. The younger players are less active and play little role in the shaping of the play during rehearsals. The feminine qualities of the younger players in dress and dance, and their positioning at the rear of the chorus, also suggest a more passive, and inferior, role for them. There is a strong cooperative air about the performance, with the two main leaders playing a major but not highly authoritarian role. All of these features mirror traditional patterns of control; among the players there is no reversal of authority roles.

It is interesting to note that there are two references to the senior leader's father in the play. In one song line (stage 4, song 2, l. 7) he is asked to get his gun and fire it because the play is on, which is a request for his support and in no sense criticizes him. In the act concerning the disputed drums (stage 4, act 2) he is indirectly praised for playing an honest role and for tricking his opponent into believing he has a role to play in the election of the new Native Authority Court member for the village. I have never heard a play leader criticize or ridicule his father at one of these plays, just as it is rare at Afikpo in other social situations.

Male and Female Roles

There are also a number of references to the sexes in the play. They are:

1. The order for silence so that they may hear the songs (stage 1, l. 6b)
2. Women who dominate henpecked husbands (stage 4, act 1, second part)
3. The women's "head-pad" society and boys' initiation (stage 4, act 5 and song 5)
4. Women who are overly interested in the secret society (stage 4, song 5)
5. A man who is foolish in marriage and with his mother-in-law (stage 7)
6. A beautiful girl who rejects all suitors (stage 8)
7. Women's failure to become pregnant because they sing secret society songs at communal fishing (stage 9, first part)
8. The dances of the akparakpa (stage 2; stage 4, song 5; stage 8)

The main themes here are that women should behave like females, following the traditional sexual role dichotomy, and that men should not behave like women or let females dominate them. The first theme is well explored in the idea that women should stay clear of the secret society and its activities and not learn its secrets or act as if they were secret society members (numbers 3, 4, 7

above). They should be passive before men (number 1). Men, likewise, should not be weak before women (number 2) by playing a feminine domestic role, nor should they act in a foolish or stingy way with regard to what women are entitled to receive from them (number 5).

A common theme in Afikpo society (P. Ottenberg 1959) is the separation of the roles of men and women. In pre-European contact times the distinction was easier to maintain than by the 1950s and 1960s. Because of the slave trade and the tendency toward fighting in the Afikpo area, women had little personal freedom. They were sometimes taken to the farms in groups and guarded by the men. They played a strong domestic role but did little else, having almost no money, carrying out only petty trade in a market dominated by males, and finding only a limited prospects for cash cropping.

By the time that my research was carried out they had much greater freedom. Restrictions on their movement because of slave trading and warring had disappeared. They had become involved in growing and preparing cassava for sale, largely in the form of gari. Cassava is still a relatively new crop at Afikpo, which the men considered inconsequential and refused to grow. It is a major cash crop because it is sold to persons at the numerous schools and the government headquarters at Afikpo. Women have a saying: "When a woman has money—what is man?" Further, the influence of education and the missions has made some females critical of the secret society and its supposed power to prevent successful childbearing among women who violate its rulings. One educated lady, the daughter of educated parents, by 1960 had borne five children without a death, although she had flouted the secret society from childhood. Others were beginning to follow her lead.

These factors make it difficult to maintain the sexual role dichotomy. In an achievement-oriented society, as at Afikpo, where there is a strong sense of individualism, it is a contradiction to try to keep women "in their place" while men achieve. A woman is expected to play a limited and essentially submissive role in a society that stresses considerable independence of individuals, and she is expected only to achieve in ways approved by men. The play expresses the men's point of view in these matters, as an extension of the secret society, which strongly espouses male dominance over females.

While the play strongly states that men should not be weak and submit to women but should fulfill male roles, one also finds the phenomenon of men acting like women in the play. In this the masks, as well as the costumes, are key symbolic elements. There are also the akparakpa dancers and the "queen." The ɔri players portray female parts in some acts,

although when their act is over they return to the ɔri group in the chorus and thenceforth are seen as males. Further, they wear essentially male costumes.

I believe that men acting as women is employed here, as it is in some other Afikpo events, to underline symbolically the sex differences. When men dress up in feminine styles and dance as females they are restating their maleness and their attitudes toward the distinctiveness of the sexes. The humor and satire of the sexual reversals help stress this distinctiveness.

It is also interesting that those who appear in the feminine roles, with the exception of an occasional ɔri actor, are the younger players. There is some correspondence of social positions here: boys, like females, should obey adult male authority and follow the roles that have been shaped for them by the secret society. Boys are also not fully mature males—their sexual distinctiveness is still in the process of formation. By the boys' acting in feminine ways the play reiterates the desire that they should act as males. It is significant, in this context, that two of the three akparakpa dances in the play just described occurred in the context of an act and song concerning females (numbers 3, 4, and 6). It is significant, also, that girls and women enjoy these feminine elements of the play as well as men.

The whole performance outwardly symbolizes the division of the sexes at Afikpo. Females are excluded from participation, even to the extent of directly giving "dashes" at a performance, and they sit in the worst seats. They do not contribute to the production of the play except for lending costume parts and serving as source material for songs and skits. There is a ritual separation of the players from females the night before and the night of the performance.

Related to the sex theme are the views as to how *men* should behave. They should take titles, be generous, be wise and strong. Certain attitudes are manifested toward persons associated with the play: the mask carver is a funny man who should not be taken seriously; the musician does not represent a major profession, though his products are necessary; and the play leaders are foolish persons who gossip and make fun of others, although everyone enjoys watching their plays. These performers all have qualities in common. They are not politically influential persons (although one ex-play leader was rapidly becoming an important spokesman in Mgbom). They have not usually taken the high titles and are not wealthy. Their efforts in carving, music, and in putting on plays are relatively unrewarding economically in a society that heavily stresses making money. They are seen as preoccupying themselves with interests that are not the most personally advantageous. In short, they are the

antithesis of the high achiever, the successful Afikpo male.

Thus the play, in which the aesthetic efforts of the "funny" carver, the "amusing" musician, and the "foolish" play leaders are joined, symbolically states the finest goals of Afikpo males by publicly negating them in the act of putting on the play. For the players themselves are foolish and funny, not acting as men should, as they are acting out the foolishness of others.

Illness and Misfortune

A number of other ideas emerge from the play. One is that persons who do not behave properly become ill or die or suffer some other misfortune. This theme is represented by the following cases:

1. Man who faints while carrying palm wine in the title ceremony (stage 1)
2. Secret society priest who died before his time (stage 1, l. 6d)
3. Persons who have no physical defects but still fail to speak up (stage 3, song 1)
4. Leaders who died as a result of disputes (stage 4, song 1, ll. 14-15 and their repeats, and l. 35, on men's resthouse fire "caused" because of dispute)
5. Man who is beaten up because of his violation of social norms (stage 5)
6. Statement that women will not become pregnant if they violate secret society rules (stage 9, first part)

The idea of a causal relationship between behavior and physical effects is both directly (numbers 1, 2, and 4) or indirectly (numbers 3 and 6) expressed. The case of the ostracized man (number 5) who is hit down by his fellow agnatic lineage mates also illustrates this theme, for his misfortune and the consequences of his "cure" are seen as a result of his failure to come to terms with his compound. This case blends a number of themes: illness as a result of breaking norms; illness as a "weakness" that feminizes a man (he is played by someone dressed as an *akparakpa)*; and the unhappy consequences of contact with outsiders.

The idea that illness and death are caused by the failure to act properly is widespread in Afikpo. Diviners frequently ascribe the cause of some illness or death to the anger of an ancestor or some such spirit over the neglecting or violation of a ritual or some other norm. It is often believed that a failure to produce offspring is the result of the woman's violation of the secret society injunctions, whether recent or in the past, whether she is aware of her actions or has no remembrance of them. Health and correct behavior are intimately bound up at Afikpo. Even the case of the loss of bodily control (stage 4, act 1, first part), or the man who becomes drunk and falls in the latrine (the last example in stage 4), can be seen as related to foolish behavior.

Internal Groups and External Relations

Another theme concerns the primary focus on the local village, with moral commentary that can be extended to Afikpo as a whole. There are a number of references in the text both to the home village and to the village-group. A neighboring village is also occasionally mentioned, especially in regard to some event that connects it with the home village, as in the Mgbom-Amuro matter over the collection of funds for their joint primary school. Basically the play represents the level of gossip known at the home village, a point that will appear again below.

The *ɔkumkpa* presented above in detail says nothing about the villages or the people of Ozizza, the northern Afikpo communities, with which Amuro has little contact. At the same time my field assistant, who was from Mgbom in the central Afikpo area, had a great deal of difficulty in understanding many of the skits and songs at the 1952 *ɔkumkpa* presented in Amorie, an Ozizza community. The play referred to local events with which he was unfamiliar. Thus, some minimal level of understanding of local events, often through gossip, seems to be necessary for a full appreciation of the *ɔkumkpa*. While the play may expose certain details, even to the point of muckraking, part of the audience probably has at least some knowledge of and information on the characters and events involved. The play, then, fills out this knowledge, makes it public, and points up the moral and the story through satire.

Although the *ɔkumkpa* is traditional in style and deals primarily with internal Afikpo matters, there are references to outside influences. Plastic beads, khaki pants, Ibibio-style masks, and other foreign costume elements blend into the production comfortably. But the songs and skits indicate a different view: the outside world is dangerous and destructive, and strangers may cooperate with Afikpo in bribery and other actions that go against the interests of the village-group and its members. This view can be found throughout the above play:

1. Man who goes away and returns poor (stage 3, song 4)
2. Stranger government workers at Afikpo arrange for many Afikpo to be sacked (stage 4, song 1, ll. 5-12)
3. Man referred to derogatorily as an Amaseri (stage 4, act 1, first part; and l. 2 and its repeats in song 2)
4. Deceit of the Edda gong maker who agrees to overcharge for village gong, but charges the true price to the second group (stage 4, act 2)
5. Forest guard's conniving with Uhyum to

accept gifts in the cutting of the tree (stage 4, act 3)

6. Unhappiness caused by the District Office police in drum dispute (stage 4, song 3)

7. The interference of the women's society, a modern voluntary organization, in secret society initiation when it should not do so (stage 4, act 5)

8. The curing of Uhyum by a Catholic priest (stage 5)

9. The statement that medicines from outside Afikpo can be hard to control and are therefore dangerous (stage 9, second part)

The views reflected here are not by any means unusual. Afikpo have a chronic suspicion of all modern governments; frequently regard neighbors (especially non-Igbo to the east) as "poisoners," not likely to be reliable or trustworthy; and resent the increasing outside control over Afikpo affairs.

Other Sociological Features

It is also important to note that direct praise of persons is rare. When it comes, it is in pleasant contrast to the spate of satire that goes before and after it. The most notable instance in this play is the praise of Urom (stage 4, song 2, ll. 3 and 18) for being generous and for behaving as a strong individual. The other direct instance, the praise of former play leaders (stage 2, ll. 1-2 and their repeats), comes early and is not as contrastive. But the characteristic approach of the play is to make its social and moral points through criticism, which appears to be more interesting and amusing to the audience.

Although Afikpo is organized into both matrilineal and patrilineal unilineal descent units (S. Ottenberg 1968), the only reference to matrilineal matters in the play just described is in the citing of the matriclans of important individuals (stage 4, song 2, l. 18). Why they are mentioned here at all is not clear. The absence of uterine reference is typical of other ɔkumkpa plays that I have seen. The events either have a patrilineal concern, involving members of a compound, which normally contains a major patrilineage; or they refer to village and village-group matters, where residential factors rather than descent dominate. The lack of matrilineal emphasis may seem surprising, for land is largely controlled by matrilineal units and movable property is mainly inherited through the uterine line, two features over which there is no end of intrigue and "palaver" at Afikpo, involving the same persons who are prominent in the villages and compounds. But the matrilineal groupings are not residentially based, face-to-face organizations; their members are scattered over numerous villages, and their affairs are not the direct concern of the villages or compounds (S.

Ottenberg 1971b, pp. 306-7). Probably for these reasons the play rarely refers to these uterine units or their affairs.

Similarly, priests and diviners are seldom mentioned, except in nonderogatory terms. The secret society priest is indirectly warned that he should act well if he wishes to live long (stage 1, l. 6d); and the diviners try to cure the man with the broken wrist (stage 5), but they are not criticized for failing to do so. Religious officials are powerful persons, like elders, but they are more feared because the source of their power is greater and less well understood by the ordinary Afikpo. Since they are believed able to act in revenge through sorcery and other mysterious techniques, they are treated gingerly by Afikpo.

References to children are almost totally absent in these plays, which concern themselves with adult foibles. Rather, children's behavior is important in the acts and events in their own imitation secret society plays. Similarly rare are references to dead persons, except those who have died as a result of a dispute or some foolish action. The play does not invoke ancestors as a source of morality as other Afikpo rituals do. The play just simply states what is improper and what the consequences of poor behavior are. Although involving masked "spirits," the ɔkumkpa is largely secular theater.

The ɔkumkpa is essentially traditionalistic in its themes, advocating strict adherence to normative behavior patterns, especially for females, and displaying suspicion of outside influences. However, these plays are not totally against change. For example, in the Mgbom play of 1960 those who collected money for the Mgbom-Amuro primary school were criticized only for spending much of it on themselves; the play went on to indicate that the school construction would nevertheless continue. Thus, innovations that have considerable internal support in the community seem to be acceptable in the play.

In this regard the traditional criticisms of the leaders of Afikpo and its villages coalesce with those of the present-day young adult progressives of the village-group (S. Ottenberg 1955). The traditional view satirizes leaders for following self-interests at the expense of traditional values, while the progressives are concerned that the elders cause dispute and "chop" the village funds, thereby slowing up progress and change. The progressives' views are expressed largely through village improvement societies (S. Ottenberg 1955; 1971b, pp. 172-84), rather than directly through the play; yet the players do represent a blending of young and middle-aged persons with views ranging from highly traditionalistic to most progressive. Some are educated, as we have seen, and the senior leader of the play just described has two occupations—photography and farming—

one modern, one traditional. While the ɔkumkpa is not a vehicle of social change and the progressive viewpoint, it is not always in contradiction to this approach, for it criticizes the elders, and upholds moral views of personal behavior and worth that are also held by progressives. For example, progressive men often do not want their wives bound by traditional Afikpo rites and beliefs, yet they prefer them to remain domestically oriented. For these reasons the young Afikpo adults of a progressive nature are not repelled by the play, but indeed relish it.

Functions and Themes

Some of these points can be reviewed in social functional terms (S. Ottenberg 1972a). The play is one vehicle among many at Afikpo through which traditional norms associated with the patrilineages, the villages, and Afikpo as a whole are stated. In this context it fits well into the theme that certain activities during the ceremonial season at Afikpo aim for social adjustments and realignments. The ɔkumkpa is a humorous scolding of those who deviate from accepted social roles and norms. Placing the statements in the context of a particular situation and specific individuals heightens their interest and effectiveness. It is a form of morality play, concerned with how persons *should* behave through showing how persons have behaved.

The ɔkumkpa is also one of a number of social mechanisms by which the men attempt to control the behavior of women according to their standards, even in the face of the increasing autonomy of females. The play functions to create an illusion of a return to traditional sex-role standards.

Third, the play is a medium through which the young and middle-aged adults can air feelings about their elders that they could not otherwise explore directly in public. Thus it acts as a tension-reducing mechanism for traditionalistic and progressive young men and for the elders who are watching the performance, in a social system in which generational conflicts are inherent. The criticisms in the play serve to control the elders' behavior, to cut down and level off the tendency of individuals to develop power and to move toward a rank individualism, which is considered destructive to the community.

The play is based on facts that are partially or fully known to members of the audience. For this reason some actions are not fully explained in song and dance, and therefore maximum enjoyment of the play depends upon some knowledge of the events being depicted. The humor comes at least partially from making public what has already been gossiped about. Insofar as gossip plays a divisive role among persons and groups living in the same community or communities, the play acts as a unifying device by publicly airing the gossip. The association of gossip with the village also separates it, as a distinctive social unit, from other villages (Gluckman 1963).

The "secrecy" of the masked and costumed players becomes a mechanism for revealing events. This is perhaps the reason the play is presented twice at the most. Its contents are particularistic to only one or two audiences; beyond them the personal names and events referred to in the play have limited meaning. And since there is no plot development, outsiders do not find much of interest in it. Contrast this pattern with the *njenji* play (see chap. 9), where masked and costumed dancers also appear, but in generalized roles: Aro slave trader, girl, boy, schoolboy, missionary, married couple, Muslim, schoolteacher, and so on. Here the players go from village to village in parade form, and the more general nature of these roles helps to create a more widespread interest in the parade among persons living in various sections of Afikpo.

By its very enactment the ɔkumkpa supports the view of the village as a unit. The quality of the performance is seen by Afikpo, either consciously or unconsciously, as a statement of the unity of the community, as a measure of its ability to organize a complex event. A well-liked play creates the impression of a well-organized village; a poor play reflects negatively on the village. And persons often comment on the relative qualities of ɔkumkpa plays given by different villages in the same and in different years.

The themes and perspectives of the ɔkumkpa reflect the Afikpo male's view of life, and the play symbolizes the dominant male role in the social and political integration of the village and of Afikpo (S. Ottenberg 1968, 1971b). Women's concerns and interests are mirrored only indirectly. Females leave home on marriage and often marry several times in their lifetime, moving from residence to residence and from village to village within Afikpo. Their ties to specific settlements are much less intense than those of the men, and they are less effectively organized for social and political matters on the village level and at Afikpo in general. They are united by a common sexual identity and outlook and life experiences rather than through formal organizations. Their views on social matters find less public expression than those of the men, although they can be equally as biting, as in their songs at the annual *Mbe* festival. But if the ɔkumkpa is community theater, it is entirely a male expression of the community.

These comments reflect intended functions, some manifest and some latent. The fact is, however, that other than acting to reduce tension between young men and the elders and to ending the divisive effects of gossip, the play probably has

little lasting social influence. Elders keep on taking bribes and acting against the interest of their communities. Women continue to move away from traditional roles. Men and women still act in foolish ways and violate norms. Men continue to be stubborn and are occasionally ostracized. New subjects for gossip soon arise, and even the information presented at the play is talked over again and again after the play and is subject to various interpretations. If the ɔkumkpa is a morality play, or expected to do away with tensions and conflicts, its consequences are minimal. It is a play of intention rather than consequences: its humor engenders direct and considerable interest and generally leaves a pleasing after-effect.

PSYCHOLOGICAL FACTORS *

Perhaps the most important psychological feature of the ɔkumkpa lies in the familiarity with its elements held by Afikpo males since boyhood. As children they see adult performances and, at least until recently, hold well-performed, sometimes elaborate, ɔkumkpa of their own. The high level of skills of the adult players is the result of years of experience and informal training going back to the first ten years of boyhood. The older adult ɔkumkpa players—the play leaders and the ɔri—represent the highest development of aesthetic expertise in masquerades. There is a continuity here of creativity and artistic development from childhood to at least middle age, after which time direct participation in this play and in other masquerades usually ceases (although some older males play advisory roles and most elders enjoy watching the play performed).

Boys clearly copy older boys and adults in preparing their masks and costumes and in putting on their own performances. There is a great deal of emulation in the ɔkumkpa produced by the uninitiated boys, although the specific events and incidents depicted in their plays may be original to them. They teach themselves to a large extent, rather than being directly instructed by older noninitiated boys or adult males.

This pattern of continual growth in aesthetic sensitivity and skill contrasts with the apparent social differentiation that distinguishes the noninitiates from the initiates into the village secret society. Initiation is a prerequisite to marriage, to taking part in adult social affairs in the village, to entrée into the rich political life of Afikpo. It is a prerequisite to the taking of the important secret society titles and, of course, to using the men's resthouses in the village

and its wards—social centers for male adults. Initiation brings the child from the level of the compound and the backyard to the village; symbolically, if not always in fact, it changes the boy socially into a man.

Yet while the initiate takes part in the ɔkumkpa and in other plays using better-made masks and more elaborately prepared costumes, with better musicians and a larger audience more varied in age range, the qualities of the experience are probably similar to those of childhood. In the area of aesthetics, therefore, initiation into the adult society does not mean a break with behavior of the past, but rather a further enrichment and interpretation of it. The aesthetic experience of the individual helps to integrate the varied and changing social activities that he is involved in during his lifetime. It provides a continuous thread that is woven into many life patterns, as are ties of descent and village residence.

While some aspects of the life of the secret society member, such as title-taking, seem particularly unconnected with childhood, the artistic aspects of this play, and some other masquerades to varying degrees, connect directly with childhood experience. I believe that this is one of the charms of the play and one reason that it holds such general interest for males of all ages at Afikpo. In any society some aesthetic experiences are clearly tied into childhood experience, while others are more immediately and directly a development of adulthood. I do not consider either more immature, more childlike, less sophisticated; it is mainly a matter of where the psychological associations lie.

It thus seems to me as fair to consider the adult ɔkumkpa as a reflection of childhood experience as it does to view the childhood play as an emulation of the adult form. Males are returning to a childhood activity that they experienced intensively, with much delight and amusement. The fact that Afikpo view the adult ɔkumkpa as something that is not serious, the carver of masks as a "funny" man, and the play leaders as "foolish" persons reinforces this view. There is a kind of game going on here, carried on with the skill and expertise of knowledgeable adults, involving mma "spirits" and using the kind of direct references in the skits and songs that children are wont to make about other persons without the internalization of adult prohibitions against speaking out. The masks, the whole apparatus of the secret society behind the ɔkumkpa, provide a psychic screen that permits this behavior.

The adult play reflects some of the mental images, goals, and interests of the growing child. One striking element is the role reversal, whereby the performers are the wise men, the moralists, those who are backed by religious forces and who pass judgments on others. Psychologically, as well

* I am very much indebted to my wife, Nora, for many of the ideas in this section; their particular development is my own.

as socially, players take the roles of their fathers: they have replaced them in leadership and they are in control. An unconscious wish of male children is acted out in the adult play.

Again, the players are divided into two main sexual groups, the ɔri and the akparakpa. The ɔri are male and are said to be "funny"; the akparakpa have a female quality and are considered beautiful, not "funny," although in fact persons are amused by their dancing and dress. The ɔri wear dark raffia costumes—the very style, incidentally, that some of them wore when they were initiated into the secret society, although not with the same masks. The masks of the ɔri tend to be dark and ugly, representing distorted male faces. The ugly mask forms that have distorted, bulbous cheeks and crooked, twisted noses might be viewed as castrated forms, the cheeks representing testicles, and the nose a castrated or distorted penis.

The ɔri players act the parts of men who are ridiculed as foolish, and are often representative of elders and leaders. The ɔri player is the prototype of the evil, castrating father, whose actions are detrimental to the young. There are many of them, perhaps because a male child is likely to be under the authority not only of his father but of other adult males in the compound, especially close male patrikinsmen of his father. "Fathers" are criticized from both the point of view of the traditionalists and the progressives among the players. Both positions of criticism are psychologically valid, although they differ sociologically. It is interesting, however, that the leaders do not criticize their own fathers in the play; in order to be less direct, their criticism is displaced to other "father figures."

The akparakpa, by representing unmarried girls, introduce the element of contrast between male and female. They are considered beautiful in mask and costume, and they dance in pretty, feminine styles. They may be foolish, as the "queen" is, but they are not seen as evil or destructive. They are brightly colored or white-faced, and delightful. In a sense they represent a child's conception of his mother, at least at a subconscious level: bright, beautiful, young, and happy. The contrast with the ɔri is evident.

The "queen" is the focus of the feminine interest. We have seen how the audience eagerly awaits her act and how men vie to secure the chance to play this role. The act concerning this figure can be interpreted as a subconscious wish that she not marry. The foolishness of the girl who rejects suitor after suitor is an indication that she has another idea in mind. It is interesting to note here how critical the audience is of her dancing: in two of the three performances of this stage of the play that I have seen, her dance was interrupted by men in the audience because it was

poorly done. Is this disapproval only associated with a certain weariness on the part of the viewers toward the end of the play? I speculate that unconsciously the male audience does not wish to see her carried away by a successful suitor, but instead enjoys her unwedded state, as a child may fantasy his mother. The lack of overt sexual references in the play, while they are elsewhere expressed in a great deal of gossip and in the ritual dancing feast, Mbe, held earlier in the year, can be seen as an attempt to put aside the growing child's sexual awareness and wishes for the sake of a mother-child affective bond, which is viewed as overtly nonsexual. There is almost complete denial of adult sexuality in the themes of the play and in the sexual taboos imposed upon players the night before and the night of the play. They sleep at night in the common and its resthouses as they did when young in the compound ancestral resthouse and the boys' sleeping house (ulote). I have only one recorded ɔkumkpa event, a short skit in the 1960 Amuro play, which contains a sexual element: a prominent Afikpo retired government worker and a politician is depicted at a political rally for the major party there flirting with women who kiss and hug him and carry his yams for him.

A related theme is that of sexual distinctiveness of males and females. We have seen how the play reiterates this feature, as does the adult secret society in general. Perhaps Afikpo males are anxious about their own masculine role and are projecting unconscious feelings upon women. Acts in the play, such as that of the henpecked husband, represent not only a wish to return to the mother, but suggest some anxiety over the male role. Further, the great interest of the audience in men who dress up and act as females, as with the akparakpa, even though elements of costume and some mask features are clearly of a mixed sexual nature, suggests male concern with femininity within themselves.

The matter is perhaps most clearly symbolized in stage 5 in the 1952 Amuro play, where a person who has been hit is cured by a diviner or another person. The sex and age of the ill individual are ambiguous, since a boy or young man dressed up in the feminine akparakpa's costume acts out this part of an older man who is considered evil and/or foolish. In this particular play he is symbolically twice castrated: he is "cut off" from his kinsmen and he has a broken wrist. The ill person in these plays comes under the control of an elder male who cures him (or her). This act can be interpreted either as the Oedipal act of attachment of a girl to her father—a projection of the reverse situation of mother and son—or the domination and control of a male, the curer, over a younger male, a strong father-son relationship. It is also interesting that in this particular play the boy is cured by a Catholic father, a person who is expected to be nonsexual and celibate.

The sexual role ambiguity can also be seen in the presence of the *ibibio* masks on the *ɔri* dancers. Ibibio forms, as we have seen, are generally classed with the beautiful female masks, yet they are worn by the *ɔri* dancers and not the *akparakpa*. In some cases this seems to be simply a matter of choice of the player, and these masks are becoming more and more popular. In other cases the *ɔri* players wear them because they will play the parts of married and generally middle-aged or older women, sometimes prominent female leaders, in the acts. The *ibibio* forms thus represent females of a different type than those worn by the *akparakpa* dancers.

The ambiguity of sex can also be seen in the *akparakpa* costume and some of the masks worn with it. The boys dress in feminine style, yet they wear male shorts. The *ɔpa nwa* mask that some of them wear is clearly female, but the *acali* worn by others is not. The *mba* used by still others has the female whiteness of face and facial form, but the top piece suggests either sexual neutrality or masculinity.

Therefore, while the acted and spoken themes of the *ɔkumkpa* espouse the separation of the sexes, and while the female *akparakpa* and the generally male *ɔri* are separated in behavior and placement in the chorus section, the play symbolizes sexual intermixture and the males' ambivalence toward females in a variety of ways. Symbolically, the play does not represent a clear-cut separation of males and females.

Related to this is the theme of the dominating woman. Afikpo men feel considerable anxiety over women who act as men and do not adhere to the restricted and limited feminine role prescribed for them by men. The major manifest function of the village secret society is to "keep women in their place," according to many Afikpo men. I was told that if I revealed the secrets of the men's secret society to anyone, the women would then come to know them and it would "spoil it." The idea of dominating women is evident in the skits concerning the henpecked husbands and the act about the women's "head-pad" society. The dominating female wears either *ɔkpesu umuruma* or *ibibio* masks, which are also worn by players representing male elders. The dominating female thus is seen as having adult male characteristics. If women would only remain in their roles, no problems would arise. The wish for the warm, nurturing mother is disturbed by the fantasy of the aggressive, dominating female. The play implies both the desire to be dominated and the wish of the adolescent to break away and to go his own way toward adult sexuality and maturity.

The desire to break away is reflected in the reiteration of the foolishness theme and the underlying admiration of the man who goes his own way and is able to accomplish his goals despite opposition. The latter is most clearly presented in the act concerning the man who takes his own titles and then is able to initiate his sons against the opposition of his village (stage 4, act 4 and song 4); but it also is expressed through the praise of the man who is like a molar tooth (stage 4, song 2, l. 18). In short, the desire of boys (and, of course, of men) to act out unconscious wishes in which they do as they please and get away with it is represented graphically in the play. The "palaver man" may be consciously condemned by the *ɔkumkpa* players and the audience, but the manner in which this is done suggests an unconscious admiration of him. The play therefore reflects the wish for female contact and domination in the mother-child situation and yet a desire to act out fantasies of independence and control, for the "palaver man" is surely in control if he is effective.

Other elements of the play follow the same line of thought. The emphasis on patrilineal groups in the compound and on the village is a male child's view of the world. As I have explained elsewhere (S. Ottenberg 1968, pp. 225-26), the boy's matrilineal descent ties are relatively minor, becoming important only in late adolescence and early adulthood. Further, the fear of non-Afikpo and the suspicion of the outside world, seen in the play, are early implanted in the child: he is warned to keep away from strangers, who in the old days kidnaped children and sold them into slavery, and who are still regarded with some suspicion. And children are told today that if they do not behave, the White Man will come and take them away.

The traditionalism of the themes of the play can be viewed as a subconscious wish to return to childhood, to an unchanged earlier time in the face of evident changes in the individual's life style as an adult and the obvious social changes occurring in the society.

In making these comments above I do not mean to suggest that the *ɔkumkpa* is an infantile or unsophisticated performance. It is mature, skillful, complex, creative, and dramatic. I wish only to state that it is a form of adult aesthetics that connects directly with childhood experience. The child anticipates adult behavior in the *ɔkumkpa* of the *enna*; the adult reiterates childhood experiences in the adult performances of this play. Analogous aesthetic forms probably exist in any society.

AESTHETIC CONSIDERATIONS

I now want to examine the *ɔkumkpa* as a form of theater, keeping in mind its contrasts with Western drama.

The play is a sophisticated and well-integrated vaudeville in which a series of separate events is carried out through acting, singing, and dance. The *ɔkumkpa* is united by certain common themes—the ridicule of elders, of

the sexes, and of foolish persons—and by the reappearance of the same foolish persons in different acts and songs. The performance is integrated through its organization into a pattern of standardized stages whose general order and style are known to the audience. It is further held together through its close relationship to the people of the community, whose foibles it explores. It is a community theater.

From the aesthetic viewpoint the major element is humor. Humor is central to the play; the quality of songs and the acts is judged largely by their humorous content. In general, if they are not funny, they are not liked very much. The humor is direct, and the emphasis is on satire and ridicule, but without sexual innuendo or the use of obscenities of voice or gesture.* The scenes and songs are topical. Only occasionally, as in stage 4, song 1, lines 1-4 and 14-37, is old material used, but even here it still remains current, for the land dispute is still unresolved.

The humor, of course, revolves around making fun of persons who are known to the community, or to Afikpo, and in observing their reactions if they are in the audience. But there are several other levels of amusement involved that add to the pleasure of the play. Adult men dress up in masks and unusual costumes, pretending to be "fairies" and gamboling about. The players perform under the pretense of being "spirits," but almost everyone can identify at least some of them. Roles are reversed, the young men and boys acting as females, the middle-aged players as elders. Many of the events depicted, the characterizations portrayed, have been discussed and joked about by some villagers privately, but they have not usually been publicly referred to before. Gossip builds up a sense of excitement and tension, and the play releases some of these feelings, engendering humor in the very act of release. Finally, there is amusement in the return to childhood status and behavior.

Much of the charm of the play lies in the presence and interplay of these humorous elements. Some seem to continue throughout the play, while others are stressed more at some points than at others. During the initial stages of the performance the audience takes great interest in the players as "fairies" and in identifying them behind masks and costumes. Further on this element becomes more accepted and stress is rather on the content of their presentation and on the various role reversals. A good deal of the beauty of the play is in the fine use of these humorous aspects by the leaders and the players.

The action of the play is continuous, with short breaks for collecting "dashes" and for

* This is in contrast to some other plays in the eastern area of Nigeria, for example among the Anang and Ibibio. See Messenger (1962) and Jeffreys (1951).

dancing but with no real intermissions. The drama extends over a long period of time; but does not require constant attention on the part of the audience, for each story or theme is briefly developed and there is a good deal of repetition of the same points. Nketia (1970) has noted a similar pattern for traditional African music in general, saying that its small or short form "may consist of short phrases and sentences which are repeated over and over again with the minimum of variation," and that "it is music that does not exploit elaborate developmental techniques to a great extent" (p. 100). These features are true for both the songs and the music in the ɔkumkpa, where there is a good deal of repetition and little development. The art involved in the more lengthy development of events, as in the drum and election disputes in stage 4 of the Amuro play, holds a greater fascination for me, with my anthropological interest in the working out of details and my Western experience with longer plot development; but Afikpo seem to like the briefer depictions at least equally as well.

The ɔkumkpa is characterized by constant movement of players—the leaders, the ɔri as dancers or actors, or the akparakpa—and an almost constant sound of either singing, music, actors' speech, the voices of the play leaders, or some combination of these. Total silence and total lack of movement as mechanisms of dramatic content and contrast are not employed.

The play is performed before almost the entire community: the audience is not determined by ability to pay an entrance fee; the players are not restricted by the expenses of the masks or costumes. It is a popular drama for everyone, concerned with people and events of which the audience already have some knowledge, rather than some faraway or imaginary place requiring the audience to create a picture in their minds through the use of props, scenery, and vocal comments.

It is fitting, therefore, that the ɔkumkpa is staged in the center of the village, where other plays and dances are held, some major village shrines are located, and important village decisions are made. No special stage is constructed; the play is performed on the bare ground of the common, which has been swept by members of young male age sets.

The expression of the play's community aspects occurs in other ways as well. It is primarily meaningful in the village where it is presented. The players know the audience, the audience the players; the audience knows one another, as do the players. The audience, especially the male members, shout approval and disapproval at will and with gusto. If the "queen" in stage 8 does not dance well, viewers rush in and stop her. At various times the leaders ask the audience whether they should continue and the audience

shouts, "Yes!" The leaders ask the viewers if they have understood the actions and the latter shout that they have not; so the leaders explain what has occurred. The audience members move about a great deal and talk to one another. There is an easy, jovial air, with frequent interaction between audience and players as individuals come out and give "dashes" to the players. The audience is very much a part of the play (S. Ottenberg 1973). Passivity, or restriction to hand clapping, would make the ɔkumkpa quite a different theater form.

The play uses no scenery and depends upon sunlight for natural lighting. It employs a minimal number of props, and the scenes in the acts are set in ordinary places known to the audience: in or in front of a home, in a village, a compound meeting place, or a market. The visual effects depend upon mask and costume and the movement of persons, not upon scenery. It is a play of exaggerated movement, as in the akparakpa feminine dancing. Grace and delicacy of motion are not attributes of the play, although the "queen" attempts these; but skill in imitation, satire, dance, and movement is very important and highly developed.

For any viewer, the backdrop of the "theater" is formed by several elements: the portion of the audience that can be seen, the wooden and raffia fences of the compounds, the covered mud and cement-surfaced long seating areas (as in Amuro), the treetops, and the tops of houses in the compound. This distant scenery, which is natural and well-known to the audience, is primarily green and brown, contrasting with the brighter and darker coloration of the players, their masks and costumes.

The visual effects depend upon the contrasts achieved through the physical movement, colors, and the juxtaposition of differently costumed players: the two leaders, the ɔri, the akparakpa, and the musicians. They are arranged in different ways at different moments of the play and change swiftly from one position to the other, while the musicians always remain in the same position and the players never leave the "stage." Four distinct arrangements are fairly standard:

1. The entire group is sitting down, with musicians in front, the ɔri to the sides and in back of them, and the akparakpa to the rear. The leaders stand facing the group.

2. Some ɔri are in front acting, with the leaders somewhere in front of the audience; the rest of the chorus is as above.

3. Some of the ɔri are dancing, mainly in front of the musicians, but also moving off to the sides and back of the chorus. The leaders are somewhere to the side explaining the action to the audience, and the musicians, akparakpa, and the remaining ɔri are seated.

4. The akparakpa are dancing counterclockwise in a circle with the leaders off to the side explaining the past action to the audience, and the ɔri and the musicians are seated in the center.

The play follows a pattern progressing from number 1 to number 2 and then to number 3 or 4, but always with a return to 1, from which design each new action commences. The changes in these forms create a fine shifting pattern of color and movement, a contrast of darks and lights, of beauty and ugliness—the masks and costumes of the akparakpa in contrast to the ɔri.

The theater consists of three circular areas: the central one, where the chorus sits in a circle; the band of ground around it, where the players move about, generally counterclockwise if they move any distance, as they act, sing, and dance; and the more or less circularly placed audience, with the village setting behind them. In contrast to this circular setting the focus of action is lineal, going between the chorus and the seated elders, with these two facing one another. The elders, the place for the acts, and the musicians are in a line, sometimes with the leaders between the elders and the musicians, which is their prime position for starting any song or stage of the play. The players become like a human body: the leaders and/or the actors out in front form the head; the musicians and the beating of their drums represent the heart; and the chorus is the body. The dancers come out to form arms and legs in motion, either in the circular and linear design of the akparakpa or the individual movement of the ɔri. The lesser players, the akparakpa, sit at the rear, just as the lesser audience—the females, as Afikpo conceive them—are at the sides and the section of the common furthest away from the primary place of action, from the head and the heart and the central line.

In fact, the theatrical arrangement is too large, the distances too great, for the audience away from this main line to see and to hear effectively at all times, particularly given the tendency of members of the audience to talk to one another. The problem of the difficulty of aural and visual perception is accentuated by the lack of height differences and angling between the audience and the players. Everyone is on much the same plane, more or less on the ground. Hence it is necessary for the two leaders to move about in front of the audience explaining the acts and verses in speech and song. This procedure slows down the pace of the play a bit and adds to the length of time involved, so that any heightening of dramatic effect tends to be leveled down; but it provides for a strong sense of audience-player interaction. Further, dramatic transformation from one event to another does not depend upon the players' leaving the arena but upon their retiring to the chorus or coming out from it. Often the musicians start or stop playing to mark such changes. The movement outward and back to the chorus transforms the player into an actor or

dancer and back to his role in the chorus.

The play is essentially a secular display in which religious elements associated with the secret society spirit and instilled in the masked players give sanction to topical ridicule and commentary, in a sort of calypso event. The form and action of the play are roughly the same in each village, although the organization and rituals of the secret society vary considerably from one community to another. Myth, proverb, folklore, legend, and history abound at Afikpo, but none of these forms the basis of the play, which is topical. Their absence adds to the ɔkumkpa's vaudevillelike qualities. Even those few animal masks that are used, especially the mkpe forms, are not employed here to suggest folklore elements. Proverbs seldom appear in the songs or acts, myths or legends of origin are not involved, and references to history are brief, as in the allusion to the Ebiri origin of Amuro village or to Anohia Nkalo as an early Afikpo community.

Folklore enters in mainly through references to persons in terms of animals, usually in a derogatory manner. There is the senior brother who returns poor but was "as fat as an elephant when he left home" (stage 3, song 4, l. 7). One person is a "rabbit of the night" (stage 4, song 2, l. 5), another is a nightjar (stage 4, song 2, l. 9), and yet another a leopard (stage 5, l. 1). In other plays I have references to persons who are flying ants and spitting cobra snakes. Even the ɔkumkpa leaders refer to themselves and their players as "the big birds of the bush" (stage 1, l. 6c), although this is not pejorative as are many of the other animal references. I have also noted that the senior leader is popularly called "owl of the night." An animal reference heightens the impact of the characterization of the person referred to; it concretizes it, and also rather implies that the individual's bad or peculiar habits are natural with him, as with the species of animal.

The animals mentioned above abound in folklore and often have the same behavioral characteristics as in the tales, but there is usually no reference to the tales in the play. The ɔkumkpa seems to stand apart from the bulk of Afikpo oral aesthetics. Many Afikpo, particularly elders, make extensive use of proverb, history, and legend, and young persons, especially females, take delight in folk tales. In this sense the players provide a third literary style at Afikpo—that of middle-aged men —in their realistically satirical songs and humor.

There are certain characteristic patterns to the ɔkumkpa songs. In the play just described there were fourteen songs, one a repeat, the others differing. Songs are associated with an act in about half the cases. The ɔkumkpa songs are nonrhyming and generally have short lines, although the last one is often drawn out. Each line tends to be sung by a different person or persons than was the preceding one, so that considerable coordination

on the part of the singers is required. The call-and-response pattern is common. The response is not an accompaniment, background, or a mere repetition of the previous line, but is a genuine reply or addition. Such interaction occurs between the two leaders in many songs, being led by the senior one in most cases. Often, especially toward the end of the song, the call-response pattern may be followed by the two leaders and the chorus, but the latter does not normally end the song and does not often attempt to sing long lines. At other times the first leader sings a line, the chorus responds, the second leader then sings a line, the chorus again responds, and this sequence is then repeated a number of times. On still other occasions the assistant leaders sing the lines of the play leaders, with the chorus responding; but the assistants do not act as respondents to the two main leaders. In some cases a choice of responding lines is possible, or a selection of names to fit into a set line.

The leaders have great freedom to arrange the singing groups and chorus response pattern as they please, and there is much variation within a play and between plays. The leaders can also resing songs that have been popular as they go along, decide when to cut off the singing or the dancing, and in the second performance of the play determine which parts are to be omitted if it is getting late. They thus make important decisions while the play is in progress rather than following a rigidly set pattern. Their leadership skill in this regard is important to the success of the play.

Other features of the singing include the use of name substitution, which allows the satire to be broadened. Puns and plays on words seem to be lacking. Teknonymy, with reference to a spouse, a son, or a daughter, is common and reflects normal speech patterns at Afikpo.

There is also some use of what might be called "nonsense" syllables.* Professor Robert F. Thompson has kindly called my attention to the fact that in West African societies these are not "nonsense" at all, so the term is hardly an apt one. There are definite vocal patterns, and these are tied into dance and drumming patterns. Nketia, for example, has nicely worked out the relationship of these kinds of syllables to Akan drumming (Nketia 1963, pp. 33-35). I do not have the expertise to do likewise, but I make a few comments below on the use of these sounds in the Amuro 1952 ɔkumkpa.

In the majority of instances they occur at the beginning of a line. In only one case is such a syllable found in the middle, and only once do these sounds comprise the whole line. They never occur at the end of a line in my very small sample,

* Stage 2, l. 2; stage 3, first song, l. 3, and third song, l. 2 and repeats; stage 4, second song, ll. 4, 6, 8, 10 and repeats, fourth song, ll. 2, 3, 5, 7 and repeats; song, ll. 2, 4 and repeats; stage 8, l. 2 and repeats.

but drawn-out syllables from "real" words are sometimes found there (see below), which perhaps results in a balancing of sounds at both ends of the lines. The "nonsense" sounds also frequently precede a proper name—the name of a person or a term for Afikpo—as if to call attention to it. A variety of vowels is employed, both front and back, and the consonants are mainly soft ones, for example, the *v* and the *w*. The "nonsense" syllables occur both with and without musical accompaniment.

In the Amuro play there are about as many instances of the drawing out of "real" syllables as of "nonsense" sounds.* The majority of the cases are at the ends of lines, although in several instances they occur in the line, and in two a drawn-out word forms the whole line. There is a tendency for elongation to occur in the first line of a song, as if to call attention to the singing. The relevant sounds are always vowels, and the last sound of most Afikpo words is usually a vowel. The whole word is not drawn out, only its end. In the one case where a word ends in a consonant (*ogbom*, in stage 4, third song, l. 4), a "*leeeeeeeeé*" is added on. In a number of cases the word means "Yes," and clearly the lengthening is employed to emphasize the word involved. In most cases this condition occurs in songs not accompanied by musical instruments.

The songs tend to fall into an eight-line pattern, but there are many variations in length, for example, in the first song in stage 4. While the first three songs of stage 3 are almost similar in terms of the number of lines, the arrangement of repeats, and who sings what at what time, other songs follow a variety of patterns too detailed and differing to outline here. What is clear is that within the framework of the general features of the singing there is much variation in song style, and that while the leaders follow general guidelines and principles, they have considerable freedom to arrange matters as they wish. This, I think, adds to the delight of the play, when it is carried out skillfully. When songs are musically accompanied, the playing of the musicians is neatly integrated with the singing. In the main songs or main parts of songs the musicians are silent so that the words will be more audible. In the play just described, music is absent during the singing of the four songs of stage 3, the second and third songs of stage 4, the song in stage 5, and the repeat song in stage 6. The musicians play during the first two songs of the *ɔkumkpa*, in stages 1 and 2, but here the words are largely standardized and do not offer detailed explanations of events. Likewise, they play when

the assistant leaders and chorus sing the repeat parts of the first and fourth songs of stage 4 and song 5, which has little content. Similarly, they perform in the short two-line song of stage 8, when the "queen" appears, where the meaning of the lines is also clear.

The tunes are carried by the voices, the musicians stressing rhythm, with the drums dominating, the other instruments following. None of the instruments sustains a long sound, although drums play tonal differences. Flutes (*ofu ɔkpɵ*) are used in some other Afikpo ceremonies, but they are usually absent in the *ɔkumkpa* and other masquerades for a reason unknown to me. The musician's role is most important, perhaps, in the periods between the acts and songs, when the dancers appear and the drumming helps to sustain the motion and excitement in the play, in contrast to the quieter and more informative periods of the major sections of singing and of acting.

Certain sectional patterns emerge. The first two stages are more or less introductory, call attention to the play, and get the players out and settled in the common. The main body of the play is in the songs of stage 3 and the songs and acts of stage 4. The largest amount of time is devoted to these two sections, in which specific events are most fully explored. Some acts here are quite long. For example, in the play described, the politics relating to the dispute over the gongs is well brought out. By the end of stage 4 most of the critical comments concerning the elders as leaders have been made. Stages 5 to 9 are shorter and there is less singing involved in most of them, as if the singers have worn out their voices. By stage 9 the leaders speak rather than sing their last lines. While interest in the play begins to wane somewhat after stage 4, many persons look forward to stage 8, where the "queen" dances; however, in this particular play they were disappointed. The play ends by returning to the opening music of the first stage. There is, in a sense, no building to a dramatic climax; rather, one finds a heightening of interest in the third and fourth stages, and again in the eighth. Remarks and acts concerning women, as well as matters involving foolish persons and the ridicule of leaders, are not concentrated in any one stage, but are scattered throughout. This intermixing also adds to the leveling quality of the theater.

The aesthetic aspects of the play depend to a large extent on the creative abilities of the two leaders, especially the senior one. It is their skill in developing new songs and skit ideas that marks the success or failure of a play. They are aided by some of the more experienced *ɔri* players, who also, of course, produce stage 7 by themselves. None of the material is written down; it is stored in the head and transmitted orally to the other players to learn at rehearsals.

Unlike Western theater, the two main

* Stage 3, second song, l. 1 and repeats, third song, l. 1 and repeats, fourth song, ll. 1, 2, 4, and 6; stage 4, third song, ll. 1-5, fourth song, l. 2.

creators of the ɔkumkpa also produce it, direct it from onstage, and are the leading actors. They are the heroes of their own production. If the play has any consistent characteristics, they can be attributed to the leaders, for they are always playing their role, a role well-defined by tradition, yet requiring endurance, skill, and taste. And it is the behavior of the leaders toward the audience, and their sensitivity to its needs, that goes a long way toward making the play a success.

Nevertheless, the leaders and most other players are not professionals in the usual sense of the word, and this is also true of actors, dancers, musicians, singers, and carvers from other Igbo areas (Ames 1968, p. 80). In the play only the musicians are hired. They are specialists who work for pay, but even here they are also motivated by the expectation of presents and the pleasure derived from playing (Ames 1968, pp. 80, 82). Thus, the only other persons who are professionals are the carvers of the masks that have been sold or rented out for use in the play. But carving and music are both part-time careers. The ɔkumkpa, then, is essentially a performance of skilled amateurs drawn widely from the community, with some persons from other villages helping out.

It has been suggested to me by several persons who have carried out research on traditional African drama that this art form tends to deal more with feelings and direct expressions and less with the exploration of general and abstract ideas than does Western drama. Such broad generalizations are often difficult to explore in detail. Certainly, the ɔkumkpa depends largely on emotional appeal in its form of humor and audience reaction and in its explicit characterizations of individuals. And the short length of every act or skit does not allow complete characterization or the detailed exploration of abstract ideas and philosophies. The absence of proverbs, myths, and rituals, through which African ideas on the nature of man, nature, and the sense of the universe are often explored, further confirms the point. Yet these contrastive stereotypes do damage to the ɔkumkpa, for this play has many well-drawn comments on morality and norms, such as how the sexes ought to behave and the manner in which leaders should and should not act. The value of tradition is stressed, and views of how human beings should behave toward one another are detailed. Thus, the play is concerned with general and abstract ideas, in the areas of norms and values rather than with questions of man's inherent nature, although the play does draw a certain view of the latter. The references are directly to the present, to the villages, and to Afikpo, not to some utopia.

A VARIETY OF MASQUERADES

The Njenji Parade

The other Afikpo masquerades differ in style and content from the ɔkumkpa, and sometimes, also, from one another. While none offers the richness of analytical detail of this play, they are not to be slighted; discussion of them is necessary for a full understanding of the Afikpo masked rituals. Some contain themes similar to those in the ɔkumkpa, such as the sex role reversal and the attack on authority. Others express ideas that have not appeared so far: physical force as a real and symbolic element, and the employment of masquerades in the transitional rites from childhood to adult status. And they are varied in style and form: almost pure dance, a parade, chasing games, and initiation rites. New masks and costumes appear, but some face covering forms from the ɔkumkpa are also seen again.

The most elaborate masquerade is the njenji (walkabout), a public parade of costumed figures wearing a variety of net and wooden masks and of cloth and raffia dress. A larger range of costumes appears in it than in any other Afikpo masquerade. The masqueraders are the boys and young adult members of the secret society in a village or a section of a village. Accompanied by costumed praise singers, they move from their community through neighboring Afikpo villages before returning to their own home for a final public display. Only a few of the players dance or act, and other than the voices of the praise singers, there is no music. The njenji is a colorful display in which the skills are in the manner of dress, the style of movement, and in the contrastive features of the various masqueraders' costumes. The play is usually led and directed by men from the village in their late twenties.

DRY SEASON FESTIVAL

Njenji is presented as part of the four-day Dry Season Festival, iko ɔkɔci (feast-dry season), in the various Afikpo villages. The northernmost Afikpo settlements, the Ozizza villages, hold this festival during the same four-day period sometime in November, although it is called by another name and has a different form than in the rest of Afikpo. In late November the Mkpoghoro subgroup of Afikpo (Ndibe and its subvillages) puts on this event. After its four-day festival the ceremonies move to the Ugwuego subgroup (Ugwuego Elu and Amaizu villages), then to the Ahisu subgroup (Ukpa, Amachara, Ngodo, Amachi, Amamgballa, Egeburu, Evuma), followed by the Itim villages (Anohia, Kpogrikpo, Mgbom, Amuro, Anohia Nkalo).* Finally, the outlying village of Ibi, belonging to the Ahisu subgroup, performs this feast alone. Kpogrikpo and Anohia, the southernmost Afikpo villages of the Itim subgroup, do not do njenji and have only a truncated Dry Season Festival; most of their young men are away fishing on the Cross River at the time.

The dry season feast marks the first major appearance of masqueraders during the ceremonial season, although the secret society has already been active for a month or more and an occasional chasing masquerader, such as the logholo or the ɔkpa, has shown himself, as well as a masquerader associated with the secret society initiation. The other plays, okonkwɔ, oje ogwu, and ɔkumkpa, follow in time, if they are given at all.

Njenji introduces this Dry Season Festival, being performed on its first day. The remaining three days are given over to visiting and feasting. The festival is a time when girls visit female friends and relatives in neighboring villages as they have their feasts, and are visited at their own feasts in turn. There is a good deal of movement of young girls from village to village to visit friends and relatives during the month or so when the festival is being celebrated throughout Afikpo. Adult men feast their daughters and go to greet sisters, sisters' children, wives' mothers, and other female relations when they are having their feasts. In turn, they are greeted by these women when they have their own. These felicitations usually involve the giving of yams and other foodstuffs and the eating of rich food together. And on the last day of the feast, ɛkɛ, married women ceremonially retie themselves to their husband's ancestors by bringing a special soup which they prepare, to the ancestral shrine, where it is eaten by their spouses and other males. This act binds the wives to the sexual rules of the major patrilineage in the compound.

Afikpo say that the Dry Season Festival "is our Christmas," perhaps because it occurs about the same time and it involves a number of rich meals shared by relatives, as well as the njenji parade. It

* For a discussion of the subgroup organization of the Afikpo villages, see S. Ottenberg 1971c, chap. 8.

is said to be primarily a female festival because of the activities of the young girls and the homage that men pay to female relatives. The *njenji* parade symbolized these features, as we shall see. Many of its players are dressed up either as girls or as married women, and the parade involves movement from village to village.

Njenji exists in two forms. In its elaborate version it is led and organized as part of the initiation of an age set in the village (S. Ottenberg 1971b, chap. 3), or by a newly organized age set. This normally occurs once every three years; in other years the village presents a much-simplified *njenji*. But two features should be borne in mind: first, the age set formation occurs in different years in different villages, so that every year there are a number of settlements that carry out the elaborate *njenji*; and second, the three-year span between the organization of a village age set is more theory than practice, resulting in much variation. For example, Mgbom put on the elaborate form of the play both in 1959 and 1960, as a new age set was formed in each year. Therefore, one cannot predict which villages will put on versions in any given year.

I saw the elaborate form in five separate Afikpo villages (Mkpoghoro, Amuro, Mgbom, Anohia Nkalo, and Ukpa) in December 1959, although not always at the home settlement. I shall first describe the general features of this version of the play, its masquerades and movements; then I shall discuss the variations that I observed, and finally say a few words about the simple form.

PREPARATIONS

In some villages rehearsals are held once per Igbo week for some time before the performance, during which the age set in charge, and interested older persons, decide who will wear what costumes and where they will be located in the parade line. Those who will have special dances to perform practice them at this time. These rehearsals are not held in the bush at night, as in the case of the ɔkumkpa, but in the afternoon or early evening in the village common, which is then closed to noninitiates. The village elders, or the village executive age grade, usually give an order that all initiates of the secret society who are of the age of the set in charge or younger must take part or else pay a fine. Thus, as in the ɔkumkpa, males have participated in the *njenji* over a number of years, playing different roles as they mature. In most villages, if an eligible male is away, a substitute must be found to avoid a fine. This is a person older than the age set in charge, generally a brother, or even a mother's brother. This older male then joins the parade, but he takes a role suitable to him, not the one the person he is substituting for might have played. However, the age level of most *njenji* players is under thirty,

somewhat younger than the upper limits in the ɔkumkpa.

In the 1960 Mgbom *njenji* I counted about one hundred fifty wood-masked players. In addition, there were some twenty or more other players who were not strictly in the parade line. While not all *njenji* are as large as this, many are of substantial size. Some wards in the larger villages or subvillages have their own separate parade line which goes ahead of or follows that of the main settlement, but is arranged in much the same pattern. In Mkpoghoro, for example, Ndibe does the *njenji* as one group and the subvillages form another; and in Mgbom the Achara and Ngara subvillages join together as a small line, often going ahead of the main Mgbom group. If a village or part of a village is small, it may only have some of the types of players found in a full complement.

As in the ɔkumkpa, the players spend a good deal of time getting together their dress, and for several days before a play is presented the resthouses in the commons are full of young men preparing their costumes and retouching their masks. This is usually a happy, playful, and gossipy time for them and their friends who help them. Some of the dancers wear elaborate feminine costumes requiring a good deal of cloth, many plastic waistbands, and other female items of dress. Men give presents in return for the loan of these things from sisters, wives, lovers, and friends. And some of the players wear net rather than wood masks.

On the morning of the *njenji* day, the performers come out to the village commons, which are closed to women and male noninitiates. They dress with the assistance of friends and relatives. Fathers often help their sons, and older brothers younger ones. The wooden masks used are some of the same types found in the ɔkumkpa; some of them may actually be the same pieces. There are no special wood masks found only in the *njenji*; but unique to the parade are some of the net mask forms and related costumes.

There is considerable talk and excitement as the players dress. The preparations take a number of hours, during which some young men take turns at beating the small wooden gong (ɛkwɛ), brought out of the resthouse in the main common, and certain men hired for the occasion shoot off guns now and then. Some of the players, especially older ones and members of the organizing age set, wear a live chick on their headdresses, or sacrifice a chick to the secret society shrine before dressing. Some wear a charm, ɛkikɛ, to make them strong; and some eat a bit of special medicine, *nsi mano*, usually prepared from dried fish and palm oil by the secret society priest or by a diviner, to give them strength. If the players have held rehearsals, they know what actions they will perform and in what order to line up. If there has been no previous preparation,

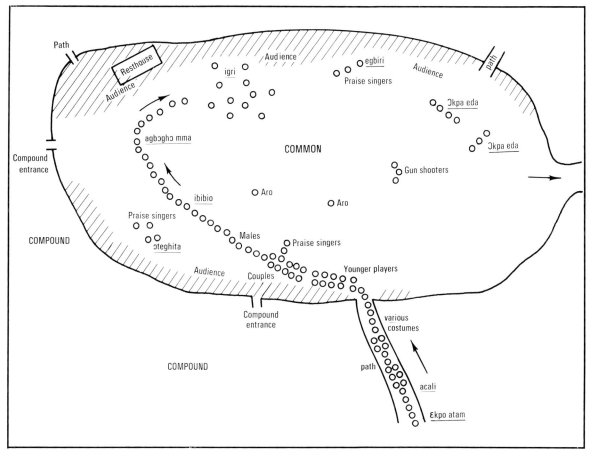

Map VII. The Order of the *Njenji* Players

their costumes have already been designated by
the age set leaders and older interested men who
act as advisers, and they are lined up after they are
dressed.

When the players are ready, in the late
morning or early afternoon, shots are again fired,
this time to signal that the commons are open to
the other persons in the compounds and that the
play is about to begin. Women and children, and
initiated males who have not been involved in the
preparations, rush out and take seats much as they
do for the ɔkumkpa play. The *njenji* players then
begin to move along in line through all of the
commons of the village (see Map VII). The parade
has begun. The main column of players is a line of
wood-masked masqueraders, at the front and
sides of which are other players in either wood or
net masks, performers who roam about and may
even come to the rear of the column. The
arrangement of the main column remains more or
less fixed while these others frequently change
their positions.

THE FRONT OF THE PARADE COLUMN

At or near the head of the main column are
some three to six men—unmasked and usually

wearing white shirts and ordinary waistcloths or
pants—who shoot off their guns to announce the
play at its beginning and each time the performers
move into a new village. Their long,
muzzle-loading Dane guns give off a loud bang
that can be heard for miles. Hired by the age set
arranging the *njenji*, these gun shooters are often
hunters from the village or neighboring
communities; they are also hired for important
Afikpo title ceremonies and other events to add to
the color of the activities.

In addition, there are between two and six
hired praise singers (*ebo*), some of whom are
found at the head of the main column. These are
the only musicians at the play, for the drumming
in the home village stops before the parade
commences. The praise singers are also employed
for important Afikpo ceremonies and are expected
to sing the praises of those directing the
ceremony. If there are none or not enough of
them from the village producing the play, they are
hired from other Afikpo communities. At least
some of them usually appear at rehearsals. For
their work at the *njenji* they are paid only a small
fee by the age set in charge, but they receive
numerous "dashes" from the audience in the
villages that they pass through.

The praise singers are masked and costumed in a manner that makes them look like gnomes or goblins. The costume is called ɔkwa ebə (figs. 47, 48, 52, 54; and Cole 1970, pl. 112). They wear the dark net aborie mask and long raffia strands over the head and face, which are attached at the top of the head. They wear even longer strands of raffia, strung from the shoulders, which go almost to the feet. The raffia is thick and coarse and ranges in color from a light to a dark brown. In order to see, the players must hold the head raffia out in front with one hand. The mask and raffia very effectively conceal even the outlines of the face.

These singers praise the age set for how strong it is and how fine the players look. They commend former leaders of the village and prominent living elders. They also remind persons to give them the customary "dashes." They may leave their place at the head of the main column and go up to a prominent person in the audience of a village they are passing through and sing his praises; in return they usually receive "dashes" of a few pennies from him. Well-known individuals in the audience are unlikely to wish to appear ungenerous by refusing to give presents in return for praise, and the players are capable of singing derisively of a person who fails to reward them. It is also said that they will mock a masquerader who is weak and has to drop out or lags behind as they march along; but I have never seen this occur. The

praise singers do not provide a beat for the little dancing that occurs at the njenji, nor do they sing to keep the paraders in step.

Often with or near at least several of the praise singers are other men dressed in special net masks and raffia costumes who are only seen at this play—players who are either of the age of the set in question or slightly younger. All net-costumed figures at this and the other Afikpo masquerades, like the wood-masked figures, are considered to be mma. But here they have the quality of familiars, who accompany the main column of wood-masked players, moving in front and about it. While the net masks and associated costumes are connected with the secret society, they are not seen as powerful and fearful spirits, but rather as amusing and delightful ones. I have earlier indicated that I believe that many of these figures represent a Cross River rather than an Igbo tradition.

One of the most interesting net mask forms at this play is ɔteghita. There are normally two of them, accompanied by several praise singers (fig. 48; pl. XIII). The ɔteghita are usually of the age set organizing the parade, or sometimes even older if there are skilled senior dancers available. As the praise singers intone, the ɔteghita face one another and dancing slowly on their toes, bring their feet up high with a hopping motion while swaying from side to side. They move little from

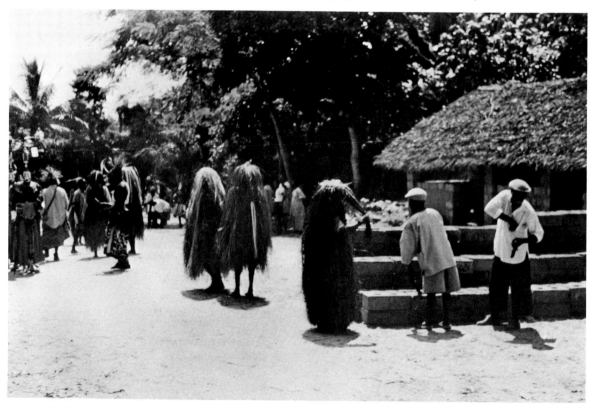

Fig. 47. Praise singers in costume at an njenji parade. One singer is about to receive presents of money from two viewers

this position while doing this. It is considered a delicate dance and is much liked at Afikpo. The ɔteghita are well "dashed" by viewers, and sometimes unmasked friends or relatives accompany them to collect these presents. At other times the two players move forward together side by side in a hopping and swinging motion. Sometimes these masqueraders, along with other net-masked players, remain in a village after the column has passed through and continue to perform for the audience. Thus they may be late in returning to their home village at the end of the parade.

The ɔteghita costume is an elegant one. On the head is worn a black top hat with red and white bands on it. The Afikpo claim that this hat has no special significance and is not the consequence of European influence; rather, it is just a colored hat. Over the face is a black and white *aborie*-style net mask. A shirt of very fine, old brown raffia is tied up at the shoulders with wound palm fibers, and white ribbon shoulder straps come down in front and in back to attach to it. The masquerader wears a large brass bell, *ikpo*, used by the senior wrestling grade at Afikpo, which is also called *ikpo*. Many of the members of the age set organizing the play have just moved out of this grade. The ɔteghita player carries a stick in his right hand, something like a drum major's rather than a walking stick, and sometimes he has a colored handkerchief tied at one of its ends. Although the praise singers accompany the two ɔteghita, there is a sense of quiet about their movements. The dancing is delicate, not strong or thrusting as is often the case at Afikpo; and the bells sound pleasantly. Afikpo claim that the ɔteghita is of Edda origin.

Another net mask form, also said to be from Edda, is ɔkpa eda (fig. 49). The net mask is partly held out by two sticks with small cross-pieces on them that project forward from the forehead area above the eyes. The player wears a fresh, yellow raffia dress which consists of raffia strands that cover the lower chest and is attached with twisted or braided raffia strings around the neck. A small brass bell, representing a somewhat younger wrestling age than *ikpo*, and a small iron gong are attached to the front waist. The ɔkpa eda players are often adolescent boys. They are likely to wear a knotted string cap, *okpu egbese* (cap hair), sometimes with porcupine quills or other objects sticking out of it. They carry small machetes or large knives in their right hands and wear wrist rattles or bracelets.

There are usually at least two of these players at an *njenji*, and often up to ten or more. They move as a group—usually without praise singers—walking, hopping, and running about at or near the head of the main column.

Another colorful net costume is *egbiri*, or *ochinza*, as noninitiates to the secret society call it

(pl. XIII). This consists of a long, white net mask with dark lines on it. There is an elaborate black headpiece, curved from front to back and troughlike from side to side, something similar to that worn by the lead players in the main column, the *agbɔghɔ mma*.

The headpiece has a number of rectangular or square mirrors placed on it, facing forward, and there are dyed colored feathers, often pink, projecting from its top edges. The player wears a long fresh raffia dress coming from the shoulders, a large number of ankle rattles, and numerous ivory or bone wristbands. The *egbiri* player grips a black horsetail tassle, *nza* (the tail of anything you use in dancing), in his right hand, which nicely contrasts in color with the lighter-colored raffia costume. He holds the net mask forward by its string with his left hand. There are usually only one or two *egbiri*—two is the ideal—and they are generally accompanied by praise singers. They are admired for their skillful dancing, which is done individually rather than in pairs and imitates women's dancing at Afikpo, employing a slow, deliberate shuffle. The *egbiri* are likely to be followed by small children who break away from the audience and who love to watch them, and the players receive numerous dashes from admirers. As in the case of the ɔteghita, the *egbiri* are usually of, or close to, the age of the set organizing the play.

Another net form, ɔgbǝ kpakpokpakpo (net-step, step, step, step), consists of a black-and-white striped *aborie*-style mask, with a helmet much like those used in whipping contests at Afikpo, which is made of braided raffia sewn together to form a headpiece. The upper part of the player's body is bare and covered with white chalk; the lower part is covered by a brown raffia shirt hung from the waist. The feet are bare. This masquerader steps about in a lively fashion, rarely resting; there are generally two or three present at the parade, to one side or following after it. A variant form of this masquerade is associated with the *logholo* players (see chap. 11).

Afikpo indicate that other types of costume have been worn in the past but are not employed today. One form is *ohwɛ ogo*, or *atǝ*, which is the term for buffalo horn. It is unusual because there is no raffia in the costume. The net mask is of the *aborie* type, but instead of a hat, two buffalo horns are attached to the head. A wrestling-style cloth is worn at the waist. The player does a galloping, jumping sort of dance.

The presence of these various forms of net

masqueraders at the *njenji* indicates that there is a rich net-mask tradition at Afikpo, one that has probably existed there for some time, but is perhaps dying out. Afikpo themselves say that it is hard to find persons to dress in ɔ*teghita* or *egbiri* today, while it is easy to locate individuals who will wear the wooden masks.

Compared to the wooden masks, the net masks seem to be a less dominating part of the total costume. Their colors are not striking; rather, they blend with those of the head and body dress. The various types of net-masked figures at the *njenji* do not coordinate their efforts so as to move

together or to appear en masse. Each type goes its own way, in contrast with the main column of *njenji* paraders, who are controlled in movement and generally remain in line throughout the parade.

THE CENTER OF THE PARADE COLUMN

However, at the front of the main column appear two types of wood-masked players who have considerable freedom of movement. One form depicts an Aro slave trader. The Aro Chuku are Igbo people from some fifty miles south of

Fig. 48. Two ɔ*teghita* players, accompanied by two costumed praise singers, dancing before the village elders during an *njenji* parade

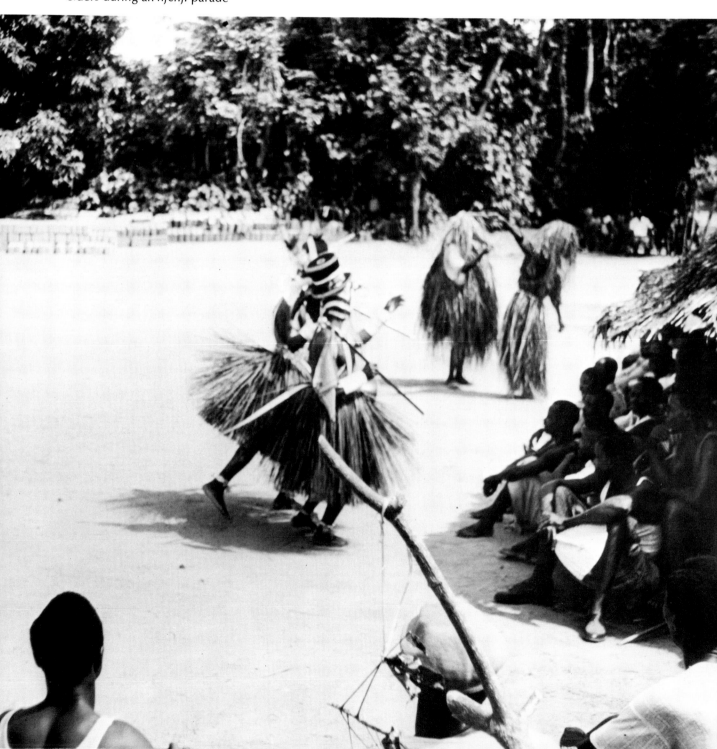

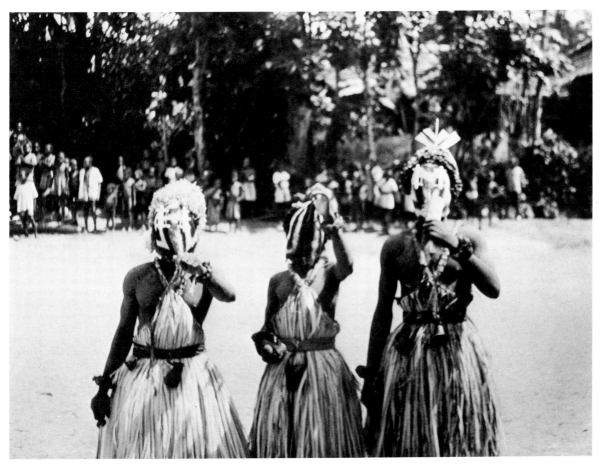

Fig. 49. Ɔkpa eda masqueraders at an njenji parade

Afikpo who once held a dominant political position in the village-group (S. Ottenberg 1958 and 1971b). There are either one or two persons dressed as Aro traders, wearing the dark, ugly wooden mask, ɔkpesu umuruma, seen at the ɔkumkpa. They are the only ones to wear this form at the njenji. They hop around at the head of the main column, looking fierce and ugly, and sometimes dancing grotesquely (fig. 50; pl. XIII). They are dressed in khaki or dark tan clothing and carry a bag stuffed with leaves to represent cowries, an ancient form of shell money that traders formerly used. This bag is slung over the left shoulder with a rope. The Aro also carries a gun, sometimes a shortened piece, at other times a full-length ancient Dane gun. Some hold a long walking stick in their right hands instead of a weapon. The Aro depicted here are said to be from Okposi, where the large Uburu slave market used to be located, and in the njenji they speak with an Okposi Igbo accent. These Okposi Aro had considerable contact with the Afikpo during the slave-trading days. Occasionally the Aro is accompanied by a second man without a gun, though sometimes with a bag, who has metal bands on one or both ankles and represents a slave working for the trader.

As the parade begins in the home village, the Aro players go up to the front of the line and stop it. One of them asks: "Who is walking here? Who owns the land on which you are walking?" Some male viewers older than the players—in some villages this includes the head leader or "chief"—bring a wood-masked boy player from the rear of the main column and offer him to the Aro. He is rejected and another boy is brought forward. Either the second or a third boy is accepted. The boy is then returned to the line and the Aro allow the paraders to pass. This act is generally repeated in every village that the players pass through. It is said that before the advent of Europeans, when Afikpo was largely controlled by the Aro slave traders, permission to perform rituals required the giving of a slave to the Aro. The Aro also controlled the major paths about and out of Afikpo. This part of the njenji symbolizes their former control over the movement of persons along them.

The Afikpo delight in seeing the Aro players and the slave, if there is one. They are in evident contrast to the beauty of most of the other costumes, and perhaps the Aro's presence represents the generalized projection of some hostility toward adult authority that we have

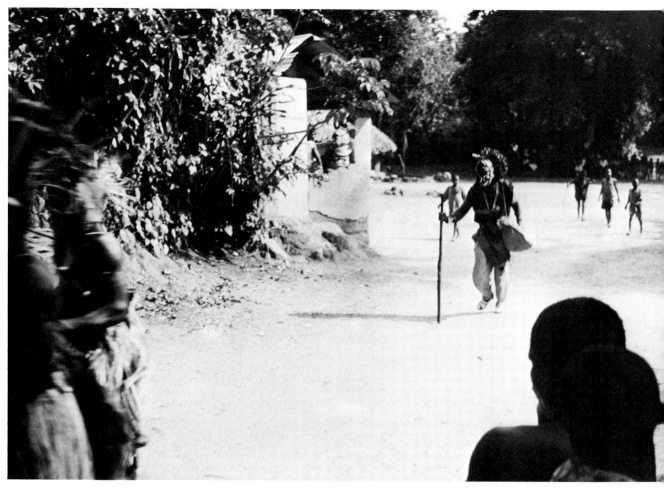

Fig. 50. *Njenji* parade player dressed as an Aro man, with *ɔkpesu umuruma* mask

already seen expressed in the *ɔkumkpa* play. Many Afikpo disliked the power of the Aro in the past and enjoy their present freedom from them. But even in the *njenji* of such communities as Ndibe, where the Aro were numerous and held a dominant position, this player appears and is well received.

The persons who act this role are often slightly older than the age set directing the performance. They are usually paid in money, wine, and fish. In the 1959 Mgbom parade one man was paid £3 to play the part. The fact is that wives do not like their husbands to dress up in this fashion and they may give them a difficult time for doing so. One wife, whose husband enjoyed performing this role, used to become quite angered at him. Although she was not supposed to know who played the part, she would recognize her husband. She would tell him to leave her because he was a foolish man, for when his friends dressed up in a fine manner he dressed "in a bad way." As one Afikpo said: "You do not get a dash from your wives if you dress in this manner."

Also at the front of the line, about where the Aro players are found, are five to twenty dancers

wearing the Afikpo form of the *igri* mask of madness and youthful exuberance (fig. 51). Occasionally one sees the Edda form (pl. XIII). The *igri*, as the players are also called, are bare-chested except for the kind of chest halter worn in the *ɔkumkpa* play by the young boy *akparakpa* dancers. The headdress consists of a type of leaf called *ekite*, coming from the top front, and another leaf, *ngwu*, from the sides of the head (pl. XIII). From the back of the head porcupine quills or other objects may project upward. The whole headdress is called *ngwu*, after the leaf. The masquerader wears a dried, flattened animal skin on his back, usually of a deer or some feline. Occasionally this is of the same kind of mat material as is used on beds. The *igri* has a short raffia skirt, ankle rattles, and sometimes a towel attached to the waist in front. He may wear a plastic waistband or two around the hip or around the neck. Some have the large *ikpo* wrestling bell attached at the waist and a sheathed machete stuck in there as well.

In their left hands the *igri* carry a sticklike apparatus known as *egede*. Almost two feet long, it consists of a frame of sticks tied together at the

center and at the ends with light-brown raffia.

Sometimes the raffia hangs down a bit; at other times green leaves are tied on the points of attachment. Afikpo say that the *egede* represents a form of shield used during the days of warfare.

In some villages, such as Amuro, the *igri* do not always wear the chest halter. Instead, the waist raffia is tied with twisted raffia strands around the neck and the raffia skirt is longer. This style appears to be from Edda Village-Group (Nzekwu 1963, p. 20).

The *igri* player, called *okpute* by the uninitiated, is often of the age set just below the one directing the play, although sometimes members of that set take this role. They are big, strong men who are good dancers. A person older than the age set in charge may also play this part voluntarily. The *igri* dance more or less in a line, circling about the common in front of the main column of wood-masked players with a characteristic stepping movement. At other times they move about individually, but never stray far from one another.

Their strength is symbolized by the vigor with which they move and the presence of the ancient *egede* shield and the machete. They are expected to protect the *njenji* players and its main column and to "clear the way" for the masqueraders. In fact, they sometimes chase small boys away who are in front of them when they pass through villages, and occasionally fights break out between the *igri* and these boys or older viewers who like to taunt them. The *igri* represent the sense of rivalry and competition between villages.

The situation may be particularly tense if there is a land or political dispute going on between two villages and the players of one are passing through the other. Often as the *njenji* paraders are about to start in the home village, an elder will get up and say that if any player knocks down a viewer, he will be fined—in one case the sum stated was 30s. But such a ruling does not always restrain the players. In 1959 Ndibe did not pass through Amaizu village because of conflict there in the past at this parade. In that year Ndibe paid a fine of nearly £200 in the Afikpo Magistrate's Court for fighting with Amaizu boys

Fig. 51. *Igri* players dancing about in an *njenji* parade at Ndibe village common

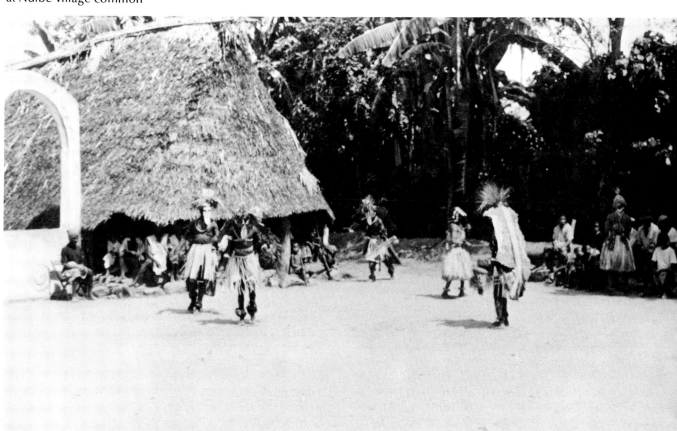

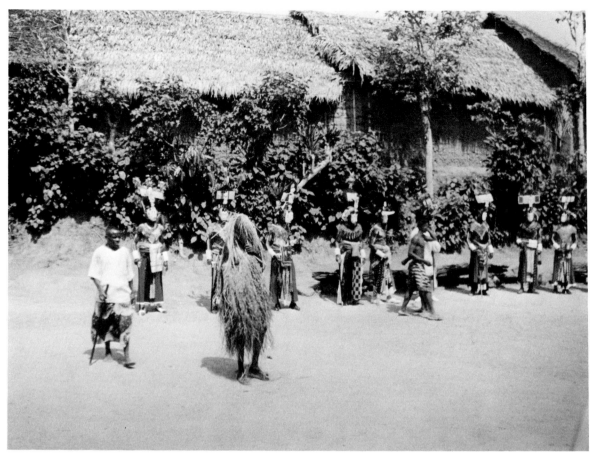

Fig. 52. *Agbɔghɔ mma* players lined up to be checked out before starting out in the *njenji* parade from their home village of Mgbom. Friends and relatives are giving money or yams to the masqueraders

two years earlier during an *njenji*. The case was first tried by the Afikpo elders, who fined Ndibe £20; but the village refused to pay, claiming their innocence and taking the case to the higher court. There they considerably worsened their position and had to pay much more. It is interesting to note that there have been rivalries between these two villages over political affairs for many years and there is rarely a year when there is not some scuffling between members of the two villages at an *njenji*. Afikpo love to discuss these instances and have no trouble in favoring one side or the other.

An incident that occurred in about 1946 indicates the freedom that the *igri* dancers feel they can indulge in. The Mgbom column was passing through Ukpa village when one *igri* was knocked into a hole by some Ukpa boys. The angered masquerader rose up, lifted up his mask, and chased the boys into one of the compounds. This created a great furor in Ukpa, for the *igri* had violated the sacred secret society ruling that a masked person should not show his face in public and another that he should not enter the compound in a village other than his own. The

Ukpa elders came to Mgbom several days later and asked for a "case" to decide on the proper punishment for the performer, and the elders of both communities jointly tried the player at Mgbom. During the discussion a bright and up-and-coming middle-aged Mgbom man, Okewa, declared that since a man wearing the *igri* is supposed to be mad, there was nothing wrong with the masquerader's actions. As one Afikpo said to me: "This stunned everyone." Okewa went on the say that Ukpa could do as they wanted: they could offer a sacrifice to smooth the matter over, but as far as Mgbom was concerned, they would not punish the man. This case reflects traditional village rivalries at Afikpo: the Ukpa elders had no power to punish the Mgbom player without the latter village's consent, and since the Mgbom leaders felt that their man had been attacked, they defended his actions. Thereafter Okewa was occasionally called by the nickname of "*igri*."

The *igri* players draw attention to the line of wood-masked players that follow them. The latter are largely in feminine dress, but do not dance. Rather, they walk with long strides in contrast to the more active *igri*. The change from one style to

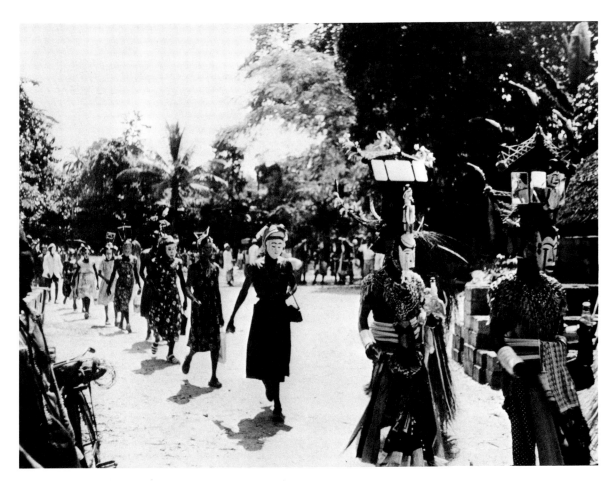

Fig. 53. *Agbɔghɔ mma* players in the *njenji* parade, followed by masqueraders dressed as married women and wearing *ibibio* masks

the other interests the audience, who delight in the *igri*, but who wait for the famous *agbɔghɔ mma* (girl-spirit) players who follow behind.

For if there is any special focus of attention at the parade, it is on these men who dress up in elaborate feminine costumes. Indeed, they are often called by the name of the play, *njenji*. There may be as many as twenty-five of these tall, strongly built men (see figs. 52, 53; pl. XII). The first four or five are usually from the age set organizing the ceremony, and there is considerable rivalry and competition during rehearsals to be first in line. The lead masquerader should be particularly well built, elegantly dressed, and able to walk with a fine posture. The players who are approximately fifth to tenth in position are generally from the immediately junior age set, which will be the next one to lead the play. Beyond them the *agbɔghɔ mma* are selected by the age set organizing the play from among tall men of any of the ages involved in the performance.

Characteristically, the *agbɔghɔ mma* masquerader wears the *ɔpa nwa* mask of the female face with the "child" on top of it. This

mask is closely associated with femininity at Afikpo. We have seen it worn by the "queen" and some of the *akparakpa* dancers in the *ɔkumkpa* play. The *agbɔghɔ mma* players represent unmarried adolescent girls. The "child" on the mask is sometimes decorated with earrings or a necklace, but the mask, which forms only a small part of a most colorful costume, is not otherwise decorated beyond its usual designs. In back of the "child" the player wears an elaborate, false black hairpiece that comes to a number of points at its top edges, between which are strung pink wool fibers and from which colored feathers project. It is troughlike in shape from front to back. At its front, and just in back of the "child" part of the mask, two or three rectangular mirrors face forward. We have already seen a similar headdress on the *egbiri* player, who also has a feminine quality.

Around the player's shoulders is a neck piece made of one or more pieces of colored cloth, or a shawl with beads and colored yarn hanging from it. Sometimes there are necklaces as well. At the waist there may be as many as ten or as few as three plastic waistbands—usually pink, yellow,

and red —of the kind typically worn by men when they wish to imitate girls. These make the waist look a bit bulgy. A blue or light-colored cloth, sometimes of Igbo manufacture, is tied to these waistbands and hangs down over them in front. Other cloths in various colors and designs are attached to yet another cloth tied around the waist under the plastic bands, and drop down almost to the ground. These cloths are seemingly not arranged to form any particular color pattern. They are generally of European manufacture, as is almost all of the cloth found in the *njenji* masquerades.

The *agbɔghɔ mma* do not usually wear ankle rattles or shoes or sandals. They have ivory or bone wrist pieces on each forearm, as many as four or five to each limb, and they often carry a colored handkerchief in their left hands. The lead *agbɔghɔ mma* is expected to wear the prettiest cloth and to look the finest of all.

All of these elements add up to give the masquerader a strongly feminine quality, although no Afikpo female ever dressed for a dance or a ceremony looking quite like this, for the hair style is not usual at Afikpo, nor are the mirrors as costume, nor the manner of wearing the cloths suspended from the waist. Surely, this is a humorous parody on femininity, on the dress of girls. And oddest of all, in the right hand the masquerader holds a walking stick or a cane, an item only rarely used by a female, and then only if elderly or ill. But the cane or stick is an important symbol of the male elders at Afikpo. I was not able to discover why the cane or stick was used, except that "it is part of the costume," or "it makes them look fine." In fact, it seems to symbolize that these are the players that are in charge. They, especially the lead members of the *agbɔghɔ mma*, are the "elders" of the play.

In movement the *agbɔghɔ mma* masqueraders proceed with long, firm steps, with the head and body erect, using the cane or stick in a precise and deliberate fashion. They set the tone for the whole walking column that follows. Their firm and deliberate movements at the head of the line contrast with the more playful motions of the players in front of them. Sometimes several of the first *agbɔghɔ mma* in line carry a glass and a bottle of native gin, palm wine, or brandy. As they pass the men's resthouses in a village, they stop and offer drink to the elders sitting there, which is accepted. At other times the drink is carried by unmasked players of older age than the set organizing the event, and thus the movement of the whole line is not slowed up.

THE REAR OF THE PARADE COLUMN

The remainder of the line of wood-masked dancers more or less decreases in size to small boys at the rear, but with one or more tall players

bringing up the very end. And this back part of the line is also arranged more or less by types of masks and costumes.

The *agbɔghɔ mma* are followed by players also dressed as females, but in a contrastive style. There may be as many as fifteen or more of these in the larger parades. They wear the *ibibio* masks with red, pink, and yellow colors predominating (figs. 54, 55); only rarely is a white form seen. These masqueraders, mainly dressed as married adult women, are called *urukpo mma* (lady-spirit). Their married status is indicated by the presence of a colored head cloth rather than the elaborate hairdo. They do not wear the traditional cloth of Afikpo wives but are in modern cotton dresses of colorful prints, or they wear a skirt and blouse, sometimes worn on Sundays as church clothes and for other "modern" events. They use women's shoes or sandals, and often carry a handbag in their left hand, and sometimes an umbrella in the other. The modern clothing is purchased new in the large Eastern Nigeria cities or used in local markets. A few of them have the ceremonial hairdo of unmarried girls, which we have already seen worn by the *akparakpa* players in the *ɔkumkpa*. This consists of five black twists, one at the center, the other four each at a corner, coming upward a foot or more from the head and connected at the tips by pink yarn. Those with this headdress are more properly *agbɔghɔ mma* than *urukpo mma*.

It is traditional for the first two players of the group wearing the *ibibio* masks to come from the age set organizing the event and to wear special headdresses. The first one has a hair style known as ɔna, which has a wide band of black hair across the back of the head coming to a pigtail that

sweeps upward: A form something like it

is sometimes seen in the hair style of the "child" on the ɔpa nwa mask. The second player in line wears the common Igbo hair style, *godogodo*, the traditional form worn by Afikpo women for feasts and dances, in which the hair is peaked up in a center crest from the front to the back of the head. Sometimes a third player wears yet another special style. It is said that the first two headdresses must be worn in order to have a proper *njenji*, but, in fact, one or even both are sometimes missing and no one seems very perturbed.

The *ibibio* masqueraders also walk in a long stride, trying to keep in step with the *agbɔghɔ mma*, although not always successfully, being somewhat shorter. These *ibibio* players do not all come from the organizing age set, and they represent the younger adult men of the village.

They are followed by as many as one hundred wood-masked players in the larger plays or only a

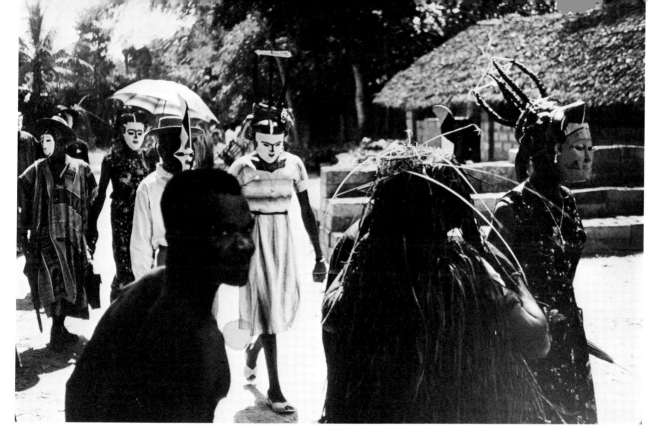

Fig. 54. *Njenji* parade players, with praise singers in the foreground

Fig. 55. Players dressed as married women at an *njenji*
performance, followed by a variety of costumed masqueraders

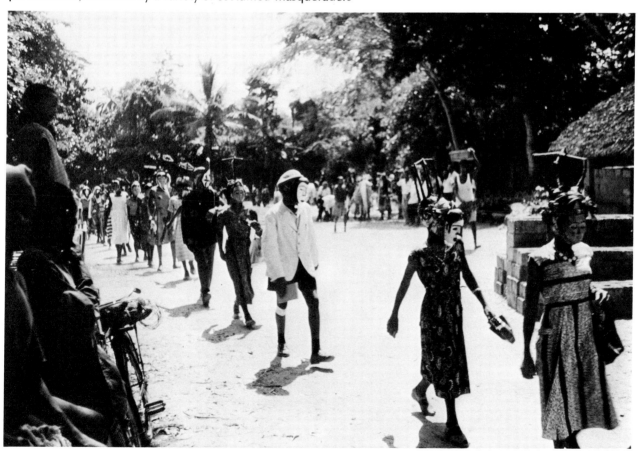

few in the smaller ones. These masqueraders are not as clearly arranged as the previous groups, but often there is first a line of persons wearing the *mma ji* masks and dressed as males (fig. 12; pl. XII) in a variety of costumes. Then come couples: the female walks on the left and wears the *ibibio* mask and costume, as the *ibibio* players already described (fig. 56; pl. XII); the male wears either the *mma ji*, the *nne mgbo*, or the *beke* mask, and any one of a variety of male costumes. The couples often have their arms locked as they walk side by side, following a European, not Afikpo, custom. Sometimes two players dressed as females, either married or as girls, walk together. Then there is a line of players dressed in male costumes with either the *mma ji*, *nne mgbo*, or *beke* masks, decreasing considerably in height (see fig. 57) until we come to a few small boys wearing the *acali* mask (see fig. 2), usually dressed as scholars or Muslims. The whole line is supposed to decrease gradually in height, but in fact after the *ibibio* group it is liable to be irregular. There is much mixing of mask types and costumes, and the line moves unevenly, sometimes bunched up and sometimes quite spread out (fig. 58). These features occur in the parades that have been rehearsed as well as those that have not.

Those who are dressed as females vary little in appearance from the *ibibio* group in front of them. Some have the unmarried girls' five-pointed hairdo, but most wear the married women's head kerchief. These players carry a variety of handbags —even plastic shopping bags are seen—and sometimes an umbrella, occasionally opened up. Again, white-faced *ibibio* masks are rarely found.

But the male costumes in the part of the line behind the *ibibio* group vary a great deal. Some players are dressed in neotraditional Afikpo style, with a cloth over the lower half of the body and a white shirt, not tucked in, above. Others have modern forms of Nigerian-style dress. Some are clothed as Muslims, in long, rich, colorful cloths. Afikpo have had little contact with Muslim women and I have never seen a player dressed as one. Players are costumed to represent schoolteachers, office clerks, and scholars. The teachers and scholars sometimes carry a book and may read from it in English. I have also seen two scholars walking together and reading and discussing as they pass by. Occasionally one sees a person posing as a Catholic father, a minister, a lawyer, or as a Yoruba with the characteristic floppy Yoruba cap. Pith helmets, felt and straw hats, cloth caps, canes and sticks, and briefcases abound among the masqueraders. I have even seen a shooting stick. Some of the players wear porcupine quill hat

Fig. 56. Masked couples in the *njenji* parade

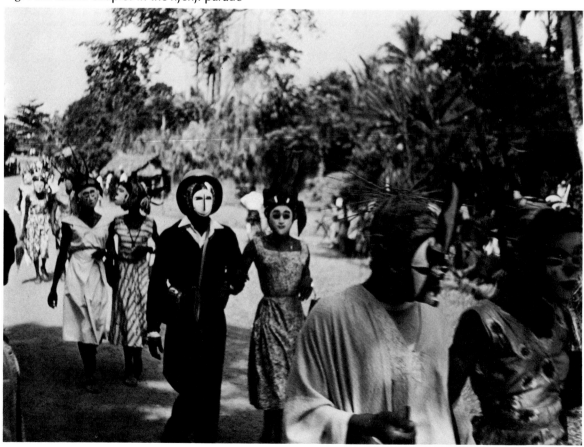

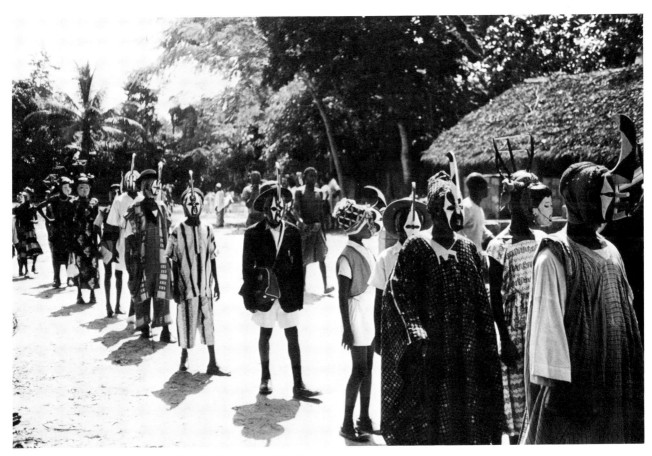

Fig. 57. Players toward the end of the line at an *njenji* parade, wearing *mma ji* and *ibibio* masks

Fig. 58. Young boy players at an *njenji* parade

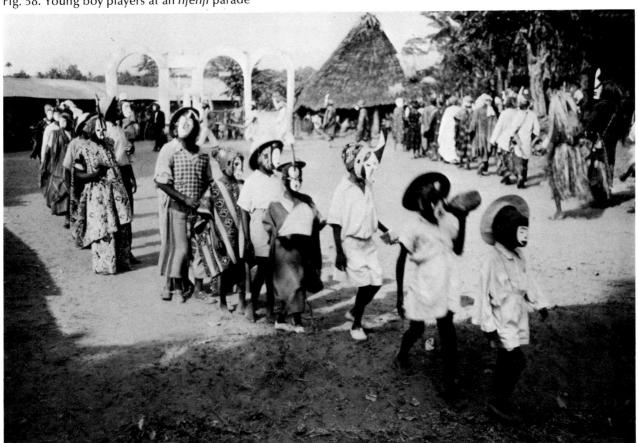

pieces. The persons representing males and females toward the back of the line only rarely wear traditional clothing. It is as if the Afikpo community were dressed up in their modern best for an Easter parade.

At the very end of the line are one or more masqueraders from the age set leading the performance. They protect the column's rear and prevent straggling on the part of young masqueraders who may find it difficult to keep up with the other players over the long walk, which takes a number of hours and may cover six or more miles. These men are called ɛkpo atam. They may be dressed as females with ibibio masks or in a variety of male styles, but the more characteristic ɛkpo atam dress is a dark wine-red shirt and a large ikpo brass bell at the left hip with cloth over the lower part of the body.

THE PROCESSION

The whole procession is most impressive. It moves into a village with guns shooting off and praise singers intoning and the various net players dancing and dashing about. The igri cavort, and the Aro men gambol about, stopping the main line in order to do their act. Drinks are served to the elders in the resthouses, and the line moves on— from agbɔghɔ mma to ibibio to the various groups down to the little boys in the acali masks and the ɛkpo atam at the end of the line. Sometimes ɔteghita, egbiri, or other net-masked players, perhaps accompanied by praise singers, linger after the main group, doing their special movements. While at a village some players may dash into one of the resthouses, remove their masks, and drink water from large pots that the village provides for the occasion. They are permitted to remove their face coverings in this house because it is associated with the secret society and the players cannot be seen by the audience outside. And sometimes, while on the way, if they are in a forest or bush area and no one is around, the players lift their masks to get some fresh air or to see their way more clearly on the road or path. This is also permitted as long as they are not being observed by noninitiated boys or by females. They may urinate while out of sight as well.

Each village has its own regular parade route, moving through most neighboring villages and generally a good many settlements that do not belong to their own particular subgroup at Afikpo. They do not go to settlements outside of Afikpo, but neither do they move too far within the village-group. The non-Ozizza villages, for example, do not usually go to Ozizza, and no one troubles to go to the more distant settlements of Anohia and Kpogrikpo in the south. Ndibe players pass through Mgbom, Amuro, Amachara, Ukpa, the Government Station, Amachi, Amamgballa,

Ugwuego Elu, Amaizu (when not disputing with them), Egeburu, and then back home through the various Mkpoghoro subvillages. When a number of villages are performing njenji on the same day, there is no prearranged order in which they visit settlements; each moves when it is ready. If players from another village are already in a community, the other performers wait their turn outside the settlement.

Sometimes logholo chasing masqueraders come out to play in a village (see chap. 11) after its njenji group has left to tour other communities, and they may play until the paraders return, or in between the passage of the njenji groups that arrive from other villages. This spectacle tends to hold the audience in the commons. One Afikpo told me that this was "to keep the commons hot" until the paraders from the home village came back. In fact, most of the audience does not remain in the commons all day, but comes and goes as new paraders appear and leave, doing other things in the village in between.

On returning, the players go through much the same routine as when they first started, passing through all the commons, again to a substantial audience. In some villages they then go through all the compounds as well, allowed at this point in the paraders' home village. The walk through the compounds is said to be mainly a test of their endurance, for the audience in the commons does not follow them. In fact, they are not expected to be followed by nonmasked persons, as I discovered when I was turned back from doing so one time. The players receive a few more "dashes" from males who happen to be in the compounds as they pass by, to add to the considerably larger sums that they have already received in the commons and while on tour. If the village has a secret society priest, the players usually go through his shrine house to be blessed before going to the compounds. In some villages, however, the players do not go to a priest's house or to the compounds.

The common is then closed to noninitiates and the scene is much as after an ɔkumkpa play. The performers take off their costumes, putting the live chicks, if they wore any, on a stick or tree in the ajaba dressing house, or in a village shrine, where they remain as a sacrifice. Friends and relatives come out with water and food and the players wash, drink, and eat bananas, oranges, and papaw. They may dance and sing secret society songs, and drumming is sometimes heard as well. They sleep there that night, and in the morning they go back to their homes with their wooden costume boxes, returning the costume parts borrowed from females and "dashing" them for the loans. In some villages on this day, ahɔ, the age set being initiated holds a large and costly feast for the village as the major part of its rite de passage, but there is no singing, dancing, or masquerading.

REHEARSALS

There is considerable variation in the elaborate form of the *njenji* from village to village. In Ndibe in 1959 rehearsals were not held beforehand, although decisions as to who should wear what costumes were made ahead of time. The precise line-up of the *agbɔghɔ mma* players was decided just before the parade started, after all the players were dressed. Also, there was no *egbiri* player, a part believed to require considerable skill and endurance. Attached to the skins on their backs some of the *igri* dancers wore posters of the major political party in the area, the National Council of Nigeria and the Cameroons (N.C.N.C.), or a picture of its local candidate for the Federal House in the forthcoming election. These were offered to the *igri* by persons running the man's campaign, but not all players accepted them. This innovation did not seem to have aroused any objections.

In the case of Mgbom's *njenji* of the same year, practice sessions were held during the evenings of the four Afikpo market days before the performance. The *igri* dancers rehearsed, as did the Aro player, and some of the net-masked players tried dancing about. The line of *agbɔghɔ mma* was organized and tried moving about. None of the players wore a costume. The set leaders determined which persons should head the line of the beautiful girls, but only after much argument throughout the four sessions, since a number of persons desired this role, much as they do the part of the "queen" in the *ɔkumkpa*. It is traditional in Mgbom for the head of this line to come from the oldest ward in the village, Agbogo; yet there were unsuccessful challengers from other wards. Some persons did not turn up for the first rehearsal, so a man older than the players decreed that all who were supposed to take part in the parade (secret society initiates from the age of the age-set down in age) should join in future rehearsals or be fined. A list of participants was made up and checked over by the parade organizers, and relatives or friends volunteered to take the places of absent persons.

A small wooden gong (*ɛkwɛ*) was brought out from the resthouse in the main common at these Mgbom rehearsals and played by various persons in turn to announce the beginning of the practice period and intermittently during the session to keep things lively. The praise singers sang and on several occasions the gun shooters shot off their ancient devices. Older interested and experienced persons advised the players how to dance or to walk, and told them which players looked best in the front of the *agbɔghɔ mma* line. Sometimes these older men danced about a bit themselves to show off or to indicate to the younger men how to move properly. It cannot always be said that they did so with the grace of former years.

The Mgbom players seemed more competitive than those of Ndibe and very desirous of putting on a well-organized performance. Perhaps the presence of an anthropologist among them may have provided some additional stimulation. But the Mgbom players also clearly enjoyed "horsing around"; in fact, this seemed to be an important part of the rehearsals. In contrast, the Mgbom *ɔkumkpa* players were more serious and more tightly organized, reflecting the stronger leadership of its leaders as well as the more complex nature of the material being rehearsed. The leadership of the *njenji* is looser and more casual. A village age set generally has a single head who emerged as its leader when the set started forming some years before performing the *njenji* (S. Ottenberg 1971b, chap. 3). He and several age mates organize the affairs of the age set for the other members and thus are in charge of the *njenji*. But there is little of an authoritarian air about the direction of the rehearsal, and the leaders had a hard time getting the players to agree to the order assigned them for the main column. Also, the actual performance more or less runs itself once it has started, unlike the *ɔkumkpa*, where direct leadership, and even decision-making, occurs throughout the play. The more informal directing in the *njenji* is largely concerned with making decisions in the rehearsal stage and with the hiring of the gun shooters, praise singers, and the Aro players.

In the years when the elaborate form of *njenji* is not performed, a village puts on a much smaller parade on the same day of the Dry Season Festival. The players are volunteers, and only a few of them wear wooden masks with a rather simplified female-type costume or *igri* costume. There are some net-masked players—*egbiri*, *ɔteghita*, *ɔkpa eda*, and a praise singer or two—but there is no organized column of wood-masked performers. The ceremony thus is reduced to a quiet playing by a few interested volunteers. In these circumstances the female activities that mark the Dry Season Festival as a whole appear more striking than in the years when a male age set is active in performing this play. In the smaller villages, such as Ibi and Anohia Nkalo, and in the subvillages that perform their own *njenji*, such as Achara and Ngara together in Mgbom, the parade in any year is much like the simpler form, for there are only a handful of players and all the masquerade roles do not appear.

INTERPRETATION

The more elaborate form of *njenji* contrasts nicely with the *ɔkumkpa* play. The latter is not integrated into a specific festival, while the *njenji* forms part of the dry season festivities and occurs only at that time. The primary theme of this festival concerns girls, and a key element in the

elaborate form of *njenji* is the older players' dressing in the fancy *agbɔghɔ mma* costumes of unmarried girls, whom they imitate in a parody of overdress.

During the Dry Season Festival the age set organizing the *njenji* completes its initiation, on the day following the parade, when it holds an elaborate feast for all village men older than itself. Or, in some villages the set has just organized, and arranging for the parade is one of its first functions. The *njenji*, then, is a test of the set's ability to perform a major task. It is also something of a test of strength: the ability to endure the long walk over a number of hours through the village-group and to ward off taunters or attackers who may appear en route. The parade marks a point of transition, for it is usually only after the age set members have done *njenji* that they begin to wear the ugly *ɔri* masks and costumes at the *ɔkumkpa*, and the Aro costume at the *njenji* if they so choose. And they no longer dress in the *logholo* costume for the chasing play (see chap. 11).

The display element is even stronger in the *njenji* than in the *ɔkumkpa*. The costumes are more brightly colored, especially from the *igri* to the end of the parade line. And elements other than display are marginal. There is no story telling, except perhaps in the act of the Aro. There is little music. The singers praise players and persons living and dead, and remind viewers to give them "dashes," but they do not explain the actions of the parade. While the *igri*, the *egbiri*, and the *ɔteghita* dance, they are not accompanied by musical instruments. It is almost a fashion parade in which the emphasis is on what one sees, whereas in the *ɔkumkpa* the aural element is also of considerable significance. This sort of display, in which dancing and music are so secondary, seems atypical of Igbo, in fact African, masquerades. A colleague, Professor Daniel Crowley, who has had considerable background in African aesthetic forms, expressed this point clearly, after hearing me discuss the *njenji*. He exclaimed: "What? They go to all the trouble to dress up and then they don't *do* anything!"

The attraction of the play depends upon two major interrelated contrasts, one of movement and one of costume. In the first the column of wood-masked players, who are in a set order and whose leaders employ the long-strided walk, contrasts with the freer motion of the players in front, to the side, or sometimes to the rear of the line: the *igri*, the Aro, the praise singers and other types of net-masked players, and the gun shooters. Each of these types moves separately and in its own characteristic style, often contrastive with the other types of free-moving players as well as with the main column. There is something of a segmental quality to the parade, as there is to the flow of action in the *ɔkumkpa*. Only a few masquerader types really interact with one another: the praise singers with *ɔteghita*, *egbiri*, and the members of the column, and the Aro with some of the masked boys. Otherwise each remains separate from the others.

The second contrast pits the net-masked, raffia-dressed players against the wood-masked figures in the line, where clothes or cloths are a major element. The *igri* are the transitional grouping, wearing raffia costumes but wooden masks, and they serve to introduce the players' line. There is considerable contrast between the leaders of the line, the *agbɔghɔ mma* players in traditional, feminine costumes that imitate nothing in real life, and the more direct and modern imitations of the female *ibibio* masqueraders and the other players that follow. And the Aro players, with their ugly masked faces and costumes, are in clear contrast to everyone else.

The parade is a commentary on the past and the present. The more traditional costume elements are at the front, with the net-masked players, while the more modern elements are at the rear. It is as if the passing of the players represented the passage of time from the remote past of net-masked "familiars" to the modern scholars, lawyers, teachers, and the females in European dress. The past is also represented by the Aro actors and the emphasis on the physical strength of the *igri*, and perhaps of the *ɔkpa eda* as well. But the players behind the *agbɔghɔ mma* stand for scholarship, modern status, and the tranquillity of the modern day: books and briefcases are carried instead of machetes and shields. The net-masked raffia figures of the front of the parade are also associated with tradition in resembling some of the net masks used in the secret society initiations and other closed ceremonies of this organization, whereas the costumes of the scholars, the Muslims, and the modern ladies do not appear in these rituals. The parade is thus a commentary on social change at Afikpo.

There are other differences. The modern elements are a satire on Western dress and manners, but the front of the parade does not appear to ridicule traditional dress or life. Few persons wear the modern dress at Afikpo except at church, school, and at other functions of Christians and the well educated. It is rare, for example, to see anyone in the *njenji* or *ɔkumkpa* audience wearing a modern dress or with clothes like those worn by the players dressed as males. For ordinary village events these styles are not seen. The modern dress, both European and Islamic, is gently ridiculed. Part of the satire may be that the modern elements in the line are the most constrained in action and movement, and the costumes do not have the graceful appearance of some of the more freely moving, more traditional ones at the front of the parade. The message is that Western influences are

constraining and a bit awkward in contrast to tradition, which is more flowing and active.

These features suggest that the elaborate, end-of-the-line wood-masked players may have been at least partially added on as an extension of the front part of an older parade. The history of *njenji* at Afikpo is unknown. But the suggestion is that in earlier times, when the settlements were smaller, the play took more of the form of the first part of the parade, perhaps through the *igri* or the *agbɔghɔ mma*. For one thing, boys were then initiated at an older age, so there could not have been as many young players to form the rear of the column. Age sets must have been smaller in size, as village populations were less, and there was probably not as elaborate a set of rituals to form new age groupings. I have argued that the raffia-costumed net-masked forms are basically an old indigenous Cross River style at Afikpo while some of the masked types are of more recent Igbo or Ibibio origin. And certainly, in the line the *ɔpa nwa*, *beke*, and *nne mgbo* are probably masks of Igbo origin. The practice of men wearing white-faced masks and dressing as girls is a common Igbo feature. Even the term *agbɔghɔ mma* is commonly found among Igbo groups for such a masquerader. And the *ibibio* mask is from the Ibibio-Anang-Efik area. But the *igri* toward the front is probably an old and characteristic local form. The mask type that does not fit this pattern is the *mma ji*, worn by some of the players dressed as males toward the back of the line, for it seems to be an old Afikpo type.

It is the older players, the mature men, who wear the more traditional costumes at the front of the line while the younger ones have on the more modern ones, so that the age of the performers is also associated with the movement from tradition to modernity symbolized by the costumes. This movement is also expressed by the footwear. In general, the net-masked players, including the praise singers, as well as the *igri*, the *agbɔghɔ mma* girls, and sometimes the Aro players, are barefoot; but everyone after the girls in the line wears shoes or sandals. At the very end, the ɛkpo atam represent a return to tradition, at least in some cases going barefoot.*

Some features of the elaborate form of *njenji* resemble the ɔkumkpa. Both are long plays in time from the point of view of the performers. The required presence of all secret society initiates below a certain age in both plays produces a large group of players. It also means that males take part in the *njenji* a number of times in their lives, as in the ɔkumkpa, starting from the back of the main line and moving upward,

changing masks and costumes through the years. The open and common quality of male experience with the ɔkumkpa is thus also found here. Age-set relationships in the village are expressed in the *njenji* (S. Ottenberg 1971b, chaps. 3 and 5), as age features characterize the ɔkumkpa. The set in charge is forming or newly formed and accepts advice from older males. The next younger set forms a part of the *igri* dancers, a number of the *agbɔghɔ mma* after the first ones in line, and some of the *ibibio* beyond the first few. This junior set plays a strong supporting role to its senior age set, just as it does in everyday village life.

The *njenji* is also community theater, for at the home village the players and audience together make up virtually the entire village population, and the players are well known and readily identifiable to the viewers. And like the ɔkumkpa the play has segments but no real climax. It is a parade of varied elements all more or less of interest where, as in the ɔkumkpa, special regard is paid to the players who represent girls. In both the *njenji* and the ɔkumkpa, skills are required, but they are probably greater in the latter, where singing and acting occur to a considerable degree.

In the *njenji* the home village sees the players briefly when they first come out and then when they return; in between they may view paraders from other villages. The size of the parading group will vary depending on the village's population and whether the elaborate or simpler form of the parade is being performed. Thus the viewers sitting in a village cannot make a strict comparison of the groups that pass by. Yet the audience is keen to see the players from other villages and to compare them with one another and with their own players. This contrastive element is an important aspect of the aesthetics of the *njenji*.

When the elaborate form of *njenji* is performed, there is also a good deal of assessment of the organizing age set's performance in comparison to those of previous sets in the village. Often the age group in charge puts forth a concerted effort to better the productions of past ones. There is a natural competitive spirit here that is part of a much broader pattern of age-set rivalry in the village. And some of the viewers particularly like to watch players who are older than the age set in charge, individuals who are substituting for younger brothers or other relatives or who have joined the play for the pleasure of it. They are curious to see how well they will move and are somewhat amused because these men are older than they should be to take part in the parade. One such man at the 1959 Mgbom parade, who was substituting for a younger brother, was laughed at by some of the viewers who knew him because he had very thin legs and walked poorly, and generally looked unimpressive. As in the case of the ɔkumkpa, there is a certain age somewhat lower in the *njenji*, beyond which men should

* There are exceptions. I have seen small boys in the main column go barefoot, and a lead *agbɔghɔ mma* wearing girl's shoes.

not take part in the play unless they want to be considered somewhat foolish.

Both the *njenji* and *ɔkumkpa* involve men dressing as females, both single and married, and acting like them. Of what significance is it that one of the main activities of the achievement-oriented age set during its formalization, or after it has just organized, is to dress up and appear exactly the opposite of how young men should dress —as beautiful girls? The next day after a formal initiation, when the set feasts their male seniors in the village as part of their coming of age, their activities are clearly typical of males. One can only see their dressing in attractive girls' costumes, then, as a symbolic statement of their maleness and their coming of age as male adults. By acting as females they reiterate their masculinity. The canes or sticks that the *agbɔghɔ mma* carry in their right hands are the symbols of eldership at Afikpo. It is as if they are present to remind the viewers that the masqueraders are after all males, and mature ones at that.

The point becomes even clearer in the sexual opposition of the *igri* dancers to the *agbɔghɔ mma* players. The *igri* represent vigorous and exuberant young male adulthood, men who are physically strong and lively, willing to attack and to defend as the parade moves through other villages than the home one. These ideals of young manhood are contrasted with the *agbɔghɔ mma* players, the adolescent girls of marriageable age in their finery and beauty. And it is, of course, men in their late twenties who often marry such girls.

The idea of physical strength is a recurring theme in the parade. It not only is found in the *igri* performers, but again in the *ɔkpa eda*, who, though smaller in size, carry machetes and small wrestling bells. It is also symbolized by the wrestling *ikpo* bells worn by the *ɔteghita*, *ɛkpo atam*, and some *igri*, suggesting an emphasis on strength. And the association of the Edda Run with this play (see following section) again points to the element of male physical capability.

I have mentioned that during the Dry Season Festival there is much movement of girls from village to village to greet and to stay overnight with girl friends and female relations. It is not surprising, then, that the *njenji* move from village to village. It is as if the players, as they approach another settlement, are saying, "well, here are the finest girls of our village, led to you by our finest men," referring to the *agbɔghɔ mma* and *igri*, respectively. And as the girls dress for this festival in traditional costume, wearing the plastic bead waistbands, so do the players who represent females.

We may also consider the *njenji,* as the *ɔkumkpa,* as a ritual of childhood associations, psychologically speaking. In the *njenji* the rather heavier reliance of the male players on females for cloths, clothes, waistbeads, and other costume elements to use in the play suggests a symbolic statement of a male dependency upon females. Here are males in the prime of life, performing one of the major ceremonies of young adults, who depend upon females—whether sisters, lovers, wives, or mothers—for success in their performance. And it is a special relationship, for each party understands what the borrowing is about, yet neither expresses it; they are bound together by a taboo of secrecy over something they both well know. The unspoken understanding is the adult male's equivalent of the boy's childhood fantasy of a certain special recognition by his mother.

Another theme common to the *njenji* and the *ɔkumkpa* concerns the beautiful girl who represents some idea of a child's mother, and of the ugly, hostile older male—here the Aro—who "takes" away the child. But the male figure is not as fully employed or developed in the *njenji* as in the *ɔkumkpa,* where it is a central theme, prevalent throughout much of the play.

The *njenji* rather emphasizes the sexuality of adult males and matured girls without any direct reference to sex in dress, motion, or song. But both sexes are presented as young, desirable, and attractive. And during the Dry Season Festival, when the *njenji* is held, older girls sometimes have liaisons when they are away from home ostensibly visiting their girl friends—a fact that is well known. Thus the festival itself has a sexual aspect for the young, and the parade expresses this interest without being overtly sexual.

It is interesting to note that noninitiates seem rarely to imitate the *njenji* in their own masked plays. I do not know the reason for this. Possibly the boys would be attacked if they walked about in masks to other sections of the village than their own, as boys fight a lot in groups within and also between villages. Or, this ceremony is too controlled and the boys prefer ones with more physical motion, such as the *ɔkumkpa* and the chasing games. Perhaps, also, at their age, they are as yet not interested in the preening behavior typical of the *njenji.*

Neither the *ɔkumkpa* nor the *njenji* seems outwardly very religious. The priest of the secret society watches the *njenji* parade but takes no direct part in it except to prepare magical aids to insure the success of individual players and to allow the players to pass through the shrine house to salute the secret society shrine. Nor does the parade tie strongly to religious sanctions of the secret society beyond the matters connected with the masks and costumes and the rules as to how players should behave. No myth or legend is enacted. The *njenji* has a strongly secular air to it.

At this point I would like to comment on a passage in my field notes, written after seeing the five *njenji* parades at Afikpo.

It is difficult to ferret out why there are certain types of players. People simply tell you that they are there, that *igri* leads the way, that Mgbom always has an *egbiri*, and that he should dance well, and that he dances in imitation of a woman, and that the line is the way it is, but no one seems concerned with the symbolism or the reasons why these occur, and I have checked carefully with various people.

The persons I talked to about the *njenji* were knowledgeable, including the carver, Chukwu Okoro. I am sure that more detailed interpretations are possible and if I were to return to Afikpo today I would be better prepared to work them out. But the fact remains that the parade is seen as a pleasant display rather than a highly symbolic and interpretive art closely tied to beliefs and myths. It was probably once associated with warfare and fighting, or at least physical strength; but since the decline of fighting at Afikpo, the *njenji* has lost some of its symbolic meaning. However, it has added new elements in dress, and probably in mask, form that have changed its character.

Njenji seems common to other village-groups in the Ada subgroup of the Eastern Igbo. Nzekwu (1963), in an article on Edda Village-Group, shows a photograph of an *ɔteghita* dancer wearing a costume similar to that at Afikpo except that the hat has a broader rim. This masquerade figure, which he calls Ekpu, "dances a gentle caper around the village square" (caption, p. 17). And he pictures an *igri* (p. 20), which he calls Egede, with an Edda-style *igri* mask, who holds a small metal gong in his right hand and whose raffia skirt is tied around his neck with twisted raffia strings. This player resembles the *igri* costume at the Afikpo *njenji*. He also has two photographs of *egbiri* (p. 24), whom he calls Oburachichi, with mirrors at the back rather than the front of the head, who are attended by praise singers dressed much as at Afikpo. Finally, he pictures several *ɔkpa eda*, whom he calls Oraka or Okpaa (p. 28), who carry canes in their hands. And Jones's description of the Ifogu play in Nkporo Village-Group (Jones 1939b) suggests the presence of similar masked players to the Afikpo *njenji*. He claims that the Ifogu originally came from Unwana—the Ada village-group just south of Afikpo and quite close to it in customs. Some type of *njenji* parade seems common to the Ada people and is probably of some antiquity.

THE EDDA RUN

There is a masked activity associated with the *njenji* parade that is more a test of strength than a display or dance. The Edda Run, as it is called in English, seems not to have a specific name in Igbo at Afikpo. In it, masked young men or older boys run or walk rapidly over a circuit of some twenty-six miles from Mgbom or Amuro villages in Afikpo through parts of neighboring Edda Village-

Group and back again to Afikpo. It is a show of strength and endurance, more so than the *njenji*. The Edda Run is not a race, for, while the runners start pretty much at the same time regardless of which village they are from, all those who are able to complete the distance are honored with presents, while those who fail may be ridiculed. Yet, a special regard is shown the person who first returns and he is much praised.

Amuro and Mgbom villages are the only ones in Afikpo to hold this run. The two neighboring settlements were once one village, and they have close historical and cultural ties with Edda Village-Group (S. Ottenberg 1971c, chap. 2); the run doubtless expresses this fact. Still, Afikpo say that it is not an ancient tradition, but only began after the British came early in this century, for persons who traveled about in earlier times might be killed in head-hunting or warfare or might be captured and sold as slaves.

The run is generally done in the early morning of the day of the *njenji* parade by older boys or young men, who take part in that display upon their return. But it is also sometimes done on other days of the dry season period, following *njenji*, usually on an *orie* day of the Igbo week. Participation is purely voluntary and is restricted to secret society members, for the runners wear its masks. Sometimes one person decides to make the run and then others agree to try it as well. As many as fifteen masked runners may run at one time.

The evening before the run, the participants visit the secret society priest of their village. He gives them a ball of *nsi mano* (food-oil), composed of fish and palm oil, which they will carry on the run, licking as they go to give them strength. It is the same substance which masked players often lick before an *ɔkumkpa*, *njenji*, or other plays, for the same purpose. If a runner is not sure of himself, he will also perform a sacrifice at the secret society shrine. He gives it a bit of kola nut or chalk and says: "Well, I am going to do this run tomorrow. If I do it all right, I will give you a chicken." This is a common form of promissory sacrifice at Afikpo. Some males scorn this ritual, regarding it as a sign of weakness.

About five o'clock in the morning of the next day the runners go to the *ajaba* dressing house in their own ward and dress up. They wear either the *igri* mask or a net mask of the *aborie* type. The *igri* mask is particularly difficult to see out of, and for this reason some persons prefer the lighter net mask. With the *igri* goes a costume that is similar to that worn by the *igri* in the *njenji*, but simpler and lighter in weight. Less raffia may be worn, the headdress is not so elaborate, the animal skin on the back may be omitted, and the *egede* stick is not carried. However, the *ikpo* bell is used. If the *aborie* mask is worn, bells are also attached at the waist, and there is body raffia, but no elaborate headdress.

After the runners are dressed, they leave the *ajaba*. Each one is accompanied by two or more unmasked friends from the secret society who cheer him on and help guide him over difficult places, especially log bridges and rocky sections of the paths. The helpers may also lick the *nsi mano* ball to give them strength. Usually some young, uninitiated boys follow along, as they also enjoy trailing masked figures, such as at the *njenji*. The helpers and young boys may complete the whole run, although some only go over a portion of it or cut across the circuit and pick up the runner on his way home. The accompanying friends receive no special credit for their part, even if they complete the run, although at a later time they are likely to be feasted by the runner to thank them. The event is a test of strength and endurance for the runner alone, since he must bear the weight of the costume and the difficulty of clearly seeing his way.

As the runner moves, he can lift his mask and lick his *nsi mano* ball if he is in a secluded spot where females cannot observe him. It does not seem to matter so much if uninitiated boys see him do this. From the Mgbom and Amuro settlements the masquerader takes the old Bende road, now a bush path, to Owutu, a central market village in Edda Village-Group. If he has friends at Owutu, or, in fact, anywhere in Edda, they may give him cash, yams, or other presents if they know he is coming or accidentally meet him. The helpers and young boys carry these gifts for him. From that village the runner takes the motor road to Osu village and then cuts through on bush paths for several miles to Libolo, an important ritual center for the Edda. Here lives an important secret society priest who receives the remains of the *nsi mano* medicine as proof that the player has come from Afikpo; he gives him another, which the runner licks as he returns and gives to the secret society priest of his own village to show that he has really been to Libolo. The Libolo priest feeds the runner and his followers if he has any food in the house, which he may not, for he usually does not know that anyone is coming. And the priest gives the masquerader some plantains to take back to Afikpo as proof that he visited Edda; these are carried by his helpers or the young boys.

From Libolo the runners go to Amaseri Village-Group along the main road and from there they follow the road to Afikpo. Just before Afikpo Village-Group is a high hill that has "finished" more than one runner. At Afikpo the route is through Amachara village to Amuro and Mgbom, where the players rest awhile in the *ajaba*, drinking water and eating papaw, oranges, and bananas (nothing else is permitted). Then they go around to neighboring villages to receive presents from relatives and admirers, and finally through the compounds of their own village for the same reason. This greeting expedition may be delayed

until later in the day when it is cooler, and the players will take part in the *njenji*, if it is held in their village on this day, for they are usually home by late morning, in time to join up. Some runners, however, make their tour to collect "dashes" on the way home from the run, going even to the Government Station to greet friends. At any rate, before retiring from his costume the runner usually goes to the secret society shrine house of his village and greets the priest to indicate that he has returned. The priest, friends, and relatives may await the runner with some anxiety.

When a player returns successfully, he is usually greeted by his age set, who give him presents of fine yams, a goat, palm wine, and other things, for it is an honor to the entire set. Sometimes the runner's father gives him a section of good farmland as a reward. This is highly prized. One runner who received a piece of land named it *ale ike* (ground-strength) to commemorate the event.

Along the way the runner can stop at men's resthouses in the villages and drink water, much as can the *njenji* players, but he is expected to eat only at Libolo. He is supposed to stop his *ikpo* bells from ringing when he passes four deserted sites in Edda where *ajaba* dressing houses once stood, in a show of respect for the spirit of the secret society, who is said still to reside in these places. If one rings his bell, it is said to remind *egbele* that his house is deserted and to make him unhappy. The runner's helpers indicate these places to him, or the secret society priest of his village has previously advised him about them. If a runner collapses or has to give up, it is sometimes said that he has failed because he forgot to respect this rule.

If the masked person does not return by dusk, he is considered not to have succeeded and men will go out and search for him until he is located. If he gives up and returns to Afikpo with his supporters, he may be ridiculed, but usually privately. One time in Mgbom village, after the runners had returned, they cavorted about the main common. One *igri* among them who had returned without completing the total circuit was laughed at by the viewers. They seemed to think it funny that he should dance about with others who had finished. If a runner collapses, some of his helpers return home and seek assistance to carry him back. As he is borne along unmasked, a secret society song is sung to scare away women, for they are not supposed to see him unmasked. And as one person said of the run: "Some used to be sick for days, some even died, but nobody thinks that it should be stopped. It is all their own fate."

Afikpo tell me that persons from Edda Village-Group make this run to Afikpo and back, carrying a *nsi mano* ball to the Mgbom village priest and receiving another in turn, plus a small

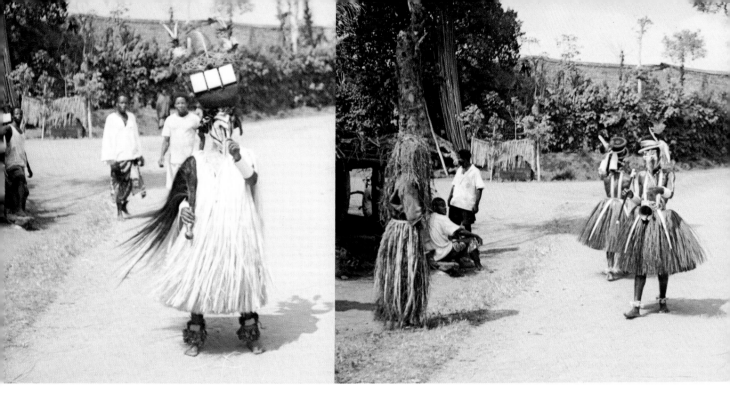

PLATE XIII

Єgbiri player at an *njenji* parade

Ɔteghita net mask player at an *njenji* parade.
A praise singer is at the left

An Edda-style *igri* mask at an Afikpo *njenji* parade

A masquerader acting the role of an Aro trader, with
his gun and ugly mask, cavorting about at an *njenji*
parade. Gun shooters are reloading in the rear

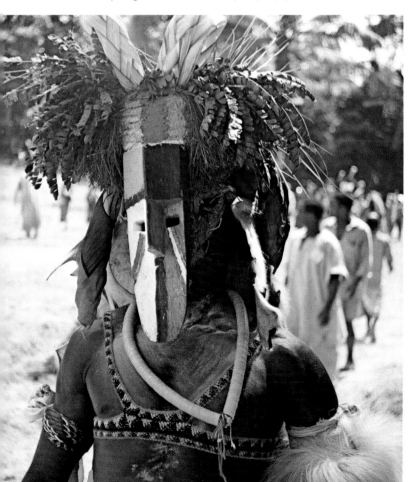

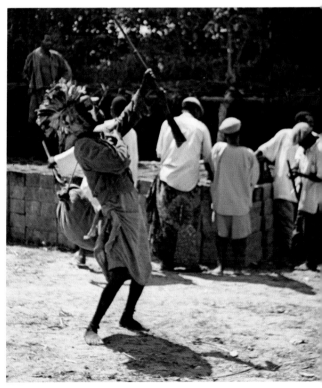

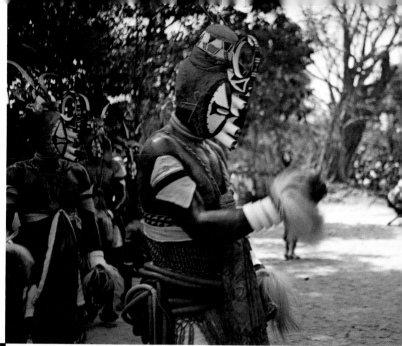

PLATE XIV

Okonkwɔ players in the Okpoha Village-Group, wearing the *mma ji* mask form with the rounded top-piece

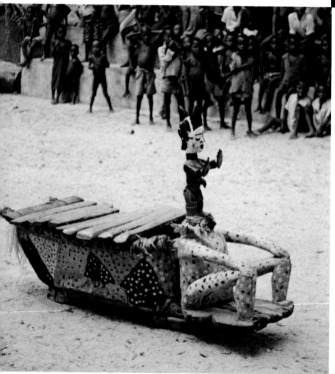

The xylophone at the Okpoha Village-Group *okonkwɔ* dance

Okonkwɔ dancers, Okpoha Village-Group. The player at front center wears an Afikpo-style *mma ji* mask, the player in back of him the Okpoha style

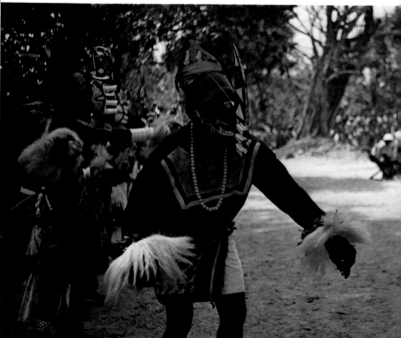

pot, but no plantain. However, I have never seen the Edda runners at Afikpo.

In this ritual the *igri* mask, the preferred form of face covering for those who are strong enough, fits nicely as a symbol of youthful exuberance. The mask, of course, is also associated with eccentricity, not out of line with the events of this sport. The run is connected to the *njenji* in terms of its costume elements and sometimes by their occurrence on the same day. Both activities are linked to ideas of male physical prowess. The *njenji* is also a ''run,'' but one that moves at a slower pace and over a shorter distance; and the display elements in the *njenji* are much elaborated, while strength is the main element of the Edda event.

Two Dances

I now turn to two rituals, one employing wooden masks and the other net face coverings, that have much in common. In both the emphasis is on the skill of dancing to music provided by other masked players. Both productions are briefer than the ɔkumkpa or the njenji; each is given not only in its home village but also in the market place and in other villages. Neither one is seen at Afikpo more than once or twice a year, if at all. And both dances are "owned" only by certain patrilineages, wards, or villages—but not necessarily by the same groups—while njenji and ɔkumkpa can be performed by all Afikpo settlements. The two differ, however, in their costumes, forms of movement, and music.

OKONKWɔ

Okonkwɔ, also called okpoha ngodo, is a dance of young adult men wearing wooden masks and costumes something like those of the *akparakpa* dancers in the ɔkumkpa, who perform to the music of a xylophone, basket rattles, and in some cases a wooden gong. In Afikpo the dance is played during or shortly after the Dry Season Festival, *iko ɔkɔci.* At least in some cases it is organized by members of the village age set who are finalizing their formation—the same males who organize the *njenji* parade.

The okonkwɔ is performed only by certain Afikpo settlements, including Ezi Agbe compound in Ukpa village, the village of Ngodo, two sections of the Ugwuego community (Ugwuego Amancho and Ugwuego Amogo), and two wards of the large village of Mkpoghoro (Elogo and Agbogo in Ndibe). These groupings are all of the substantial size needed to draw a good number of players.

The dance is not commonly given at Afikpo. I never saw it done there in full form, and I know that it was not performed in 1959. In 1957 Ngodo produced one; in 1958 Ezi Agbe did; and in 1959 I saw a rehearsal at Elogo in Mkpoghoro, although a full performance did not eventuate. There is no order in which it has to be given in the settlements that produce it.

The origins of the groups that perform okonkwɔ at Afikpo are diversified: some are of Aro beginnings, but some, like the Ugwuego groups, are of ancient Ego stock. It is likely that the dance has been borrowed by one group from another. It is given in settlements belonging to three of Afikpo's five major subgroups—Ahisu, Mkpoghoro, and Ugwuego. The pattern of ownership of the rights to perform the dance is much like the pattern of control of certain shrines by particular agnatic groupings at Afikpo (S. Ottenberg 1971b, chap. 8).

The one full dance that I witnessed took place in the Eastern Igbo community of Ɔha Nwego village, in neighboring Okpoha Village-Group (one of the Ada groups), on their market day, *ahɔ,* 9 January 1960. It was organized by the village age set finishing its formation, consisting of men in their late twenties, roughly within three years of each other. Older men can take part if they wish, and several did so at this dance, including a well-known local diviner who enjoys participating.

About 9:30 A.M. men shot off guns to announce that it was time to start the preparations. There is no *ajaba* dressing house in this village, and the dancers prepared in a special bush dressing area near the settlement, coming out to the village common as they were ready rather than waiting to emerge en masse. As in the Afikpo ɔkumkpa, friends, relatives, and dressing experts came to assist in these preparations, including my carver friend, Chukwu Okoro, a comrade of the diviner taking part in the play.

There was one basic costume, much like that of the *akparakpa* at Afikpo, but more elaborate. The dancers wore the *mma ji* mask of the circled Okpoha variety, although a few had the Afikpo-style *mma ji* with the straight "knife" on top. Unlike Afikpo masqueraders, they also wore a decorated wooden or calabash cap and a red woolen headpiece. Not only were these dancers older than the Afikpo *akparakpa*, but they wore many more sets of plastic waistbands (some even had them up on their chests) and they had numerous small bits of colored cloth on their bodies and waists. But they lacked the raffia waist piece worn by the *akparakpa*. They dressed in white shorts, without singlets, and wore the cloth chest halter found at Afikpo, although tied somewhat differently in front. They carried white cow- or horse-hair tassels in each hand, and had ankle rattles made of smaller-sized seeds than those worn at Afikpo.

Some of the dancers had a protective charm tied around one of their upper arms (S. Ottenberg

1970, pp. 44–45). This is prepared by a diviner from magical substances, wrapped up in leaves, and tied on with still more leaves. And some dancers attached a live chick to their headpieces. It is believed that both the charm and the bird give the player strength. Chukwu's friend, the diviner, chewed some hot pepper and spit it inside his mask four times, and then ate some of the magical preparation, *nsi mano* (see chap. 9), before donning his mask. Hot pepper is frequently employed at the start of a sacrifice to "wake up" a shrine so that its spirit will be active.

The actual performance began at about 11:30 A.M. and lasted for some two hours before a packed crowd, which included many women and children as well as males. The audience was arranged much as at an Afikpo *ɔkumkpa*. A xylophone (*igeri* or *akware*) was in the center of the common. Composed of nine boards, without calabashes underneath, it was colored orange, black, and white, with red, black, and white spots on it. There was a human figure at the end (pl. XIV), consisting of a large seated torso with bent knees and arms. In place of a head there was a small human statue, about two feet high, placed there only after the xylophone was brought out. The xylophone was played by two musicians seated on chairs to each side of it. These men wore white-faced masks looking something like the *nne mgbo*, but with a more elaborate hairdo, and with white feathers around the edge of the mask. They also wore pith helmets, as did a third musician sitting nearby, who held a hand rattle in each hand, conically shaped out of basketware with raffia grass hanging from them and filled with pebbles. These are the standard rattles used in the Afikpo *ɔkumkpa*. This musician had the Afikpo-style *mma ji* face covering with the three horizontal projections coming outward from the face.

When the three musicians commenced to play, the dancers formed a line and moved about counterclockwise. They did not seem quite as well prepared as some of the Afikpo dancers, and they tended to bunch up, so that members of the audience shouted for them to move on. They were mostly of the same age and not arranged according to size. While dressed as females, they did not attempt to imitate female dancing. There were about six different dances, each one performed in turn to music of its own (fig. 61; pl. XIV). Occasionally, one of the players darted to the center of the common and danced about a bit alone, but he soon returned to his place in line. Members of the audience—only the males—went out and gave the dancers "dashes" as they moved, or in between dances, when there was a pause.

There was no singing or the playing of skits as at an *ɔkumkpa*. But there was some pantomime. Two male dancers in the center, near the musicians, were dressed as women, with waistcloths and white-faced masks that were something like the Afikpo *nne mgbo* except with a more elaborate hair style on the top part of the mask (fig. 60). They danced around and imitated the motions of women. And two men, wearing *mma ji* masks, were dressed as Aro slave traders. They both carried long guns, and one had a large gunny sack to represent a bag of cowrie shells. They also danced about, waving their guns. At one point the music stopped and the two Aro went to the line, pulled out one of the "female" dancers, and then rejected her. They repeated this action with another dancer, much as if they were selecting a person to purchase as a slave. Then a third "female" came out of the line, ran to the xylophone, put her hands underneath its boards, and brought out two papaws, giving one to each Aro; then she returned to the line. The Aro were pleased and danced about as the music commenced again. The dancing line moved on and the Aro men joined it. A similar act occurs at the *njenji* parade, although it involves a boy rather than a female. Here the slave "begs" her freedom by a gift of fruits, but the symbolism is the same.

The *okonkwɔ* rehearsal at Afikpo that I attended took place on the small market day (*ahɔ*) in the Elogo ward common of Mkpoghoro, involving only male players from that ward. It began about 5:30 P.M. and lasted a number of hours, put on by the players from this ward who had the day before taken part in the *njenji* parade —men in their late twenties. There had already been a practice session that morning.

The *okonkwɔ* here, and in Afikpo in general, is also called *igeri*, one of the two names used for the xylophone at Afikpo. The instrument at Elogo had five rounded playing boards, but was undecorated. There were not only two xylophone players and the rattle performer, but also a musician hitting the wooden gong, *ɛkwɛ*. In this case the common was closed to all but secret society initiates, as it was a practice session; but there was a good-sized audience of males, from youths to elders, not only from Elogo ward but from other parts of Ndibe. The players wore no costumes but carried leafy twigs in each hand as a substitute for the tassels that they would carry if in costume. They waved theirs about in set patterns as they danced in the usual circular line in a counterclockwise direction. Several older men than the age set involved acted as teachers, leading and directing the dancers. Some of the elders danced about on the sidelines, encouraging the young men.

Shortly after the dancing began, a middle-aged Mkpoghoro man came out and stated that those of the age set involved who did not take part would be fined 2s. 6d.

At times the dancers were bunched up at one end of the common, and the leaders of the age set selected single individuals to come out and dance.

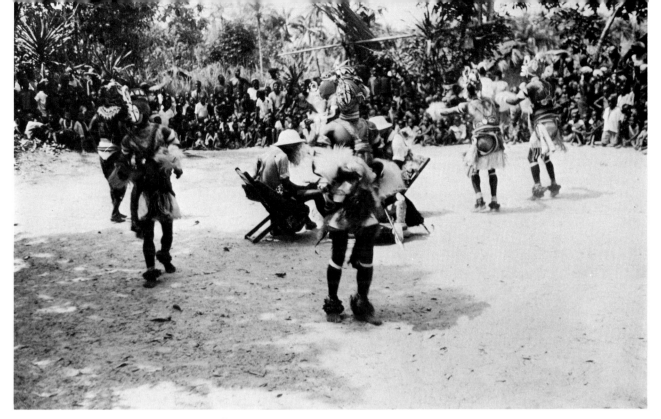

Fig. 59. *Okonkwɔ* dance at Okpoha Village-Group.
Xylophone players are seated at center

Fig. 60. Player imitating a female standing in front of
the xylophone musicians at the *okonkwɔ* dance,
Okpoha Village-Group

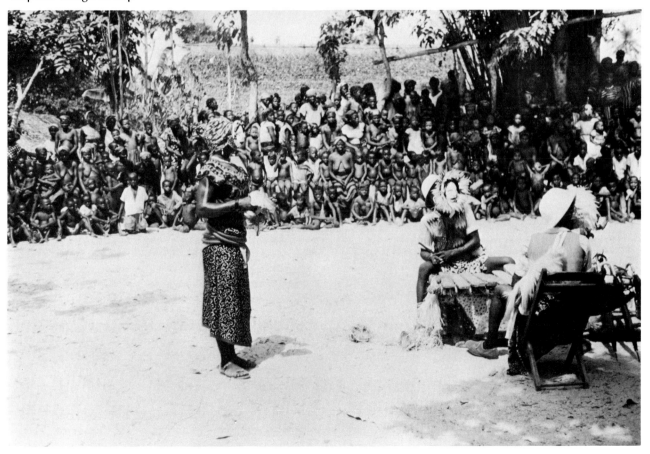

At other times the dancers were arranged in a circle according to height, with the tallest in front. There were no representations of females or Aro and no one was in costume. The okonkwↄ is one of the few events in which the xylophone is used at Afikpo; it is not a common musical instrument there. It is also heard at some logholo chasing plays, and it is used in some forms of secret society initiations.

The uninitiated boys put on this dance play, also using a xylophone, in their own special areas where they have their own resthouse and play spot in back of the compounds. They are not allowed to perform this play in the ward or the village commons.

The Afikpo okonkwↄ seems much like that at Okpoha, although there is a difference in the number of musicians and some variation in mask forms. Running through the play is the theme of men dressing up as women and in some cases imitating their movements. Also, male authority is alluded to through the Aro traders, persons still much feared and respected in the area. But the main point of the performance seems to be a display of dancing skill and the appearance of brightly colored costumes. The pleasure of the audience is in viewing the movement and hearing the music.

OJE OGWU

I do not have a list of those compounds, wards, or villages that "own" this net-mask dance at Afikpo. In 1959 Amachara village produced it, and in 1960 the only oje ogwu that I have ever witnessed was put on by the compound of Ezi Akane in Ukpa village. I know that Mgbom has done it in past years. Since the dance requires some thirty or more young players, the residential or agnatic group that organizes it should be of some size. Rarely performed more than once or twice a year, it is often put on about January, although practice sessions may start in December, after the Dry Season Festival. It is said that if some persons in the settlement are planning to perform it while others plan to do the ↄkumkpa the same year, the oje ogwu will be dropped, for it is not considered to be as popular or as interesting. Yet, when it is produced, it draws substantial audiences and much interest.

The play is organized by one or more interested adult males who direct the rehearsals, where the best dancers are selected. Those who can hardly dance at all, or do not wish to, become the musicians. The musical group is composed mainly of amateurs and is larger than the more professional ones employed at the okonkwↄ and the ↄkumkpa.

I attended the first practice session of oje ogwu for Ezi Akane compound on 16 December 1959. It was rehearsed every other day in the afternoon (every ahↄ and ɛkɛ day of the Igbo week) until presented on 3 January 1960.

The impetus for the rehearsals came from an ex-army man, known as "The Major," who was in his forties and had recently come home to retire after years away in the service. Educated and a "progressive" in local community politics, he nevertheless was greatly interested in some traditional rituals and was a skilled and knowledgeable dancer. His counterpart can be found in at least some of the other villages of Afikpo in one form or another: educated men who retain a strong sense of interest in village life and wish to "raise up" the community and Afikpo in general in a variety of ways, from building roads, schools, and bridges to putting on fine traditional festivals.

Most of the Ezi Akane secret society members from the age group of boys and young men took part in the rehearsals and the actual performances. The musicians at the rehearsal that I watched stood at one end of Agbogo common, used by Ezi Akane, each singing and beating two sticks together to create the rhythm. At this first practice session two other musicians played the wooden gong, ɛkwɛ, and one the single-piece iron gong, ɛgɛlɛ. Dancers came out individually and tried their skills in front of the musicians, with The Major and a substantial audience of boys and men from Ukpa, and even persons from neighboring communities, looking on. Although the common was closed to noninitiates, there was a goodly number of viewers, for the rehearsals themselves are a form of entertainment. The dancers wore foot and wrist rattles, and carried small branches with leaves in each hand to represent tassels, as at the okonkwↄ rehearsal. They had no chest coverings, but wore shorts, generally with a cloth over them. The Major directed the rehearsal, helping to choose the best dancers and to instruct them on how to move.

The first dancer to come out and move before the musicians did very well and the crowd shouted their approval. Someone commented that he was surprisingly young to have danced so skillfully. A second player moved poorly and stumbled, and the crowd laughed at him. Someone called him a drunkard and another person agreed. A third dancer did well but was followed by one so poor that he elicited hoots and shouts from the viewers. A skillful middle-aged dancer followed. And so it went. A good dancer takes his time and moves by the audience with confidence. After he has danced in front of the musicians for a while, he drops down suddenly to a crouching position, while facing them, to end his dance. A poor dancer cannot do this well, or does not even try to. I have not seen any other Afikpo dance where this particular method of ending the dancer's movement is employed. The Major danced last, performing with skill. Then he led all the dancers

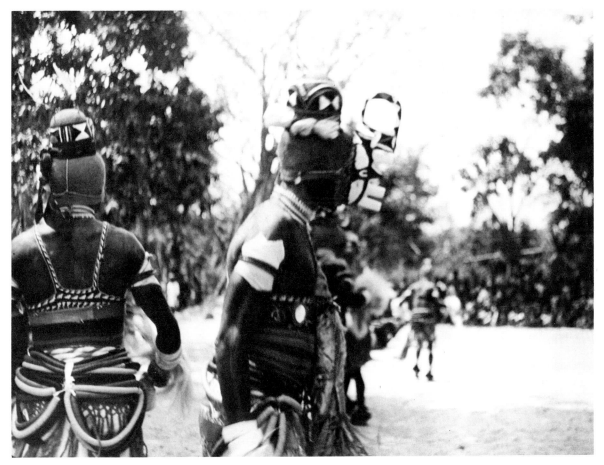

Fig. 61. Dancers with the circular-style "knife" on the *mma ji* mask at the *okonkwɔ* dance, Okpoha Village-Group

in a circle around the common some five times, with the dance steps changing as the musicians altered their beat. This ended the rehearsal for the day, lasting something over an hour.

The audience was noisy and thoroughly enjoyed making quite vocal criticisms and comments. I have seen such public commentaries at *njenji* rehearsals as well, but the night practice sessions of *ɔkumkpa* were more subdued and controlled, with the leader more in charge. But in all of these rehearsals there is pleasure in the practice session itself: it is not just a job to be done. And an awareness that the ritual will be shown before even wider audiences and in other communities provides a stimulus to make it a fine performance. The reaction of the audience at practice sessions of these plays and dances reflects the interest of the local community in putting on a good production before others in Afikpo. And in this particular case, the *oje ogwu* players of Ezi Akane compound will represent the village of Ukpa in the eyes of the onlookers from other Afikpo communities, some of whom do not even know that it is actually put on by just one compound of that village. Thus the whole community has a stake in putting on a fine show.

But the behavior of the viewers at the rehearsals of this dance and at other masked events at Afikpo also represents a common Afikpo, and probably Igbo trait. There is a marked willingness to vocalize praise and criticism and to give forth aesthetic opinions. This penchant was evident at the actual performance of the *ɔkumkpa* discussed in chapter 7.

Oje ogwu was given on an Afikpo market day. The day before, a feast was held in the compound to which friends, elders, and influential persons from Ukpa and neighboring communities were invited, as well as persons who were to help the dancers with their costumes. This is a sort of feast that is sometimes held after other masked rituals, but it was explained that this pre-performance one helped to advertise that the dance would be held. The day after the performance the players held a celebration just for themselves.

There are three types of masquerades at the dance: the musicians, called *akopia eka* (knock-hand); the *erewe*, who are the better and generally older dancers who perform individually as well as in the group; and the *ebulu*, the poorer and generally younger dancers who move only as a dancing group.

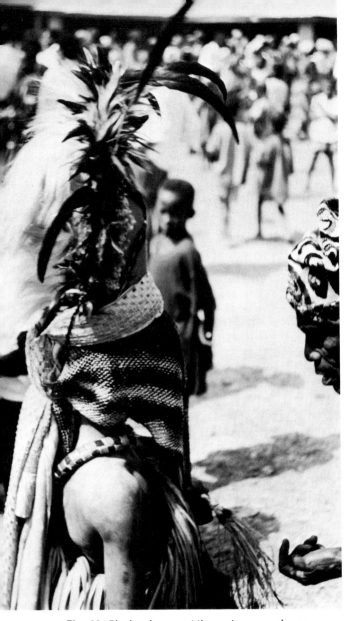

Fig. 62. *Ebulu* player at Ukpa *oje ogwu* dance

A good-sized audience of males and females of all ages was present, much as for an ɔkumkpa play. Viewers came out and gave "dashes" to their favorites during or between the dances. All dancers were barefoot, and all had net masks and some form of raffia body covering, usually light in color. The raffia moves gently as the players dance, with a slower and more settling motion than the dancer. This gives the dancers a flowing, smoother appearance than their actual body movements might indicate. The dancers are vigorous and entirely male in style and dress. While Westerners may tend to associate raffia dress with femininity, or with South Sea female dancers, it is largely a male element at Afikpo: it is worn by men during part of the secret society initiation and is used as backing for the wooden masks and in many costumes. Only occasionally, as in the *akparakpa* dancers in the ɔkumkpa play, and the *egbiri* in the *njenji*, is it associated with feminine costume.

The eighteen musicians all wore a dark brown net mask with black lines on it, and a variety of head coverings (fig. 63). Some had porcupine quill hats *(ebi)* and some headpieces of feathers, called *okpu ebuba* (hat-feather). A few wore simple cloth caps. In this *akopia eka* costume, the raffia drops down from the shoulders and covers them and the upper arms and chest, reaching to the ankles. The raffia on a few players was older and brownish rather than the more usual yellow color.

The musicians wore shorts, and some had on shirts or singlets under the raffia. Some also donned ivory or bone wrist bracelets. Most of them played the single-piece iron gong, ɛgelɛ, held in the left hand and hit with a wooden stick in the right hand. A few had the wooden ɛkwɛ gong, played in much the same manner, and several others just hit two sticks together. The musicians played a series of set rhythms to which they sang standardized words of certain secret society songs that are sung only when the face is covered. Unfortunately, I did not collect the words to these and am therefore not in a position to provide a detailed explanation of even the apparent meanings of this particular masked ritual. But the songs largely praise present and past dancers who excelled in the *oje ogwu*. They are not songs of ridicule, as in the ɔkumkpa.

The costume of the more skilled dancers, *erewe*, of which there were thirteen (figs. 63, 64; pl. XV; and S. Ottenberg 1973, pls. 1, 2, 5, 6), consists of a dark net mask with two or three white bands on it coming to a "V" at the front midline of the face. This contrasts with the *egbiri* net mask of the *njenji* parade, which is composed of dark lines on a white background. The characteristic headgear of the *erewe* consists of long, black feathers pointing out in different directions from the top of the head, which move about with some freedom and in a delightful fashion as the masquerader dances. Interspersed with them are shorter feathers dyed a bright pink. These dancers usually wear a green leaf in their headdresses, which they call ɔno ato (mouth-to- kill or to press down). This is believed to prevent the wearer from becoming ill or dying if he is praised for his skill in performing. It is a sort of protective charm, but different in purpose than the chicks used in other plays or the *nsi mano* and the pepper employed before donning a mask, which are used to ensure a good performance.

The headpiece of the *erewe* dancer is bound at its base by one or more cloths, either white or colored, which circle the head and drop down almost to the ground in back. The body is covered with raffia down to just below the knees. The whole raffia costume is tied up with braided raffia at the upper chest front and upper back midpoint, making a "V" as the braided cord splits and goes up over the shoulders. This complements the "V" design on the net masks. The shoulders and arms

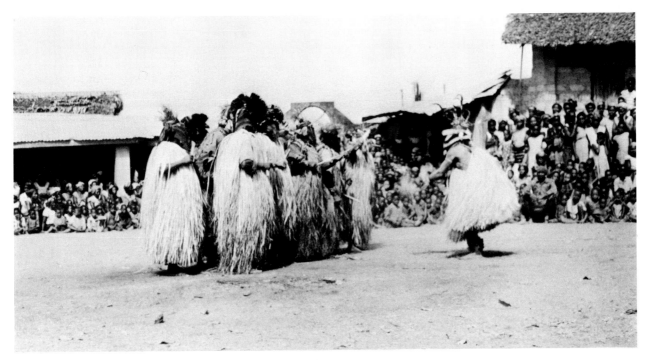

Fig. 63. *Erewe* player dancing before musicians at Ukpa village *oje ogwu* dance

are bare. Sometimes a white chalk line is drawn down the outside of the arms, which is a design worn in wrestling costumes and at other nonmasked ceremonial occasions by Afikpo men. The *erewe* carry colored tassels of animal hair in each hand and they wear wrist and leg rattles. When they enter the dancing arena for the first time, each holds a long stick as a cane in his right hand, which is put aside before the dance commences.

The *ebulu* (fig. 62) costume of the poorer dancers involves a similar body costume and net mask to the *erewe*, but the headpiece differs, although it often also has the green leaf in it for protection. On the head is worn a red cloth, which is peaked and surrounded by feathers, sometimes with an animal-hair tassel stuck beside it. The whole is bound in cloth, as in the *erewe* headpiece. But here the feathers are more vertically oriented and do not move about as freely.

Fig. 64. *Erewe* players dancing at Ukpe *oje ogwu* dance

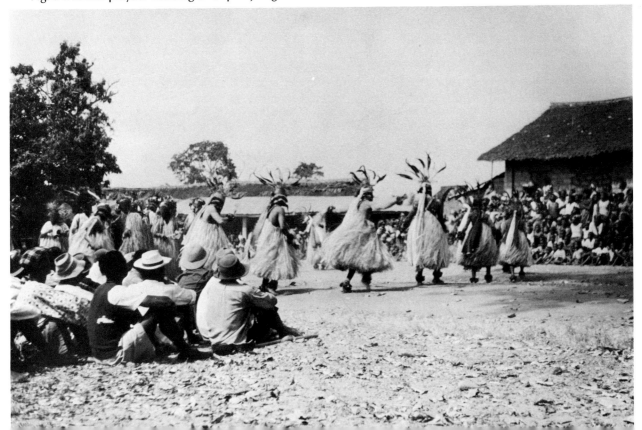

It is said by Afikpo that in former times another type of costume, called ɔba, using a calabash mask, was sometimes employed. But it was not present at this dance, and I could not obtain a good description of what it was like.

The dance began with the musicians playing while entering the south end of the common and facing north, with the dancers about one hundred yards to the north of them, beginning to hop about. Then two young ebulu brought a yam apiece to the musicians as gifts, dancing about a bit before moving back to their group. The rest of the ebulu did this is pairs, except the last one, who moved alone; and then the erewe went through the exact same procedure. After this an erewe returned to the musicians with a pot of water and several others came with money as "dashes." These gifts are the musicians' pay. Compound leaders then collected the items, putting them aside to clear the space in front of the musicians for persons to dance there. Each erewe then came forward alone, dancing in front of the musicians for a while and then suddenly dropping down to the ground to end his performance. He then returned to the group. This went on until all the erewe had performed, including The Major. There was much shouting from the audience, mainly of approval as the poorer dancers had been eliminated during rehearsals. It is here that the finest dancing of the day takes place and the players involved receive their best "dashes" from the viewers.

Then, the erewe and the ebulu danced in a single circle, one group following the other, moving counterclockwise. Again, persons came out and "dashed" the players. From this circle individual erewe broke out and danced again before the musicians as they pleased, then returned to the group. Several times during the performance uncostumed "progressive" friends of The Major shot off guns, to add excitement to the dance.

The performance lasted about an hour, being held in the late morning. When it had ended, the players walked to neighboring Amachara village to perform again, some stopping at the men's resthouses on the way to lift their masks and drink water. The players spent the rest of the day dancing at other central Afikpo villages. They also performed before the Afikpo elders and a large crowd of persons at the main Afikpo market, where the trading was in full swing.

The oje ogwu dance is simpler than the ɔkumkpa play or the njenji parade, being more akin to the okonkwɔ dance. It takes a short period of time to perform and is based on only a few contrastive elements. There are the three types of costumes, each of which has special movements and activities associated with it. There is the contrast of the darker faces and generally darker headpieces of the musicians, who remain pretty

much in one place, with the brighter and more multicolored face and head coverings of the two more physically active net-masked groups. These two groups are graded by skill, which roughly coincides with age differences, so that an age factor, so common to other Afikpo masked rituals, is present here as well. The musicians, however, are of varying ages.

A light, airy feeling about all of the costumes is imparted by the prevalence of light-colored body raffia, which also renders the body movements graceful. The music is steady but not dominating: in contrast to the heavier drumming sometimes found at Afikpo festivals, it has a light quality in the oje ogwu.

While the quality of the music and the singing were subjects for comment, the greatest interest was in the dance movements, and especially in the skill of the individual erewe dancers. Afikpo generally feel that everyone should be capable of dancing about in a circle as part of a group, but recognize that individual dancing takes skill. If a person is to so draw attention to himself, he should have something to offer; otherwise he is a fool. The contrast between the skilled individual and the less skilled group dancers is also found in the ɔkumkpa in the movements of the younger akparakpa as a group with the older ɔri dancers as individuals. The okonkwɔ is more simply a group dance, though now and then a player breaks out of the line and dances alone for a while.

Neither the okonkwɔ nor the oje ogwu is particularly associated with a specific festival, but rather with a season. There seems to be less pressure for a village to put on either of these than the ɔkumkpa play or a splendid njenji parade. The two dances are more casual, given when the persons concerned wish it, and thus are less frequently seen. It is interesting to note that while they are "owned" only by certain agnatic and residential groupings, both dances are closely associated with the village secret society, following its rules as in other masked events.

Other dances occur at Afikpo, of course, without masks and elaborate costumes, and women take part in some of these. But the most visibly pleasing and interesting ones seem to be associated with the secret society.

As a result of the paucity of comparative material from other parts of the eastern Nigerian area, it is difficult to say much about the history of okonkwɔ and oje ogwu. The former employs a mask form, mma ji, indigenous to the area and probably old. The oje ogwu involves net mask forms and raffia costumes, which are also ancient to the area and differ from the cloth costumes and cloth masked players found in some Igbo areas. Afikpo do not consider either dance to be a recent introduction, so it is likely that both are old forms.

CHAPTER XI

Masquerades of Physical Force

There are two classes of masquerades in which direct physical action plays an important role. One of these includes masks and costumes used for social control, especially over females and small boys. The other is a sports contest. Both lack the emphasis on public display found among those masquerades already discussed. They involve boys —both initiates and noninitiates—and young men, and are concerned with the matter of status. I do not believe that Afikpo think of them as a single group; nevertheless, they share elements in common. Some of these masquerades also play roles in the secret society initiations, and this aspect of their activities is discussed in chapter 11.

THE CONTROLLING MASQUERADES

There are two masked costumes worn by secret society initiates that males put on in the men's resthouses in the commons rather than in the *ajaba* dressing houses, in the bush, or the men's latrines. In this case the players are not required to remain in the village common overnight, but can return to their homes. In the Itim villages, which have secret society priests, players in either of these two costumes are forbidden to go near or enter the priest's house, although most other masquerade forms can do so. These features suggest that they are of a different order than other masquerades, perhaps of a different origin, and not as well integrated into the secret society. Yet they play important roles in the secret society initiation, as we shall see. The costumes are stored in the village resthouses.

One form, *ɔkpa* (fig. 65; pl. XVI), is a full head and body net costume, lacking a special design in the facial area. The name of the costume—its noninitiate term—simply refers to the costume and the player wearing it; it has no other meaning. Secret society initiates use the term *ekpa* (bag) for it. It is the only form of "nondetachable" mask (Cole 1970, pp. 36-38) at Afikpo. Colored dark brown with wide bands of white, it fits tightly to the body and only the feet and hands are exposed. The costume, made of native fiber or European cord, is heavy and rough to the feel and uncomfortable to wear.

The head section of the *ɔkpa* that I obtained in 1952 is made with cross-knit looping (Emery 1966, p. 32 and fig. 12) quite tightly done. The neck and body are of single interconnected looping (ibid., p. 33 and fig. 16), more loosely done.* The material used appears to be native fiber that is not too long, as there are a fair number of knots where pieces have been tied together. The fiber was colored before the looping was done.

ɔkpa is entered through the front waistline, where there is a horizontal opening. The player gets into it feet first, pulling up the lower part and then putting the remainder of the costume over him. There is a raffia knob or ball on the top of the head. In order to help the player see out, a stiff raffia cord, which comes out from about the center of the forehead region and back in around the chin area, is held out from the face in the left hand when the player wishes to see better; but his visibility is never very good. There is raffia attached at the waistline and again slightly above it, but in neither instance does it drop down very far. Nevertheless, the raffia effectively conceals the entrance to the costume in the front and the viewer has the impression that *ɔkpa* is manufactured right onto the body. There are also bits of raffia attached at the foot and hand openings, which add color to the costume. The player holds a stick in his right hand, which he uses as a whip, and he sometimes carries a pole in his left.

side view

ɔkpa is of foreign origin and is not made at Afikpo, although sometimes produced in neighboring Igbo village-groups. It apparently derives from the lower Cross River area, in the Efik and Ekoi regions, where it is a popular form (see photograph in McFarlan 1946, p. 26). It is difficult to locate for purchase in the Ada village-groups, of which Afikpo is a part. Because of its association with the secret society among the Ada, it is not sold publicly in the markets there, but has to be purchased in private. But I have seen them on

* I wish to thank Virginia Harvey of the Department of Home Economics at the University of Washington, who furnished this information for me.

public sale in the large Igbo market of Uburu some miles northwest of Afikpo. In 1952 a costume cost about £2 or £3, but in that year I was able to buy an ɔkpa in Amaseri Village-Group for 15s. It had been made there for a group in an Afikpo village that decided not to purchase it.

Ɔtero (he bites), the second form, consists of a body costume of dried pieces of banana leaves, light to dark brown, which trail to the ground but do not cover the arms, although concealing the legs and the body (pl. XVI). The player often rubs ashes or charcoal on his body to darken it. The costume has a net mask that fits flat on the face, with a string to hold it out at the bottom front. It is like a form called hihi or hihihi and contrasts with the aborie net mask types that were used in the njenji, where the face is more outwardly pointed and the string attached farther up. The costume has a red or pink cap of raffia fiber. The player often carries a stick in one or both hands and wears an ikpo bell at his waist. The costume is made at Afikpo. It seems at least as common as the ɔkpa and it is not difficult to prepare.

These costumes are often found in association with one another, but they are not part of a "performance" in the sense of the masquerades that we have previously described. They do not usually sing or dance, although ɔtero shouts and yells. Instead, they chase about. The ɔkpa in particular has a galloping, skip-and-jump motion. Either an ɔkpa or an ɔtero—or sometimes both—is seen during the dry season on nonfarming days (ahɔ and ekɛ), and on feast days, such as Mbe and during the njenji parade. Sometimes as many as three or four of one type appear. The days that these masqueraders come out are usually ones in which children are about, for they play with them. The players move through the commons, chasing uninitiated boys, who often follow and sometimes challenge them. A masquerader may scoop up a terrified youngster, only to release him. The boys may go near the secret society priest's shrine house for protection, where the masqueraders are not allowed to follow them. The boys, however, do not usually attack the players or attempt to knock them down.

The ɔkpa also chases uninitiated boys in the compounds as well as the commons. He moves quietly, but girls will shout warnings to the boys. The player dances for girls there, who sing his praises in return. Sometimes girls and women mock the ɔkpa, however, calling it wicked ("ɔkpa oro aleoo": name of costume-being-wicked), and it chases them. Ɔtero also enters the compounds, but girls fear it greatly, do not sing or taunt it, and do not speak up to warn the boys. Rather, the girls slip away and hide, and ɔtero usually does not chase them. While these types of plays do not attract a large audience, there are always some men, and sometimes females, who enjoy watching the action.

Ɔkpa is considered to have a relatively peaceful nature, but if the boys roughhouse too much and knock it down, as occasionally happens, it becomes angry. One Afikpo called ɔkpa the "mother of ɔtero," metaphorically speaking, as ɔkpa does not have a particularly feminine appearance. If ɔkpa is knocked down, the masquerader says: "All right, I will call my son, ɔtero," and he will arrange for the latter to appear if one is not about already. Then ɔtero attacks those who knocked down his "mother." It is said to be a very fierce masquerade, as its name suggests, and the person who plays it should have strength. As one Afikpo said: "Any weakling can be ɔkpa, as they do not have to do much, but ɔtero must be strong, as he must be fierce." Ɔkpa moves silently, almost in balletlike fashion, but ɔtero, with its bell and the shouts or yells of the player, is anything but quiet.

Sometimes, when the uninitiated boys have built up their own secret society compound in back of a section of the village, and show by their play and masquerades that they know a great deal about the real secret society, a group of ɔtero and ɔkpa from the village attack them and chase them away. Occasionally the masqueraders collect all of the boys' goods—masks, musical instruments, and shrines—and burn them, along with the houses that they have constructed. In this attack ɔtero plays the major role: the boys are free to go after this masker, who, unlike ɔkpa, must be physically able to defend himself. If an ɔtero gets thrown by a boy, he is ridiculed. There is a general expression used for a person who is considered weak: he is called "ɛredu ɔtero" (weakest ɔtero).

Parents of the boys, especially mothers, sometimes "dash" the masqueraders to stop them from destroying the boys' place and bothering their sons. The actual destructive act rarely occurs, although its threat is common. The "dashes" are clearly one of the incentives that encourage young adult men to dress up voluntarily in these costumes. Women never give dashes directly in this or other instances, for they are not to touch the masqueraders. They give the present to a secret society member, who passes it on. If the imitation secret society bush is actually destroyed, the boys will rebuild it after a while. The destruction is said to be "to keep the boys from learning too much" about the secret society. It also suggests to some of the boys' fathers that it is time to begin initiating their sons into the real society.

Occasionally if a boy is persistently troublesome in the village, an ɔtero will come out and flog him as punishment. This does not require the consent or the connivance of the father.

If a man is taking a title and the women who have been asked to prepare the food for him (his wives and sometimes other females of his compound) do it poorly, the man is much

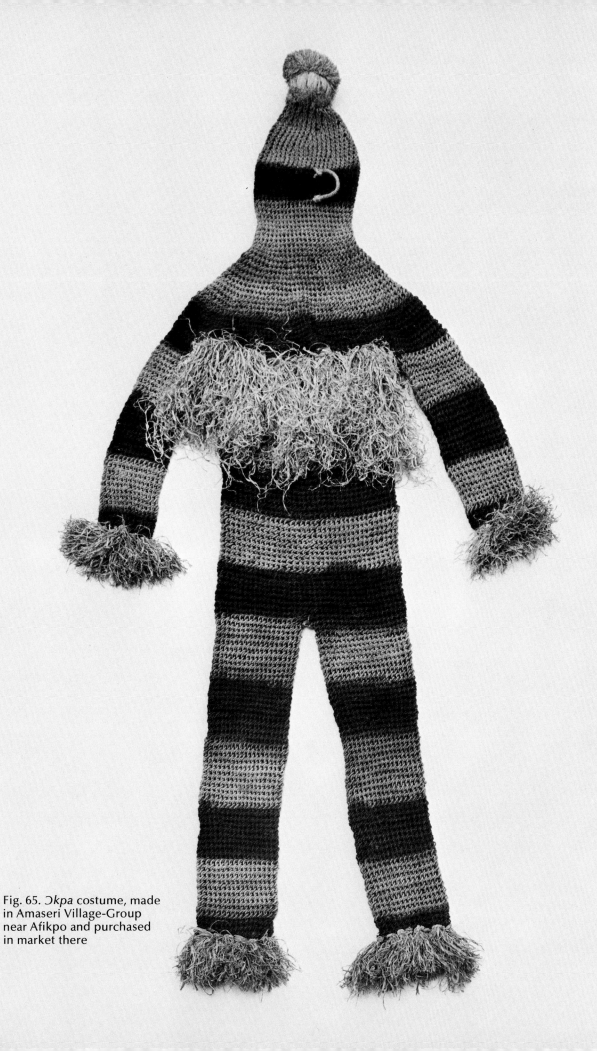

Fig. 65. Ɔkpa costume, made
in Amaseri Village-Group
near Afikpo and purchased
in market there

embarrassed, for the persons he feasts will be reluctant to accept his food in fulfillment of part of his title duties. As a result, a number of ɔtero and ɔkpa may appear, sometimes at the suggestion of the angered title-taker, and they chase the poor cooks about. Then the ɔtero threaten to jump on the roofs of the women's houses and to break them down. The ɔkpa encourages the ɔtero to act by insulting it, saying, for example: "Gɛrɛ nkɛbɔ agɔ jamua odu" (Look, I am a fearful tiger and I have delivered a weak one), referring to the ɔtero. This inspires the ɔtero to prove this assertion false by acting even more fiercely and threateningly. But, as in the case of the boys' imitation secret society, physical damage is rarely inflicted, for the ɔkpa then says, "All right, if you want to stop this fighting, what will you give me?" or something to that effect. Then women "beg off" by presenting the ɔkpa with "dashes" of yams or money through male intermediaries. Sometimes alarmed friends and relatives do this for them. Or a criticized woman may run and hide until others pay for her. The ɔkpa and ɔtero then go away and divide the gifts amongst themselves. A husband sometimes uses the threat of the masqueraders as a reminder to those who are to cook to prepare the food as splendidly as possible.

But usually ɔkpa and ɔtero just come out and play around on important feast days, chasing boys and frightening girls who yell "slave, slave" as a taunt.

In some communities the young men's grade of the village, ukɛ ɛkpɛ (S. Ottenberg 1971b, chap. 4), or a section of it in a ward or compound, corporately owns one or more ɔkpa, here called ɔkpa ɛkpɛ. The age grade or grade section acts as a form of police and regulatory agency under the elders' guidance in the residential group with which it is involved. Here the costume is put on to coerce females. For example, it was worn at a girls' wrestling competition in Mgbom in 1952 by a number of men of the grade to keep the females from behaving in an unruly fashion. It was accompanied by small drums played by uncostumed age grade members. The ɔkpa galloped about, although they did not actually do a dance. Formerly, in some villages, if the married women were bickering a lot among themselves, men would dress in ɔkpa and go to the women and tell them that they had to come out and wrestle, that they were "making too much mouth." The ɔkpa would supervise the sport. But nowadays only unmarried girls wrestle.

The ɔkpa and ɔtero are used on other occasions by this grade to keep females under control, but only, of course, during the dry season when these masqueraders can appear. They are part of a general pattern of control over females by members of this grade, who also have the responsibility for keeping peace and regulating the behavior of males younger than themselves.

Sometimes the proper grade does not keep an ɔkpa or lets it fall into disrepair. The village elders may then insist that the grade purchase another and the members will have to take up a collection among themselves and arrange to buy it. In one Mgbom ward the grade charged 1s. every time a person used its ɔkpa and saved the money to purchase a replacement when it wore out.

Sometimes the ɔkpa get a bit playful and out of control. For several years before 1952, schoolboy initiates were dressing up in the costume and chasing after and playing with boys on the grounds of some of the schools in the Afikpo area. Some Afikpo men objected and brought the matter to the Afikpo elders, who felt that the boys should not play secret society games at the schools and thus charged the Afikpo Native Authority Council to get the schools' headmasters to forbid this traditional play on school grounds. This was done and the practice died out.

There is also a story told at Afikpo that suggests the existence of anxiety over the aggressive role of the ɔkpa, even though it is not as fierce a masquerade as ɔtero. There is an open grassland area called uko, which is not suitable for farming, near the Afikpo Catholic Hospital, where ɔkpa from neighboring villages often play and boys and girls chase or follow them and are chased by them, as a friendly game. In the ancient past an ɔkpa came to play who stole and beheaded children. It was believed that the guilty person belonged to one of the original peoples at Afikpo, the Ego, who had been defeated through years of incursions by Igbo groups. One day this ɔkpa went to the village of Evuma, where Ɔnoha Chiali, an Igbo relative of the legendary founders of some of the central Afikpo villages, took away a child that the masquerader was holding and killed the player. The Afikpo rewarded Ɔnoha with a piece of public land, which is still owned by the village of his descendants. It should be noted that child-stealing was not uncommon during the slave-trading days, and the ɔkpa's scooping up of a young person today, even if only to hold him momentarily, symbolizes this kind of action.

Another example illustrates the relationship of ɔkpa and physical force. The six villages that comprise the northern Afikpo subgroup of Ozizza have a different form of secret society than the rest of Afikpo, centering on a shrine, ɛzɛ ale (chief-ground), located in a rocky, swampy place. On the afternoon of the day in October when the Ozizza secret society opens for the year, there is a ceremony called ɔnɔka, in the main common of Amorie village, only part of which I will describe here. Before an assembly of Ozizza's chiefs and many of its men and women, a drummer outside of the men's resthouse starts to play and is answered from inside by another playing the very large village gong. They drum back and forth to one another for a time, and then an ɔkpa emerges

from the resthouse and runs about the common carrying a machete. He whips this instrument around in the air once, as if he were fighting, and then runs back into the house. Eleven others follow, two players representing each Ozizza village. There is an interval of drumming between the appearance of each. It is said that in ancient times in Ozizza only men who had taken a head could dress in this costume.

Then an unmasked man, called *agba*, appears; he wears eagle feathers on his head, has his body painted up, and carries an ancient form of spear with sheep hairs on it. The twelve ɔkpa go with him to perform a sacrifice at an important shrine. Then the ɔkpa, as if released, go home, traveling through all of the Amorie village compounds to the Ozizza market place and then to their home villages, where they also pass through the compounds. In both cases when in these residential sections they dance about and play with initiated boys, but females and uninitiated children stay shut in their homes, for they are not supposed to see the masqueraders in their compounds on this occasion.

There is also an ɔtɛro for the uninitiated boys' groups. There is usually no ɔkpa, though an attempt to imitate one may be made. The boys' ɔtɛro is somewhat similar to the secret society form (pl. XVI), except that instead of a red hat and a net mask he wears a raffia headdress that completely covers the head and face. Over the body one finds the usual banana-leaf costume and the bell attached at the waist. The ɔtɛro of the uninitiated is not a destructive figure. It chases boys and girls about the compounds and it moves about playfully, but without attempting to seize persons. The girls like to taunt it, singing such phrases as "ɔtɛrohuuuuuuuuuuuuuuu," calling it a slave.

To return to the ɔkpa and ɔtɛro of the secret society, some summary comments can be made. Ɔkpa is clearly of foreign origin, a form that appears not fully incorporated into Afikpo culture since it is put on in a different place than most Afikpo masquerades, and the wearer does not have to spend the night in the common. The history of ɔtɛro is unknown.

The actions of these two forms are not displays in the sense of the masquerade performances that have been previously discussed. There is no large audience; most of the action involves only small numbers of onlookers. While the players are dressed up as *mma* spirits, they do not represent girls, women, elders, the Aro, or other specific kinds of persons; rather, they are seen as controlling and destructive spirits. I do not think that Afikpo consider them particularly ugly in appearance, like the ɔkpesu umuruma at the ɔkumkpa; however, perhaps the ɔtɛro, with its banana leaves that drag on the ground and give off a rustling sound, and its clanging bell, has

something of this same quality. But if not ugly, these masqueraders are feared for their actions as aggressive beings. The aesthetic elements in this masquerade, aside from some delight in the way the ɔkpa dances about, are fear or anxiety on the part of those being chased, and amusement for older males.

These masqueraders strongly reiterate the significance of status differences at Afikpo, a pervasive feature in the whole society (S. Ottenberg 1971b). They stress the importance of the maintenance of these differences through social control: older males over younger ones, the initiated over the uninitiated, and males over females. Girls are to be scared, if only in play, and women must be kept in their place. Uninitiated boys are to be reminded that they are not yet men or secret society members. The very acts of chasing girls who should not touch them and of receiving "dashes" indirectly from mothers through a male initiate suggest a strong separation of sex roles and the dominant place of males. And even the females' taunting of ɔtɛro and ɔkpa, when the girls, or sometimes even married women, call them slaves, is a statement of status differences: it is an aggressive response to being considered inferior by acting as if the attacker were inferior to them.

These status themes are reflected in many other areas of Afikpo life. Males believe that women should docilely follow their role of cooking well, rearing children, farming successfully, trading a bit, and not causing palaver or bickering too much. And boys should not act as if they were men with knowledge of the secret society, for they are boys. The secret society is the symbolic manifestation of adult maleness and of the control of adult males over women, children, and the world. Boy noninitiates are equated with women or girls: all are physically weaker than adult males. The property of these inferiors is subject to destruction if they behave improperly, and they are to be excluded from the mysteries and the excitement, as well as the power, of the secret society.

Why all this elaborate mechanism of male control? Is it simply a question of social role maintenance that is involved here? I think that these acts of the masqueraders described above, as well as other masquerading elements discussed earlier—for example, the criticisms of women at the ɔkumkpa—suggest that adult males feel considerable anxiety over their own roles and this is projected on male children and on females in general. They are threatened by the woman who acts like a male, the controlling or dominating female figure, and the boy who develops skills prematurely. There are elaborate rules at Afikpo, which are in fact broken as much as they are observed, that forbid sons to take higher titles than their fathers when the latter are alive; and no

male should better his living older brothers in titles and political matters, but should give his senior relatives the first chance. There is the ridicule of the man who behaves as a woman and the female who acts as a man. Males also must follow the age-hierarchy rules of behavior concerning manner of address, eating, drinking, and a thousand other things that stress that authority lies with the more senior male in any situation. Some of the actions of the masqueraders seem to portray an older brother putting down a younger one or a brother beating up or teasing a sister. The status game is taken very seriously at Afikpo, and persons who violate it are quickly and openly criticized. Aggression and hostility of persons toward others over many issues are likely to be expressed in terms of criticisms of improper role activities. The acts of these masqueraders reflect these points in symbolic form.

The destructive son who wishes to dominate is suggested by the ɔtɛro, the "son" of ɔkpa who destroys the noninitiates' special quarters, repeats the act in the initiating boys' enclosures (see chap. 12), and wishes to destroy the roofs of women's homes. It is like the angry boy who is threatened by younger siblings, who is upset because his mother's cooking is poor, who "acts out" in ritualized forms of destruction. And it is like the child who threatens to be destructive unless the parents give him presents to placate him— expected behavior in a society where children are quickly picked up and held by adults when they cry and where parents are most sensitive to the emotional needs of their infants.

And ɔkpa, symbolically the "mother" in some instances, is viewed as playing in a nondestructive manner, although the player in fact supports ɔtɛro's actions and threatens to call ɔtɛro out to be destructive. Is this dichotomy not a representation of men's feelings about females at Afikpo? They are playful and motherly on the one hand, yet threatening and hostile on the other.

A sexual element is found in the act of masqueraders chasing girls. It is both a form of flirtation, in which the males play the aggressive roles and females encourage them with taunts; and it is also a reflection of male-female sibling feelings toward one another, especially perhaps in the case of the uninitiated boys' ɔtɛro, who chase girls much of their same age. And for the uninitiated boys, the ɔtɛro play with girls often comes at a prepuberty or puberty stage when there is an awakening of sexual feelings and early attempts at sexual play.

THE CHASING GAMES

There are a number of masked and costumed figures, called by the general term of logholo, who play about in the commons of their villages and are chased by uninitiated boys, who try to throw them to the ground while they attempt to ward them off. There may be several logholo playing at once, although often there is but one, or only one at a time.

The costume of the most common form of logholo consists of a light-yellow raffia cover from the shoulders to below the knees, underneath which the player wears a jersey or singlet and shorts (fig. 66). The raffia part is freshly prepared each time that the game is played. The player collects the leaves and stores them for several days in advance, usually making the costume the morning of the game, for it does not take a long time to make.

A wooden mask goes with the costume, the acali and the mba being the two most common forms. Beke, nne mgbo, ɔpa nwa, and mkpe are also used. There seems to be a prohibition against using igri, the ugly ɔkpesu umuruma types, and the mma ji. The acali is particularly popular among the younger and least experienced players, for its good-sized square eyeholes afford better vision than some of the other forms, and it is lightweight and easy to wear. The more skilled and generally older players use the heavier and larger masks, such as mba and ɔpa nwa, which require more expertise. To do so and to play well at logholo brings praise and admiration. The mask wearers do not represent the images that their face coverings suggest. All players act roughly the same regardless of what mask they wear; the differences are in the skills and the tactics of the masqueraders. Sometimes a particular mask is worn simply because the player has ready access to it.

The logholo also usually has a long, thin stick in his right hand that he uses as a whip to beat off attackers. These players formerly carried a thick stick with a rope smeared with mud attached to its end, but this is no longer used.

The logholo moves swiftly about the commons, twirling around as much as possible to ward off unnoticed boys who sneak up from behind, where it is difficult for him to see because of his mask. The boys—there may be as many as fifty going after one or more masquerader—try to throw down the logholo by grabbing him by his body or his raffia dress. Sometimes several boys join together and try to attack him simultaneously from different sides.

The player wards off the boys with his stick and hands, but he usually does not aggressively chase them about. Unlike the ɔkpa and related forms, the logholo acts more defensively. If he drops to one or both knees, the attackers must stop and go sit or stand at the edge of the commons until he rises. I have seen weak logholo do this numerous times to protect themselves from being thrown. Similarly, if he is seated, he cannot be attacked, and the boys must retire to the sidelines until he rises from the log bench,

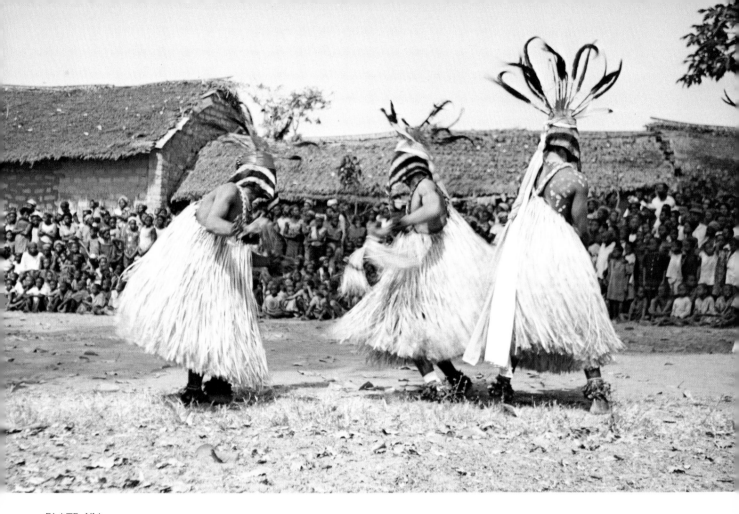

PLATE XV

Erewe dancers at the *oje ogwu* dance, Ukpa village, 1960

The *ikpɵ* net-masked chasing player *Isiji* players at the initiation of first sons in Ukpa village

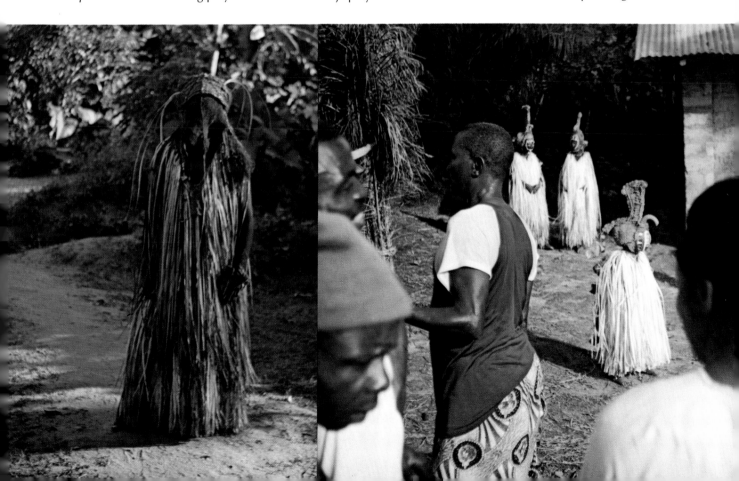

PLATE XVI

Uninitiated boys' ɔtɛro masquerader playing with girls
in the compound of the carver, Chukwu Okoro

Ɔkpa player Ɔtɛro of the secret society moving through a compound

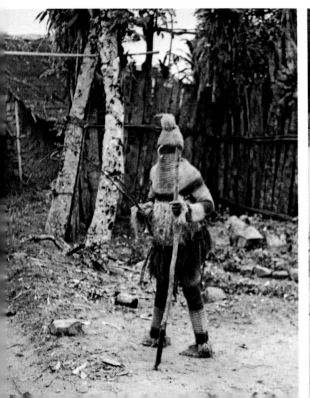

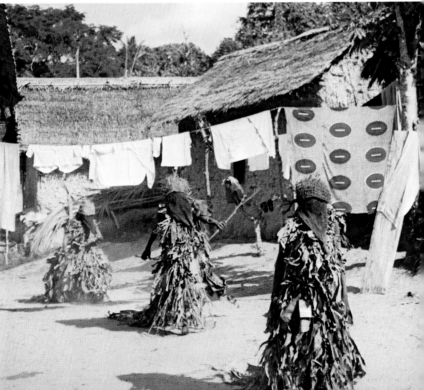

stone, or other seat where he is resting at the edge of the common. The young boys keep a close watch on him as he sits, and as soon as he rises they rush after him.

When the *logholo* has been thrown, all attacks on him cease until he rises; defeat does not mean his retirement as a rule, and he will continue to play. When the masquerader wishes to end the game, he puts his stick under his left arm and walks away. This is a sign that he is through and that no one should attack him again. A player may participate for several hours, even all day, if he is strong. While the play is on, men, including elders, sitting in the resthouse or about the common shout encouragement to the *logholo* and yell warnings to him if he is being approached from an unsuspected quarter. These bystanders enjoy watching the play. There may be some other spectators about, including women and girls, but the play does not attract a large audience. It is not a display, but a sport for the participants.

The age of the players varies from young boys who have recently been initiated into the secret society to men in their twenties. Every initiate is expected to play this game at least a number of times, no matter how physically unskilled he is. Some villages enforce this custom by a law, usually requiring boys who have just finished or are finishing their initiation to put on this masquerade, which is then called *logholo isubu* (*logholo*-end of initiation). It is considered to be part of their duty as initiates, although their rites are otherwise over. They use the *acali* mask, and a sheep's scrotum is worn around the neck as a sign that they are newly initiated. They are assisted in dressing by older initiates, who give them advice on how to move about. The new players can talk, but they are not permitted to sing as older players are allowed to do in some villages. They are also expected to visit the Afikpo market the first time they dress in this costume. They go as a group, protected by strong men and attacked by uninitiated boys, very early in the morning of market day. Shouting "*awa, awa, awa*" as they move, the masqueraders run about the market and then return to their village commons, where they play *logholo* all day. In the evening they dance about the compounds and then spend the night in the commons.

But except for these new initiates, the players are usually volunteers, strong boys and young men who enjoy the game. To indicate their greater maturity, older initiates sometimes wear duck feathers (*ɔkpu ebobo*) stuck out sideways from the raffia backing on the mask. And when men, reaching their late twenties officially form their age set, and the members have put on the *njenji* parade, they no longer dress in *logholo*, although they can advise others how to play it and help them to perform it.

In some villages, before the game commences and while it is on, young, uncostumed

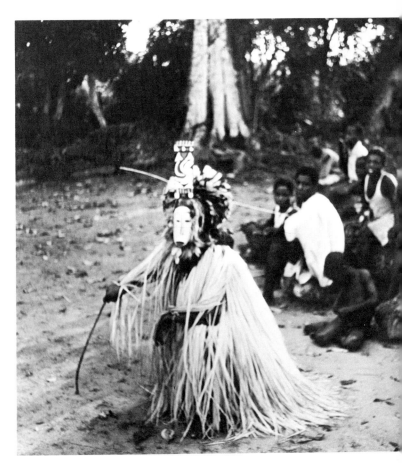

Fig. 66. Resting *logholo* player with *mba* mask

initiates in the resthouse in the common play the xylophone and beat a wooden gong to announce the play. The music attracts the uninitiated boys and is also said to give strength and encouragement to the *logholo*. In some communities these instruments are also played the night before to indicate that there will be a *logholo* game on the morrow.

I have seen weak *logholo* thrown again and again and good ones who were never upset and who walked away proudly at the end of their play with their sticks under their left arms. The uninitiated boys quickly figure out who is in the costume, and if he is known to be weak they attack him freely. If he has a reputation for being strong, only the bolder boys go after him, while the others move around and watch. A strong *logholo* does not need to use his whip to ward off the boys who rush him. And there are usually some small noninitiates who are new to the game and pretty scared. They hide near the compound entrances, peeking out, for the *logholo* does not chase into the compounds. The number of *logholo* players does not affect the procedures, as the masqueraders act independently of one another.

I have also seen a case where in the tussling the *logholo*'s mask came off. The men watching immediately yelled that the commons were

closed and they chased the uninitiated boys away, as they are not to see the player's face. Then they reset the costume. Several men criticized my friend, Chukwu Okoro, who had helped the player to dress, for letting a relatively inexperienced person wear the large and heavy ɔpa nwa mask, which also has poor visibility, rather than the acali. But comments were also directed at the player, who before dressing up had drunk a good deal of palm wine.

Uninitiated boys from neighboring villages are free to join in the sport. If they hear that it is going on, they will come down to the village in numbers and take part. Sometimes "rascal boys" are among those who come from nearby communities, ones who are already initiates and who should not take part in the game as attackers. But the masquerader and watchers may not know them. Such a boy has an advantage over the uninitiated attackers, for he has worn masks and probably played the game himself. He knows the areas of poorest visibility, the difficulties of movement, and he can attack with maximum advantage. These instances, if discovered, sometimes lead to bitter feelings toward the rascal boys on the part of the player. One such occurrence reminded an adult Afikpo to tell me that there is a saying that is used when someone is trying to spoil something or to give out a secret: it is said that he is "playing the game of logholo."

Sometimes a logholo visits neighboring villages that are holding a feast or masquerade, such as the ɔkumkpa or the njenji. He may move about a bit but usually does not play the game away from home.

Logholo is played in most Afikpo villages on ekɛ (market) day, but in the Itim subgroup of Mgbom, Amuro, Anohia Nkalo, Anohia, and Kpogrikpo, it is performed on orie days. In either case this is usually in October, after the start of the secret society season, and in November and December during the dry season and its festival. It is not played in every village on every day possible, but it is popular and not difficult for Afikpo to get to see. Logholo usually appears on feast and ceremonial days, a convenient time because then there are plenty of uninitiated boys about. I have seen it performed on the day of the njenji, village boys having obtained permission to dress up in this way rather than to do the walk, and also I have seen logholo on the day of an ɔkumkpa play. It is sometimes played at the funeral rites of a man at the request of the eldest son, who organizes the funeral. Here several may appear, hopping about to the accompaniment of drums.

This masquerader does not play with girls and they do not attack it. They are not supposed to touch it—even in the noninitiate form that is described below, as they should not touch other masqueraders. Rather the girls swiftly flee from it and are allowed to do so.

There are four variant forms of the initiates' logholo. In one, called ɔkwə (fig. 67), the player wears the goat mask (mkpe), beke, or nne mgbo, and a headpiece of raffia strands that comes down almost to the neck. There is a short raffia skirt, or older and more brownish material than the usual logholo dress, and shoulder raffia suspenders, which are crossed. The masquerader's chest is bare. The player holds a stick in his right hand and an ikpo bell in his left. Ɔkwə is not as common as the usual logholo form, but it is sometimes seen in their company. It is found mainly in the Itim subgroup of Afikpo villages. Generally worn by a strong and skillful player, its brief and light costume makes it possible for the masker to run about more freely than other logholo.

A second form, obuke, is a logholo used in the non-Itim villages of Afikpo. It consists of the wooden bird mask, ɔtogho, with a raffia skirt and a singlet or jersey. The player carries a wooden replica of an ancient form of machete, which has the same name as the costume. The masquerader struts about, with vigor and in a proud manner. He also chases and is chased by boys.

Another form, ikpə, wears a dark net mask with a snoutlike front and a string attached at its base (pl. XV). The costume consists of a dyed red raffia hat with red raffia fibers dropping down the back, and green palm leaves on the player's body from the shoulders to the ground, leaving the arms uncovered. Sometimes some of the leaves are dry rather than fresh. This form carries no stick, but has a reputation of being a fierce logholo, one that is said to bite someone who is wicked. The costume allows the player good freedom of movement and it is difficult for boys to throw him. He is sometimes found alone, sometimes in the company of other ikpə, and sometimes with the more usual logholo form.

A fourth type, antankwiri, is only found in some villages: for example, it is absent from Mgbom. The player is dressed in dry, dark leaves with a bark belt and a hat, called ekɔrɔ,which is used in secret society initiations. This has green leaves and yellow fibers coming out from it. He also wears a mask like that of the ikpə masquerader. This player moves faster than the usual logholo, waving his arms about vigorously.

Then there is the logholo for the uninitiated players (fig. 68), in which the players wear masks of coconut, coconut fiber, cloth, cardboard, and other nonwood and non-net substances, as well as a raffia costume like that of the main form of logholo in the secret society. A group of these players dresses up and prances around the commons of a village, or in back of the compounds, playing around, chasing one another, and sometimes trying to throw each other. They may chase or be attacked by uninitiated boys. And if a woman violates the boys' society by seeing something that she should not and she refuses to

give an egg in sacrifice, the boys dress up in ɔtɛro and carry a pot filled with a solution made from the roots of a special tree, ɛto isi (chew-smelling), the wood of which is used to keep the teeth clean. They go to her home, place the pot on the ground, and one boy blows with a hollow tube into the liquid until it foams up and lathers. They tell the woman that this is egbele, which has come into her house. She quickly gives an egg, for she fears this spirit, even in the form associated with noninitiates, and believes that if it is angry it will make her ill or sterile.

The main feature that differentiates the secret society forms of logholo from ɔkpa and ɔtɛro is the agent of aggression: in the ɔkpa and ɔtɛro the aggressive actions lie largely in the hands of the masquerader, while in logholo the uninitiated boys are attacking the players. The logholo is also a status game. The appearance of the logholo invites the uninitiated and lower-status boys to join in a ritual form of aggression whose rules are clear: they attack their superiors in status and age and attempt to overthrow them physically and also, I believe, symbolically. The uninitiated boy or boys who succeed are much praised and admired among their peers. The play reflects differences in age and skill between the masquerader and the noninitiate, two major components of status at Afikpo. It is as if the logholo serves as a sort of training ground in regulated aggression which is to carry over to many spheres of adult life, where persons continually try to move beyond their age, descent, and other role determinants. It is also training for the young initiate masquerader in defense against the aggression of usurpers. The players' behavior, while outwardly defensive, is not without its aggressive aspects—whipping boys, threatening them with a stick, and scattering their attacks.

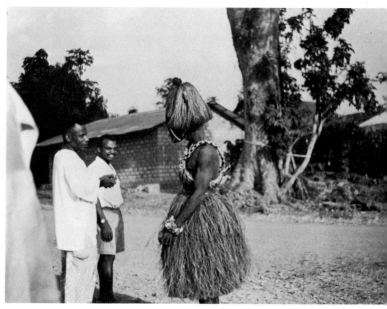

Fig. 67. Ɔkwe, a variety of logholo, wearing a black goat mask

This game at Afikpo was formerly associated with training for warfare and head-hunting for both the logholo and those who attack them. It has the sort of emphasis on physical strength and skill that has already been indicated in discussing the igri and ɔkpa eda in the njenji parade.

Logholo is but one form of physical contest at Afikpo that hardens and trains boys. Major intra- and intervillage wrestling bouts are held in June of every other year and annual whipping contests in October or November. In all of these forms of sport there is a great deal of emphasis on speed and on skill in handling one's body. In wrestling and whipping there is a conscious effort to match boys of equal size and physical skill; in logholo

Fig. 68. Uninitiated boys playing logholo at Mgbom village

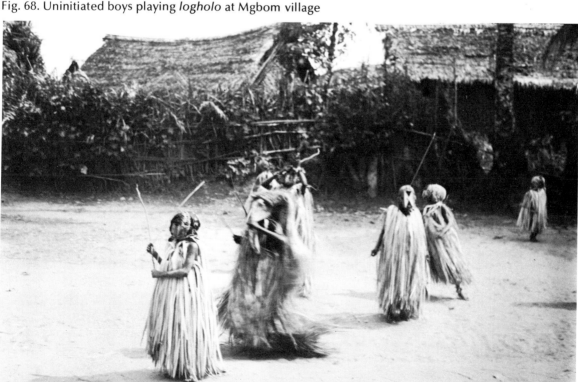

the masquerader is bigger and stronger than his attackers, but he is handicapped in movement by his costume and must oppose many boys at once.

As for any aesthetic element, the game is largely for the players themselves and not directed toward an audience as a performance. And, as in ɔkpa and related masquerades, there is no attempt to dress up in fine or beautiful costumes, although the players try to dress nicely. The skill is in physical ability and not in aesthetic expression. Yet the movement of the players, especially of skilled logholo who twist and turn about, is not without a certain interest to the viewers.

Logholo is a widespread and probably old masquerade in the Ada subgroup of Igbo village-groups, even though some of the wooden mask forms worn in it may be of relatively recent origin. Jones (1939a, fig. 4 and p. 33) pictures and discusses a wooden horned mask from Edda that differs from Afikpo types, which he says is employed in "lugulu." Starkweather (1968, p. 58) mentions the "Lughulu feast" held in May in Okpoha Village-Group as being one of the two major festivals in Okpoha where masks are employed. Some form of chasing play is probably common to all of the village-groups of the Ada people.

The Initiation Masquerades

All male youths must be initiated into the village secret society. This event marks the transition from the time when the boys use children's masks and imitate adult ceremonies to the period when they participate in the adult society and its masquerades: they cease being emulators and observers of the secret society and become active members. It is not surprising, therefore, that in the initiation ceremonies the boys are in direct contact with some of the adult mask and costume forms and wear some of them for the first time.

Boys are initiated between the ages of five and their early twenties. The age of entrance depends upon: how wealthy the father is; whether the father is alive or not; whether the boy is the eldest son; and how many older brothers he has. There is no single form of initiation common to all the Afikpo villages. Most settlements have a long and costly initiation for a man's first son, but other sons perform a variety of shorter forms. Some boys go through more than one type of initiation, others only one. Certain youths even go through the *rites de passage* in a village other than their own. Some of the initiation rites are of Afikpo origin, associated with the ancient Ego people; others have come from Aro Chuku with the famous slave traders; and still others are from nearby Edda Village-Group. In recent years the length of the initiation period has tended to be shorter, and the shorter forms have been used more often, for boys are often at school or living with parents or other relatives away from home.

Masks are used in most types of initiation, but they are, of course, only one feature of the rituals. There is stress on physical hardship and competition, and the following of numerous taboos, such as not showing one's teeth, refraining from touching the ground with the hands, and not eating certain foods. All forms of initiation involve the separation of the boy from his normal activities for a while. In the longer forms there are periods when the initiate returns home to live.

I will describe the major forms of initiation at Afikpo as they pertain to masking, emphasizing the types found in the Itim subvillages of Afikpo— the ones that I best know. Other Afikpo initiations follow the same general features described here.

ISIJI

The longest and most elaborate initiation, for eldest sons, is *isiji* (head-yam). It is carried out in a village once every six years, with different villages doing it in different years. The calabash mask, *mbubu*, is always used. Afikpo say that this initiation derives from Edda Village-Group and first came to Amamgballa village at Afikpo, where it was once done every year, and from where it spread to most of the other Afikpo settlements, except the Ozizza villages to the north, part of Amuro, and a few subvillages of larger settlements. It may also be done in the Afikpo villages in off years when a man takes the highest Afikpo title, omumɛ. Then he puts a surrogate first son through *isiji*, for he has already put his own through it. In this case there are some changes in the ritual, and a special form of the *mba* wood mask, *mkpere*, is worn. Unfortunately, I have no information on this masked ritual. Several men may take this title together, using surrogate sons, and other men seize the opportunity to initiate their eldest sons at this time.

The *isiji* consists of two periods, each an Igbo month of twenty-eight days. In the first period the boys live in the initiation bush and wear the *mbubu* calabash mask on certain occasions; during the second they reside in their compounds and no masquerading is involved. The *isiji* begins after the New Yam Festival, in some villages the day after it is finished, in September, and in others not until after the Dry Season Festival. The ritual is an important event for the boy's father, who is usually in his thirties or forties. It is a title (*mɛmɛ*) for him, one that is costly and time-consuming. As it is one of the rites of mature adulthood, the father must do a great deal of entertaining and feasting. The presence of the first son in the rite, masked and unmasked, is a public statement of the father's importance. Thus the son is urged to play his role well by his father and his father's close agnatic kin.

During the first month of the initiation, called *ababa na ɔhia* (run-in-bush), the initiates are separated from their families, living in a specially constructed bush area near the main village

common. Here they "discover" a buried sacred shrine of the secret society and go through a physical ordeal of initiation. During this month they perform the *isiji* dance with the calabash mask.

This first stage is preceded by many preparations. The fathers of the initiates meet together some months ahead and plan for the ceremony. They carry out sacrifices recommended by a diviner to insure a successful initiation. They pay a sum of money to all other village men who have put their first sons through this initiation in order to "buy" the initiation bush, as the Afikpo phrase it, and they feast these men sumptuously. For several months before the ceremony the boys who are being initiated collect wood for the continual fire that is maintained in the bush throughout the first month. And just before the rites commence, the boys feed initiated friends who will help them and protect them during the ceremonies. These friends and other initiated males who have not yet put their own first sons through the *isiji* build up the fences surrounding the initiation bush, starting several weeks ahead of time. The fence fronts on the main village common. There are two side entrances and a main one at the front center, from which a perpendicular construction is built up some forty feet or more into the air.

During this first month each boy wears a towel around his waist, a red coral necklace, and arm and leg bracelets. His hair is cut in the back of the head in a particular manner and charcoal is applied to his face. These features mark the boys' status as males undergoing initiation. They are forbidden to show their teeth, and consequently they look glum and serious. They cannot talk to females; they talk to uninitiated males only with their backs to them or with their mouths covered with their hands, and only outside of their bush area. Their penises are not exposed to women or to noninitiates. They fetch water and go about collecting palm fruits, bananas, and other fruits. But they move quickly outside of their bush, not tarrying long. At night they sleep in the village resthouses and the commons are closed to noninitiates. A leader, and sometimes an assistant leader, is selected through a test of strength from among the boys on the first day in the bush or through divination previous to entry (the means varies from village to village). The leaders help locate the sacred shrine and are responsible for seeing that the sacred fire is maintained.

The boys go into the initiation bush on an *nkwɔ* day of the week. The following day, *ɛkɛ*, they go through their actual initiation, which has certain arduous aspects. The next day, *orie*, they come out to dance in the public *isiji* masquerade wearing the calabash mask. The dancing is repeated the second, third, fourth, fifth, and seventh *orie* days. In between the boys collect

fruits and remain in the bush or resthouses talking, eating, and playing. The dance, one of the highlights of the first stage of the *isiji*, is a major public spectacle in which noninitiates and females also take part.

The number of masqueraders involved ranges from as many as two hundred in the larger settlements to as few as five or six in the smaller ones or when the *isiji* is being presented in an off year for title-takers. On the first and second *orie* days all of the boys being initiated appear as masqueraders, although in some villages on the second day only the better ones are selected to do so. For the next three *orie* days the dancers come out according to the age of their fathers: the third *orie* is for boys with the youngest fathers, the fourth day for those with older ones, and the fifth *orie* for those with the eldest. This arrangement allows more time for individual dancing than at the earlier sessions where everyone appears. These three sessions are known as *eko ukwe* (strike-noise), for the fathers of the boys go around shouting "*kwe, kwe, kwe, ha, ha,*" and hop about as if a bit mad, while they do not participate so extensively in the first two sessions, when many more of them are out. On the sixth *orie* day, known as *orie mma* (day of week-spirit), no one dances. It is said that on this day the spirits, *ndɛ mma* (people-spirit), dance about, although there is no special ritual to mark this activity. On the seventh *orie* day, called *mgbachi* (close up), only the best dancers appear, selected usually by the initiates themselves. If the dancers' fathers are aware that their sons have been chosen for that day, they will come and dance about with them, although this is not required on the last day.

In many villages the dance is practiced by the boys on the evening of the day that they enter the bush, without costume and under the guidance of old initiates. In some villages the session is held in the initiating bush, but in others it is carried out in the closed village common. Previously initiated males who will form the singing group for the masqueraders at the actual public performances also come out and practice. In some villages there is an earlier practice session held on the afternoon or evening of the *ɛkɛ* day of the New Yam Festival.

The *isiji* dance marks the first time that the boys wear a secret society mask, and it is fitting that the *mbubu* face covering is a highly sacred form, used only at this ceremony. In addition to the *mbubu* they wear a reddish orange headpiece that projects upward in the front midline of the head and covers the sides and back of the skull. This is made from a seed, *akpɛro atɛte umuruma* (seed-clitoris-children), which looks something like a clitoris when growing. The masqueraders also wear a light-yellow raffia dress from the shoulders to the feet (see pl. XV). The feet are bare.

The boys are helped into their costumes by

initiated friends and other persons—the same ones who have built the bush enclosure. Friends gather the raffia leaves and the seeds the ɛkɛ day before the particular boy is to dance; the raffia especially must be new and fresh-looking each time the initiate appears. These helpers assist the boys to don the costumes in the initiating bush and instruct them during rehearsals. There is keen interest in seeing the boys dressed up well. It is said that a boy's compound is concerned to see that he is properly costumed, so men from this residential area go into the bush to supervise the process. As in other initiation rites at Afikpo, the mothers of the initiates are cajoled out of money. The husband and his friends come to her and say that they need funds to purchase wool for the headdress of the costume, for the seed affair looks like colored wool from a distance. The mother, as anxious to see her son well dressed as are the compound men, gives money, not realizing what is actually employed.

The dance lasts a number of hours in the afternoon or early evening. The village gong in the main resthouse is beaten and the common is closed to noninitiates. Then the masqueraders come out of the bush area, one by one, facing backward. This traditional position symbolizes that they do not communicate directly with females and male noninitiates. When they are out in the common the area is opened and the crowd assembles: men, women, and children from the village, as well as some strangers (see Map VIII). The seating is much as in the ɔkumkpa play. The boys dance about, either singly or in twos, or occasionally threes, near the main resthouse of the common, while the gong beats not in time with the movements but intermittently, to maintain the level of interest. The steps of the dancers are regulated by a good-sized group of initiates—fifty or more—sitting on the ground in front of the resthouse. They are not in costume and do not employ musical instruments; but the older ones sing—middle-aged, skilled volunteers led by an expert—and also clap time with their hands, as do the younger initiates sitting there. The latter rarely sing, for they have yet to develop this skill. These younger persons are the same ones who have helped the boys to prepare their costumes.

One or several isiji masqueraders in turn come up to the musical group, dance in front of it for a time, once around it, and then back to the main entrance of the initiates' bush area. Here they wait for the end of the performance, when all of them return to the bush at the same time. A poor dancer, as at many another Afikpo masquerade, is liable to be laughed at by the crowd. As might be expected, the range of ability among the isiji is quite wide. The singers use special songs. One, as a gesture of praise, calls forth the names of farmers who have plenty of yams. Another ridicules a woman who once picked up and threw back the stems of the leaves of a certain plant that boys throw at noninitiates in another secret society initiation ritual. At other times the group sings nonsense syllables, such as "ahe, ahe, ahe," or "ahehe ahehe." If a dancer is particularly good, the musical group sings out something to which he replies by tapping with his feet. For example, the group sings: "If I come to your house and you don't give me something, I will take your mother." To this the masquerader replies, "Please don't," or something like it. Or the group sings, "Who is a hunchback?" and the dancer taps out the names of ones he knows of. This feat is considered the height of the isiji dancing skill. Few of the new initiates are experienced enough by that age even to attempt it.

The dancing is soft and gentle and the music quiet, rather than heavily rhythmic and loud, perhaps because of the use of the hands rather than drums. The costume also has a delicate quality. It is not considered feminine, yet it is light, the calabash fragile, and the body raffia flows gracefully. The physical movements are in considerable contrast to the roughhousing and physical competitiveness of some of the events of the two previous days of the initiation, which are carried out in private. It is at this public event that the initiating boys are first seen by their mothers, joyous yet somewhat frightened, as they are unsure of what has been going on in the bush.

Yet there is an interesting contrast here. On the days when only part of the boys being initiated dance (third, fourth, fifth, and seventh orie days), those who do not dance come out in their usual initiation dress with charcoal faces. They look glum and generally sit to one side with the musical group, but do not join in. Sometimes one or several of them rise up and act oddly. They throw dirt at the audience when it is noisy, and they chase after uninitiated boys watching the performance, who are generally frightened of them and run away. The isiji like to go after older and bigger noninitiates, for this is one time they have the advantage over them. At one isiji I saw one of these charcoal-faced boys take the hat off of an old man in the audience and throw it to the ground, as if offended that he wore it at this ceremony. Although it was raining, this boy also later took an umbrella from a male elder and threw it down. Another time he waved a stick about to scare persons. These hostile acts, carried out by the boys with their deadpan faces, are in direct contrast to the gentler actions of the dancing masqueraders and symbolize another aspect of the initiations. They are humorous, of course, to the audience of onlookers not directly attacked. During one isiji I saw two of these dark-faced boys carrying water in haste back to the bush, spilling it as they moved and looking.

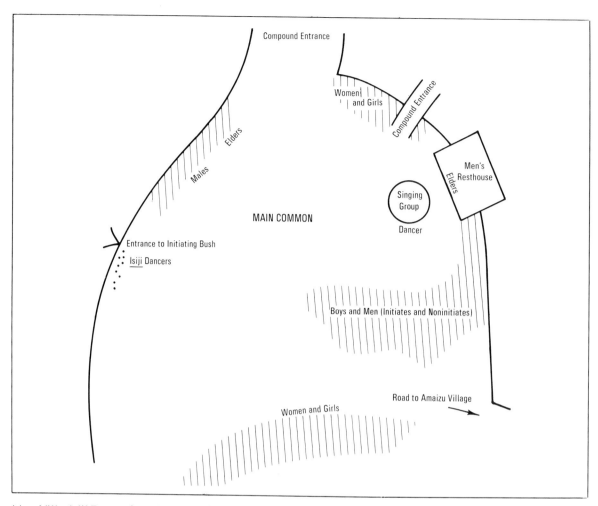

Map VIII. *Isiji* Dance for Initiation of Title Holders, Mkpoghoro Village, 1952

serious. The crowd laughed at their actions.

There are also other elements to the masquerade setting. Each time a son appears in costume, the father dances around the common with his friends. His village age set forms a separate dancing group, or sometimes joins him, on at least one occasion when the child dances. All of these men wear shirts and waistcloths. Some, particularly the father, also have hats with feathers sticking from them. Sometimes they carry canes, or horsetail tassels, and one or more may have a gun, which he occasionally shoots off. These men dance about, sometimes employing male steps and at other times in imitation of women's dancing, to make fun of the females.

The father gives palm wine or native gin to the elders sitting in the main resthouse and small sums of money to the singing group. The age set often also throws coins to the audience and the singers. This group plays the kind of supporting roles here that it does when one of its members carries out any important ceremony.

The mother, her co-wives, and women of her

compound also dance as another group as the son moves about. These females may throw coins to the singers and the audience. They wear the ceremonial headdress of married Afikpo women: hair parted to a ridge at the midline, a waistcloth but no top piece, bone or ivory wrist bands, and a colored handkerchief in one or both hands. While the son dances, his mother is allowed to imitate his movements. This marks the only time a woman is ever permitted to move in a dance of the secret society. But few women actually do this.

The executive age grade of the village (S. Ottenberg 1971c, chap. 4), a group that has many social control functions, keeps the audience a bit quiet, going after persons by waving small branches or leaves at them. Women and children are particularly likely to be disorderly, as they scramble for coins thrown to them by the unmasked dancers; some of them seem more interested in the money than in the dancing. The grade also urges young initiates to come out and join the musical group, even just to clap, and it may threaten to fine initiated boys who do not.

The leader of the *isiji* is usually a strong person and a good dancer. He is given special time to perform, often on the fifth *orie* day, when he carries a raffia palm frond in his left hand as he moves about. This symbol of his special role distinguishes him from the other dancers, who do not hold anything. As he finishes the dance, the leader tosses up the frond to a center part of the initiating bush, or tries to toss it over the bush fence. He is expected to do so with skill and not carelessly. In some villages he again dances and throws a palm frond on the final dancing day. Every *orie* before the boys come out to dance, this leader carries out a sacrifice with an egg at the shrine in the initiation bush, for he is considered the priest of the bush. His assistant is the assistant priest. And each dancer also performs a ritual over the shrine with the same egg in order to ensure a successful performance.

When all the *isiji* players have danced and their relatives have done their part, the singing group gives out with "*he he he he he*" a number of times to signify that the masquerade is at an end, and this group then rises up. Women, girls, and uninitiated boys move quickly away and are expected to do so without looking back. Then the common is closed and the *isiji* and their friends make a dash for the bush entrance, crushing one another while fighting to get through first. Sometimes a mask is knocked off—one reason the area is closed at this time. Thus the end of the dance symbolizes a return to the state of physical roughness so characteristic of the initiation bush. The masqueraders undress in the bush and return to their usual initiation costume.

The *isiji* is an unusual masquerade for Afikpo in that while the masqueraders are its central feature, many unmasked persons also take part. It also differs from other ones in that there is a strong family element about it. Mothers and fathers and compound men and women dance about. The *isiji* boys are assisted by friends, sometimes from their own compound. The *isiji* player is a *mma* spirit, but he is also intimately known to those involved, he is much a son. For the father the ceremony is important for his own status position, while the mother takes considerable pride in the achievement of her son. The dance is pervaded with a sense of family, in which the relatives are saying "good-by" to the boy and "hello" to the man.

There is the contrast of the masqueraders' gentle and sometimes highly skilled performance and the crude and aggressive comedy of the charcoal-faced boys. The event has a strong sense of physical movement: the *isiji* dancing; the hand-clapping of the musical group; the movement of father and friends and of his age set, and of the mother and compound females; the noisiness of the crowd and the movement of its members. For the initiated boy it is the first time

he wears a real secret society masquerade costume, a first public exhibition before the village as a whole—as much an aspect of the initiation as are the secret rituals of the bush.

On the day following the last *orie* day of dance, these boys move to the compound for another Igbo month, a period shortened or lengthened in some villages. They replace their coral necklaces with raffia ones, from which comes the term *enya ɛgwɵ* (hand-on-raffia) used to describe this stage. They stop darkening their faces, but are still subject to taboos, such as not showing their teeth. Their hair is cut again, in another special style. They live in boys' resthouses in their compounds. It is a leisurely time for them —collecting fruits to eat and helping their fathers at farming. The fencing of the initiation bush is dismantled. No masquerading takes place in this second half of the *isiji*.

In the southern Afikpo villages of Kpogrikpo and Anohia the *isiji* is somewhat different in style and arrangement, and the masked calabash dancers wear a much more elaborate headdress (see description of the calabash form in chap. 3 and fig. 27; pl. XV), but the essentials of the ritual are the same as in other Afikpo communities. This form occurs, or at least used to, at Edda Village-Group. In 1935 the Afikpo district officer reported on it:

The boys are dressed with a tall mask the face of which is made from calabash and slotted to allow air to circulate. The head piece is made from palm fronds and plaited grass and rises to a high point. The boy is covered from shoulder to ankle with a mantle made from long strips of "bamboo" grass. The arms come through and are bare except for a wristlet of beads. The costume must be exceedingly hot and the head piece heavy. The movements are not by any means strenuous, but nevertheless the whole procedure must be a fairly stiff endurance test. [Anon. 1935]

In the Afikpo villages that have the *isiji*, boys who go through another form of initiation rather than this one still must be introduced to the calabash mask and must "dance" the *isiji*. This is done just previous to or at the beginning of the other ceremony. An elder or an initiated friend of the boy from his compound takes him to the initiation bush at night, or out to the closed common, and brings out one of the calabash masks, which is tied to the boy's face with a single string. A seed of the type used to form the *isiji* headdress is attached to the boy's hair with a piece of raffia or some other material. The boy may dance briefly in imitation of the *isiji* dance and he may say to the spirit of the shrine of *isiji*: "Here, I know you now, do not trouble me. I will never be initiated into you again." The boy then sleeps that night in the village common.

Whatever the form of initiation, the transitory nature of the initiate's life at this time is perhaps indicated by the fact that he never wears this

particular mask again, although he may help other boys to dress in the *isiji* costume.

ƆKA

Although some eldest sons cease going through any further initiations following the *isiji*, properly they should and often do continue through the stage of *ɔka* (fence), also called *ababa na ɔka* (run-in-fence), which follows immediately for another Igbo month. It only occurs in a village the same year as the *isiji*. Other sons than the first ones at Afikpo often take this form of initiation as their own. During *ɔka*, and the brief concluding initiation period that follows it, there is again an association of the boys with masquerades, but generally of a less gentle nature than in the *isiji*.

In this initiation the boys' head hair is completely shaved off and they wear a special raffia costume from the waist to the knees. It is said that at this time they look like girls. They live together in special enclosures called *ɔkwɔ*, in back of their compounds of residence, from which they cannot emerge, although uninitiated boys visit them and feed them there, and they eat well. Afikpo say that they are being "fattened" as girls used to be through a period of seclusion before marriage, when they ate fine foods and did no work—a custom that has now died out in the village-group. In their enclosures the boys cook yams and other foods for themselves and make raffia twine, which they use in preparing *aborie* net masks. It is their first experience with them, for net masks are not used by noninitiates. And here the boys play a xylophone and practice the *akparakpa* of the *ɔkumkpa* and other dances, but without costumes. They also play at a special dance, *ɔgbuba akware* (dancing-xylophone).

Before going to their enclosures the boys carry their newly cut hair to the village burial grounds, where they leave it. At this time the *ɔtero* and *ɔkpa* masqueraders, as well as uninitiated boys, come out to chase and bother them. To the already initiated, these actions by masked figures, and those that follow in the weeks to come, are regarded as a sort of joke. For when the boys live in their special enclosures, the masqueraders appear again and again to go after them and to seize them, particularly on every other day, the nonfarm days of *ahɔ* and *ɛkɛ*, but also in the evenings of the intervening days. In the enclosure there is an *ɔba* (yam barn) where the boys store their yams, bathe, and go to the latrine. The masqueraders cannot follow them there but can chase them elsewhere about their enclosure. There is also a tree platform in their area to which the *ɔkpa* has difficulty in climbing, with his tight costume, and they can retreat to it. However, the *ɔtero*, moving more easily, can usually chase up the improvised ladder and catch them. The boys are much harassed by these

masqueraders. They disturb them while they are trying to eat and take their food away. When they catch them, they flog them, *ɔkpa* with a broom and *ɔtero* using a stick. Some of the *ɔkpa* also go to the boys' parents and other close relatives and demand food and money to keep them from summoning the more feared *ɔtero* to harm the boys. This payment is usually made. During these initiation times *ɔkpa* and *ɔtero* chase both uninitiated and initiated boys about the village commons. Chasing initiated boys is unusual at Afikpo. Those who masquerade in this period are strong and interested young men. It is a voluntary activity for them.

On the *ahɔ* day before the start of the Dry Season Festival, that is, three days before the *njenji*, the boys are shown the "secret" of *ɔkpa*. A skilled *ɔkpa* player comes to their enclosure wearing the costume but without the raffia waist pieces tied to it. He walks about their benches four times, kneels down, pulls off the top section of the costume, then quickly puts it on again, and rushes out. No word is spoken. The omission of the raffia waist pieces permits the boys to see clearly how the costume is worn. The secret of *ɔkpa*, then, is not in who wears it but in how one gets into and out of it. This process is not repeated for *ɔtero* because it is easy to see how this costume is worn, for it is more of a standard style net-masked costume. Besides, there is a noninitiates' *ɔtero* with which the boys are already familiar, while the noninitiates' *ɔkpa* is a rare form.

On the evening of the same day, a number of *ɔtero* go into the boys' enclosure and destroy almost everything there. That night the boys sleep on the open ground. This is the end of the *ɔka* period.

The next day, *nkwɔ*, the boys begin the short, final stage of their initiation, when they are taken to the secret society shrine and initiated. The following day, *ɛkɛ*, they dress in the *aborie* net masks that they have made, with a body costume of green leaves. They continue to wear this dress on the next day, *orie*, the day of the *njenji* parade. For these two days they dance and play around and can be seen in public, but they do not appear in the parade itself. Since in any Afikpo village this form of initiation is usually carried out only once every seven years, these masqueraders are not often viewed.

On the following day, *ahɔ*, they go home where their parents dress them in fine new cloths and splendidly feed them. In the afternoon of that day they are brought into the closed common before the *oke ekpa* (big-bag) masquerader with whom they play and wrestle. This is a variant form of *ɔkpa*, which is also called *ɔkpa owerewere* (name of costume-syllables employed to mean "flowing about"). The player wears net body costume with raffia attachments and similar coloration as the *ɔkpa*, although it is much looser fitting and has no

arm and leg coverings. Its base ends in a wide skirtlike affair. However, instead of a net costume covering the face there is a white, wooden *ibibio*-style mask, with a black head that lacks the elaborate hair style sometimes found in this form. This particular type of *ibibio* is associated only with this costume and is not otherwise seen at Afikpo. In fact, the *oke ekpa* is a rare form.

When it appears, the boys bring to it, and to one or more *ɔkpa* who appear, presents of yams or money. As they do so, the masqueraders grasp the boys' heads and bodies and shake them. This scares some of the youths, although men who watch laugh. In some villages the *oke ekpa* wrestles with the boys in a gentle fashion. These activities are meant to familiarize the youths with these masqueraders. It is the first time that *ɔkpa* has not actually chased them. The *ɔkpa* masqueraders, followed by *oke ekpa*, then dance off and beg gifts from the boys' parents, and the boys follow them around.

The final stage of the initiation, then, involves direct confrontation of the initiates with these masquerade forms, the learning of the mystery of the *ɔkpa*, and a familiarization with that spirit and the *oke ekpa*, which usually only appears once every seven years and never to the general public. Symbolically, the boys go from the "weak" status of maturing females living in the enclosures, in which they are chased, restricted, and finally everything is destroyed, to a point where they join with the masqueraders, giving them presents and following them to their parents' homes. In a sense the boys move to the masqueraders' side of things, for they are now entitled to dress in these costumes and to chase uninitiated boys and females of all ages, as well as to take part in the various masquerade plays of the secret society. And they have learned how to make net masks, which they can now wear. The activities of *ɔkpa* and *ɔtero* in this initiation also reflect the status considerations that were discussed in the previous section on those two forms: males of a higher position are putting down boys of lower status.

ISUBU EDA

There is an annual short form of initiation, usually occurring in November, called *isubu eda* (end initiation–Edda Village-Group), which is found only in the Itim subgroup of the Afikpo villages. In these settlements all boys have to do it regardless of what other forms of initiation they go through. If they perform *isiji* and/or *ɔka* they stage this short form the following year because of a timing overlap. For sons other than the eldest, the *isubu eda*, which derives from Edda Village-Group, as its name implies, has become the most popular form, for it interferes little with school or other activities; even boys from villages in the non-Itim

area of Afikpo come for this ceremony, although they may go through other initiations at home. In this form the boys are initiated in a forest bush area one evening, spend the night in the common, and are free to leave the next morning. There is no masquerading at the time of the initiation, but boys from the home village will be "shown" the *isiji* calabash mask previous to the rite in the manner described above. The other boys are expected to perform this rite in their home villages.

However, early the following morning, a number of *ɔkpa* masqueraders, played by interested volunteers, appear in the village common as the boys prepare to depart. The new initiates go to the priest's shrine house at the edge of the main common and have a special medicine sprinkled on them before they leave, as an antidote to the power of the secret society spirit. Then all uninitiated male children go to receive the liquid for their general protection. As these noninitiates are guided to the priest by their fathers or older brothers, the *ɔkpa* try to catch them and to swing them up in the air, as if to abduct them. The boys attempt to run around the masqueraders, who hang about the compound entrances waiting for them to come out to go to the priest. The fathers or brothers try to lead the children, many of whom are frightened. Some noninitiates attempt to run back to the compounds, but their protectors make them face the *ɔkpa*, which moves about silently. After all the noninitiates have received the antidote, the *ɔkpa* go into the compounds and dance for the women, who "dash" them. The females know it is their time to go to the priest's house to receive the medicine for their own protection.

For the next six *orie* days those boys from the home village who are initiated into *isubu eda* are supposed to dress up in the *hihi* masquerade and dance about the village. In fact, many boys do not, or only do so once or twice. But it is said that if one really wants to know the secrets of the initiation, one should perform this masquerade. On the seventh *orie* the initiates put on the *acali* wooden mask and play at *logholo*. Then they are free.

The *hihi* costume has a mask of the same name, which is something like the *aborie* net mask, only flatter (see "The Net Masks" in chap. 3 and fig. 69). The net mask is dark and usually has a headpiece, called *ekɔrɔ*, of leaves with long yellow fibers sticking out from it. In one case, however, I saw a cloth cap with eagle feathers on it used with this costume. A raffia dress is worn from the shoulders to the feet, which are bare. The *hihi* like to dance about together, shoulder to shoulder, singing the songs used in the annual whipping ritual day in the village, a ceremony without masks occurring during the secret society season, but not open to the public. Some of the songs are mocking, asserting, for example, that the members

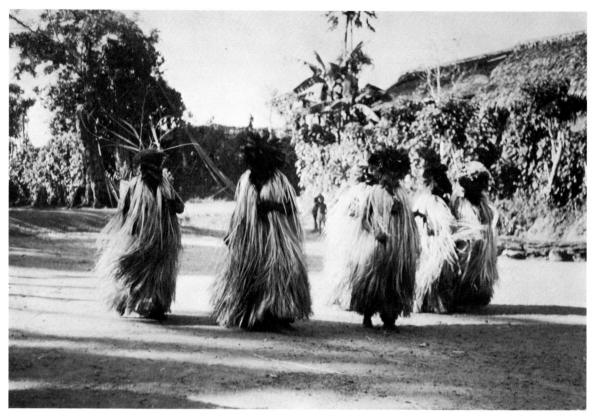

Fig. 69. *Hihi* net masks and costumes worn by boys being initiated into the village secret society

of an age set in the village were so drunk that they never came out to whip on the proper day. Others praise the priest of the secret society or the society itself.

Thus even in the shortest form of Afikpo secret society initiation there is an introduction to the masqueraders through the ɔkpa and *hihi*. The latter is also sometimes worn by new initiates in non-Itim villages at Afikpo on the ɛkɛ day following the termination of other forms of initiation.

IKWUM

There is still another type of annual initiation which goes by a variety of names, but is commonly known as *ikwum*. It is a form for a first son whose father has died, where his close agnatic relatives raise money to put him through. As such, it is a shorter and cheaper initiation than *isiji*. Nowadays, however, it is often used by persons who put other than a first son into the *isiji* and then have the boy skip the ɔka stage, but wait for the *ikwum*, which comes a little later. Or, sometimes a father puts a younger son through only this form of initiation, which is a little longer than the *isubu eda*, a bit more prestigious, and, in fact, includes the main initiation rite of *isubu eda*. But generally *ikwum* is looked on as an inexpensive form of the finer *isiji*

ritual. One Afikpo called it "the poor man's *isiji*." It is derived from Edda Village-Group, and is most prevalent in the Itim subgroup of the Afikpo villages.

The *ikwum* initiates, and there are rarely more than eight or ten in a village, first appear the day before the *isubu eda* initiation, at the time when the whipping contests occur in the village. Their bodies are rubbed red with camwood and they wear raffia waist pieces. The boys somewhat fearfully watch the whipping, which noninitiates do not normally see, but they do not take part. That evening they are shown the calabash mask of the *isiji* initiation in the manner already described. The next day they are the first in line, after any sons of the secret society priest, to go through the *isubu eda* initiation. They go early, it is said, because they have the hardest form of initiation to do. After returning to the common, they have their wrists tied together and then sit down. Among other restrictions, they are forbidden to touch the ground with their hands.

On the next day, ɛkɛ, still tied up in this manner, the boys are hidden from public view in the men's resthouses, for the common is open and the other new initiates have left. Initiated friends of each *ikwum* go to the bush and cut palm leaves for the costume he is to wear on the morrow, the day of *Mbe*, the famous Afikpo feast of the turtle.

The helpers sacrifice an egg, a fish head, hot pepper, and palm oil in a small sacrificial pot at the base of the tree before climbing it. This is not usually done before the preparation of other costumes at Afikpo. The *ikwum* for whom the material is collected is never supposed to be shown that particular tree by his helpers, for it is believed that he will become ill or have other problems.

On the next day, *orie*, the *ikwum* are washed and fed by their helpers and their hands are freed. The costume that they wear has been prepared in back of the *ajaba* dressing house by their helpers, but it is taken to the forest bush area of the secret society where the *ikwum* are dressed. Called *ikpem mbe*, it consists of white or yellow raffia palm leaf strips in the form of a skirt, and a raffia shirt. Various protective charms made from leaves are attached to the body and limbs. Cloth is put on top of the head and an Afikpo-style *mma ji* wooden mask is sewn onto it. Two eagle feathers are tied to the headpiece. As each *ikwum* is dressed, he is taken to the priest, who prepares a special sacrifice. The priest tells the boy to take a specially prepared leafy arrangement of seven bundles of *agbɔsi* leaves tied together with an *ikpo* bell, and to throw it with his right hand as he runs about. He does so, then picks it up and repeats this action a number of times. He is freed, by this ritual, from the taboo of not touching the ground with his hands. Then the priest asks: "Who has the egg?" and a helper of the *ikwum* produces it. The *ikwum* touches this to his mask and chest seven times and breaks it over a sacred shrine. Then the helpers take the *ikpo* bell and tie it to the masquerader's waist at his back. The egg sacrifice is repeated at several village shrines. These sacrifices prepare the boy to wear the sacred *ikpem* costume.

As the *ikwum* return to the village commons these areas are opened to the public and the *Mbe* festival begins. The mothers of the *ikwum* come out as a group, singing: "When you see the *ikwum* himself you have to see the mother and the stick of fish." The women bring the boys, who are sitting outside of the *ajaba* dressing house, a dried fish each and cooked palm kernels. The boys' fathers cut off the fish heads and the youths move into the *ajaba* to eat, as they are masked and must lift up their face coverings. Then mothers go and give presents to the elders of their respective compounds. The boys recover their faces and come out to dance in the commons.

By this time there are many men and women dancing in separate groups in the commons, as well as small girls and boys. *Mbe* is a feast of sexual derision in which persons of both sexes in ceremonial dress, but without masks, sing ridiculing sexual songs about one another, using both general phrases and specific names and incidents.

During this period the *ikwum* masqueraders move about in a line, aided by their helpers, for they are wearing a difficult mask for inexperienced players to use. "Dashes" of money, yams, and other items are given them, which their helpers hold for them. Chairs are brought for them to rest on. At one point they dance through all of the compounds of the village. They are accompanied by many men who sing the following lines over and over again, led by one or more of their group:

Leader(s)
1. *ikpenle le. haghayi hayi*
 ikpenle le. haghayi hayi

Group
2. *hwo hwo hwo hwo hwo hwo hwo hwo hwo*
 (etc.)
 secret society yell

Leader(s)
3. *orie alagha haghayi hayi*
 day-of-week gone *haghayi hayi*

Group
4. *hwo hwo hwo hwo hwo hwo hwo hwo hwo*
 (etc.)
 secret society yell

Leader(s)
5. *Nnege nɔwa ndə ge tie nkala-ogo*
 Mother-your is alive you dance *ikpem*-dancing

Group
6. *hwo hwo hwo hwo hwo hwo hwo hwo hwo*
 (etc.)
 secret society yell

Leader(s)
7. *Nnage nɔwa ndə ge tie nkala-ogo*
 Father-your is alive you dance *ikpem*-dancing

Group
8. *hwo hwo hwo hwo hwo hwo hwo hwo hwo*
 (etc.)
 secret society yell
9. *ɔnwa ewurum haghayi hayi*
 this sorry-my *haghayi hayi*

The song means that "on this *orie* day your mother and father are alive and yet you take the *ikpem* initiation. I am sorry for you." This is a form of mockery of the boys for being poor, or for having poor parents, and thus having to settle for this type of initiation.

Then the masqueraders go to their own homes, where they are given gifts by friends and relatives. They return to the commons to undress in the *ajaba* houses and spend the night sleeping in the men's resthouses there.

On the next day, *ahɔ*, they are finished with the initiation and can go home. However, formerly they would put two eagle feathers on their heads

and dance and sing in the continuation of the *Mbe* festival that occurs on that day.

On the following *ɛkɛ* day the *ikwum* initiates are expected to wear the *aborie* net mask and associated costume and to dance about. And they are to do so the next day, *orie*, and the five *orie* days after that. Then on the last *orie* they wear *logholo* for the first time, with the *acali* mask. They live at home except on the nights when they wear the masks. The playing on *orie* days coincides with the appearance of the *hihi* net-masked dancers following the *isubu eda* initiation, and the *hihi* and *aborie* players move about together, but in separate groups. But, as in the case of the *hihi* masqueraders, few *ikwum* bother to finish these Igbo weeks of play, as they want to get on with school or work, or their parents wish them to, so that no one may dance the last few times.

Although *ikwum* may be the "poor man's initiation," particular attention seems to be paid to the *ikpem* masquerader, who appears to have a special sacred quality. The *mma ji* mask, of course, is one of the older and more respected Afikpo types. The costume is striking and effective. The whole initiation is integrated with the whipping day, the *isubu eda* initiation, and the *Mbe* festival. Its special quality lies in the *ikpem* masquerade. While the initiates appear during the day of ribald sexual singing, they do not appear particularly associated with it by their dress or actions, or the behavior of others toward them. It is rather a time when there will be many persons about to see them. It is, however, the only occasion at Afikpo when I have observed a masked figure in anything close to a context of overt sexuality, and perhaps symbolically it represents the masquerader's entrée into adulthood, for he dances in the milieu of the sexual singing even if he does not join in.

COMMENTARY

It is difficult to abstract out the masquerade elements of the secret society initiations without also discussing other aspects of these rites, but some features do stand out. In every form of initiation the boys are introduced to some types of masks and associated costumes. Net, calabash, and wooden face coverings are involved. The net forms are most common, perhaps suggesting their greater antiquity at Afikpo than the wooden types. Virtually all of the boys are introduced to the calabash mask, an important and probably ancient Afikpo type, but otherwise each kind of initiation has its characteristic masquerades. It would seem that a general introduction to masquerade is important here, even though the specific forms are variable. It also does not matter which type of initiation a boy passes through. Once finished, he is free to use the secret society masks appropriate to his age and skills; his access is not limited by

the kind of initiation that he has undertaken. And while the initiated boys no longer are permitted to play in the back of the compounds with the uninitiated boys in their plays and masquerades, they bring the experience of that time to bear in their own initiation and in their adult masquerading lives, for they have already worn masks and costumes and learned how to dance and to play. Initiation does not represent a sharp break with the past but a movement from the nonsacred masks and costumes of the boys to the spiritually more powerful ones of the secret society. It means, of course—and this is quite clear from the *isiji* dance of the first son, the *ikpem mbe* masquerade, other initiations, and many of the adult masquerades—that the boys no longer perform for a limited audience, largely of their own age and often in back of their compounds, but before large numbers of the general public, on occasions virtually the entire village population, as well as before strangers.

When in the imitation secret societies, the uninitiated youths operate largely on their own, without parental support. This is also true of the activities of the real secret society. But in the initiation rituals and its masquerades, there is a strong sense of family, of the interest of the father and mother and other relatives of the boy, particularly agnatic ones. The initiation of the child is sponsored by the father, backed by his patrilineal kin, and provides status for the sponsor. It is the one time in the masquerader's life when there is a close association of masquerading and family, though family life may be portrayed in the skits of the *ɔkumkpa*. In adult ceremonies he may still be helped to dress and advised how to move by older brothers or other relatives, but he is on his own, in terms of the masquerades, as he was before his initiation.

CONCLUSIONS

Interpretation of the Afikpo Masquerades

I conclude this study of the Afikpo masquerades with some remarks on their sociological, psychological, and aesthetic features, much as I did in my analysis of the ɔkumkpa play. Interconnections between these three factors are Specifically pointed out only when they are not obvious.

SOCIOLOGICAL FEATURES

Some nonmasquerade ceremonials at Afikpo, such as the New Yam Festival, involve feasting, visiting, and sacrifices, just as the masked rituals do. And singing, dancing, and the use of musical instruments are elements in other nonmasked rituals such as the Mbe festival, second funeral ceremonies, some title-taking activities, some of the rites of formation for male village age sets, and wrestling competitions. Thus the masquerades obviously form only part of the rich Afikpo ceremonial and aesthetic experience; yet they are impressive and important. They often involve many persons and a substantial audience, and they appear with some frequency during the ceremonial season. Most masquerades require the preparation of masks and costumes and some have rehearsals.

What features distinguish these masked events from other rituals that also have aesthetic elements? What differences does the face covering make in the nature of the ritual?

The masquerades, excepting those of the noninitiates, are carried out only by male secret society members, while other ceremonies are performed by either or both sexes through various nonsecret groupings. There is only one cult group at Afikpo associated with masking and that is the village secret society (again excepting the children's groups). Unlike other people, such as the Yoruba, or the Bembe of Zaire (Biebuyck 1969, pp. 2-3), where different art styles are associated with different groups within the society to the point that it is difficult to characterize a style for the whole society, at Afikpo there is a close association of art, the secret society, men, and the village. The masqueraders are not generally connected with matrilineal or patrilineal groupings; the secret society is the major basis of an art style.

The masking is characterized, in contrast to some of the nonmasquerade rites at Afikpo, by the absence of direct sexual references and by taboos on sexual relationships the night before and the night of the performance. The masquerades are also noted for their symbolic separation of the sexes, deemed necessary for effective performances, at the same time that some of the masqueraders in their actions represent females in dress, behavior, and dance.

The masqueraders, unlike other dancers and players at Afikpo, represent the qualities of the mma spirits, and are associated with the secret society spirit, egbele. The players employ special preventive charms and medicines. Females do not touch them. These spiritual qualities lead to a make-believe attitude toward the masked plays: "We know who you are but we pretend we don't."

The players are allowed and encouraged to behave in ways that would otherwise not be permissible. These include (1) acting foolishly, (2) making direct and public criticism of others, (3) using aggressive force against others when they have not done anything wrong, and (4) exhibiting a strutting display of finery.

The masqueraders are limited by a range of taboos. They must dress and undress in designated places, unobserved by outsiders; spend the night before the performance in the commons; and not unmask in public. They are permitted in the compounds of a village only at certain times and under specific conditions. There are also more personal restraints: to refrain from eating (although water may be taken), from defecating (although one can urinate), and sometimes from singing or speaking.

All of these elements distinguish the masquerades from the other rites at Afikpo, with their own singers, dancers, and musicians. The mask and its associated costume lend the distinctive qualities to the activities discussed in this book.

The masquerades are public performances. Except for a few occasions during the initiation rites, the ceremonies are held in the village for all to see. They form the major public expression of the secret society. It is true that in some of the society's initiations the boys involved can be observed and they live in or near their compounds; that the senior titled group of the secret society holds a public meeting once a year;

that the village secret society priest, if there is one, makes public appearances; and that females sacrifice at the spirit shrine of the society. Nevertheless, the major projections of the secret society into the public arena are carried out through the use of masquerades. The masquerades function to interrelate and integrate the social boundaries of everyday life and the activities of the secret society. Other activities, such as whipping contests, the production of mysterious sounds at night, or the rites associated with the secret society titles, take place in secrecy; here the persons involved are masked in other ways than through the use of face coverings.

The masquerades have a close association with the village as the basic community. They are largely community theater: those in the village who do not take part in the play form the audience, which is vocal, critical, often physically restless, and in some ways almost as active as the players. The secret society is closely associated with the village and the sense of community. It is a group aesthetics, a highly shared and popular activity.

It might appear at first view as if the village was not the crucial unit in masquerading. The ceremonies of the noninitiate masked groups are associated with a compound or ward; the *okonkwɔ*, *oje ogwu*, and *logholo* masquerades of the secret society are only sometimes village-based, being performed on other occasions by a ward or a compound. An Afikpo can buy or borrow a mask in another village and keep and use it in his own. A man can take part in a masquerade (particularly as a musician or praise singer) in a village other than his own; and the players in some masquerades walk through or perform in other communities than their own.

Nevertheless, masked rites put on by a compound or ward are often viewed as being "for the village," and frequently take place in its main common. The sense of competition over the excellence of masquerades is between villages, and in keeping with other forms of intervillage competition, especially wrestling contests, it is tied into prestige matters. A person's masks can be kept in the main village resthouse regardless of what ward and compound he lives in. The village sets the rules for the storage and use of the masks. As a rule, the secret society is organized at the level of the village, which thus forms the primary basis of Afikpo masking.

No masked ceremony is organized on a pan-Afikpo basis. This is not surprising, for with the exception of certain events associated with Afikpo shrines (S. Ottenberg 1971b, chap. 8), such as the yam shrine, and the rites connected with the upward movement of the Afikpo senior age grades, there are few general ceremonies. While every village has a rainy and a dry season festival, these are organized independently within each village and its component units—even some of the general Afikpo festivals take place on different days in different sections of the village-group.

Since Afikpo has a fully developed pattern of double unilineal descent, one would suspect that the masquerades reflect descent matters and conflicts (S. Ottenberg 1968). There is some connection of patrilineality to the masked rites. A number of the *ɔkumkpa* skits are concerned with internal matters within the compound and its agnatic groupings, for example, the case of the man who started his own title society. Some masquerades, such as *okonkwɔ* and *oje ogwu*, may be owned by patrilineal groupings. A boy's patrilineal groupings are concerned with his performance during his initiation masquerades. And certain village conflicts brought out in the *ɔkumkpa* reflect disagreements among village patrilineal groupings.

But at Afikpo major fields of social tension are between matrilineal groupings over land and between matrilineal and patrilineal groupings over both inheritance and land (S. Ottenberg 1968, chap. 5). These are not even symbolically indicated in the masquerades, and matrilineal aspects are almost entirely absent.

I can conceive of only one area in which matrilineality figures, and here it does so symbolically. There is a resemblance between male attitudes toward females as expressed in the masked rites and their attitudes toward key females—wives and sisters—in matrilineal matters. The masquerades express a certain male dependency on females in the borrowing of female costume elements. But they also contain the theme of the separation of sex roles, advocating that women should not act as men but perform their proper role as childbearers and domestics. These contradictory features of dependency and yet separation are present in the actual relationships of men to wives and sisters in the matrilineal sphere. A man relies on his wife's matrilineal relatives—therefore in an intimate sense upon his wife—for much of his farmland. He is dependent upon his sister's having children in order to pass on his matrilineal line. A man is separated from his wife by her matrilineal ties, and the relationship of a husband and wife is often not a close one (P. Ottenberg 1958, 1959; S. Ottenberg 1968). Similarly, a man's sister often lives elsewhere than her brother and he has difficulty controlling her behavior, although he is concerned about her because of the children she bears. The masquerades mirror the sense of dependency of men upon women, men's anxiety over female behavior, and the idea of the separation of the sexes that matrilineality suggests structurally.

But in general there is little emphasis on descent matters in the masquerades. They are staged at the level of the village, acting as a unifying force, cutting across descent lines and the conflicts within and between unilineal groupings.

It is everyone together in the community at the performance, the masked and the unmasked, interacting regardless of patrilineal and matrilineal ties—doing so with a sense of public unity to the outside world and a competitiveness with other villages. The mere act of performing a masquerade seems to lessen and to redirect social tensions of a descent nature.

The major areas of tension reflected in the masked rites are over (1) age differences and authority, (2) the maintenance of distinct sexual roles, and (3) the question of individual enterprise versus the ideal of the cooperating group. These are expressed directly in the ɔkumkpa, but are also found in other masquerades. The Aro figure appears in the okonkwɔ and the njenji; players are dressed and act like females in many of the masked rites; physical force is used by the ɔkpa and ɔtɛro against lower-status persons. These three represent tensions that are general to Afikpo and not restricted to specific types of descent or residential groupings. Thus the masquerades deal with broad matters concerning general social relations. This helps to explain their general interest and popularity. Let us look at these three elements in some detail.

Age and Authority

The principle of status distinctions based on age differences, part of the fabric of Afikpo society (S. Ottenberg 1971b), permeates the masquerades. The rites are led by the older players. The particular role—mask and costume—that a person takes depends to a large extent upon his age.

The ages of the masqueraders of the secret society can be broken down into four general but overlapping categories: young boys, about 5 to 15 years old; older boys, about 15 years old to into the early twenties; younger men, in their twenties; and older men, in their thirties and early forties. The masks worn by particular ages are shown in Table 3. It can be seen that certain masks are worn only by certain ages at certain masquerades, but the specific patterns are variable from one masquerade to another.

The more traditional and ancient Afikpo masks are those worn by the younger and older boys only, by the young men only, and by older men only, allowing for an occasional exception. Each ancient form of mask is limited quite specifically to an age group, and each type is generally restricted to use in only one to three ritual activities. The more modern forms are employed by persons over a wider age range—boys through young men—and are often used in a greater variety of masked rituals. They are, of course, less sacred.

Mma ji (possibly also mba) and at least some net forms are exceptions, as they belong to the ancient category but are widely used by a range of ages. I suggest that mma ji and at least some net mask forms were popular ancient types at Afikpo, employed by persons of various ages, but that other forms that are relatively modern—ibibio, ɔpa nwa, beke, and nne mgbo—have also become common and popular.

The masks of the noninitiates are worn nowadays by boys in the five to fifteen age category. Because the initiation into the secret society tends to take place today at an earlier age than formerly, the noninitiates' category considerably overlaps with the boys' category of secret society masquerades. At the other extreme, men over forty only occasionally take part as masquerade players.

Boston (1960), writing on the four northernmost Nri-Awka groups of the Igbo, indicates that the masks worn by the senior males are more sacred and fewer in number than those used by the younger men. At Afikpo the ɔkpesu umuruma is certainly seen as a mask with some power and it is worn only by older players; but it is not rare. The ɔkumkpa leaders' masks are also worn by older players or sometimes by younger men than those using the ugly masks, and the igri is used by young men. Both igri and the leaders' face coverings have sacred qualities and power, and neither is common. The calabash mbubu mask, although quite sacred, is worn only by the young boys in the secret society initiation. Boston's interesting conceptualization does not seem to have validity for Afikpo.

The association of age and type of mask and costume is to some extent obscured by placing all of the major rituals together. In looking at individual masquerades, the age distinctions become even clearer.

At the ɔkumkpa the younger and older boys wear the mba dress of the akparakpa with the acali, mba, mma ji, and ɔpa nwa masks. The younger and mature men dress in the ugly dark ɔri raffia costume and wear the beke, ibibio, igri, nnade ɔkumkpa, nne mgbo, ɔkpesu umuruma, and occasionally the acali mask—the only form worn by both mba and ɔri players. The musicians (young adults, as a rule, although sometimes older men play this role) are arrayed in everyday clothes and wear mkpe, ibibio, nne mgbo, beke, and mba face coverings—masks also worn by the ɔri players. The musicians rarely use ɔkpesu umuruma or nnade ɔkumkpa masks.

The age principle is also evident in the njenji parade. The men who wear the Aro slave trader's costume and ugly mask are quite senior in age among the players. The young adult igri masqueraders who gambol about ahead of the parade column are about the same age as or younger than persons who are at its head. The parading column decreases in age from front to rear, and with masks of one kind generally grouped together.

TABLE 3

Mask Styles by Ages and Uses

Name of Mask	Young Boys	Older Boys	Younger Men	Older Men
acali	ɔkumkpa njenji logholo		ɔkumkpa (occasionally)	ɔkumkpa (occasionally)
beke	njenji	njenji logholo okonkwɔ	ɔkumkpa njenji logholo okonkwɔ	
ibibio		njenji	ɔkumkpa njenji oke ekpa	
igri			ɔkumkpa njenji Edda run	
mba	isiji (only mkpere)	ɔkumkpa logholo	ɔkumkpa (musicians) logholo	
mbubu	isiji	isiji		
mkpe			ɔkumkpa logholo	
mma ji	njenji ikwum	njenji ikwum ɔkumkpa	njenji okonkwɔ ɔkumkpa	
nnade ɔkumkpa			ɔkumkpa (occasionally)	ɔkumkpa
nne mgbo	njenji	njenji logholo okonkwɔ	njenji logholo ɔkumkpa	
ɔkpesu umuruma				ɔkumkpa njenji
ɔpa nwa		ɔkumkpa logholo	njenji logholo	
ɔtogho	logholo	logholo		
net masks	various initiations	various initiations		
	njenji oje ogwu	njenji oje ogwu	njenji oje ogwu Edda run	njenji (praise singers) oje ogwu
enna forms	various	various		

TABLE 4

Masks Worn by Various Ages

Younger and Older Boys	Boys through Young Men	Young Men Only	Older Men
acali[a]	beke	igri	ɔkpesu umuruma
mbubu	nne mgbo	mkpe	nnade ɔkumkpa[c]
ɔtogho	ɔpa nwa		
	ibibio		
	mba		
	mma ji		
	net masks[b]		

[a] Occasionally worn by young men or older men
[b] Occasionally worn by older men as musicians in *oje ogwu* and *njenji*
[c] Occasionally worn by young men

I offer another interpretation concerning age and masks, taking only the masks that are considered purely masculine. The *acali*, usually worn by young initiated boys, is small, much like the *enna* masks, but of wood. It has a small projection, perhaps symbolically representing a boy's penis. The *igri*, worn by late adolescents and young men, represents youthful activity and exuberance of the fully developed young male. Its face is similar to that of the *acali*, although it is lengthened and the forehead and head sections differ. The *igri* is phallic, or at least the section above the eyes can be seen in this manner. The leaders' masks for the *ɔkumkpa* play have a quality of strength, which represents greater maturity than the *igri*. The senior leader's face covering has some of the same basic features as *igri*, although the face is rounded from side to side, rather than being flat, and the surfaces of the brows, nose, chin, and the front top of the mask are also rounded. The junior leader's mask bears some resemblance to the ugly *ɔkpesu umuruma*, worn by the older men, particularly in its bulging upper eyelids. The *ɔkpesu umuruma* group marks an accentuation of the rounding off of features begun in the leaders' masks, to the extent that the ugly masks have little in the way of sharp or angular lines, but are composed of rounded and curved surfaces, with considerable feature distortion. It is as if the face had broken down and deteriorated. Any sense of a phallus is lost, leaving an implication of castration.

The face coverings worn by the various ages thus represent stages in the life of an Afikpo male: youth, youthful maturity, adult strength and leadership, and old age.* Every male, as he goes through life, changes masks. A man in his forties has taken part in a variety of masquerades by the time he retires from masking. He has been required to take part in some by initiation needs, the rules of the village elders, or by his forming age set; others have been voluntary. This wide range of masquerade experience is consistent with other elements of Afikpo life—its open quality and the manner in which it permits similar opportunities for persons of the same sex (S. Ottenberg 1971b). It may also explain why masks are frequently rented rather than purchased: one style of face covering will hardly do for a lifetime. If owned, it is outgrown, like children's shoes, and passed down to younger brothers and other relatives to use.

Let me illustrate these points by the hypothetical example of a male called Ibe. Between the ages of about five and ten he is a member of the junior group of the noninitiates' secret society. He wears various masks, often crudely produced, and makes and uses a number of different costumes. He imitates, in unsophisticated fashion, the masquerades of the older noninitiates and of adults. Ibe also makes his first masks at this time, but he turns out not to be good at this and does not continue producing them.

At about the age of ten he joins the senior boys' group of noninitiates, and for some five years he continues to play at masquerade roles but in better-organized performances. At a minimum he takes part in a number of boys' *ɔkumkpa* plays, in *logholo*, *ɔtɛro*, and similar chasing games of the noninitiates. He is also chased by adult *ɔkpa* and *ɔtɛro*, and chases the secret society *logholo*.

Then Ibe is initiated. He is not a first son, so he does not take the long form; but he is "introduced" to the calabash mask and he dances in the *hihi* net mask and costume. At the end of his initiation he plays *logholo* with the *acali* mask a number of times. He enjoys this, is good at it, and during the ceremonial seasons he continues to play this game for some years. As an adolescent

* I find no extended sequence for the femalelike masks, although age distinctions among women are also important. However, the *ɔpa nwa* is used to represent adolescent girls of marriageable age while the *ibibio* is employed for older unmarried and married females, and there is a shift from angularity to roundness as one goes from the first to the second form. But both of these masks are worn by a wide range of ages.

and young man he several times takes part in his village's ɔkumkpa plays as an akparakpa, first with the acali mask and later with the ɔpa nwa and the mba face coverings. He also appears in four or five njenji parades in this postinitiation period, dressing up one time as a scholar, another as a Muslim, and later on as a female, again with the appropriate masks. If his community puts on the oje ogwu, he joins in it. Thus, by his mid-twenties he has become thoroughly familiar with masking and the associated costumes, and he has helped younger boys with their initiation masquerades, even for forms he did not go through, for he has acquired knowledge of them. When his age set organizes in his late twenties, he plays the role of a lovely agbɔghɔ mma female in the njenji parade. His age set also does the okonkwɔ and he is a dancer there. After his set's formation he gives up play at logholo, but since he is strong he occasionally does the ɔkpa or the ɔtero. Until his forties he takes part in the occasional ɔkumkpa presented in his village as an ɔri, but he is not good at acting and so just sings as a member of the chorus and dances between the events. He continues to give some advice to younger masqueraders, but he is now less interested in the masked rites because he is busy at farming, marrying, and taking titles. By the time he is forty he has completely given up mask activities except as an observer.

Our hypothetical Ibe, then, is familiar with a wide range of masks and costumes. He has been involved in masquerading during just about every annual ceremonial season from the ages of five to forty, gradually building up experience and knowledge, and changing his masquerade roles as he matures. He is likely to do various dances, to parade, to sing, to act, to chase and be chased in various masquerades. His range of experience is wide, his exposure just about average. There is considerable variation from person to person, for there are volunteer masked activities as well as required ones. Masquerading is clearly an important aspect of Ibe's growing up and early years of maturity. Eldership, or more strictly speaking, movement into the junior elders' category, is the dividing line at one end; the transition from babyhood to childhood is at the other. The age factor is crucial in gaining an understanding of the masquerade processes.

Thus there is both the continuity of experience from childhood onward, discussed in the section on the psychological interpretation of the ɔkumkpa, and the changing experience of the growing male with different masks, costumes, and players' roles through time. Each role an Afikpo plays reflects his age and experience.

The masquerades, particularly the ɔkumkpa, are also employed to dramatize and to expose the frictions in relationships between elders and younger males. In the ɔkumkpa young and middle-aged men reverse age roles and act as elders in order to say something about how these elders appear to them. Age-authority relations are a crucial area of tension in the village, and often in descent groups as well. The masquerades of physical force—ɔtero, ɔkpa, and logholo—are employed to stress age-authority differences where persons of certain ages ritually put down males of other ages. These masquerades generally occur in a crucial age period for males at Afikpo; maturing adolescence, when competition over sexual, property, and other matters increases.

I cannot likewise analyze the female experience with masks because I know too little about it. Females play different roles in terms of masquerades than males: they are chased by masked figures when girls; they observe the masked rites from childhood to old age; they lend costume elements to relatives and friends throughout much of their lives. They are certainly involved in masquerading from childhood onward, but rather than playing a creative role they are one target of its activity. Their own aesthetic concerns focus to a certain extent on group singing and dancing performances, often with original words and sometimes with newly created songs— occasionally highly satirical events particularly directed toward males. In their dancing and singing there is continuity of practice from early adolescence to middle age, and here there is aesthetic skill, growth, and creativity to match that of the males.

Sexual Distinctiveness

Sexual distinctiveness, a markedly male idea at Afikpo, has its roots in childhood experience. It is also historically based in a society that was involved in head-taking, slavery, mercenary military activities, and warfare, where physical strength for males was of primary importance and women were much restricted to the home and the domestic life. Probably the matrilineal descent situation has also played a role in the pattern of sexual distinctiveness. Although the social situation has changed greatly at Afikpo since pre-European contact days, the masquerades still reflect the emphasis on maleness and strength: masked rites such as logholo are training grounds in physical expertise.

The very performance of a masquerade is also a symbolic statement of sexual distinctiveness. Females are excluded from participation and they cannot give presents directly to masked figures or have physical contact with them. Women do not enter the common for a performance until given permission, and they leave immediately after, as the common is then usually closed.

In the masquerades there is also a good deal of male strutting and preening, the showing off of male capabilities. The igri maskers in the njenji

exemplify this, as do some of the ɔri dancers in the ɔkumkpa and the players in the oje ogwu and okonkwɔ. Male virility and colorfulness appear in these and other dances without overtly sexual gestures. Some men clearly enjoy the opportunity to "show off" in public and before many females.

Individualism and the Group

The third major area of tension, individualism versus the corporate will or conception of good behavior, is also evident. In the ɔkumkpa the "palaver man" is ridiculed, and elders are exhorted not to go their own ways for personal gain. Also, females who become too individualistic and who break with custom are criticized.

One may note the emphasis on individual skill for the logholo player and for his attackers. And individual effort in the ɔkpa and ɔtero masquerades, as well as in the Edda run, is generally encouraged. On the other hand, criticism of the misuse of individualism is implied by the tale of the child-killing ɔkpa. Ɔkumkpa leaders are encouraged and supported in their efforts to organize a good group performance without overstepping a delicate line in criticizing elders and other persons. Many of the masquerades, especially the more complex ones such as ɔkumkpa, njenji, oje ogwu, and okonkwɔ, represent public models of the use of personal initiative in controlled and cooperative ways. If well done, they present an image of effective cooperation combined with individual initiative.

A corollary to this ideal is volunteerism. While the village elders or the executive grade can order young secret society initiates to take part in the masked rituals, as in the ɔkumkpa, njenji, and logholo, many of the masqueraders' activities rely upon interested volunteers. The production of the ɔkumkpa depends on the interest of skilled leaders, and the oje ogwu dance at Ukpa owed its success to the interest of one individual willing to organize it. The playing of ɔkpa, ɔtero, and logholo relies to a considerable extent upon voluntary interest. While certain things pretty much arrange themselves in the njenji parade, where a forceful and individualistic leadership is less necessary, most masquerades are sustained by interest rather than through authority and compulsion. Similarly, the helpers who assist in dressing and arranging performances do not usually participate out of a sense of duty but rather through interest and for their own pleasure. For some it is a vicarious reliving of their own masquerading days. The volunteeristic element is a major aspect of the masked rites, where the rewards are largely in the pleasures of doing rather than in monetary or other substantive gains.

The secret society leaders put little pressure on persons to hold performances, except for initiation rites, and they play largely supportive roles in the masquerades. They prepare protective charms and medicines for the players. While sometimes participating directly in the initiation masquerades, the leaders are still mainly passive and supportive here, too. The masqueraders operate much within a spirit of cooperative volunteerism in a climate of autonomy, guided by custom through the agency of experienced hands.

Yet there is constraint here as well. When some of the public performances are planned, members of the younger village age sets are required to take part. Secret society initiations and postinitiation activities demand the participation of males in certain rites. These events represent forced status-enhancing activities: boys and young men gain prestige from taking part even though the events may be nonvoluntary.

The secret society itself is highly achievement-oriented. A boy must successfully go through the initiation rite. He has the choice of numerous titles within the society that he can take at varying expenses to raise his status and influence in his village. And as a masquerader his skills and failures in performance are weighed and evaluated. There is much praise for the young boy who skillfully dances the isiji, for the lad who portrays the "queen" well in the ɔkumkpa, for the leaders of a well-organized ɔkumkpa, and for the logholo who cannot be thrown. Masquerading is an important area for the public display of skills and abilities in a competitive situation and Afikpo achievement values fit nicely here (S. Ottenberg 1971b, chap. 12).

Social Cleavages and Art

I can now comment, with reference to Afikpo, on Wolfe's explanations (1969) for the "high" level of art in some African societies. He argues that artistic production is "high," in quality and quantity, where males are divided by social cleavages, and that this art, in some unspecified functional way or ways, helps to handle these social separations. One form of male cleavage, he believes, is through matrilineality, and African matrilineal societies have a high incidence of developed art forms. At Afikpo, matrilineal groups are important and they are certainly associated with matters that tend to divide males, often in the same or neighboring villages. Wolfe feels that a strongly developed art tradition is correlated with nucleated settlements, rather than dispersed ones, and with fixity of settlement. Also, there is a strong relationship between the presence of a number of association groupings in a society and a well-developed art tradition. All of these elements are present at Afikpo, which is not in his cross-cultural sample of African societies, so that this village-group would seem to support his contentions. His theory offers a sociological explanation of the development of a rich masking

tradition there rather than a technological or ecological one.

The problem is that Wolfe does not show how art actually acts to deal with these cleavages. It seems to me that every society has cleavages among males that divide them in some ways. At Afikpo there are not only those connected with matrilineality, but the cleavages within the fixed nucleated settlements between patrilineal groupings and also between age groupings cutting across descent lines. It would, indeed, be hard to find a society in which social cleavages among men really do not exist, despite Wolfe's views. Further, at Afikpo it seems that the masquerades are directly and in important ways concerned with the social cleavages between the sexes, a matter with which Wolfe does not deal in detail.

Wolfe's explanation of the presence of a rich art tradition contains other difficulties, which are brought out by the commentators on his paper (1969, pp. 29-41) but cannot be discussed here for reasons of space. But I can offer this contention: at Afikpo the conflicts involving matrilineality are not handled directly in the masquerades, but the very act of producing masked rites draws persons together—both as players and as members of the audience—regardless of matrilineal ties and conflicts and of matrilineal-patrilineal tensions. Thus the plays smooth over, if only in a symbolic and temporary manner, frictions associated with matrilineality. They give persons some things interesting and important to do as a group, as a community, regardless of other ties, and these are emotionally releasing. Further, the masquerades directly deal with those three areas of widespread friction at Afikpo—age and authority, the sex role dichotomy, and individualism and the group. Here the symbolism is pointed and immediate. Clearly the art at Afikpo deals with a variety of social tensions. It is not my belief, however, that either art or masquerading is the only manner in which these are handled at Afikpo, nor is either a necessary or sufficient way in any society. Alternatives are possible. Wolfe's suggestions offer no real explanation of the richness of art in a society. For Afikpo, a combination of functional and diffusion explanations is necessary. The art tradition actively exists because of contact with the considerable artistic milieu of neighboring groups and also because it relates to certain major tensions in Afikpo society. I could conceive of the tradition's presence without being related to these social tensions if the art is present in neighboring groupings, and I could conceive of its being there in the absence of a neighboring tradition if related to social tensions at Afikpo.

Social Readjustments

I close this section by returning to an idea presented in the first chapter: that the Afikpo ceremonial season is one of social adjustment and realignment in which the masquerades play roles along with other social activities. I have noted the presence of the social commentaries at the ɔkumkpa plays. The initiation masquerades are a public statement of the transition from boyhood to manhood, and in the case of the first son also represent an important status change for the father. The njenji and okonkwɔ are produced by a newly organized or an organizing village age set, a transitional period. The masquerades of physical force are concerned with status maintenance or change: the putting down of the uninitiated and the attacks on the masked. And the masquerades restate village solidarity and the residential community of interests, after a period of farming and intense family life in which the nonresidential matrilineal farmland interests play an important role.

PSYCHOLOGICAL FACTORS

When an Afikpo dons a mask and costume, he goes into a special behavioral state. There is an element of secrecy about him that is also not secrecy, for he is often recognized or, at any rate, it is certainly known that he is a human. As a projection of the power of the secret society, he has a special force. The masked player represents a special conception of self. He demands or commands attention: he is to be viewed, sometimes interacted with, but not usually ignored.

The masquerader sometimes acts the part of a fool or an amusing spirit and he is protected by his anonymity. But this protection is also an illusion. As Welsford (1961, p. xi) says: "The tragic hero is inseparable from his tragedy—he is the central figure about whom the story is told, and when the curtain falls he vanishes once more into the nothingness out of which he was summoned by his creator." But the fool does not vanish. "He is an amphibian equally at home in the world of reality and the world of imagination, and it is this striking difference between him and the tragic hero which suggests an additional reason for the study of his peculiarities" (p. xii).

While the Afikpo masquerades allow men to act out the foolishness of others, to amuse the viewers by their dancing, dress, and various actions, there is a particular attitude that those associated with masquerading—the leaders musicians, helpers, carvers—are funny men, and perhaps a bit foolish. They do not follow the main lines of achievement but preoccupy themselves with masquerades, which have something of a childhood aura around them. In this sense there is some congruence between masquerade roles and the persons who play them.

Masquerading involves other kinds of actions. One is identification with the aggressor. The

masquerader becomes the aggressor toward those who he feels have aggressed in some way against him: family, elders, females, Aro, Europeans, and "modern" Africans. The player acts out his interpretation of these persons' behavior and the result is humor. The Aro man is laughed at, the elders look foolish and women ridiculous and shortsighted. The scholar or missionary in the *njenji* line is amusing because of the meticulousness of his Western dress and his seriousness. These are types of persons who are believed to have acted against Afikpo males. Identification with the aggressor is in itself an aggressive act, clothed in masquerade form.

Masking allows for exaggeration of physical motion. The mask at Afikpo is expressionless, with the exception, perhaps, of the ugly masks, which have something of a look of disgust or even anger. The absence of expression is even more noticeable in the case of the net masks. Thus the player cannot depend on facial expressions in creating characterization. Sometimes he can employ his voice to help make up for this deficiency, but at other times he is restricted to the use of body movement. There is a considerable emphasis on gesture, pantomime, and stance as indicators of character and behavior. We have seen how carefully the *agbɔghɔ mma* females in the *njenji* parade perform their walk, and how significant movement is in the case of some scenes in the *ɔkumkpa* play and in depicting the Aro traders. In this regard there is something of an association with childhood, for youngsters gesture, pose, and mimic with considerable use of the body and limbs, while adults rely more on the voice.

The elements of constraint on the masquerader are major: he cannot see well; his hearing may be reduced by the nature of his headpiece; he cannot take food; he is not allowed to defecate; and he may not remove his face covering in public. Required to fulfill his role in the masquerade, he constrains himself in certain directions and seeks release in others. There is an exchange of taboos between everyday life and masking. The restrictions on the masquerader redirect his energies, deflect him from his ordinary self to a temporary new role, where he can act creatively.

It has already been pointed out that the players are relatively free of the direct authority of the elders and the secret society leaders, that there is considerable autonomy and volunteerism. The same pattern is evident in the masquerades of the noninitiates, who are largely independent of parental control and the pressures of older boys. The sense of autonomy in the initiates' performances largely duplicates the earlier forms. Autonomy is reduced during the transition from the younger to the older uninitiated boys' group, when the parents must pay certain fees for their

boys, and in the masquerade initiation rites into the secret society, when parents and the boy's agnatic relations play important guiding and supportive roles. At another transition point, that of age-set formation, the masqueraders are already adult enough so that parents and agnates play no significant part. But the two earlier transitional periods reflect support and dependency.

The secret society players also try to affect autonomy from females, but here there are ambiguities. The masqueraders are often dependent upon females for part of their dress. Performances are often put on in front of the whole village, and while the masqueraders' interest is largely in watching the reaction of the adult male audience, they are not ignorant that females are there and reacting to them. And females give presents to the players. There are important social interactions going on between the females and players, so the autonomy is hardly complete.

There is also considerable sexual ambiguity expressed in the plays. The sexual identification of the masks is not always clear or simple. True, there are some forms that are clearly male: *igri, mbubu, nnade ɔkumkpa,* and *ɔtogho*—all probably ancient Afikpo forms. In the female category are the modern *ɔpa nwa* and the *ibibio;* the first is explicitly female in its roles in the *njenji* parade and in the "queen" event in the *ɔkumkpa.* But for both of these masks, as with other face coverings, problems arise when we consider other activities in which they are used. The *ibibio* is worn by persons in the *ɔkumkpa* play dressed in *ɔri* costumes and without a particularly feminine appearance. These players portray either males or females in the skits, or they act as male dancers. The *ɔpa nwa* is one of several masks used by the *akparakpa* dancers in the *ɔkumkpa.* Now their *mba* costume is both male and female. Often they add elaborate female-style headdresses and female plastic waist beads. The players dance in girls' styles, acting like young females. Yet the dancers wear singlets, shorts, and ankle rattles, elements of male attire. The *akparakpa* do not seem as explicitly female as the *ɔpa nwa* of the *njenji* parade. And dressed in the *akparakpa* style at the *okonkwɔ* dance, other players move in male steps. Thus neither the *ibibio* nor the *ɔpa nwa* mask is always used in a totally female context, even though both are generally considered female.

There are other face coverings that are associated with maleness or male costume but have some feminine associations. Included are some of the masks worn by the femalelike *akparakpa* dancers: *acali, mma ji,* and *mba. Acali* is a young boy's mask, and *mma ji* is associated with the yam knife. The yam, grown by men at Afikpo, is connected with male fertility and the penis. Yet,

while *acali* and *mma ji* are used with the feminine costume of the *akparakpa* in the ɔkumkpa play, in the *njenji* parade both are found only in association with male costumes. And the *mma ji* is also used in the okonkwɔ dance where the players dress up in feminine style but dance male movements. The *mba* mask, worn by the femalelike *akparakpa,* is also occasionally used by ɔkumkpa musicians, who are clearly male and carrying out men's work. Thus the sexual distinctiveness of males from females is an illusion, an autonomy not achieved.

Although the ɔkumkpa play is the clearest example, some of the other masquerades exhibit psychological associations with childhood. A good number of the adult masquerades first appear during childhood in an equivalent form: not only ɔkumkpa, but ɔtɛro, logholo, and okonkwɔ, among others. Further, the adult ɔkumkpa, njenji, and okonkwɔ contain representations of both female figures and male authorities. It is interesting that in those three events in which females are most explicitly depicted one also finds male authorities —elders in the ɔkumkpa and Aro in the *njenji* and okonkwɔ. This adds to the view that male and female parental figures are psychologically involved: the female is looked on as attractive and friendly, the male as hostile and representing authority. Then there is the aggressiveness of the persons involved in ɔkpa, ɔtɛro, and logholo, which mirrors hostilities felt toward and emanating from seniors. Patrilineal and village affairs, so much involved in childhood, are stressed rather than the largely adult concerns of matrilineality.

But it must be understood that I use this concept in a psychological sense. I do not believe that adult men "become" children, childlike, or simple-minded—a view that has certainly been misapplied to Africans more than once. The masquerades are adult in organization, complexity, skill, creativity, and aesthetic quality. I mean that Afikpo adults, like adults elsewhere in the world, carry out or are involved in some behavior that mirrors childhood experiences.

At the same time there are some initiation masquerades that do not operate in this manner. The *isiji,* with its calabash mask, and the *aborie* and *hihi* players are different in several respects. The boys are wearing masks not experienced during childhood. Their actions are not seen as humorous or aggressive but as pleasantly skilled. They do not indulge in playful chasing; the players are more dignified. * These initiation rituals do not relate back to childhood, but these forms do not

* This generalization does not apply, however, to the *ikpem mbe* masquerade of the *ikwum* initiation, for the mask resembles childhood forms and the masqueraders are ridiculed for taking the "cheap" form of initiation. It certainly does not apply to the ɔkpa, oke ekpa, and ɔtɛro masquerades in the ɔka initiation.

last; they are rarely employed after initiation, if at all. The initiate quickly moves toward playing the chasing *logholo* at the end of initiation and participation in the masked rites, such as ɔkumkpa. It is interesting that this brief period of transitional masking, with its own psychological "feel," coincides with a time when parents and agnates are quite supportive of the child and when the masquerader's autonomy is negligible. It is as if the support of parents and relatives adds a certain dignity, while autonomy allows for more foolish behavior. The transitory initiation rites, which bridge the two periods of autonomy, carry with them a special aspect of maturation and growth.

AESTHETIC ELEMENTS

The Afikpo aesthetic carries with it the idea of participation. The community is very much involved in the masquerades: those who are not masqueraders form the audience, who are vocal and critical and almost a part of the rites rather than being passive observers of them. All males take part a good many times as masqueraders, and while the secret society is an exclusive organization, its masked rites are generally public.

The aesthetic also has elements of competitiveness, in which the players are compared to others in the same and different performances in the same community, to those in other villages, and to general standards of acceptability. It is a highly judgmental aesthetics.

It is an aesthetics of movement. There are few standing sculptures at Afikpo: a carved figure or so in a few resthouses, an occasional statue on a decorated village drum or a rare carved wooden post (S. Ottenberg 1972b). There are no wooden statues associated with shrines, such as the *ikenga* horned figures so common to other Igbo areas. There are no figures in mud and clay of the *mbari* type, such as are found among other Igbo-speakers, and there is practically no wall painting. The major art tradition is in the mask: design is found mainly in masks, costumes, and the arrangements of players.

The masks and costumes are viewed not as stationary objects, for they are never so displayed, but as part of an active, moving masquerader. We are dealing with an aesthetic that emphasizes action, in which beauty and ugliness, delight and foolishness, come out of doing rather than being. And the movement has a sense of character, of display, and of showing off.

Beier (n.d.) makes an interesting comparison of Igbo and Yoruba art in which he relates the respective styles to cultural and social differences. Igbo art is tense and dramatic, Yoruba art has harmony, balance, and repose. Igbo carving aims at a sense of movement, Yoruba is static. In Yoruba art the forms are organic, while in Igbo they are

angular and geometric. The Yoruba carver is in harmony with the material that he uses, the Igbo artist sees a challenge in it. The Yoruba uses color sparingly and in a subdued fashion; Igbo artists create contrast with color, and "the design of the painter often cuts across the basic shapes of the carvings" (p. 48). Yoruba facial markings underline the structure of the face, while Igbo ones "cut boldly across anatomical features" (p. 49). These features are briefly connected by Beier to the particular traditional forms of government, relationships between the sexes, and religious beliefs of the two ethnic groups. The implications are clear: the Igbo are tense and energetic, and they are involved in conflict, while the Yoruba seek unity and the avoidance of friction. The art of each group reflects basic patterns of living.

Such broad generalizations are difficult to evaluate on account of their subjective quality and because cultures such as the Igbo and the Yoruba show a great deal of internal variation. Also, these ideas employ quite Western concepts of the static and the dynamic in art, of tension and repose. Further, Professor Robert F. Thompson has suggested to me that Beier is talking mainly of the Oshogbo-Erin-Ilobu area of Yoruba and no clearly defined Igbo region, and that his comparison is suspect.

Nevertheless, it is interesting to consider the Afikpo material in these terms. The oval, pouted, sometimes toothed mouth of the *beke*, *ɔpa nwa*, *ibibio*, *mba*, and many of the ugly masks suggests tension. Only a few forms, such as *nne mgbo*, seem quiet. The contrast between its relaxed, almost smiling mouth and the pouting one of the *beke* is remarkable; the effect of the latter is to make the face seem active. The difference is striking since both mask forms have similar elements of form and design outside of the mouth area.

But it is the tenser forms that dominate the Afikpo masking tradition. The suggestion, then, is that these reflect a sense of activity, as do the masked rituals themselves.

The point has also been made that there is some stress on aesthetic ambiguity at Afikpo (Leach 1961, p. 24). This feature is not readily apparent: the actions of the masqueraders seem clear and precise. But the masks have an expressionless quality, and their sexual identification and that of some of the costumes are unclear. Further, the masked players are variously considered spirits or people or both—part of the humor of the masquerade lies in this ambiguity. And there is considerable uncertainty in the symbolic meanings of some of the masquerades, particularly the less explicit ones such as the two dances, *oje ogwu* and *okonkwɔ*. These ambiguous features are not created by any weakness in the anthropologist's analysis; they exist in reality and they often delight the players and observers.

The Afikpo rituals are an expression of aesthetic variety. There may not seem to be a large corpus of secret society masks: twelve basic wooden types, one gourd form, and several net types, as well as some variable forms in the boys' groupings. But the masks are employed in a wide variety of costumes. Table 5 lists the Afikpo masquerades and the associated costumes. There is a total of thirty-four different costumes for the twelve masquerades. Although raffia, ankle rattles, and wrist or arm ornaments are frequently employed, each costume is at least a little different from the others, has its required mask or masks, is recognizable and named, and is associated with particular forms of behavior. This list is substantial enough to suggest the importance of variety in the masquerade tradition. The range of action is also great: from the delicate dancing of the *isiji* and some of the net-masked players to the rough and aggressive behavior of *ɔkpa* and *ɔtero*, to the buffoonery of some of the *ɔkumkpa* players, to the emphasis on physical strength and youthful vigor of the *igri* maskers. There is surprisingly little repetition of action in the twelve masquerades.

This sense of variety is also found in the musical forms, which are listed in Table 6. Seven masquerades always have music and two more have it sometimes. Of these nine the kind of music —whether produced by instruments, through clapping, or by use of the voice—differs in all but the closely related *isiji* initiation and *omumɛ* title forms. Not only are the means of sound production different, but also the musical styles. There are no standard instrumentation or music forms for the Afikpo masquerades as a whole, although one can say that they are essentially based on percussion and/or singing. And in about half of the cases the musicians are masked, while in the other half they go without facial coverings.

Variation also occurs in the dancing, which is not normally duplicated from one masquerade to another. One is hard put to talk of a single masquerade dancing style for Afikpo in terms of steps, number of dancers, or physical arrangements, other than a tendency to dance in circular lines counterclockwise. The information on dancing is listed in Table 7. Masqueraders who do not actually dance may hop or skip, as do the Aro and *ɔkpa eda* in the *njenji*, and the *ɔkpa* as he chases others. Some forms of movement seem transitional between these and dancing, particularly those of the *aborie* players in the *ɔka* and *ikwum* initiation and the *hihi* maskers in the *isubu eda* initiation.

The sense of variation is created by the particular manner in which elements of costume, music, voice, and motion are associated, so that again, except for the *isiji* initiation and the similar *omumɛ* title form, there is a wide range of situations. That variation should be characteristic of the aesthetics of the masquerades is not

TABLE 5
Secret Society Masquerades and
Associated Costumes

ɔkumkpa

1. akparakpa or mba
2. ɔri
3. play leaders
4. musicians

njenji

5. ɔkpa eda
6. egbiri
7. ɔteghita
8. ɔgbə kpakpokpakpo
9. praise singers
10. Aro
11. igri
12. agbɔghɔ mma
13. ibibio
14. younger males, various costumes
15. younger females, various costumes
16. ɛkpo atam

Edda run

(11.) igri
17. aborie

okonkwɔ

(1.) like akparakpa
18. several players dressed as females
(10.) Aro
19. musicians

oje ogwu

20. erewe dancers
21. ebulu dancers
22. musicians

controlling masquerades

23. ɔkpa
24. ɔtero

chasing games

25. logholo proper
26. ɔkwə
27. obuke
28. ikpo
29. atankwiri

isiji initiation

30. mbubu

omumɛ title and isiji initiation

(30.) mbubu
31. mkpere

ɔka initiation

(23.) ɔkpa
(24.) ɔtero
32. oke ekpa
(17.) aborie

isubu eda initiation

(23.) ɔkpa
33. hihi
(25.) logholo

ikwum initiation

34. ikpem
(17.) aborie
(25.) logholo

surprising. It ties in with other aspects of Afikpo life: the stress on achievement and alternate means to success, and the use of variable skills. Different persons sometimes have a choice of roles to play in exploiting their own particular talents. And the idea of variety fits into the mixed history of the Afikpo area, with its tendency to incorporate different peoples, rituals, and customs without forcing them all into a unitary system (S. Ottenberg 1968, pp. 18-23).

There are several aesthetic elements in the consideration of the masks and costumes as art objects. There is a tendency toward the simultaneous occurrence of whiteness in masks and light and bright colors in both masks and costumes. This feature is associated with two general forms: persons dressed as females— generally adolescent girls—and as elegant and nonaggressive males. Examples should be apparent from previous discussions, such as the femalelike dress and masks of the akparakpa in the ɔkumkpa, and the ibibio and agbɔghɔ mma in

TABLE 6
Musical Groups in the Secret Society Masquerades

ɔkumkpa

> skin drummers
> rattle player
> *ekwe* player ⎫
> iron gong player ⎬ masked
> two leaders and chorus ⎪
> two assistant leaders and chorus ⎭

njenji

> praise singers (masked)

Edda Run

> none

okonkwɔ

> two xylophone players ⎫
> rattle player ⎬ masked
> *ekwe* player (sometimes) ⎭

oje ogwu

> masked musicians singing and playing iron gongs
> (*ekwe*) or hitting sticks together

controlling masquerades

> *ɔkpa* sometimes accompanied by unmasked
> musicians playing small drums, or at Ozizza by
> village drum and small drum; otherwise no music

chasing games

> *logholo*, with unmasked *ekwe* and xylophone
> players (the latter sometimes present)

isiji and *omumɛ* title with *isiji*

> singing and clapping group (unmasked)

ɔka, isubu eda initiations

> none in masquerade parts

ikwum initiation

> singing group (unmasked)

TABLE 7
Dancing in the Secret Society Masquerades

ɔkumkpa

> *akparakpa*, one or two groups in a circle, female
> style
> *ɔri*, as individuals, strong male style
> "queen," alone, female style

njenji

> *ɔteghita*, two together, delicate dance, male
> *egbiri*, two together, female style
> *igri*, as a group, male style

Edda Run

> none

okonkwɔ

> main dancing group in a circle, male styles

oje ogwu

> *erewe*, as a group and individually, male style
> *ebulu*, as a group only, and part of *erewe*, male
> style

controlling and chasing masquerades

> none

isiji initiation and *omumɛ* title with *isiji* initiation

> one or several dancers together, delicate, male

ɔka initiation

> *aborie*, group, male style, transitional between
> dancing and moving

isubu eda initiation

> *hihi*, group, male style, transitional between
> dancing and moving

ikwum

> *aborie*, group, male style, transitional between
> dancing and moving

the *njenji* parade. The nonhostile elegant male is seen in some of the initiation masquerades: *isiji, ikpem, hihi,* and *aborie.* It is present in the *oje ogwu* dance and in some of the net-masked players in the *njenji,* for example, the *ɔteghita.* Perhaps it occurs with the *igri* in this parade, although there is a note of aggression in this player's behavior.

Darkness, expressed in black, browns, and grays, is also often common to both mask and costume. The *ɔri* players wear the ugly masks and the dark raffia in the *ɔkumkpa,* and the Aro players, with like masks, wear dark tan or brown clothes in the *njenji* parade. *Ɔkpa* and *ɔtɛro,* the hostile chasing costumes, are both costumed in darkish colors. There is therefore some equation of darkness with ugliness, hostility, and aggressiveness.

There are exceptions to this categorization. Some *ɔri* players in the *ɔkumkpa* wear light or bright-colored masks. The Aro players in the *okonkwɔ* dance at Okpoha that I witnessed wore bright-colored *mma ji* masks, and the musicians were not in dark costume. Nevertheless, white and dark, bright and somber colors are opposites, associated with different masquerade forms and behavior. The presence of these different elements in a performance affords aesthetic contrast.

Ardener (1954), in his study of skin color among the Igbo of Mba-Ise, in quite a different section of Igbo country, felt that paleness and lightness of human complexion among Igbo there were seen as beautiful and not unusual, while dark colors or black were viewed as ugly and common. This general view, also found in everyday life at Afikpo, translates readily to the masquerades, where there is a similar opposition of beauty/ lightness and ugliness/darkness. One notes that at Afikpo, as at Mba-Ise (Ardener 1954, p. 71), black and white are the only two true color terms. They are more properly translated as "dark color" and "light color," for they extend beyond black and white. Other color terms have special referents. One notices, also, the use of light-colored raffia in certain costumes to make them "fine," while the darker raffia is associated with the ugly masks. White hens or cocks are preferred over other colored fowls for important sacrifices, black is associated with death in ceremonials, and so on. The connection of these two colors with aspects of Afikpo life is strong and wide-ranging.

With the exception of some of the modern Ibibio forms, the basic colors in the Afikpo masks in terms of large color masses are black and white. Masks are either predominately white when considered beautiful, predominately black when thought of as terrifying or ugly, or a mixture of black and white when not viewed at either extreme, for example, in the case of *acali, igri,* and the *ɔkumkpa* leaders' masks. Thus considerations of light and dark permeate all aspects of the

Afikpo masquerades.

It is the lighter colors, of course, as Ardener points out for Mba-Ise, that are unusual. Everyday life in the Afikpo villages is full of dullish browns, grays, and darker colors: the houses inside and out, the cooking utensils, much of the cloth and other articles of dress. The vegetation about the village is darkish. There is little Mediterranean lightness there despite the tropical sun and light. Lightness is unusual enough at Afikpo to suggest the equation of light colors and beauty. It is worth noting that the village commons, where many of the Afikpo masquerades are held, are out in the open, in one of the lighter areas of the villages. These commons are open and lack the vegetation and housing of the compounds and areas in back of them.

Like the presence of flowers on trees and plants in the natural landscape at Afikpo, the reds and oranges in the masks play a secondary role. They add small specks of color here and there, but they do not usually form large color masses, and they are often tucked into design elements. They are found on the lip or mouth areas of some white-faced masks, in the lip and eye regions on the ugly forms, and as elements in a variety of masks in the cheek marks, along with black and sometimes white. Reds, yellows, and mixtures of these colors are usually found in the projections above the head and out from the face. The association of reds, yellows and intermediate colors with the eyes and mouth seems clear. By coloring these areas of inner tissues perhaps they are representing blood and life itself. Their presence as design elements on top pieces and in the more abstract mask forms can be seen as a way of giving life to these forms.

I have already indicated that cheek marks seem to serve no symbolic purpose. When they do exist, they cut the cheeks into sections, breaking up what would otherwise appear as large masses of white or black. In this they may have aesthetic value. While absent from the ugly *ɔkpesu umuruma* forms, they do not follow any general pattern at Afikpo (see Table 8). They are present on some of the older Afikpo forms of masks, but are also seen on some newer types. They occur on some predominately female masks, but also on some male forms. They are found with some masks that have a top piece, but not on others. They are missing from the more abstract forms, such as *ɔtogho, mbubu,* and *mma ji* and the distorted *ɔkpesu umuruma* types, but they appear in only some of the more naturalistic forms. They are associated with some masks used in secret society initiations but absent from others, and they are present in mask forms worn by a wide age range of males, from young players wearing the *acali* face covering to the *ɔkumkpa* leaders with their special masks. In short, while they may suggest either facial cuttings, or simply designs,

they appear to constitute an aesthetic ambiguity: they fit no regular pattern or classification, nor do Afikpo seem to see them as doing so.

Other features characterize the plays. Motion tends to be circular, curved, and counterclockwise in almost all of the masquerades. There is often exaggerated movement on the part of the players; but slow and highly controlled motions, such as are characteristic of Japanese masked plays, are not common. The movements tend to be large and quick, of the whole body and/or limbs, without the use of delicate hand movements, such as are found in Ashanti dancing, to make symbolic statements.

If there is more than one costume type present, those of each kind tend to group together and to move as a unit, apart from the others. And music, except for singing in some instances, is almost always accompanied by dancing. In the masquerades it is rare to have nonvocal music without some physical motion on the part of other players. Such music for its own sake is generally absent, and there are no real musical interludes, no overtures, no codas. Singing is common in the masquerades, occurring in six of the twelve, but it is only sometimes directly associated with dancing. The words of songs are short sentences or phrases (with some exceptions, as in the ɔkumkpa), often repeated again and again, rather than being long epics or poems. The musical instruments stress percussion rather than tune, yet they sometimes bring out tonal elements in Igbo words and phrases.

There is also a sequential rather than a climactic quality to the elements of the masquerades. While there are high points to many of them—the dancing of the "queen" in the ɔkumkpa, the agbɔghɔ mma females in the njenji parade, the dancing of the leader at the isiji initiation masquerade—the pattern is a sequence of actions with slight changes in the levels of skill and intensity; there is little growth to a point of climax or high intensity. There is often a good deal of repetition of the same acts or events, as in the chasing and controlling masquerades, the isiji dance, and some of the popular songs in the ɔkumkpa. And time is not of the essence. Many of the masquerades go on for hours, some even all day (the chasing and controlling games), with little need for time compression. Everyone is given his chance to perform. The sequential arrangements, lack of strong climax and development, tendency toward repetition, and lack of time pressure all fit together as related aspects of the same aesthetics —they are not elements that fight with one another.

There is an almost continual element of humor in the masked rites for the viewers and players. Afikpo are amused to see men acting as mma spirits and strutting about and they laugh a good deal rather than becoming angry at inept

TABLE 8

Presence or Absence of Cheek Marks on the Masks

acali	usually
beke	no
ibibio	no
igri	usually
mba (proper)	no
mkpere	usually
mkpe	usually
mma ji	no
nnade ɔkumkpa	usually
nne mgbo	no
ɔkpesu umuruma	no
ɔpa nwa	usually
ɔtogho	no
mbubu calabash	no
net masks	not specifically identifiable, although colored lines occur on some of the faces

actors. There is a sense of delight, of happiness in the masquerades. Even in the case of the aggressive masquerades, such as ɔkpa and ɔtɛro, where the persons attacked may be anxious or fearful, to the aggressors and the viewers it is a playful and funny affair rather than a serious one. While there are underlying serious values (S. Ottenberg 1972a)—the criticisms in the ɔkumkpa, the initiation masquerades in the transition from boyhood to manhood, the njenji as an expression of village age-set formation and of history, the logholo as a training ground in physical skills and aggression—which are important and reflect major facets of Afikpo social relationships, the overlying tone is one of amusement. The humor and delight ease tensions that surround the more serious social themes.

Are the masquerades creative or merely repetitive? Creativity is difficult to define. If one asks whether there is an emphasis on originality and innovation in the masked rites, the answer is no. True, some rites have been shortened because of lack of interest, and others have changed, as the njenji must have, or are relatively new, as the Edda Run. I believe that there is greater stress on the Igbo-style masked forms and less on the net-mask styles than in the past. The content of the masquerades is changing, being sensitive to the changing social world, as in the nature of the skit material in the ɔkumkpa play. There is not, though, radical innovation as a rule. The creativity comes rather through the individual development of particular skills in organizing or performing

something that is essentially traditional. It is the quality of a well-dressed and finely walking *agbɔghɔ mma* female in the *njenji* parade, the skill of an *ɔkumkpa* leader in producing a new play, or the fineness of an *oje ogwu* dancer. Creativity is perhaps not the issue as much as quality of skill.

There is another point to be made here. We have seen how a person plays different masquerade roles as he grows older, involving new motions and behavior. He must therefore learn new skills all the time, so that for the individual there is a sense of newness, of innovation, of accomplishment as he matures, whereas from the point of view of the society the emphasis is on the repetition of traditional behavior.

Finally, we are dealing with an aesthetics of the present. The *ɔkumkpa* deals with topical matters, the *njenji* and initiation rituals with rites of transition that are going on at the moment, the *logholo* is a game of the time. I have shown how little the Afikpo masquerades make use of legend, myth, and history, how seldom they seem to make direct use of the past. The *njenji* parade is the only clear case, in its panorama of Afikpo's history. Yet, in another sense the masked rites very much reflect ancient times. The variety of masquerades and costumes suggests the mixed history of the village-group. The masquerades explore and reiterate some of the basic traditional values of Afikpo culture and social relationships: the superior role of men, the dichotomy of sex roles, achievement through personal enterprise but with group support, the importance of men of physical strength, and the suspicion of persons in authority. While the masquerades largely deal with current affairs, they do so while expounding tradition, and with a sense of action rather than of reflection.

Glossary

aborie. (1) A form of net mask with a holding string attached high up on the center face; (2) the wearer of such a costume.

abɔsi. A sacred tree in the masqueraders' dressing place *(ajaba)*. Also found growing elsewhere at Afikpo.

acali. A small wooden mask worn by young masqueraders.

agbɔghɔ. An adolescent girl.

agbɔghɔ mma. (1) Costume of young men dressed as adolescent girls at the *njenji* masked parade; (2) the players wearing this costume.

agbɔghɔ ɔkumkpa. The "queen" masquerader at the *ɔkumkpa* play, representing the girl who is reluctant to marry.

ahia. (1) An iron rod that is heated and used to bore holes in masks; (2) a raffia rattle.

ahɔ. Third day of the four-day Igbo week, a nonfarming day on which two small markets meet at Afikpo.

ajaba. Roofless dressing house found in each common in Afikpo villages belonging to the Itim subgroup. The house is used for changing into and out of masked costumes for secret society masquerades.

akopia eka. (1) Musicians at the *oje ogwu* masked dance; (2) costumes of these musicians.

akparakpa. (1) Costume worn by younger *ɔkumkpa* players who imitate females in dress and behavior; (2) the players wearing that dress.

akware. Wooden xylophone (also called *igɛri*).

anwɛrɛwa. A leaf used as sandpaper in mask-making.

aso. A small, braided leaf arrangement worn by some Afikpo masqueraders.

atankwiri. (1) A form of *logholo* costume with a net mask and a dark green, leafy costume having a fiber and leaf hat; (2) the player wearing this costume.

atɔ. (1) A small adze; (2) a U-shaped or J-shaped cutting tool; (3) a chisel. All are iron tools used in the carving of wooden masks.

beke or *mbeke.* (1) White person; (2) a wooden white-faced mask that is said to resemble white persons.

ci. (1) A personal shrine established by married women at Afikpo; (2) the spirit of this shrine. In other Igbo areas *ci* is the personal spirit of both men and women.

ebɵ. A praise singer.

ebulu. (1) The younger and less skilled dancers at the *oje ogwu* masquerade; (2) their costume.

egbele.	The village spirit of the secret society (also called *omume).*
egbiri.	(1) A net-masked, raffia-body costume with an elaborate black headgear. The player carries a horsetail switch. (2) The wearer of this costume.
egede.	An ancient form of shield worn by *igri* players at the *njenji* masked parade.
Ego.	One of the ancient peoples of Afikpo, probably of non-Igbo origin.
ekɔrɔ.	A headpiece with leaves of that name and yellow fibers, which is employed in several masquerade costumes.
ekwu.	A cooking-pot stand, usually consisting of three stones.
enna.	A boy (occasionally an older male) who is not yet an initiate of the village secret society.
enya.	(1) Openings in the raffia backing of masks to allow better viewing; (2) the eye.
erewe.	(1) The older and better dancers at the *oje ogwu* masquerade; (2) their costume.
ɛgɛlɛ.	A single-element iron gong.
ɛgwu.	Raffia.
ɛkɛ.	The first day of the four-day Igbo week, a nonfarming day on which the main Afikpo market meets.
ɛkikɛ.	A protective charm or shrine in which leaves or fibers are tied together.
ɛkpa ukɛ ɛsa.	The middle grade of the Afikpo elders.
ɛkpo atam.	(1) A costume involving a wine-colored shirt and a large *ikpo* brass bell worn at the hip with a waistcloth. Used by the rearmost players in line at the *njenji* parade. (2) The players themselves.
ɛkwɛ.	A wooden gong.
gari.	Cassava meal.
hihi.	(1) A net mask with a holding string at the lower center of the face; (2) the wearer of such a mask.
ibibio.	(1) A people living south and southeast of the Igbo who are culturally much like them; (2) a type of wooden mask used at Afikpo which is of Ibibio origin.
ibini ɔkpabe.	(1) A famous Igbo oracle located at Aro Chuku; (2) shrines at Afikpo associated with this oracle; (3) the spirit of an *ibini ɔkpabe* shrine.
igɛri.	(1) A xylophone (also called *akware*); (2) another name for the *okonkwɔ* masked dance.
igri.	(1) A wooden mask, of greater vertical height than most Afikpo masks, whose wearer acts eccentric or somewhat mad; (2) the wearer of this mask.
ihie ogo.	A masquerade of any form.
ihu.	(1) Face; (2) mask.
iko udumini.	The Rainy Season Festival.
iko ɔkɔci.	The Dry Season Festival.
ikpem.	(1) A costume consisting of a raffia skirt and shirt with a *mma ji* wooden mask used in the *ikwum* form of secret society initiation; (2) the wearer of such a costume.

ikpirikpɛ.	A small skin-headed drum.
ikpo.	(1) The highest wrestling grade; (2) a type of brass bell worn by this grade and also by certain players in the *njenji* masked parade.
ikpθ.	(1) A form of *logholo* costume with a dark net mask and a body costume of green leaves; (2) the player who wears this costume.
ikɔro.	A large wooden slit gong found in every Afikpo village. Commonly called the "village drum," although technically a gong.
ikwum.	A short form of secret society initiation for first sons whose fathers have died before they were initiated, but also a form sometimes taken by other sons.
inyiri.	Charcoal ash used to blacken masks and the false hair pieces in some masquerade costumes.
isiji.	The form of initiation into the village secret society performed by a man's eldest son.
isubu eda.	A short and popular form of initiation for sons other than first sons done in the Itim villages of Afikpo and deriving from nearby Edda Village-Group.
logholo.	(1) A variety of masks and costumes worn by secret society men who are chased by uninitiated boys; (2) the most common form of *logholo* in which the player wears one of a variety of masks in wood and a raffia body costume; (3) a costume worn by uninitiated boys using nonwooden and non-net masks with a raffia skirt who are chased by uninitiated boys; (4) the players who wear any of the above.
mba.	(1) A wooden mask style with a white face and a decorated board projecting up from it, generally worn by younger masqueraders; (2) a type of wood used in making some Afikpo masks.
mbubu.	A gourd (calabash) mask of abstract design worn by an eldest son as part of his secret society initiation (*isiji*).
mɛmɛ.	The term for any "title" at Afikpo.
mkpe.	(1) The horn or horns of an animal; (2) a form of wooden mask resembling a goat's head.
mkpere.	A variety of *mba* mask employed in the *omumɛ* title ceremonies associated with the initiation of the eldest son into the secret society. It has triangular cut-out sections on the vertical board above the head.
mma.	(1) A general term for spirits, including ancestral ones; (2) a term for masked players.
mma ji.	A wooden mask whose top-piece has the appearance of a yam knife.
mmaw.	A term found in other Igbo areas than Afikpo and its environs, probably similar in origin to the Afikpo *mma*. Used for (1) white-faced masks with elaborate headcrests which represent females; (2) the name of the mask and costume together. Not found at Afikpo.
ndɛ ɛrosi.	The ritual group within the village secret society.
ngwu.	(1) A headdress worn by *igri* players at the

	masked *njenji* parade; (2) a particular leaf forming part of that headdress.
njenji.	A masked parade performed at the Dry Season Festival.
nkwa.	A musician or musicians.
nkwɔ.	The fourth day of the four-day Igbo week. A farm day at Afikpo.
nnade ɔkumkpa.	(1) The special forms of wooden masks worn only by the senior and junior leaders of the *ɔkumkpa* masquerade play; (2) the names given to the leaders themselves (also called *ɔkumkpa odudo*).
nne mgbo.	A white-faced, female-style wooden mask form.
nsi mano.	A protective medicine made from dried fish, palm oil, and other ingredients.
nto.	The mask carver's working place in the bush.
ntutu.	An iron needle used in making the raffia backing for the masks.
nwea ɛrɛ.	Wool chest halter worn by certain masqueraders.
nzu.	(1) A whitish chalk used in decorating masks, the human body, and as a sacrificial material at certain shrines; (2) the color white.
obuke.	(1) A form of *logholo* costume using *ɔtogho*, the bird mask; (2) the player who wears this costume.
oca.	The color white (also called *nzu*).
ocici.	A wooden bowl for hot pepper sauce used in eating kola nuts and other foods.
odo.	(1) A yellow powder from the bark of a certain tree, used in decorating masks and the human body and as a sacrificial material; (2) the color yellow.
odudo ɛgwu ale.	The assistant leaders at the *ɔkumkpa* play.
ogbukpɔ.	(1) Carver; (2) carpenter, or one who works in wood.
ogo.	(1) Village; (2) subvillage or ward; (3) village men's secret society.
oje ogwu.	A net-masked, raffia-costumed dance.
ojii.	Black or dark—a characteristic color of the ugly group of Afikpo masks.
oke ekpa.	(1) A form of *ɔkpa* masquerade with a loose-fitting net body costume and an *ibibio* mask; (2) the players who wear this costume.
okonkwɔ.	A wood-masked dance of men imitating females (also called *igɛri*).
okpoha.	A variety of the ugly wooden *ɔkpesu umuruma* mask form deriving from nearby Okpoha Village-Group.
okwe.	A light, porous wood used in making some masks.
omenka.	(1) Carver; (2) carpenter, or one who works in wood.
omomo.	An iron gong.
omume.	A term for the spirit of the village men's secret society (also called *egbele*).
omumɛ.	The highest and most expensive Afikpo title.
orie.	The second day of the four-day Igbo week, a farming day at Afikpo.

ovu ɛjo.	A society of prominent and wealthy women at Afikpo.
uhie.	(1) Camwood, a tree with reddish wood; (2) the powder ground from the wood of this tree and used in decorating masks; (3) the color red.
ukpu egwθ.	A form of raffia dress worn in secret society initiations and at the *ɔkumkpa* play by the older players.
urukpo mma.	(1) The costume representing married women at the *njenji* masked parade; (2) the players wearing that costume.
ɔba.	A yam barn or yam racks (for storing yams).
ɔgbθ.	(1) A net mask made of string fiber; (2) a fishing net.
ɔgbθ kpakpokpakpo.	A net-masked, brown raffia-costumed player with a braided raffia headpiece, appearing in the *njenji* parade.
ɔhia θmθ enna.	Boys' imitation secret society located in back of the compound.
ɔka.	A form of secret society initiation taken both by first and other sons.
ɔkpa.	(1) Full head and body costume made of native fiber or European string which is worn tightly on the body; (2) the wearer of the costume, who likes to chase about.
ɔkpa eda.	Net-masked, raffia-costumed players who carry small machetes or knives in the *njenji* masked parade.
ɔkpesu umuruma.	An ugly, dark-faced wooden mask form, often with distorted facial features (also called *ɔri*).
ɔkumkpa.	A masked play, with songs, dances, and skits, satirical in nature and performed by the members of the village secret society.
ɔkumkpa odudo.	The two *ɔkumkpa* play leaders (also called *nnade ɔkumkpa*).
ɔkɔci.	The dry season.
ɔkwa ebθ.	Raffia costume of praise singers in the *njenji* masked parade.
ɔkwθ.	(1) A form of *logholo* costume with the goat (*mkpe*) mask; (2) the player who wears this costume.
ɔpa nwa.	A white-faced wooden mask of a female face having a wooden human figure on top of it.
ɔri.	(1) Dress of dark raffia strands worn by older *ɔkumkpa* players; (2) the players who wear this dress; (3) the *ɔkpesu umuruma* masks; (4) something ugly; (5) evil.
ɔteghita.	Net-masked, raffia-skirted players, wearing black high hats, in the *njenji* masked parade, who generally dance in pairs.
ɔtɛro.	(1) A net-masked, banana-leaf costumed dress worn by a threatening and destructive player; (2) a costume of banana leaves and a raffia head and face piece worn by uninitiated boys; (3) the player wearing either of these costumes.
ɔtogho.	A wooden mask somewhat resembling a bird's face employed in certain masquerade chasing plays.

Bibliography

Ames, D.
 1968 "Professionals and Amateurs: The Musicians of Zaria and Obimo," *African Arts*,
 1 (no. 2): 40-45, 80-84.

Anon.
 1927 "Intelligence Report, Afikpo Division, Ogoja Province." Unpublished ms.

Anon.
 1935 "The Cult of Arisi Edda by D. O. Afikpo." Afikpo NA 106/vol. 2, p. 41. Unpublished ms.

Ardener, E. W.
 1954 "Some Ibo Attitudes to Skin Pigmentation," *Man*, 54 (art. 101): 71-73.

Bascom, W.
 1967 *African Arts*. Berkeley; Calif.: R. H. Lowie Museum of Anthropology.

Beier, U.
 1960 *Art in Nigeria*. London: Cambridge University Press.
 n.d. "Ibo and Yoruba Art," *Black Orpheus*, 8: 46-50.

Biebuyck, D. P. (ed.)
 1969 *Tradition and Creativity in Tribal Art*. Berkeley and Los Angeles: University
 of California Press.

Boston, J. S.
 1960 "Some Northern Ibo Masquerades," *Journal of the Royal Anthropological
 Institute*, 90 (no.1): 54-65.

Bravmann, R. A.
 1970 *West African Sculpture*. Seattle and London: University of Washington Press.

Cole, H. M.
 1969 "Art as a Verb in Iboland," *African Arts*, 3 (no. 1): 34-41, 88.
 1970 *African Arts of Transformation*. Santa Barbara: The Art Galleries, University of California.

Daji. [pseud.]
 1934 "Okorosia," *Nigerian Field*, 3 (no. 4): 175-77.

Emery, Irene.
 1966 *The Primary Structure of Fabrics: An Illustrated Classification*. Washington, D.C.:
 The Textile Museum.

Fagg, W. and H. List
 1963 *Nigerian Images*. London: Lund Humphries.

Forde, D., and G. I. Jones
 1950 *The Ibo and Ibibio-Speaking Peoples of South-Eastern Nigeria*. (International African
 Institute, Ethnographic Survey of Africa, Western Africa, Part III.) London:
 International African Institute.

Gluckman, M.
 1963 "Gossip and Scandal," *Current Anthropology*, 4 (no. 3): 307-16.

Great Britain, Colonial Office.
 1951 *Traditional Sculpture from the Colonies: An Illustrated Handbook for the Exhibition of
 Traditional Art from the Colonies held in the Art Gallery of the Imperial Institute,
 May to September 1951*. London: Her Majesty's Stationery Office.

Harris, R.
 1965 *The Political Organization of the Mbembe, Nigeria* (Great Britain, Ministry of Overseas
 Development, Overseas Research Publication, no. 10.) London: Her Majesty's
 Stationery Office.

Himmelheber, H.
 1960 *Negerkünst und Negerkünstler*. Braunschweig: Klinkhardt and Biermann.

Irvine, F. R.
 1950 *West African Agriculture*, 13th impression. London: Oxford University Press.

Jeffreys, M. D. W.
 1951 "The Ekon Players," *Eastern Anthropologist*, 5 (no. 1): 41-48.

Jones, G. I.
 1938 "The Distribution of Negro Sculpture in Southern Nigeria," *Nigerian Field,* 7 (no. 3): 102-8.
 1939a "On the Identity of Two Masks from S. E. Nigeria in the British Museum,"
 Man, 39 (art. 35): 33-34.
 1939b "Ifogu Nkporo," *Nigerian Field,* 8 (no. 3): 119-21.
 1945a "Masked Plays of South-Eastern Nigeria," *Geographical Magazine,* 18 (no. 5): 190-200.
 1945b "Some Nigerian Masks," *Geographical Magazine,* 18 (no. 5): 200, plus 8 plates.
Kemp, S. J.
 1967 "Some Relationships between Style and Tool Form in Kwakiutl and Afikpo Carved
 Masks." M.A. thesis, Department of Anthropology, University of Washington.
Leach, E. R.
 1961 "Aesthetics," in E. E. Evans-Pritchard (ed.), *The Institutions of Primitive Society,*
 pp. 25-38. Oxford: Blackwell.
McFarlan, D. M.
 1946 *Calabar: The Church of Scotland Mission, 1846-1946.* London: Thomas Nelson.
Merriam, A. P.
 1965 "Music and the Dance," in R.A. Lystad (ed.), *The African World,*
 pp. 452-68. New York: Praeger.
Messenger, J.
 1958 "Reflections on Esthetic Talent," *Basic College Quarterly* (Michigan State University),
 4 (no. 1): 20-24.
 1962 "Anang Art, Drama, and Social Control," *African Studies Bulletin,* 5 (no. 2): 29-35.
 1971 "Ibibio Drama," *Africa,* 41 (no. 3): 208-22.

Nigeria, Census Superintendent.
 1953-54 *Population Census of the Eastern Region of Nigeria,* 1953 (8 parts). Port Harcourt:
 C.M.S. Niger Press; Zaria: Gaskiya Corporation.
Nketia, J. H.
 1963 *Drumming in Akan Communities in Ghana.* London: Thomas Nelson and Sons.
 1970 "The Music of Africa and African Unity," *Insight and Opinion,* 5 (no. 4): 90-103.
Nzekwu, O.
 1960a "Masquerade," *Nigeria Magazine* (special independence issue), pp. 135-44.
 1960b "Gloria Ibo," *Nigeria Magazine,* 64: 72-88.
 1963 "The Edda," *Nigeria Magazine,* 76: 16-28.
Okosa, A. N. G.
 1962 "Ibo Musical Instruments," *Nigeria Magazine,* 75: 4-14.
Ottenberg, P.
 1958 "Marriage Relationships in the Double Descent System of the Afikpo Ibo of
 Southeastern Nigeria." Ph.D. dissertation, Northwestern University.
 1959 "The Changing Economic Position of Women among the Afikpo Ibo," in
 W. R. Bascom and M. J. Herskovits (eds.), *Continuity and Change in African Cultures,*
 pp. 205-23. Chicago: University of Chicago Press.
 1965 "The Afikpo Ibo of Eastern Nigeria," in J. L. Gibbs, Jr. (ed.),
 Peoples of Africa, pp. 1-39. New York: Holt, Rinehart and Winston.
Ottenberg, S.
 1955 "Improvement Associations among the Afikpo Ibo," *Africa,* 25 (no. 1): 1-25.
 1958 "Ibo Oracles and Intergroup Relations," *Southwestern Journal of Anthropology,*
 14 (no. 3): 295-317.
 1967 "Local Government and the Law in Southern Nigeria," *Journal of Asian and African*
 Studies, 2 (nos. 1-2): 26-43. Reprinted in John Middleton (ed.), *Black Africa:*
 Its Peoples and Their Cultures Today, pp. 111-25. New York: Macmillan, 1970.
 1968 *Double Descent in an African Society: The Afikpo Village-Group.* (American
 Ethnological Society Monograph 47.) Seattle and London:
 University of Washington Press.
 1970 "Personal Shrines at Afikpo," *Ethnology,* 9 (no. 1): 26-51.
 1971a "A Moslem Igbo Village" *Cahiers d'études africaines,* 11 (no. 2): 321-60.
 1971b *Leadership and Authority in an African Society: The Afikpo Village-Group.*
 (American Ethnological Society Monograph 52.) Seattle and London:
 University of Washington Press.
 1971c "The Analysis of a Traditional African Play," in Ghana Museums and
 Monuments Board, *Annual Museum Lectures 1969-1970, pp. 50-60.*
 Accra: Ghana Museums and Monuments Board. Reprinted in *Research Review,*
 Institute of African Studies, University of Ghana, 7 (no. 3): 66-84.
 1971d *Anthropology and African Aesthetics: An Open Lecture presented at the*
 University of Ghana, January 28, 1971. Accra: Ghana Universities Press.
 1972a "Humorous Masks and Serious Politics at Afikpo," in Douglas Fraser and Herbert M. Cole
 (eds.), *African Art and Leadership,* pp. 99-121. Madison: University of Wisconsin Press.

| | 1972b | "The House of Men," *African Arts*, 5 (no. 4): 42-47, 85-88. |
| | 1973 | "Afikpo Masquerades: Audience and Performers," *African Arts*, 6 (no. 4): 32-35, 94-95. |

Plass, M.
1956 *African Tribal Sculpture*. Philadelphia, Penn.: University Museum.

Segy, L.
1969 *African Sculpture Speaks*. 3rd ed. New York: Hill and Wang.

Starkweather, F.
1968 *Traditional Igbo Art, 1966*. Ann Arbor: Museum of Art, University of Michigan.

von Wendorff, G., and L. Okigbo
1964 *Some Nigerian Woods*. 2nd ed. Lagos, Nigeria: Ministry of Information.

Welsford, E.
1961 *The Fool: His Social and Literary History*. Garden City, N.Y.: Anchor Books.

Willett, F.
1971 *African Art*. New York: Praeger.

Wingert, P. S.
1962 *Primitive Art: Its Traditions and Styles*. New York: Oxford University Press.

Wolfe, A. W.
1969 "Social Structural Bases of Art," *Current Anthropology*, 10 (no. 1): 3-44.

Index